To Penelope
My partner in life and travel.

THE GRA

Harry Seidler Travelling the World with an Architect's Eye

ND TOUR

TASCHEN
Bibliotheca Universalis

**EACH AND EVERY TASCHEN BOOK
PLANTS A SEED!**
TASCHEN is a carbon neutral publisher.
Each year, we offset our annual carbon
emissions with carbon credits at the
Instituto Terra, a reforestation program in
Minas Gerais, Brazil, founded by Lélia and
Sebastião Salgado. To find out more about
this ecological partnership, please check:
www.taschen.com/zerocarbon
**Inspiration: unlimited.
Carbon footprint: zero.**

To stay informed about TASCHEN and
our upcoming titles, please subscribe to
our free magazine at www.taschen.com/
magazine, follow us on Twitter, Instagram,
and Facebook, or e-mail your questions
to contact@taschen.com.

© 2019 TASCHEN GmbH
Hohenzollernring 53, D-50672 Köln
www.taschen.com

© for all photographs: Harry Seidler

Original edition: © 2007 TASCHEN GmbH

© 2019 VG Bild-Kunst, Bonn,
for the works of Walter Gropius, Ludwig
Mies van der Rohe and Frank Lloyd Wright

© 2019 Barragán Foundation/VG Bild-Kunst,
Bonn, for the works of Luis Barragán

© 2019 FLC/VG Bild-Kunst, Bonn,
for the works of Le Corbusier

Designed by Massimo Vignelli
Translation by Latido, Bremen

Printed in China
ISBN 978–3–8365–4460–3

Contents

Introduction

This book aims to depict the foremost accomplishments in architecture and the built environment that I have seen in my travels around the world. The photographs which I took over a period of more than 50 years, juxtapose images of structures dating back as far as 3000 BC with the most modern architectural achievements. My predisposition to travel started involuntarily at the age of 15 in my native Vienna, which I left following the Anschluss in 1938. After a 10-year circuitous odyssey – from internment in England, then in Canada, to studies there and in the USA, and afterwards to work in Brazil – I finally settled in Australia and began my career as an architect in 1948.

After some years, my global journeys started with ever-increasing frequency, and I saw at first-hand the most celebrated buildings in Europe, Asia and America. With frequent stops in Rome to consult the engineer Pier Luigi Nervi about my concrete structures, I first experienced the true impact of historic architecture, developing what I call a "passive" appreciation and respect for the great building achievements of the past. I perceived this as a simultaneous "active" love and dedication to the idea of developing an appropriate architecture that was expressive of the artistic and technological impact of building today. One can appreciate traditional architecture in the context of its period and the given circumstances of its creators' artistic aspirations, technical means and the social-political conditions of its time whilst retaining involved and active enthusiasm for the masterpieces of the time in which one builds oneself.

The ease and speed of jet travel opened up the world in the 1960s. My frequent visits to Rome were extended, later involving trips to my buildings undergoing construction in Paris, Mexico, Hong Kong and recently in my hometown of Vienna. In addition, teaching and lecturing in many countries extended this routine to long-distance flying three or four times a year, but always afforded me time for photography, recording the delight I felt seeing

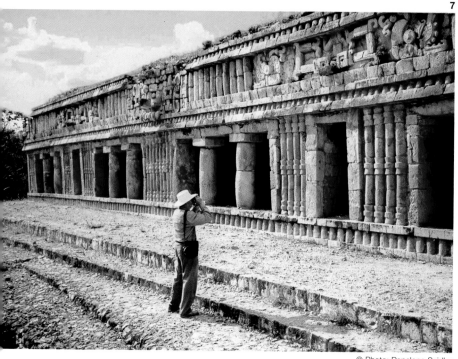

© Photo: Penelope Seidler

vnship environments and iconic buildings
all eras.

e extensive assembly of images in this
ok aims to be of international interest to
lay public, architects, students of
hitecture and historians equally, in the
e that they will be encouraged to travel,
to seek out what I feel to be much of
finest architecture man has achieved in
time and throughout recorded history.
brother, the photographer Marcell
19–1977), gave me simple advice when
arted to record architectural sites: "Only
Leica cameras and Kodachrome film,
ch is archival." I adhered to this when
ng all the images in this book, some
r 50 years ago.

Egypt

Egyptian antiquity has always been regarded as unique. The works handed down to us are of gargantuan size, built millennia ago of solid stone, and include pyramids, obelisks, temples, sculptures and artworks. It seems inconceivable to visualise how these enormous works, such as 250 ton stone obelisks, were physically brought into existence, extracted and erected, with the minimal technical means available, 5,000 years ago.

Spread along the fertile Nile Valley, these great structures lie on both sides of the river. It was all developed by people with the longest-lasting stable civilisation in antiquity.

The autocratic kings, who were worshipped as divine royalty, had huge works built as visible memorials – burial chambers contained in the great pyramids, or colossal statues of their images. They left evidence of their riches through the luxury articles and solid gold masks found in their tombs. One outstanding example is the temple built in honour of the god Amun at Karnak by pharaoh Ramesses II, with its closely spaced sandstone columns some 25 m high and 3 m in diameter. The capitals are of lotus form, covered with incised figures and hieroglyphics in the Hypostyle Hall, which is lit from above through clerestory openings. The surfaces of depository limestone or sandstone walls and columns have inevi-tably deteriorated and fretted away with time. The Ancient Egyptians must have been well aware of this because when it came to sculpturing the images of their gods, such as the falcon bird Horus, or the heads of pharaohs, they used igneous stone such as solid granite.

The image of Horus, made of Aswan black granite, has been standing exposed to the elements flanking the entrance of the Temple at Edfu for the last 3,500 years. It in perfect condition, with edges sharp and features undisturbed. Today's salesmen of newly developed materials claim that their products will stand the test of time, but I prefer to believe in the irrevocable evidence offered by Horus when I choose exterior materials for my buildings.

The form-language used by the Ancient Egyptians in their structures is minimal. The silhouettes read distinctively and powerfully even from a distance. It is only when approaching that one becomes aware of the human figures and hieroglyphics incised in them, which gives richness to the geometric forms. The characteristic, outwardly tapered temple walls display evidence of an intuitive response to the need for lateral structural stability and resistance to earthquakes. The benign frost-free climate of Egypt has contributed to the remarkable condition of these structures, which have survived for millennia.

With the construction of the Aswan High Dam in the 1960s, numerous ancient monuments and temples were threatened with inundation. Under the initiative of UNESCO, some of them were saved by being moved and reconstructed on higher ground. The most dramatic examples were the Abu Simbel colossal sculptures of Ramesses II, which were rebuilt against an artificially constructed mountain, but the final result was identical to the original.

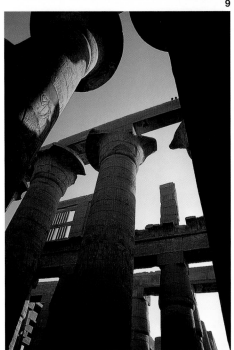

1 **Karnak, Temple of Amun, 1550 BC**

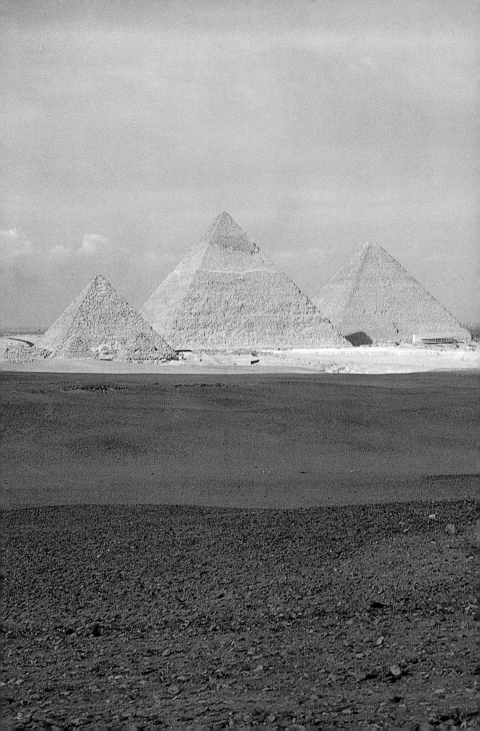

Gizeh, Pyramids of Cheops, 2250 BC

The very icons of Ancient Egypt, these giant minimal sculptures stand in a sandy desert area near Cairo. The largest is 146.6 m high on a square base of 230 m, built of solid limestone blocks weighing some 2 tons each. The pyramid contains the King's and, below it, the Queen's burial chambers near its centre, reached by an internal sloping grand gallery made of granite. Originally, the pyramids were covered in finely finished limestone with the peak reputed to have been covered in gold. All of this, however, was pillaged over the centuries.

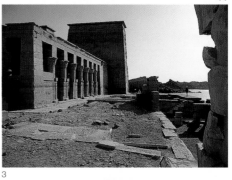

3

Philae, Temple of Isis, 330 BC

Rebuilt on high ground to avoid dam inundation.

Edfu, Temple of Horus, 237–57 BC

The great pylon-portico has the characteristically tapered profile of a number of temples, which gives lateral stability to the 30 m high structure. A beautifully proportioned entrance is topped by a stone wing element and opens onto an internal colonnaded court leading to the inner sanctum of the temple.

4

5 Sakkara, 3000 BC
Entrance into a palace court with beauti-
fully proportioned opening and recesses
in the masonry surface.

6 Karnak, Temple of Amun
Incised figures and hieroglyphics on a
limestone wall.

7 Karnak, Temple of Amun
Entry into the Hypostyle Hall flanked by
huge granite figures.

8 Karnak, Temple of Amun, 1550 BC
Hypostyle Hall with closely spaced huge
columns, incised with figures and
hieroglyphics.

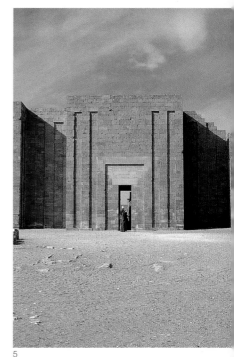

5

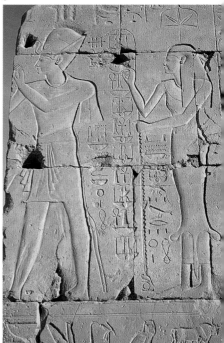

6

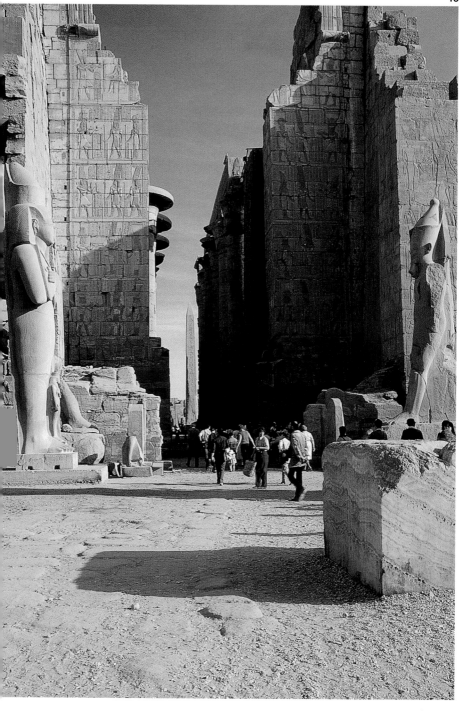

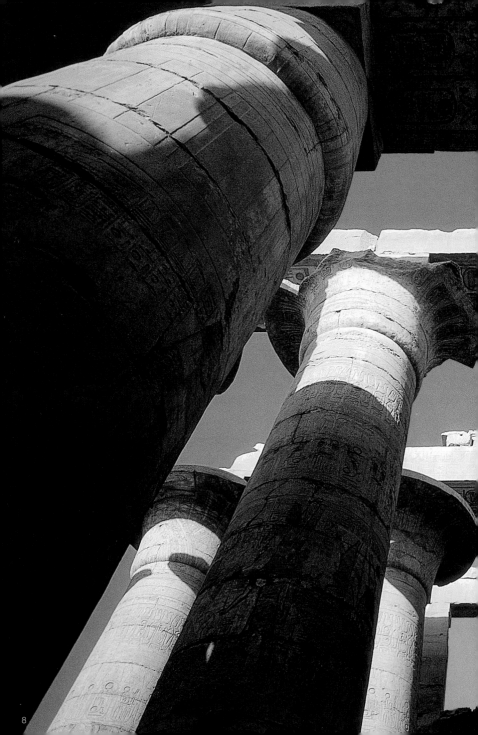

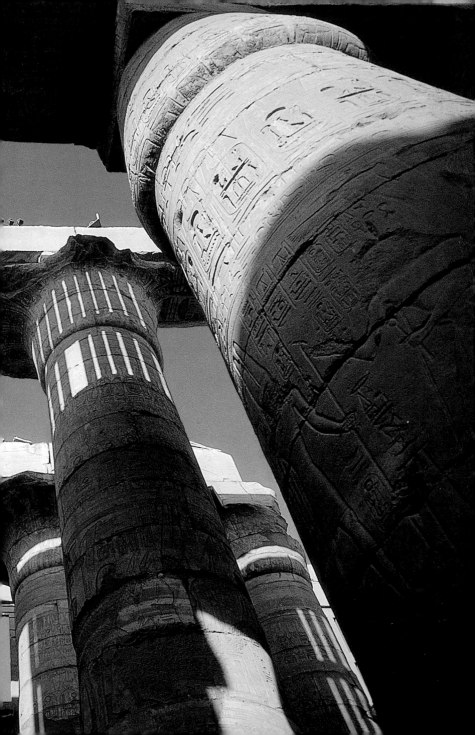

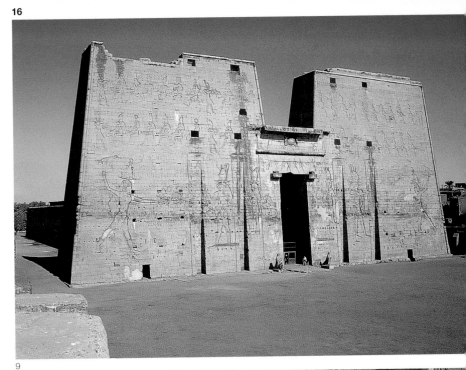

9

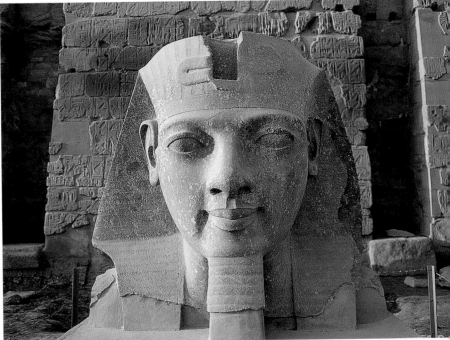

10

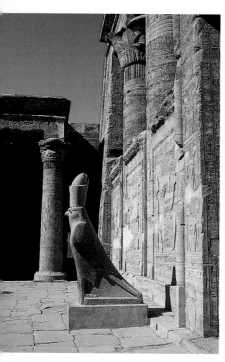

9 Temple at Edfu, 237–57 BC

10 Luxor Temple
Head of Ramesses II.

11 Temple at Edfu
Granite figure of Horus at the entrance.

12 Luxor Temple
Entry to the Temple, with seated figures and obelisk. The missing right-side obelisk was taken to France in the 19th century and erected on the Place de la Concorde (see France, photo 45).

13 Philae, Temple of Isis, 330 BC
The Temple was raised and rebuilt faithfully on a high-ground island prior to the flooding of the Aswan Dam. The symmetrical portico structure is reminiscent of other temples, but the opposing irregular spatial disposition of the arcaded forecourt wings catches the eye. Beautiful, ever-changing spaces result as one walks through the complex.

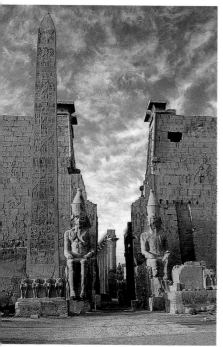

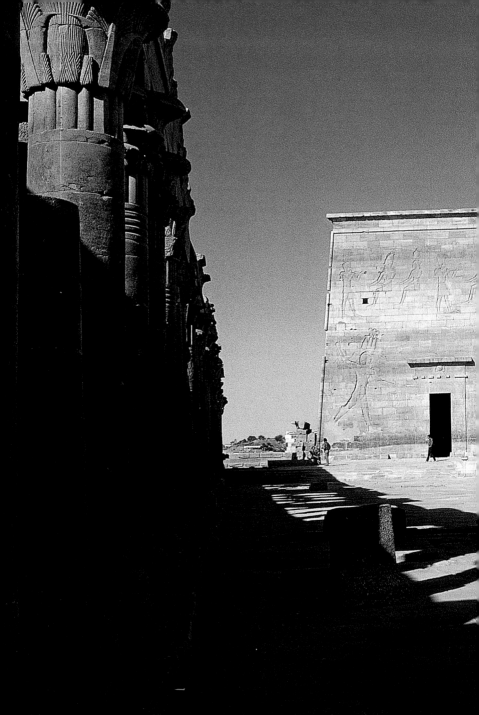

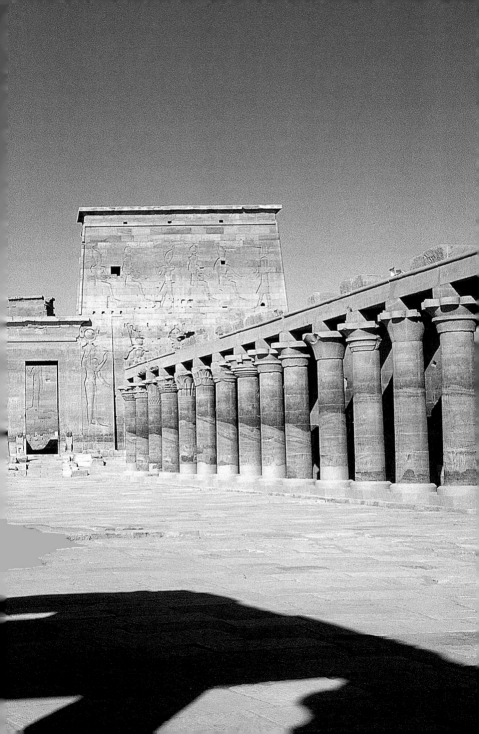

14, 17 Nubia, Abu Simbel
The giant, rock-hewn sculptures of
Ramesses II, raised and rebuilt.

15 Nubia, Kalabsha Temple
The Temple, rebuilt on high ground, is only
reachable by water.

16 Esna, Chnum Temple
The Temple stands in a town and is
surrounded by buildings. It is smaller
than others with a colonnade enclosed
by screen walls.

18 Gizeh, The Sphinx, 2500 BC
Although damaged over centuries, its
human head and animal body remain
an unforgettable image.

19 Thebes, Temple of Queen
Hatshepsut, 1550 BC
Architect: Senenmut
The setting of this terraced mortuary temple
is spectacular. From the Nile Valley it is
approached by ramps to three levels rising
toward the base of dramatic high rock cliffs.
Double colonnades surround walled courts
with fine incised relief sculptures.

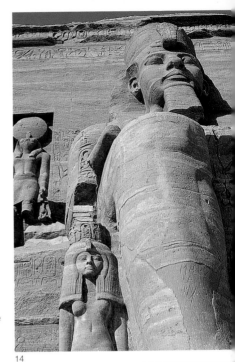

14

15

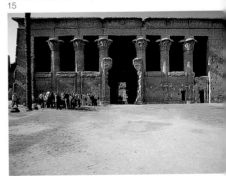

16

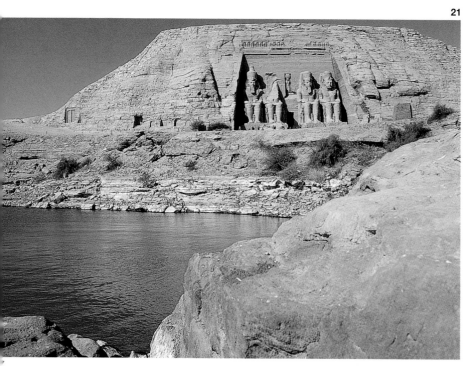

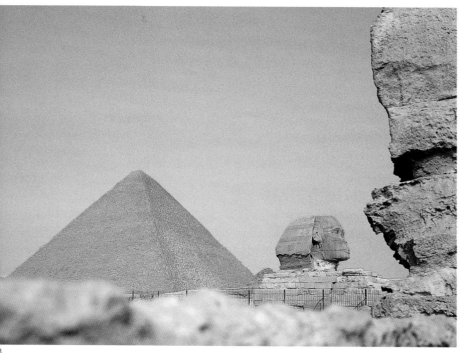

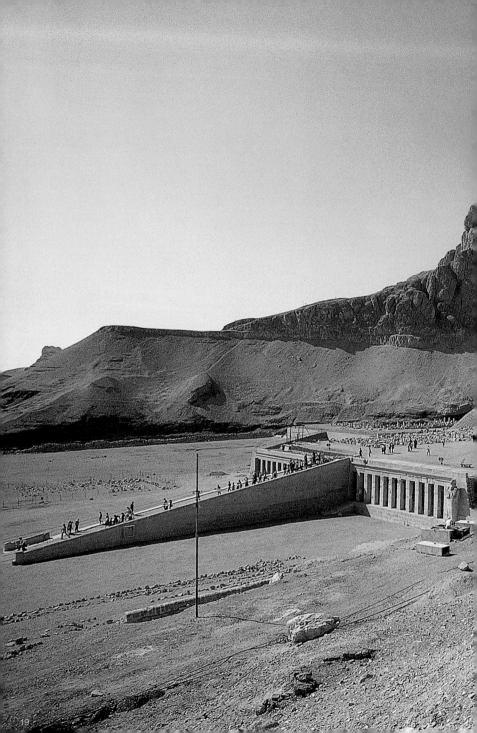

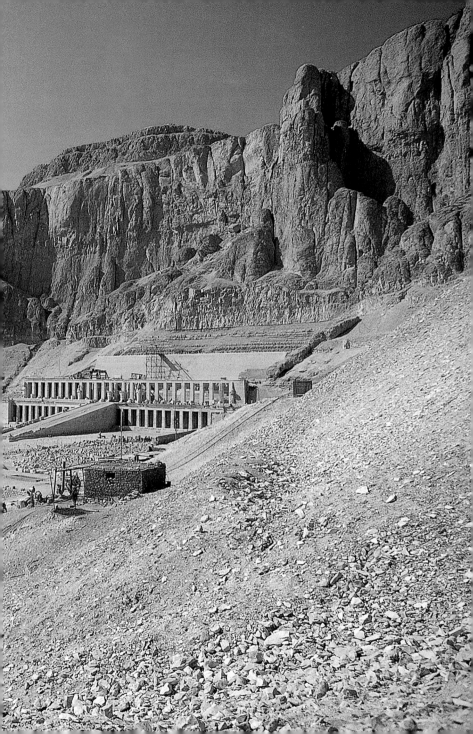

Greece

The rich legacy of Ancient Greece between 500 and 300 BC formed the fountainhead of Western civilisation – in the arts, in literature, in skills of government, and especially in architecture. The design of temple buildings contained such subtle depths of aesthetic sensibility that it became the prototype for important buildings and monuments for the next 2,500 years. This heritage can rightfully be called the "International Style" rather than 20th-century architcture, which the term is often used to describe, as this changed constantly and was not a style.

Greek architectural practice has been recorded and studied, particularly the optical refinements of temple façades, which were repeated for centuries on important buildings throughout most of the civilised world. Perhaps the finest ancient examples are the sanctuary buildings on the Acropolis in Athens. They possess the visual adjustments devised to combat optical illusions and achieve a "corrected" view of reality for the onlooker. Marble column shafts were tapered toward the top to appear straighter and more graceful. Building bases were convex in the centre to look more horizontal and the spacing of portico end columns was made closer so as to appear more equal with the adjoining group, etc.

Column designs followed one of three main "Orders": Doric is the simplest, with fluted sharp arrised grooves, Ionic has voluted scroll capitals, and Corinthian is sculptured in the form of acanthus leaves. Our eyes are fully attuned to seeing these ubiquitous Greek forms on buildings, which were a prescribed style in certain periods of history. Construction of such buildings is highly labour-intensive and virtually impossible to replicate today, but yet many people still feel comfortable with them and relate to them more than they do to much of the architecture of our own time.

In more recent centuries, the architecture and urban fabric of the Greek Islands developed from the use of arches and domes, especially in the celebrated steep hillside towns of Mykonos and Santorini.

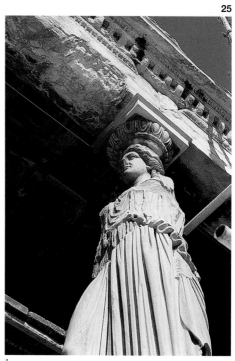

1

1 Erectheion, 421–406 BC
Caryatid (a column in the form of a statue
of a woman), Erectheum, Athens.

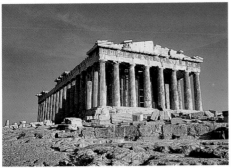

2

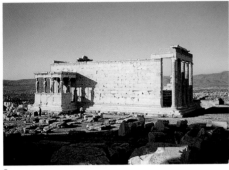

3

2 Athens, Parthenon, 440 BC
Architects: Ictinus and Callicrates
The Parthenon Temple of Athena,
considered the most perfect building in
classical antiquity.

3 Athens, Erectheion, 421–406 BC
Architect: Mnesicles
An irregular building on the Acropolis with
an attached porch supported by caryatids.

4 Athens, Propylaea, 437–432 BC
The portico to the Acropolis.

5 Athens, Acropolis
Built on a platformed mountain.

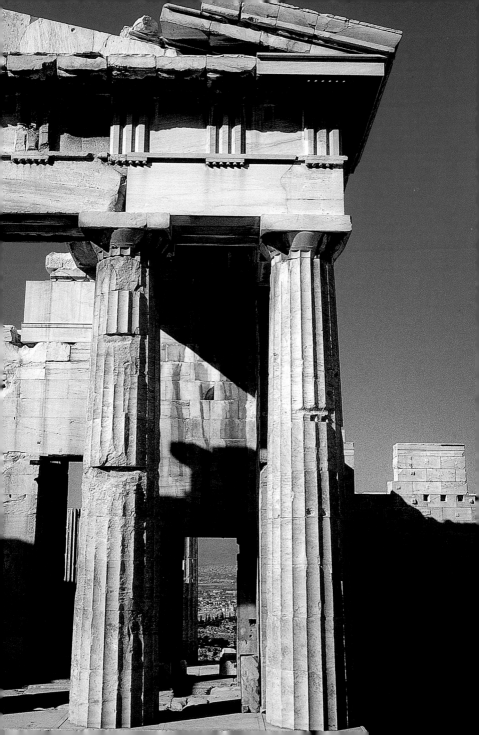

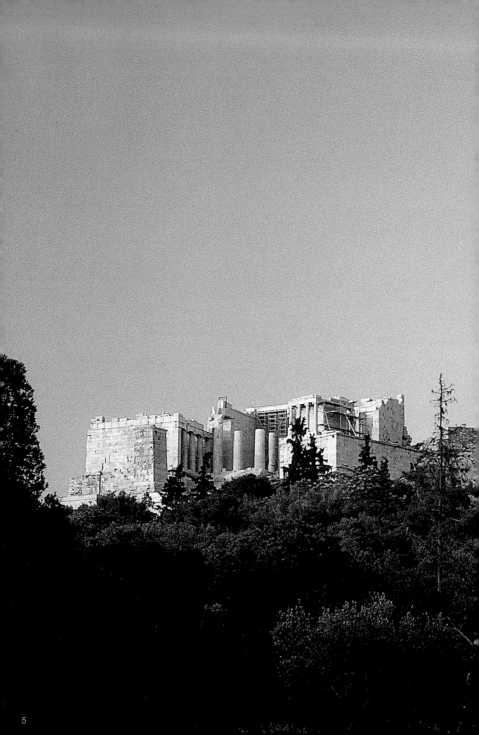

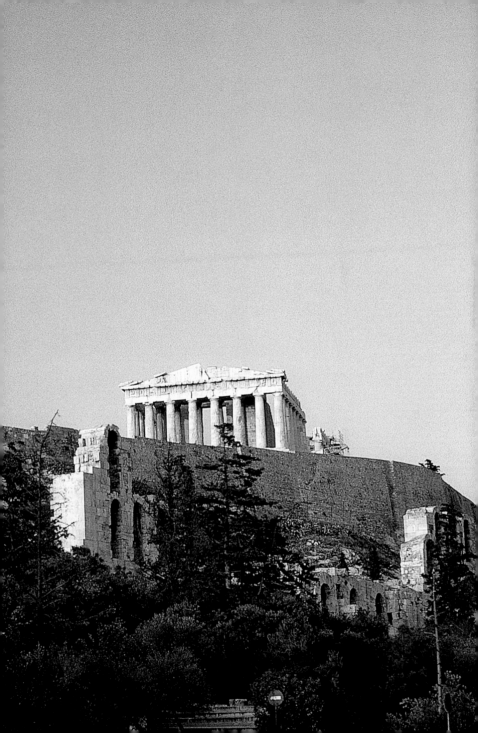

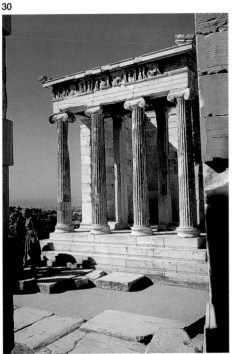

6

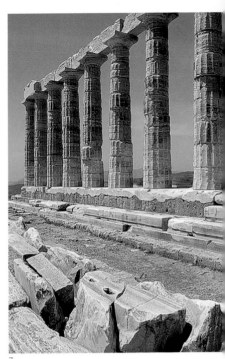

7

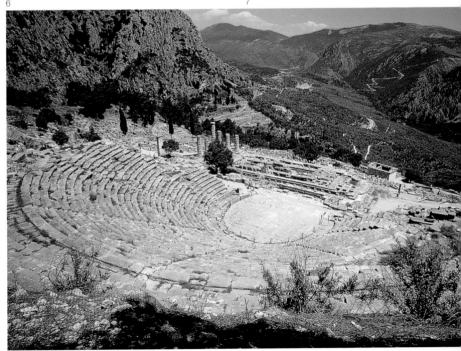

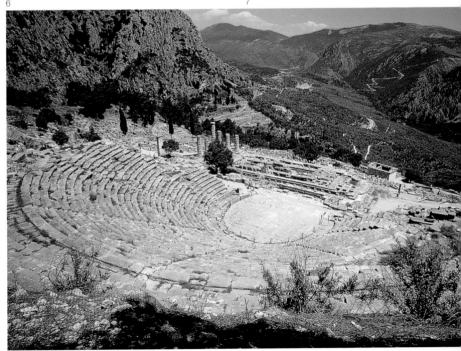

8

Athens, Temple of Athena, Nike pteros, 427–424 BC

chitect: Callicrates

e small structure defies regularity by ing placed at an angle, resulting in a namic spatial relationship with the jacent Propylaea.

Sounion, Temple of Poseidon, 440 BC

ilt on a dramatic promontory east of hens, overlooking the Aegean Sea.

Delphi, Amphitheatre

in many other Greek theatres, the semi- cular seating is built into the natural slope the land and overlooks the splendid puntain setting.

Delphi

e circular temple structure at the bottom its sloping site.

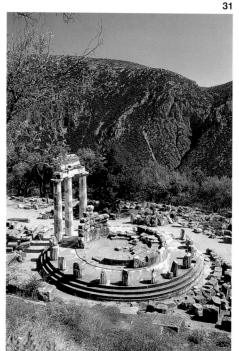

9

Italy

If there is one country that has continuou contributed most to Western civilisation throughout the last 2000 years, it must surely be Italy. It started with the vast Roman Empire, its colonising tentacles stretching out to most of Europe. There a the daring engineering structures: the architectural form-language was inherited from the Ancient Greeks, but the way in which the Romans applied this to huge structures bears testimony to their intuitiv engineering skills. These survive, mostly intact, to this day. The Romans were not inventors of the supporting arch, but its extended use in vaults and intersecting barrel shapes and domes is theirs. Structures such as the Pantheon in Rome or the impressive aqueducts they built, th Pont du Gard in France and at Segovia in Spain, the huge public baths, stadia and theatres, boggle the mind – they were based on experimental, empirical skills without the aid of mathematical systems analysis that we rely upon today.

In the Middle Ages, Italian towns grew no with a clear devised plan, but as an orga assembly of tightly packed environments with narrow streets that burst open into most delightful public plazas that remain the joy of both the inhabitants and, of course, envious hordes of tourists. After about the first millennium, Italy became th cradle of Romanesque architecture. It spread throughout Europe, much of it taking forward its structural daring with minimal visual elaboration.

Born out of this, around the 17th century was the baroque era. It is my view this period marks one of the architectural highlights of Western civilisation. The structural scheme of domed support was refined into a spatially complex and darin background for the visually exuberant painting and sculpture of the time. My favourite is Borromini and his masterful Quattro Fontane and St. Ivo church interiors, which achieved a structural virtuosity by geometrically minimal means In this, his work differs from that of his exuberant rival Bernini, best known for hi brilliant sculptures and elaborate fountain

ich are dotted throughout Rome, or from
uarini's buildings in Turin. It is still
orromini's structural inventions that have
ost to say to us to this day, in that they
ow arched interiors whose rib elements
rrow and deepen toward the top of
omes, recognising intuitively that greater
ffness is needed there. This is confirmed
today's method of structural analysis.
owever, the hallmarks of the baroque era,
ide from structural innovation, were its
corative embellishments, which have
ver ceased to fascinate and delight.
nong the best examples are Pozzo's
agnificent frescos in St Ignacio. He
mained in demand beyond Italy, as did
e muralist Tiepolo. The period's structural
ventiveness bore fruit, was repeated and
tended by the great engineer-architect
lthazar Neumann in 18th-century
ermany (see Germany, photos 6–8).
ie late Pier Luigi Nervi, in our time, is
orromini's structural descendant. He
resents the highpoint of 20th-century
pressive engineering. His structures are
t only mathematically and construction-
y logical, but deeply satisfying aesthe-
ally in that the static laws of nature are
ade evident and are given form without
y painterly or sculptural embellishments –
ch as in his Olympic stadia of the 1960s.

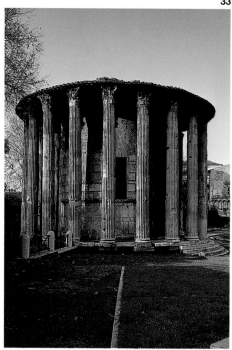

1

1 Rome, Temple of Portunus
1st century AD, by the Tiber.

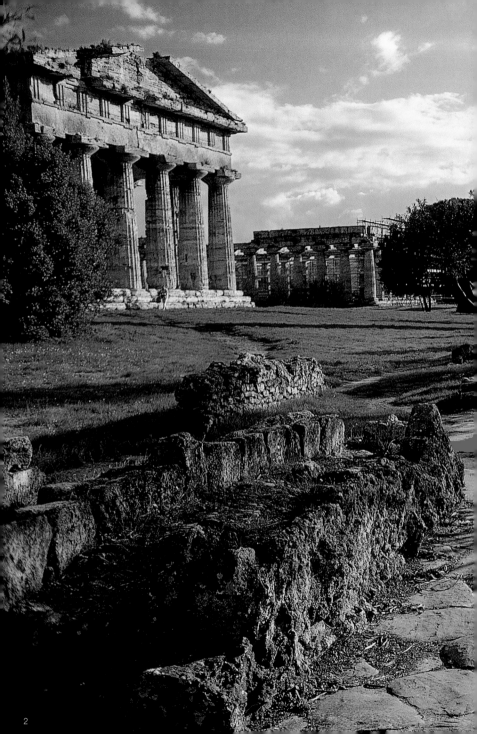

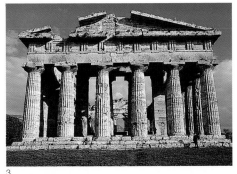

3

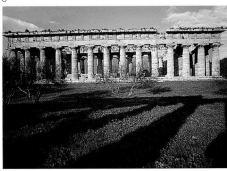

4

**2–4 Paestum, Temple of Neptune,
500 BC**
The best preserved early Greek temples.
The Doric columns in the centre are heavier
than later ones and are in two
superimposed tiers.

**5 Pompeii, Patrician's House,
2nd century AD**
Interior courtyard.

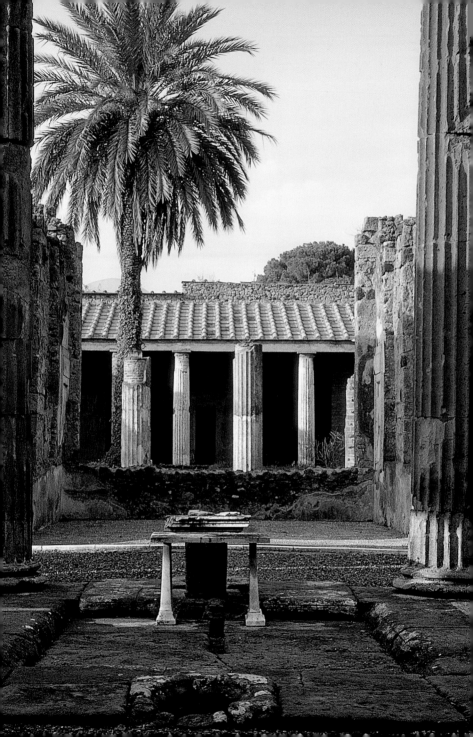

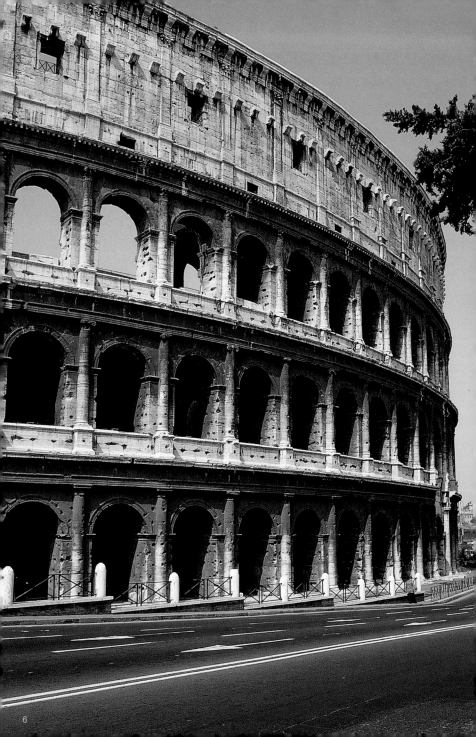

Rome, Colosseum, 70–82 AD

Perhaps the most magnificent of Roman amphitheatres, the Colosseum accommodated 60,000 spectators. It was an amazing feat of engineering for its time.

Taormina Theatre

The originally Greek and later Roman theatre overlooks the beautiful coast of Sicily.

10 Rome, The Pantheon, 118–126 AD

The circular building has the same diameter and height (about 50 m). It is an engineering triumph, built in successively diminishing rings of stone with an open oculus in the centre.

7

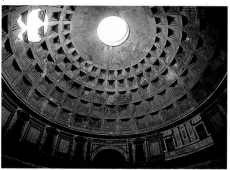

8

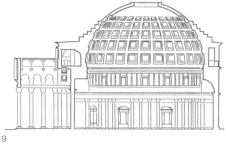

9

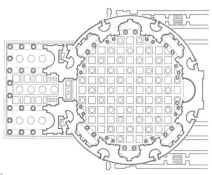

10

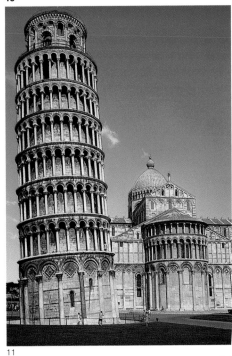

11

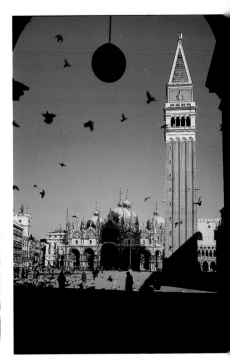

12

13

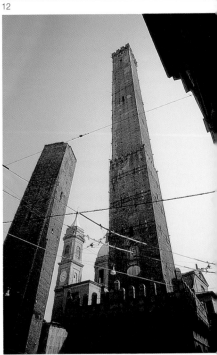

14

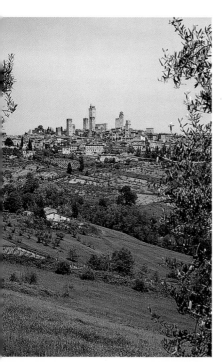

11 Pisa, Dom St. Maria Assunta and the Leaning Tower, 12th century

12 Venice, St Mark's, 13th century
Campanile rebuilt after collapse in 1902.

13 Siena, Palazzo Publico Tower, 1300
Overlooking the public plaza. Famous for its yearly horse race, the Palio.

14 Bologna, brick towers, 1100
Torre Asinelli and Garisenda.

15, 16 San Gimignano
The Tuscan hill-town has high brick towers built by ruling families in the 10th and 11th centuries. Their purpose is unclear and may have been for protection, storage, or simply rivalry between families to build high.

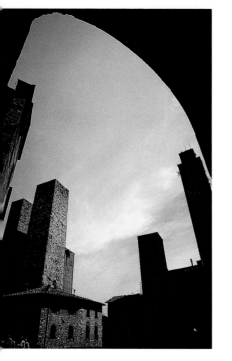

42

17–19 Mondavio

In the Marche area of eastern Italy are 15th-century fortified hill-towns surrounded by high walls of brick. The "Rocca" defence towers are of extraordinary geometric shapes corbelling outward at the top.

20 Senigallia

The fortifications on the Adriatic Coast.

17

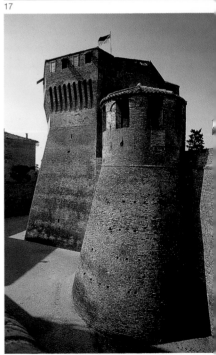

18

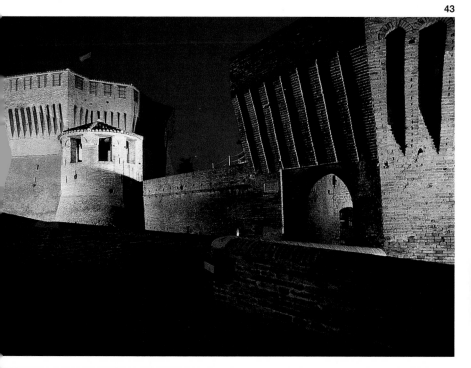

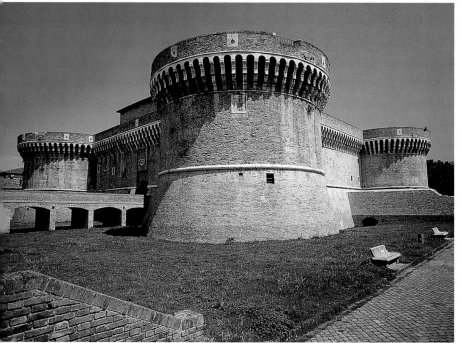

21 Orvieto, Cathedral, 1290–1500
Architect: Arnolfo di Cambio
Has a quasi-Gothic façade decorated with
colourful mosaics.

22 Rome, Tempietto, 1502
Architect: Donato Bramante
A small circular domed High Renaissance
temple is built in the cloister of S. Pietro in
Montorio.

23 Florence, S. Maria Novella, 1300
Architect: Leon Battista Alberti
The Renaissance façade of 1460.

24 Mantua, S. Andrea, 1470–76
Architect: Leon Battista Alberti
The deeply recessed arched entry is one of
the earliest Renaissance structures.

25 Venice, S. Zaccaria, 1450
Has a deeply moulded façade with beautiful
arched roof forms.

26 Venice, Scuola di San Marco, 1490
The highlights of the arched elements of the
façade can be seen on either side of the
entrance portals. The pictorial compositions
made of coloured marbles appear to be
three-dimensional.

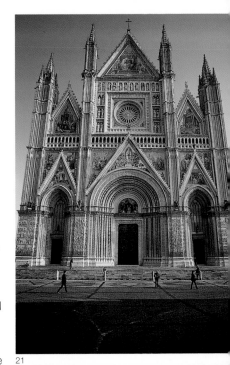

21

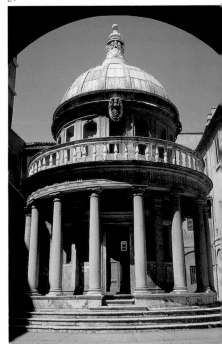

22

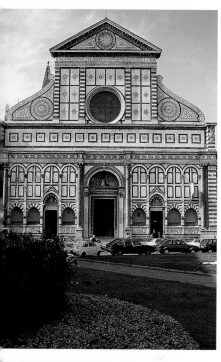

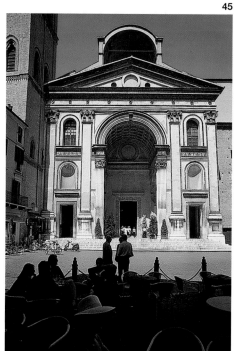

24

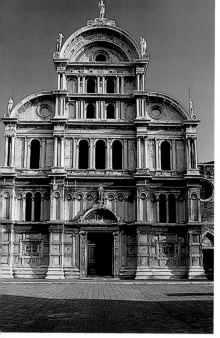

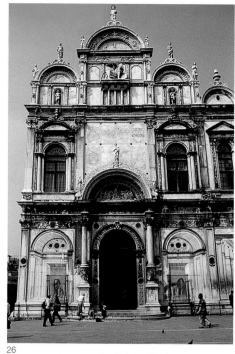

26

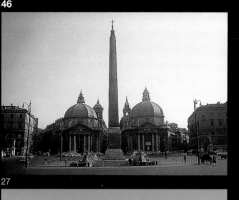

27

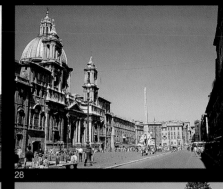

28

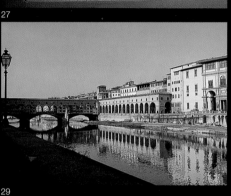

29

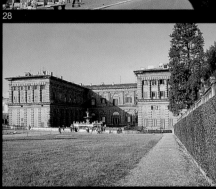

30

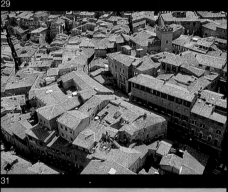

31

32

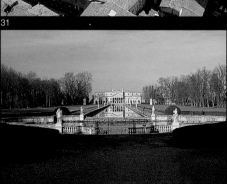

33

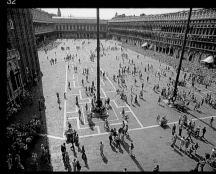

34

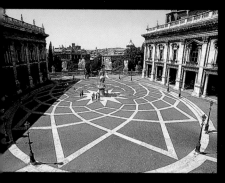

27 Rome, Piazza del Popolo, 1670
Architect: C. Rainaldi
The central obelisk marks the converging point of three streets, flanked by two domed churches.

28 Rome, Piazza Navona, 1600s
Francesco Borromini's concave façade of the Sant' Agnese Church.

29 Florence, Ponte Veccio, 1345

30 Florence, Pitti Palace, 1460

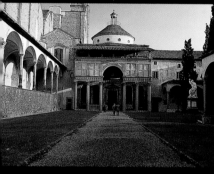

31 Siena, 12th century
The tight network of the city's narrow medieval streets.

32 Siena Piazza del Campo, 14th cent.
The open Campo, focus of the city.

33 Stra, Palace Pisani, 18th century
The theatrical façade is merely a stable.

34 Venice, St Marks Square
The grandest urban space in Europe.

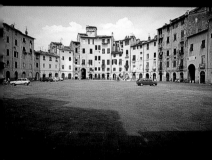

35 Rome, Piazza del Campidoglio, 1538
Architect: Michelangelo
The three buildings defining the trapezoidal plaza are placed apart to defy perspective and appear parallel.

36 Florence, Pazzi Chapel, 1429-61
Architect: Filippo Brunelleschi

37 Lucca
The oval-shaped central space follows the form of an Ancient Roman amphitheatre.

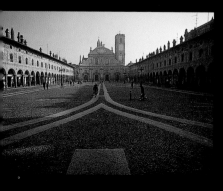

38 Vigevano, 1492
Attributed to Donato Bramante. The painted façades are reputed to be by Leonardo da Vinci.

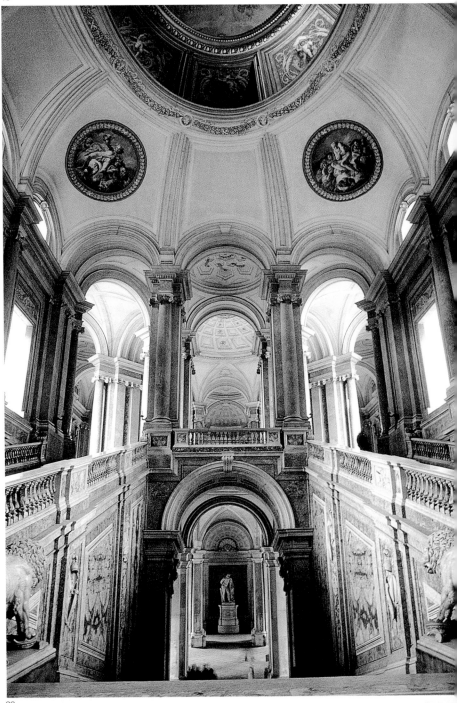

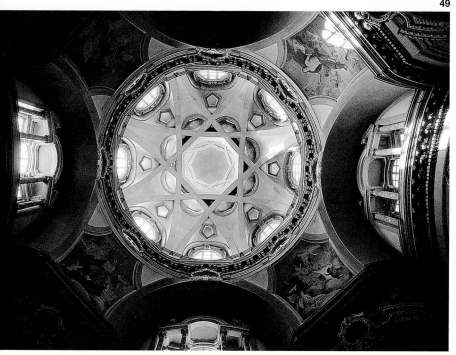

39 Caserta, Royal Palace, 1752
Architect: Luigi Vanvitelli
The grand staircase in the octagonal vestibule creates several vistas that lead off in different directions.

40 Turin, San Lorenzo, 1668–87
Architect: Guarino Guarini
Based on octagonal geometrics, the plan ends in a top-lit dome supported by eight interlocking ribs.

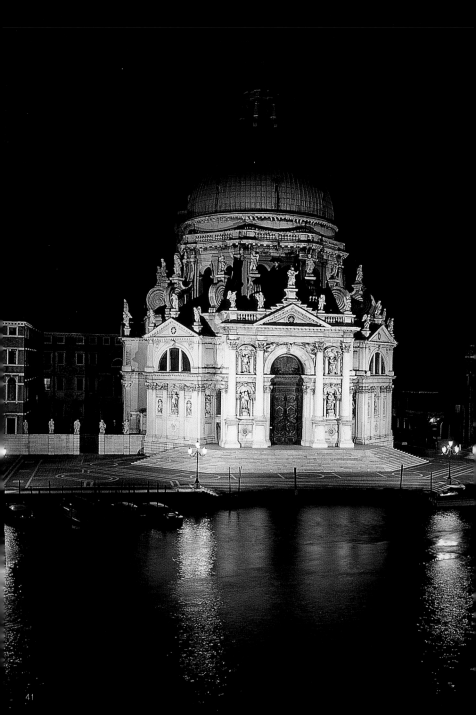

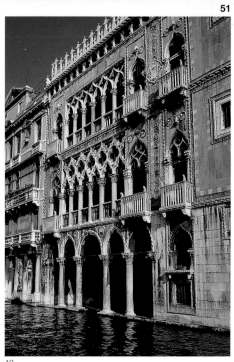

42

41 Venice, Santa Maria della Salute, 1630
Architect: Baldassare Longhena

42 Venice, Ca' d'Oro, 1430
Architects: Giovanni and Bartolommeo Buon

2

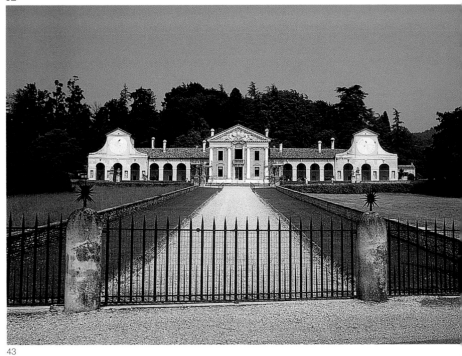

43

44

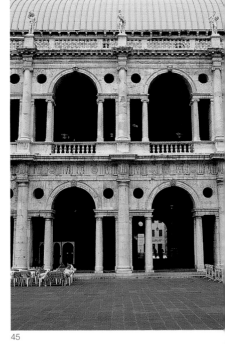

45

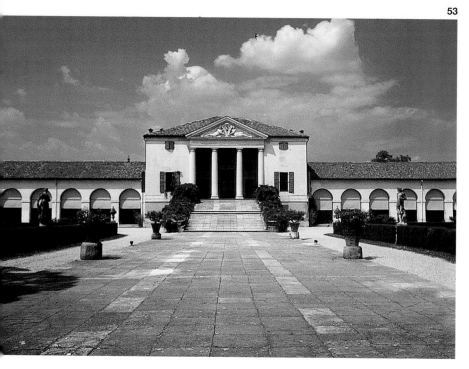

43 Maser, Villa Barbaro, 1550
Architect: Andrea Palladio
A country house combined with farm buildings.

44 Maser, Villa Barbaro, 1550
Architect: Andrea Palladio
Interior. The central wing has life-size wall frescos by Paolo Veronese.

45 Vicenza, Basilica, 1549
Architect: Andrea Palladio
The façade with the typical "Palladian" motive of Serliana openings of arches and columns.

46 Fanzolo, Villa Emo, 1565
Architect: Andrea Palladio
As with Villa Barbaro, a combined residence with arcaded access wings.

47 Urbino, 1450
The fortress-like palace of the Duke Federico da Montefeltro dominates the dramatic walled hill town.

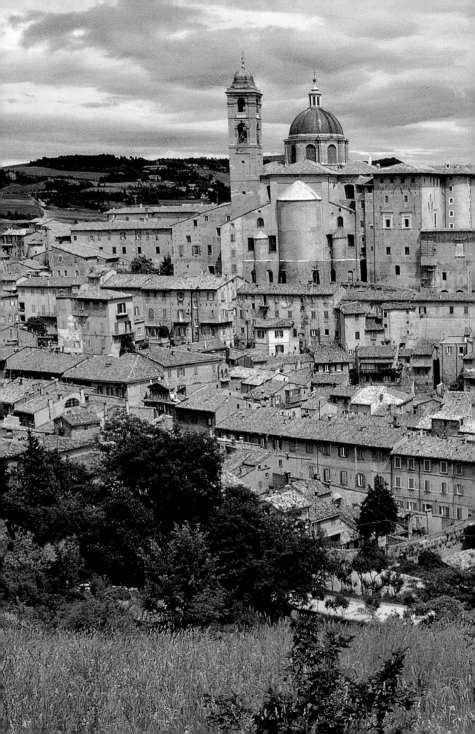

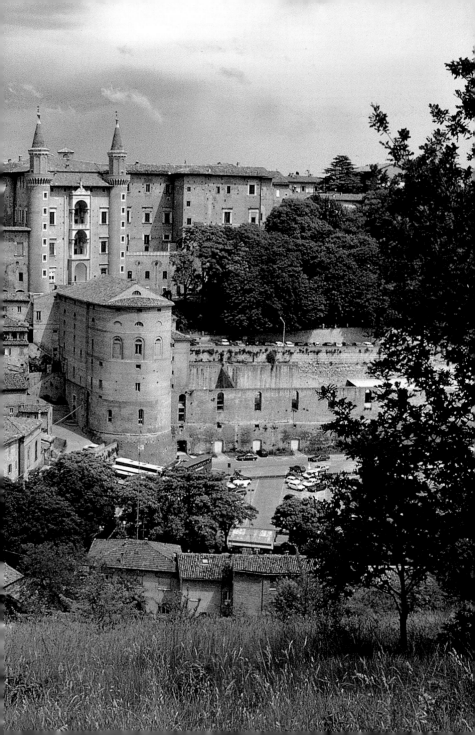

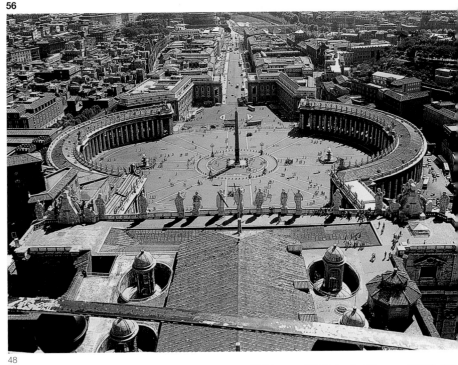

48

48 Rome, St Peter's Piazza, 1656–67
Architect: Gian Lorenzo Bernini
An appropriate setting for large crowds of
pilgrims, enclosed by huge semi-circular
colonnades scaled to relate to the façade
of St Peter's.

49 Gian Lorenzo Bernini, 1598–1680

50 Rome, St Peter's
Detail of the encircling colonnade's column

**51 Rome, St Peter's Basilica,
16th and 17th century**
Designed successively by a number of
architects, Donato Bramante, Michelangelo
and Carlo Maderno. The focus of the
enormous interior is Bernini's Baldachino
supported under the great dome by twist
bronze columns (looted from the Pantheon

52 Rome, St Peter's Basilica, plan

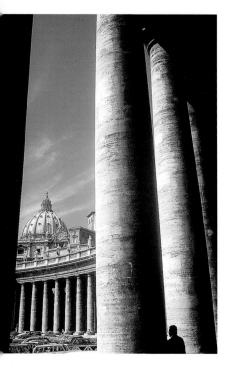

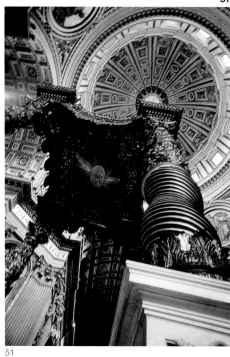

51

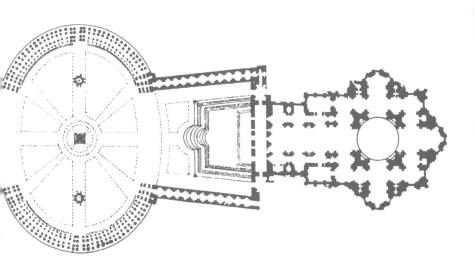

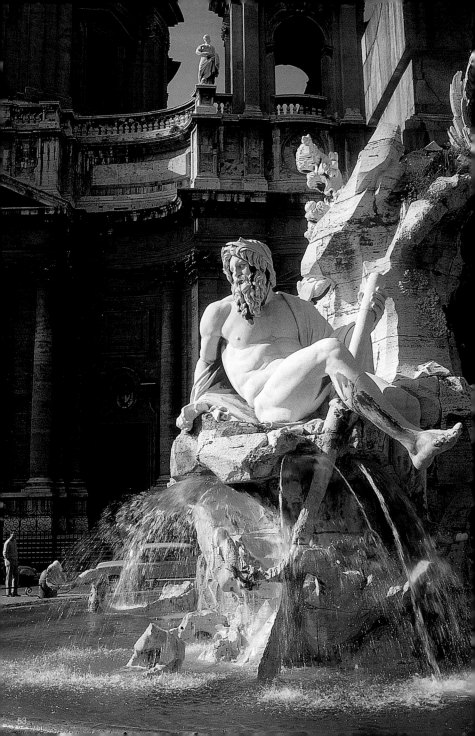

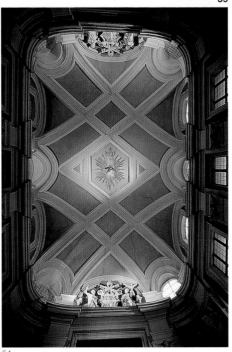

54

53 Rome, Piazza Navona, "Four Rivers" Fountain, 1648–51

Architect: Gian Lorenzo Bernini
The fountain is fed by water from restored ancient aqueducts. It is situatated in front of the concave façade St Agnese, the church built by his architectural rival, Borromini.

54 Rome, Chapel in the Collegio di Propaganda Fide, 1660

Architect: Francesco Borromini
The interlocking ceiling ribs emanating from the four corners of the hall indicate an early awareness of structural forces (see page 70).

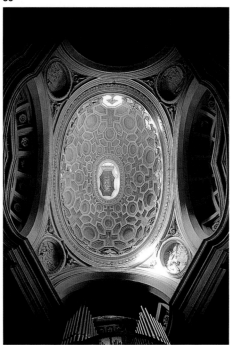

55

55, 56, 58 Rome, S. Carlo alle Quattro Fontane, 1638-41

Architect: Francesco Borromini

Although it is small, this church is one of the most celebrated masterpieces of early baroque architecture. Its pulsating, undulating façade is unique for its period. It is based on clear geometric themes of related circles and ellipses, which extend to the interior, and displays an intuitive response to structural forces.

The interior of the dome is composed of three geometric coffer forms, said to be symbolic of the Trinity. They diminish in size toward the top, thereby increasing the apparent height of the dome. In addition, the closer spacing of the ribs at the top gives the structure increased stiffness to resist the bending forces where they are greatest.

This building offers a rare simultaneous architectural solution to symbolic requirements, geometric-structural needs and aesthetic fulfilment of the totality.

57 Francesco Borromini, 1599–1667

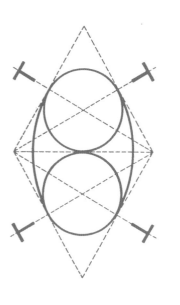

56

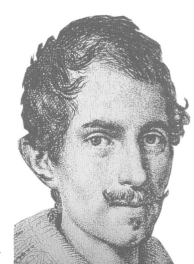

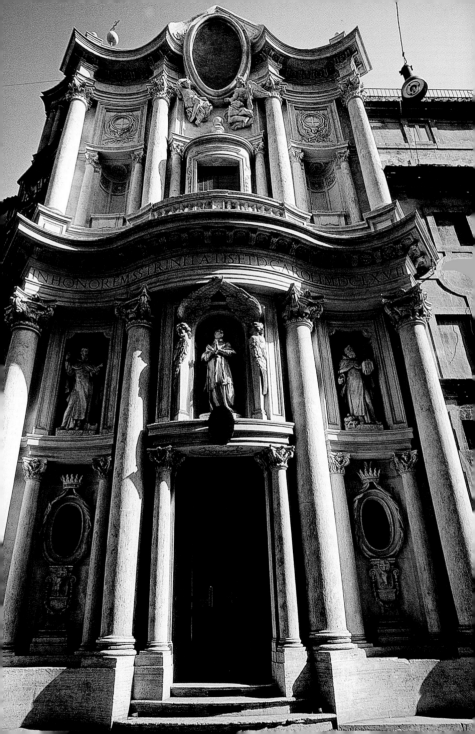

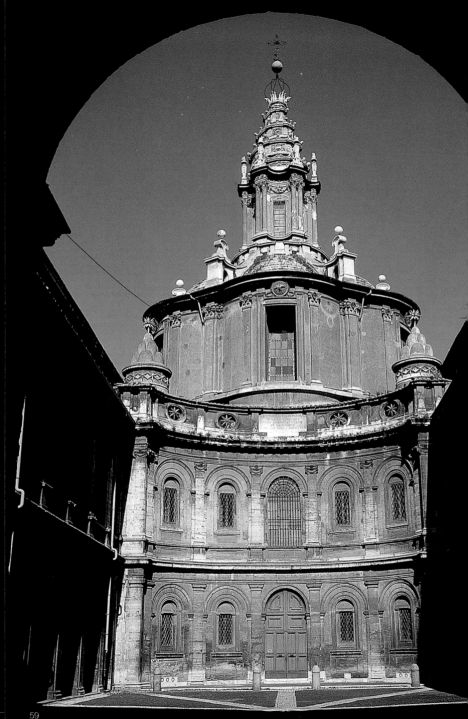

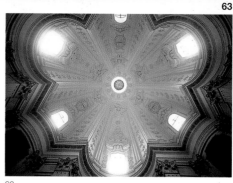

60

59–61 Rome, S. Ivo alla Sapienza, 1642–50
Architect: Francesco Borromini

The plan forms a six pointed star, with each "point" replaced by alternating convex and concave curves. These are carried up to the base of the dome. The geometry changes and transforms toward the top into a circular oculus, which supports the lantern.

61

62, 63 Rome, S. Maria Della Pace, 1656–57

Architect: Pietro da Cortona

The projecting form of the church increases the apparent size of the small urban square surrounding it. Opposing convex and concave quadrant-shaped curves create a dynamic visual effect both horizontally and vertically.

64 Rome, Collegio di Propaganda Fide, 1660

Architect: Francesco Borromini

The concave-convex entrance façade.

65 Rome, S. Ignacio Church, 1691

Fresco by Fra Andrea Pozzo

The huge illusionary painting creates the impression of great height.

66 Rome, Piazza S. Ignacio, 1727

Architect: Filippo Raguzzini

The oval shape of the plaza, reminiscent of a stage set, is created by the concave façades of surrounding buildings.

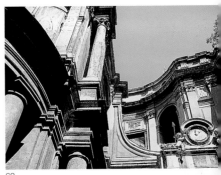

62

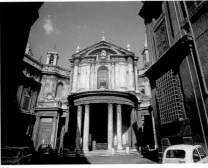

63

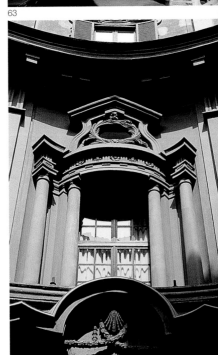

64

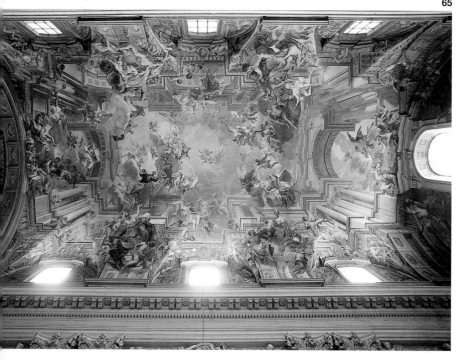

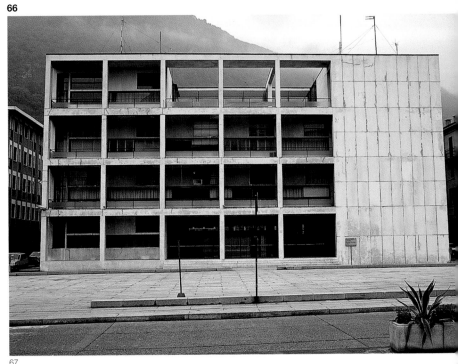

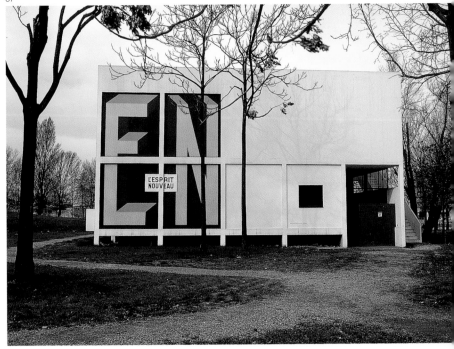

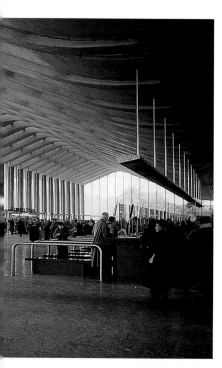

67 Como, Casa del Fascio, 1936
Architect: Giuseppi Terragni
A pure and minimalistic example of Italian modern architecture, with a beautifully proportioned façade and spatial interiors.

68, 70 Bologna, L'Esprit Nouveau Pavilion
Architect: Le Corbusier
Reconstructed by the City of Bologna in a park, the exhibition pavilion was first built for the 1925 Paris display. It contains a fur-nished maisonette apartment, the prototype for the 1947 Unité d'Habitation in Marseilles. In an attached wing are top-lit dioramas of Le Corbusier's concept drawings for his ideal city "Ville Radiense".

69 Rome, Railway Station, 1950
The entrance hall is given great height by upwardly shaped concrete roof beams, which form a projecting portico on the exterior.

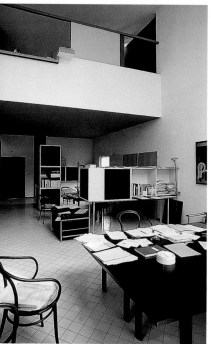

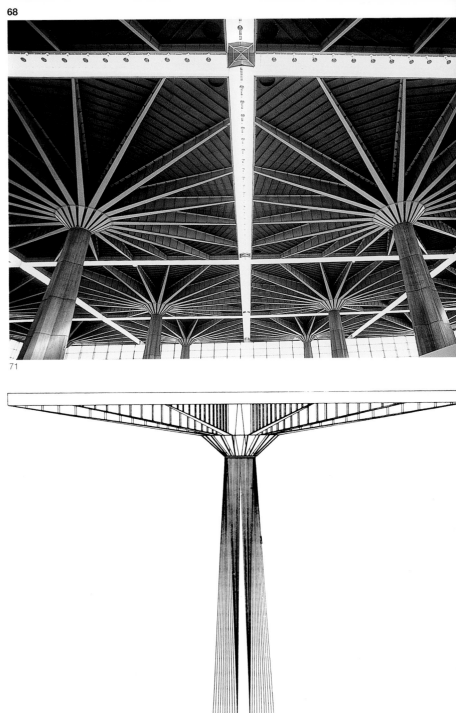

71

72

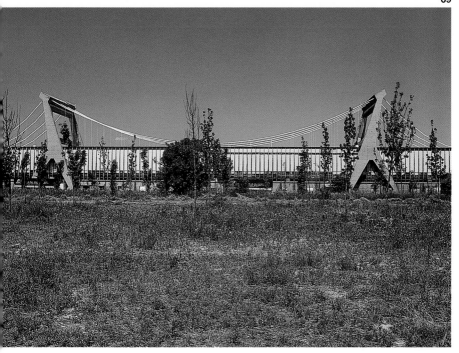

72 Turin, Palace of Labour, 1960
chitect: Pier Luigi Nervi
e cantilevered steel roof beams are
pported by expressively tapered concrete
umns.

Mantua, Burgo Paper Mill, 1961
chitect: Pier Luigi Nervi
e 165 m span suspension structure is
ried by concrete trestles.

Pier Luigi Nervi, 1891–1979

Rome, Palazetto dello Sport, 1957
chitect: Pier Luigi Nervi
s, the smaller of the two Olympic stadia
It for the 1960 Games, was constructed
pre-cast "ferro cement" pans, a system
ented by Nervi, to form interlocking
ncrete ribs poured between them to
an large distances.
e building represents a rare fusion of
onal structure with a sculpturally
isfying aesthetic result.

74

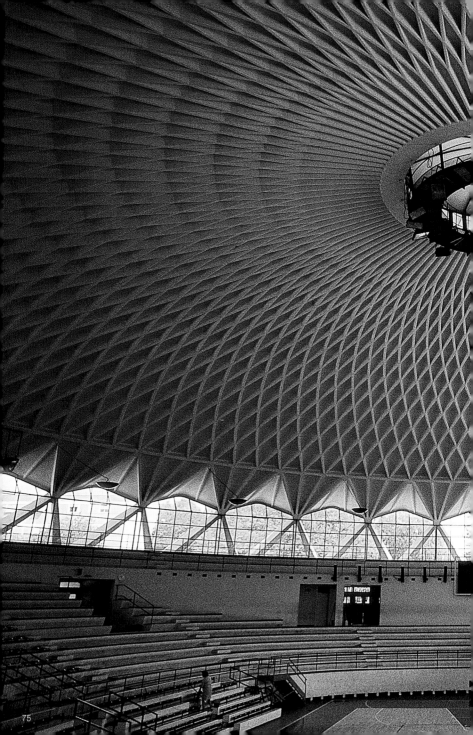

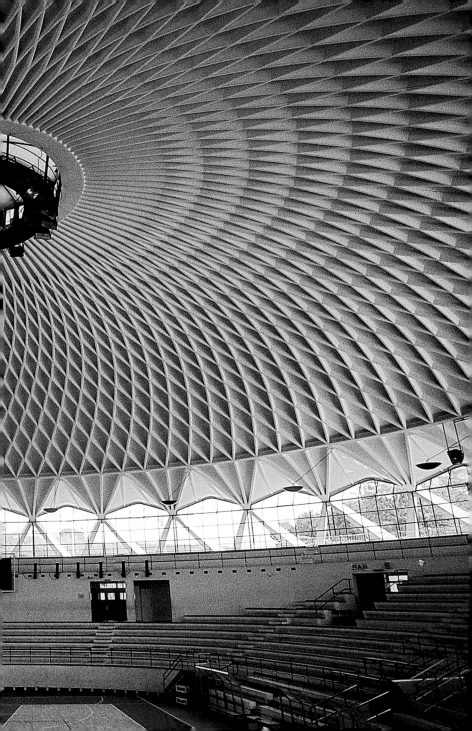

Germany

Germany was not alone amongst Europe countries in losing many of its architectura treasures during World War II. However, great buildings in cities, country environments and small towns remain, an have mostly been painstakingly restored. The highlights are the medieval towns, w their half-timber buildings and charming squares; but in particular there are the palaces and churches of the baroque era Many of these are centred in the south-e of the country, which came to be called "Pfaffenwinkel" ("Parsons' Corner"), such the churches Wies, Ettal, Ottobeuren, etc The work of the 18th-century architect Balthasar Neumann (originally a military engineer), is especially known for his pilgrimage church of Vierzehnheiligen ("Fourteen Saints"). It is a splendid rococo building with interlocking twisted profile ri supporting the wide masonry roof vaults. After a mid-19th-century fire in the timber roof, the structure was found to contain embedded iron bars in the stone and cor crete vaults and ribs. I believe this to be t earliest and intuitive use of the principle c "reinforced concrete". The white ceiling a its exuberantly colourful frescos remained intact after the fire.

Germany's unique contribution to archi- tecture dates from the pioneering develop ments of the 1920s and 30s which were centred in the establishment by Walter Gropius of the Bauhaus, in Weimar, 1919 and later in Dessau, 1925. That teaching and experimental institution has had a cc tinuing influence on architecture, industria design and art throughout most of the world to this day.

The principles developed at the Bauhaus aimed to bring into unison considerations of practical need, advanced technology and the art of the time, to form a "Total Work of Art" ("Gesamtkunstwerk"). Its far reaching influence is to be seen througho the civilised world. The resulting forms of design remain in perpetual flux. They will change with time, responding to altered needs, advances in technology and developments in art. The many celebrate 20th-century buildings in different countri

stify to the fact that modern architecture
annot be called a "style", with fixed design
haracteristics.
he methodology developed at the German
auhaus remains valid with the passage
f time.

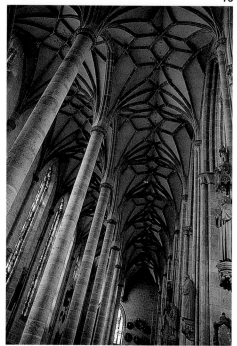

1

1 Ulm, Cathedral, 1377–1477
The Gothic ribbed-vaulted nave.

2 Munich, Nymphenburg Palace, 1730
Architect: Joseph Effner
The summer palace in its park setting.

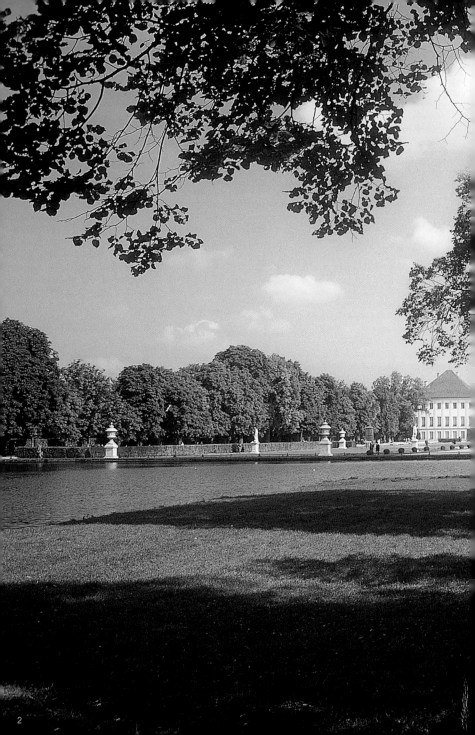

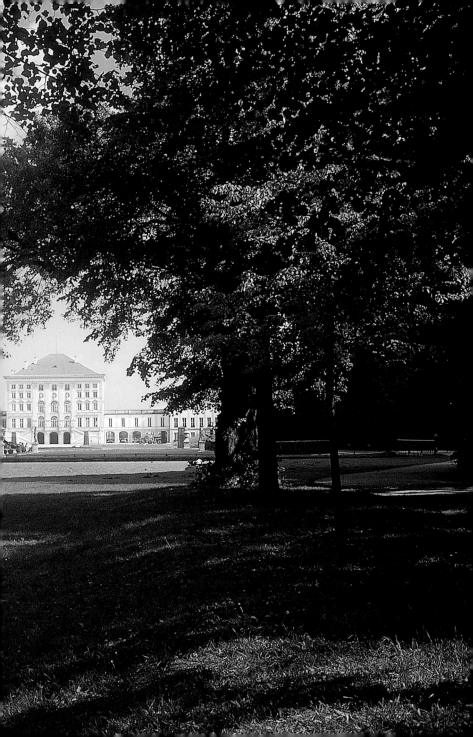

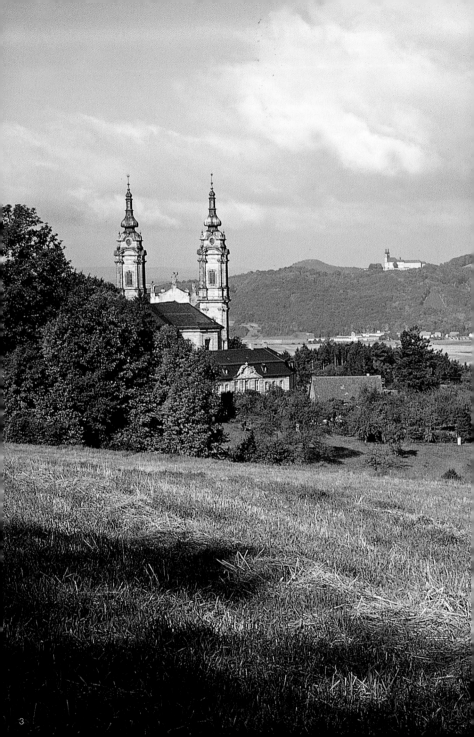

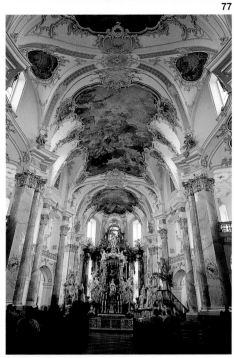

4

5 Vierzehnheiligen ("Fourteen Saints"),
'50

chitect: Balthasar Neumann
th the Monastery of Banz in the distance
/ Johann L. Dientzenhofer), this church of
grimage is a supreme example of rococo
chitecture in Germany. The comparatively
iet exterior bursts forth inside into a
lliant assembly of frescoed oval and
ptical vaults.

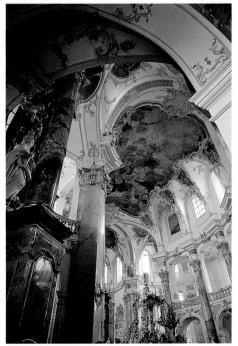

5

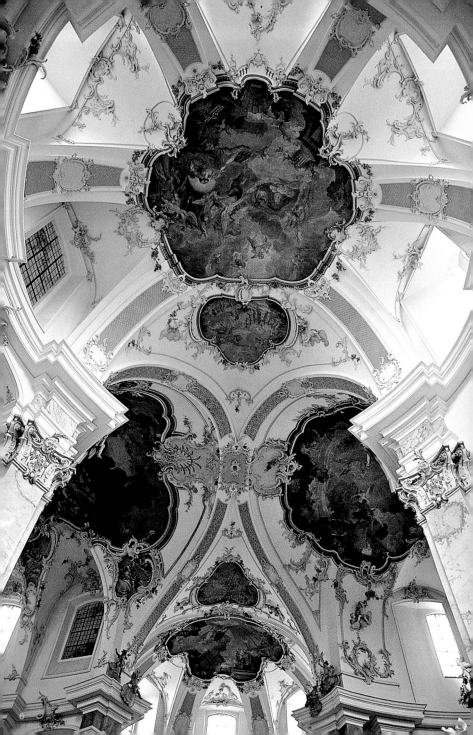

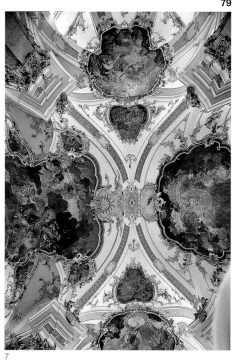

7

6-8 Vierzehnheiligen, 1750

Architect: Balthasar Neumann

The luminous quality of the interior comes from the light admitted from large windows, reflected from a white structure that contrasts with the colourful fresco paintings. The structural ingenuity of the building is evident at the "Vierung", the interaction of four vaults at their merging. The twisted surfaces of the supporting ribs are reminiscent of the works of Pier Luigi Nervi, built 200 years later.

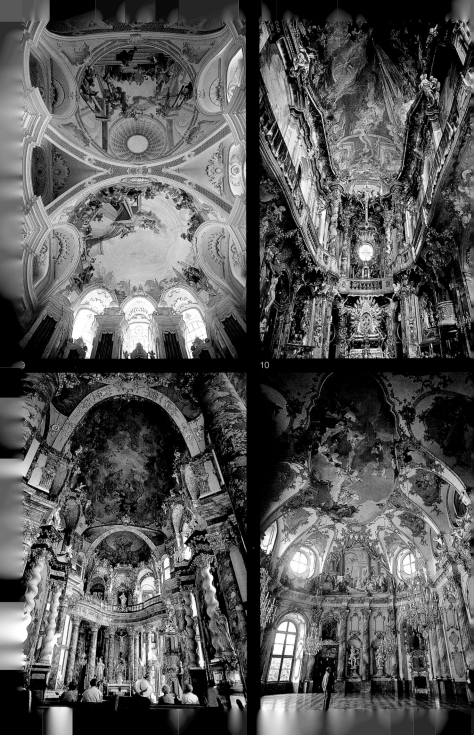

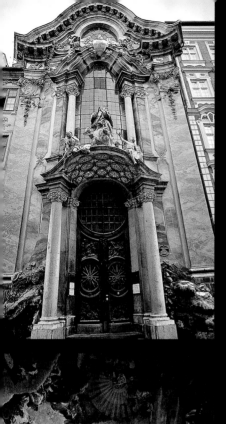
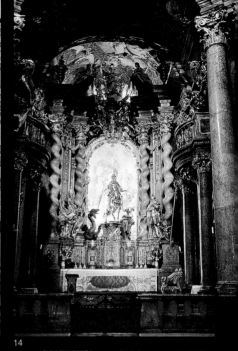

14

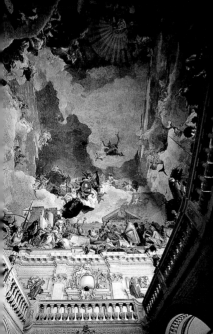
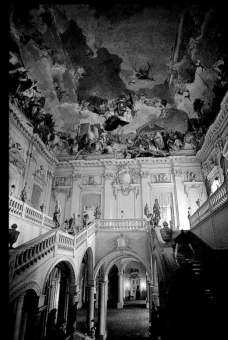

Neresheim, monastery, 1745–64
Architect: Balthasar Neumann

10, 13 Munich, S. Johann Nepomuk, (Asamkirche), 1733–46
Architects: Asam Brothers
Built on a narrow city site, this rococo church is riotously decorated with undulating forms without any surface left plain.

11, 12, 15, 16 Würzburg, Residenz Palace, 1750
Architect: Balthasar Neumann (and others)
The chapel, and emperor's halls, contain frescos by the celebrated Venetian painter Giovanni Battista Tiepolo.
The grand staircase of 1735, with its ceiling fresco also by Tiepolo, are the most satisfying and grandiose works of German baroque.

14 Weltenburg, 1716–39
Architects: Asam Brothers
This Benedictine abbey is distinguished by indirect natural light from above, with the effect of intense artificial spotlighting falling on the focal altar and central sculpture of St George and the Dragon. The impact is that of a dramatic stage setting.

17 Neresheim, monastery, 1745
Architect: Balthasar Neumann

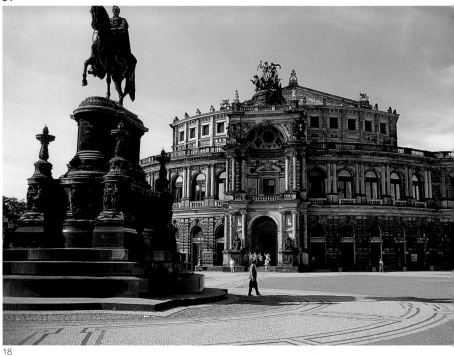

18

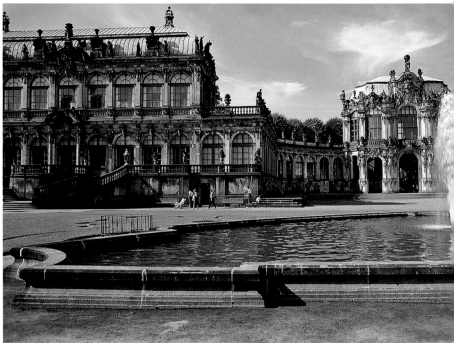

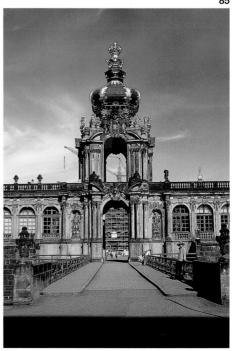

20

18 Dresden, Opera, 1878
Architect: Gottfried Semper
Badly damaged during World War II, but
reconstructed faithfully.

19, 20 Dresden, Zwinger, 1710–28
Architect: Matthäus Daniel Pöppelmann
The suspended gilded crown dome over
the entrance to the complex across a
bridge.

21

21–23 Potsdam, Sanssouci, 1745

Architect: Georg Wenzeslaus von Knobelsdorff

Built as a retreat for Fredrick the Great, this structure is approached through a semi-circular colonnade that leads into a long, one-storey pavilion with a sumptuously furnished domed oval hall. The grand stair leads down to a large fountain flanked by terraced orangeries and vineyards.

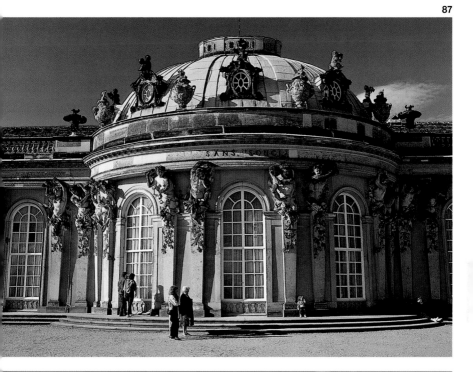

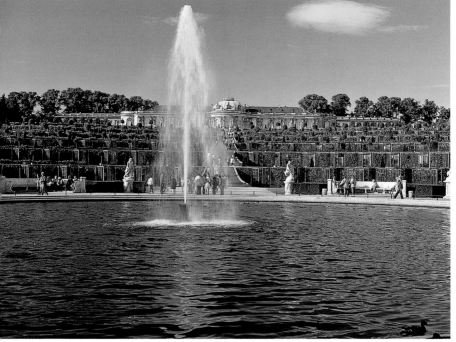

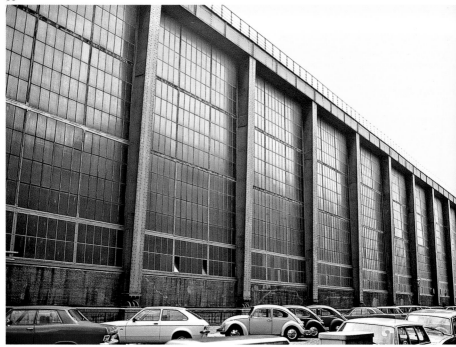

24

25

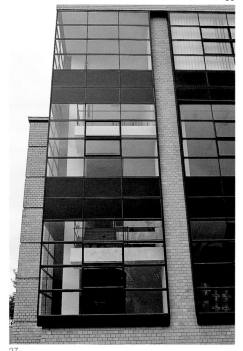

27

24, 25 Berlin, AEG Turbine Hall, 1908
Architect: Peter Behrens
A pioneering industrial steel structure with riveted exposed columns on pivoted supports.

26, 27 Alfeld, Faguswerke, 1911
Architect: Walter Gropius
A glass "curtain wall" building – revolutionary for its time – covering the floors and structure, except for the expressed columns.

28 Walter Gropius, 1883–1969

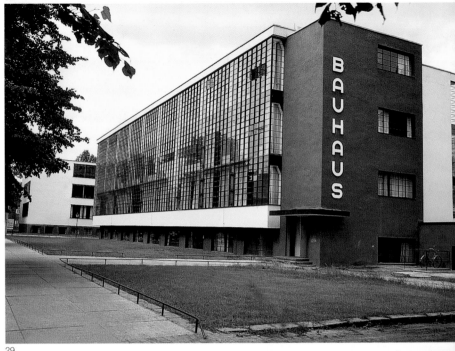

29

29, 32 Dessau, Bauhaus, 1925
Architect: Walter Gropius
Not only did this building house an institute
developing a new approach to architecture,
industrial design and art, but it is also a
famous example of architecture expressive
in its parts of diverse purposes.
The workshop wing is fully glazed for
maximum daylight. Classroom wings have
continuous horizontal ribbon windows; the
"Prellerhaus" students' studio and living
quarters have individual balconies, etc.

30, 31 Dessau, Bauhaus, 1925
Examples of innovative industrial design:
exposed and connected fluorescent tubes
on the ceiling in patterns recalling abstract
paintings of the time; and the tubular steel
folding theatre seating designed by Marcel
Breuer.

30

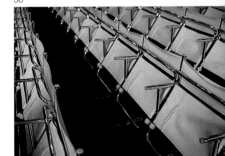

31

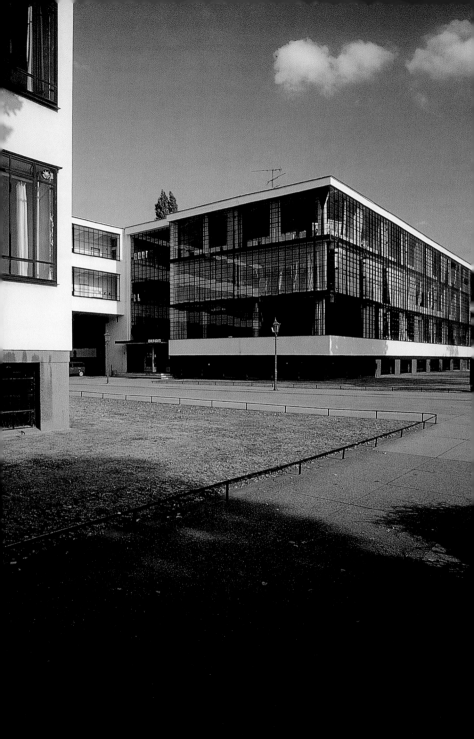

33 Berlin, Gropiusstadt, 1963–73
Architect: Walter Gropius
A huge housing development in an open park setting, with low-, medium- and high-rise structures.

34 Berlin, 1927
The residence of architect Erich Mendelsohn.

35 Berlin, Neue Nationalgalerie, 1968
Architect: Mies van der Rohe

36 Frankfurt, Museum für Moderne Kunst, 1987–90
Architect: Hans Hollein
The building takes on the shape of its triangular site. On the interior new concepts of spatial interplay dominate.

37, 38 Munich, Olympic Site, 1972
Architect: Frei Otto
A covering structure of plastic panels is suspended from metal poles. The huge hanging roof seems to deny conventional concepts of gravity.

39 Weil am Rhein, Vitra Design Museum, 1989
Architect: Frank Gehry
The unconventional geometry defying regular repetitive structure evolved from computer equipment to generate and produce any shape of structural elements. The large entrance sculpture depicting carpentry tools is by Claes Oldenburg.

40 Stuttgart, Weißenhof Siedlung, 1927
Architect: Le Corbusier
Duplex Housing in the influential Deutscher Werkbund Housing Display.

41-44 Bonn, Kunstmuseum, 1985–93
Architect: Axel Schultes
Its architecture maximises spatial effects by fusing areas horizontally and vertically.

33

34

35

36

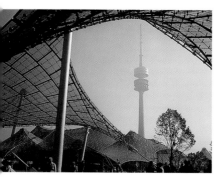

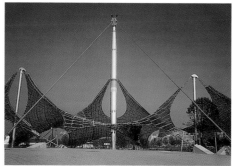

38

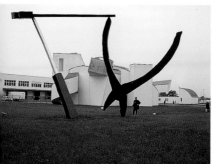

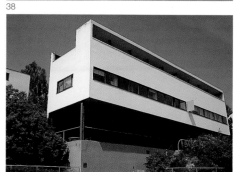

40

42

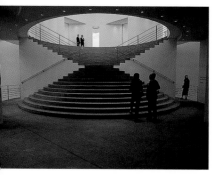

44

France

The development of architecture in France reached many high points throughout history. From the Ancient Roman province of Gallia, some daring engineering structures remain, such as the Pont du Gard, 50 m high aqueduct of unadorned three-tier supporting stone arches built 2,000 years ago.

The Romanesque era of the 11th and 12 centuries produced unique churches and fortified towns. A peak was reached in th Gothic period when dramatic cathedrals with majestic stained-glass windows wer built higher and wider than any others in Europe, such as at Beauvais. The structu ingenuity involved in achieving such huge enclosed spaces by means of thin stone piers stabilised by double flying buttresse is truly admirable.

The 16th century saw elaborate fortified palatial chateaux built by the aristocracy beautiful natural settings, often surrounde by water. The 17th century, ushering in th era of sumptuous chateaux, also saw the development of man-made monumental formal gardens with axial vistas extending as far as the eye could see. One of the most brilliant of these chateaux is Vaux-le Vicomte, built for Nicolas Fouquet, a Stat Minister under Louis XIV, who commis-sioned the architect Le Veau, the garden architect Le Notre and interiors by Lebru The King, invited to the extravagant opening celebration, became furious that one of his ministers dared to outdo him with such a sumptuous establishment. H ordered the house closed, put Fouquet i prison and commandeered his team of designers to build him such a palace, on bigger and better. The result was Versail Bigger it most certainly was, and more sumptuous, but it is not as exquisite.

In prison, Fouquet was often visited by h architects, but never recovered from his misfortunes. He died 19 years later.

With the advent of the Industrial Revoluti the great rebuilding of Paris took place in the middle of the 19th century under Napoleon III and his town planner, Hauss mann. The grandeur of the boulevards a axes of Paris was made possible by the

on of this powerful Emperor and his
:hitect. Their plans cut through the
ngested medieval parts of the city to give
nore light and air, but also served a
ategic purpose of allowing unhindered
tary movement to quell citizens' revolts.
lowing the Industrial Revolution in
gland, the inspiration drawn from the
v iron structures and machines, together
h the ambition to display the latest
ovations in the Paris World Exhibition of
39, drove architects to produce some
narkable buildings. By the end of the
ntury, the new architectural icons were
ge assemblies of cast-iron elements,
ch as the Eiffel Tower. It took a long time
give true visual expression to the
ential of the new materials. Initially, the
ilted forms of traditional masonry
hitecture and even floral and foliate
corations were imitated in iron. In the
ly years of the 20th century the transient
hion of Art Nouveau used decorative
vilinear forms made of cast iron in stair
ngs and for the entrances to new
derground stations of the Paris Metro.
e most significant new development
our own time took place about the end
World War I. Stimulated by the new art
he day, such as the work of Cubist
nters, architecture employed not only
ovative technology and materials but
o responded to the emerging need for
hitectural rationality.
ading the way in this, from the 1920s
ward, was the great architect Le
rbusier. He devoted his time to painting
he morning and architecture in the
ernoon. His prolific output in paintings,
ilding, visionary town planning schemes
d furniture, are without equal. It is
possible for an architect working in the
h century or today to claim that he is
influenced in some way by Le
rbusier's visions and executed work.
gether with Gropius, Mies van der Rohe
d Frank Lloyd Wright, France's Le
rbusier is the greatest of these recog-
ed "form givers" in architecture, whose
rk is beyond fashion and remains valid
ctically and visually, to this day.

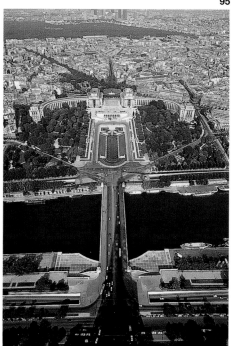

1

1 Paris, Trocadero
View from the Eiffel Tower.

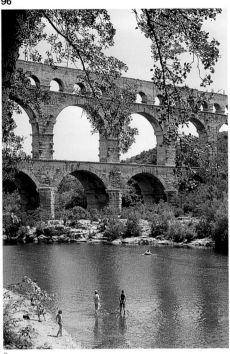

2

2 Nîmes, Pont du Gard, 19 BC

A Roman aqueduct. At 50 m high, it is a
spectacular feat of engineering. The
supporting arch structure remains
unadorned to serve its utilitarian purpose
purely.

3 Poitiers, Notre-Dame-la-Grande, 1140

A Romanesque masterpiece with a
sculptured entrance façade, conical turrets
and dome.

4 Paris, Notre-Dame Cathedral, started 1163

The high nave is braced by double-span
flying buttresses. Large circular transept
stained-glass windows are held by thin
stone tracery.

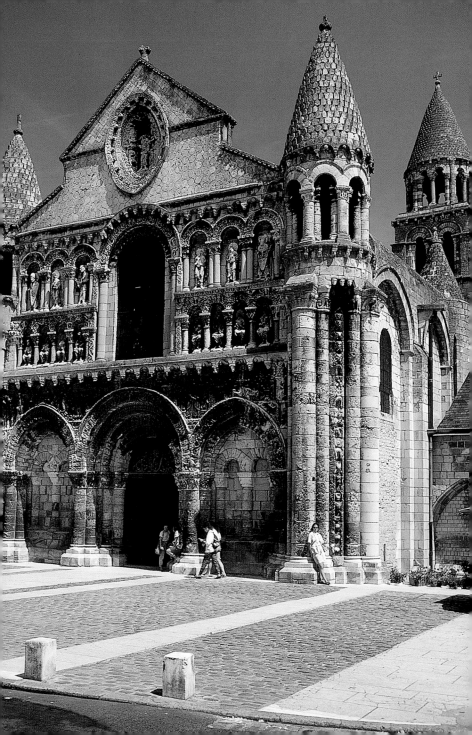

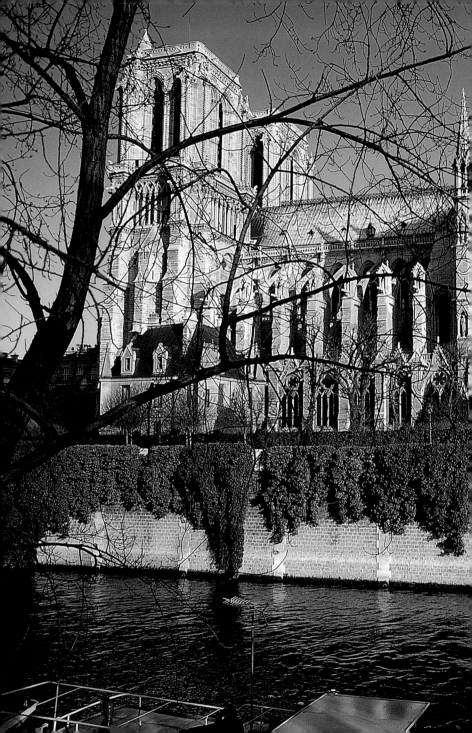

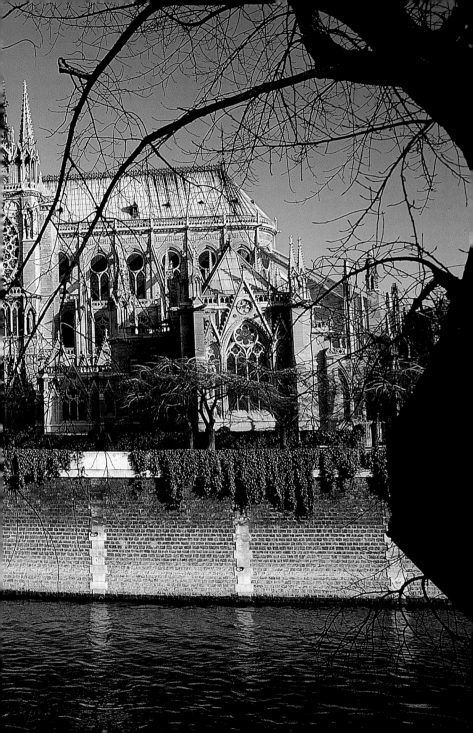

5 Beauvais Cathedral, started 1247, completed in the 16th century

At 50 m it is the highest and widest of the Gothic cathedrals, plagued by structural failures and rebuilding during the long construction period. Only the apse end remains, which is awe-inspiring with its high clerestory windows.

6 Vézelay, S. Madeleine, 1089–1206

A Romanesque church with a high unadorned two-tone semi-circular stone arched nave.

7, 8 Chartres Cathedral, 1220

The building, with its two towers of unequal height, is made famous by the magnificent (predominantly blue) stained-glass windows.

9, 10 Paris, Sainte-Chapelle, 1240

Architect: Pierre de Montrevil
A small court chapel, but very high for its width, dominated by its 15 m high stained glass. The vaulted ceiling is painted bright blue.

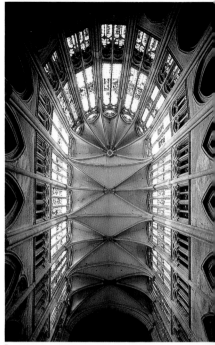

5

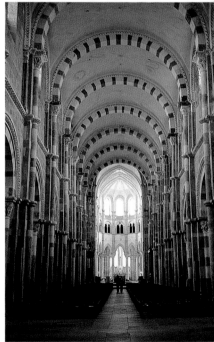

6

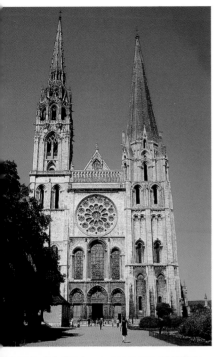

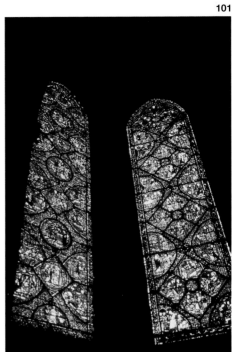

8

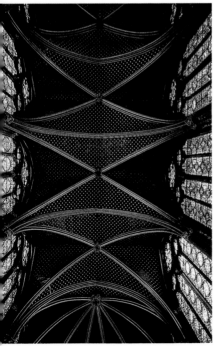

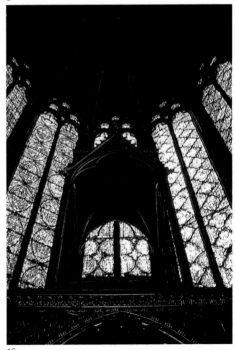

102

11, 13 Carcassonne

A fortified medieval town containing a castle, churches and a theatre. Having fallen into disrepair, it was restored in the 19th century by the architect Viollet-le-Duc.

12, 14 Albi Cathedral, 1280-1390

A fortress-like brick structure with projecting round piers. Attached to its side entrance, a finely ribbed Gothic portico was added which creates a fascinating contrast to the ponderous main building.

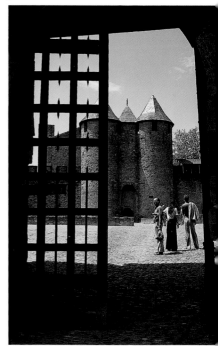

11

12

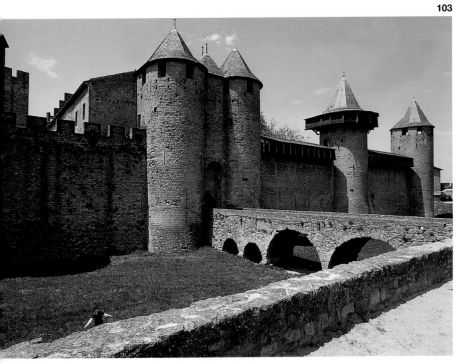

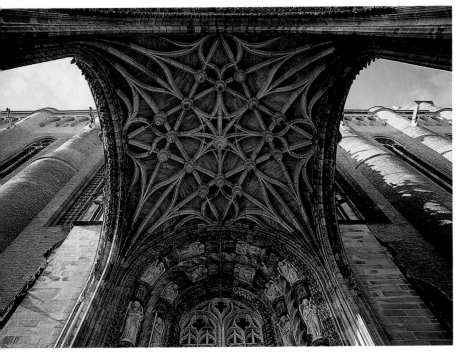

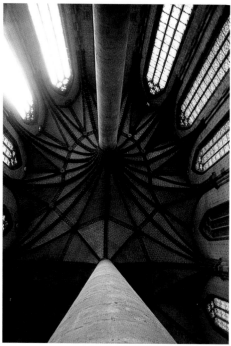

15

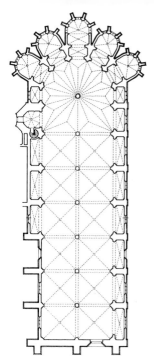

16

15, 16 Toulouse, Les Jacobins, 1260

The early Gothic rib-vaulted roof is supported by a central row of columns, which culminate in a beautiful palm-tree like semi-circular apse end.

17 Vendôme Cathedral, 1300

This small flamboyant Gothic structure has flame-shaped window tracery and wide-span flying buttresses.

18 Amboise

Seen from the high platform surrounding the chateau overlooking the Loire. The regularity of the sloping roofs, which are covered in grey slate, creates a serene, consistent townscape.

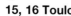

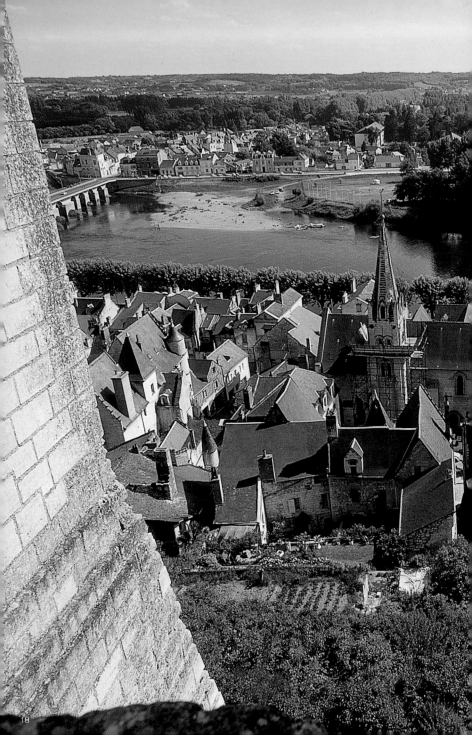

19

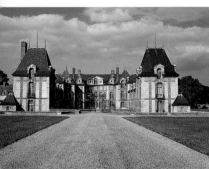

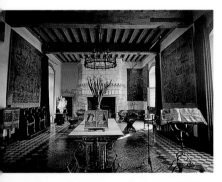

19 Rocamadour
Clinging dramatically to the cliffs of a river gorge, the stepped and ramped streets offer charming internal spaces and outward views of the Dordogne Valley.

20, 21 Saint-Cirq Lapopie
A charming country townscape with medieval timber-framed and brick-infilled houses.

22 Grosbois, Chateau, 1580
A typical formally planned, steep-roofed structure.

23, 24 Langeais, Chateau, 1460
The interiors have exposed materials: masonry walls, timber ceilings and glazed tile floors. Tapestries lend warmth to the hard surfaces.

25 Azay-le-Rideau, Chateau, 1520
One of the most exquisite chateaux in the Valley of the Indre River. The nearest thing to a fairy-tale castle, the chateau is surrounded by water and superb forests.

26 Chenonceau, Chateau, 1540
Built across the river, this elegant building with long galleries overlooking the tranquil water could tell many stories of different kings, their wives and mistresses, and their rivalries.

27 Vaux-le-Vicomte, Chateau, 1660
Architects: Le Veau, Le Notre and Lebrun
The most elegant and grandiose of chateaus and formal gardens. Its owner, Fouquet, was put in jail for daring to outdo the King with such a sumptuous establishment.

28 Chambord, Chateau, start of construction 1590
Architect: Domenico da Cortona
Of all the 16th-century chateaux, this must be the most unbelievably bizarre, bristling with gables, pinnacles, domes and decorated chimneys surrounding a long turreted structure. Its ingenious central double spiral staircase allows a person walking up not to be seen by someone descending.

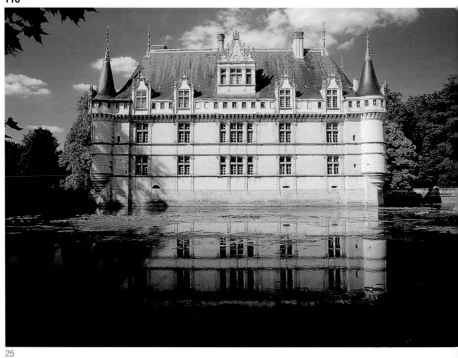

25

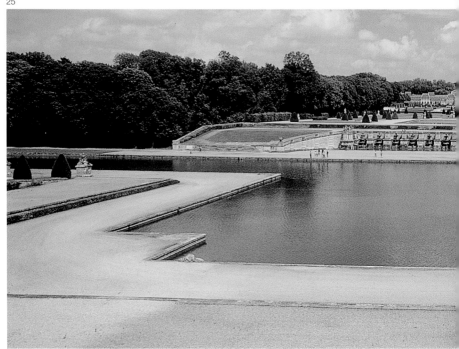

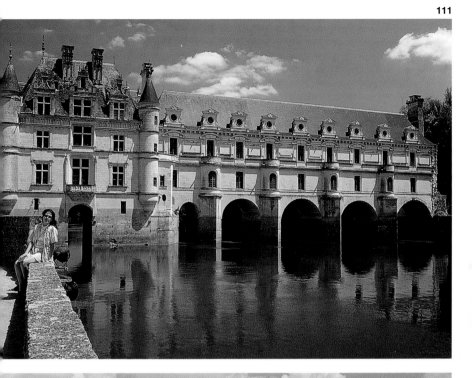

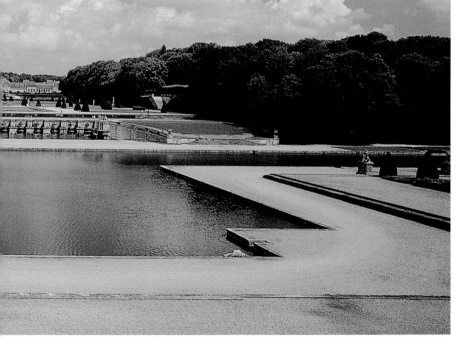

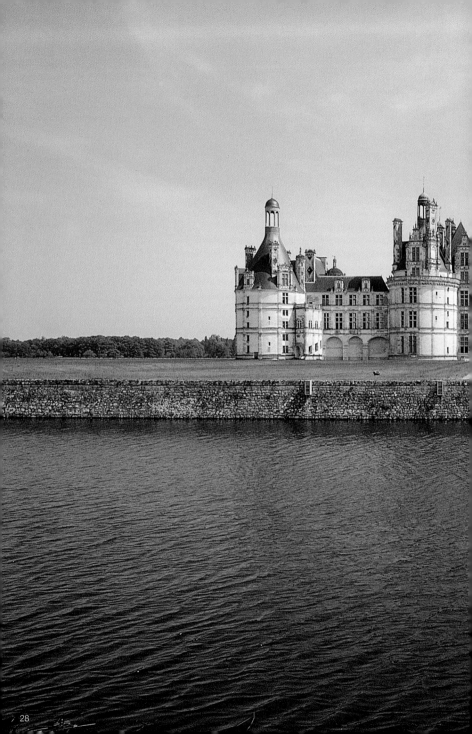

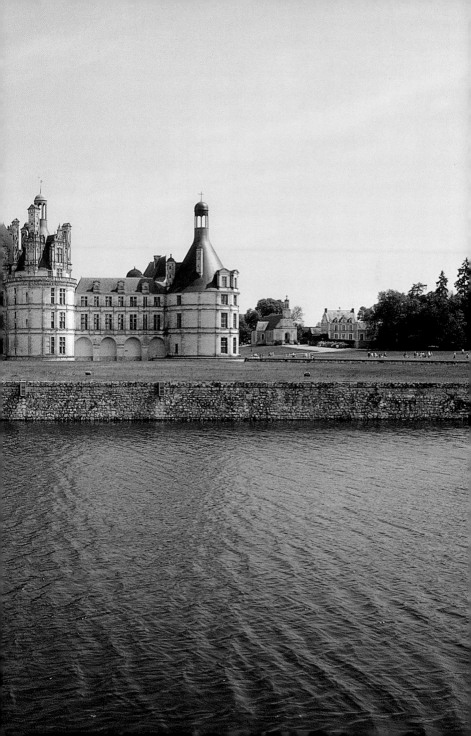

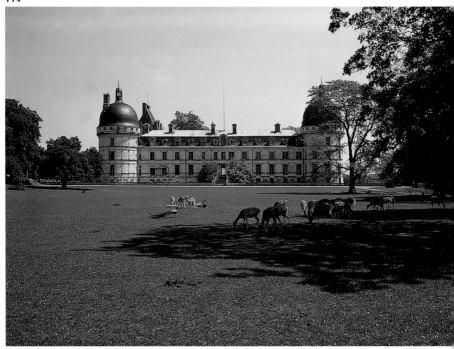

29

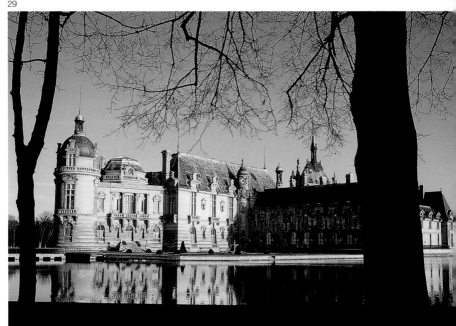

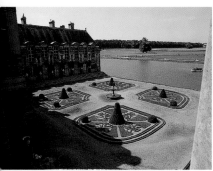

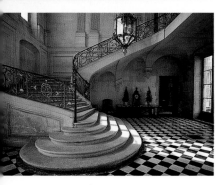

29 Valençay, Chateau, 1540
Set in extensive grounds, with a deer park surrounding the chateau, this building is given a distinctive silhouette by its unusual corner domes.

30, 32 Chantilly, Chateau, 1560
Architect: Bullant
Set in a lake, every façade of the building is of different design, and yet it achieves aesthetic cohesion.

31 Blois, Chateau, 1520–1630
Architect: Mansart
This chateau's distinctive element is the polygonal open staircase tower, which offers changing spatial through-views into the courtyard as one ascends.

33 d'Anet, Chateau, 1550
Architect: Philibert de l'Orme
Has a fine curvilinear entrance staircase in one of the few remaining parts of the building.

34 Cheverny, Chateau, 1634
Architect: Boyer de Blois
Axially approached, the symmetrical building's flat façade achieves distinction by means of its varying height and the shapes of its roof. One of the most elegant chateaus in France.

35 Paris, Place des Vosges, 1605–12
Architect: Louis Metezeau
A fine urban square surrounded by arcaded individual residential buildings, each with its own roof. The two larger axial pavilions were reserved for the King and Queen.

34

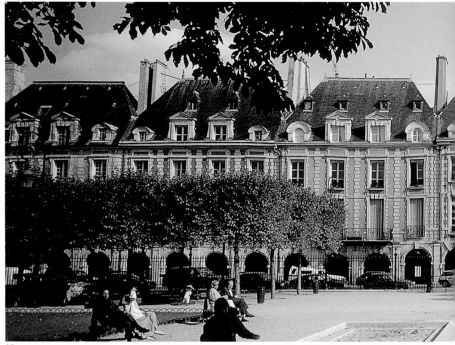

35

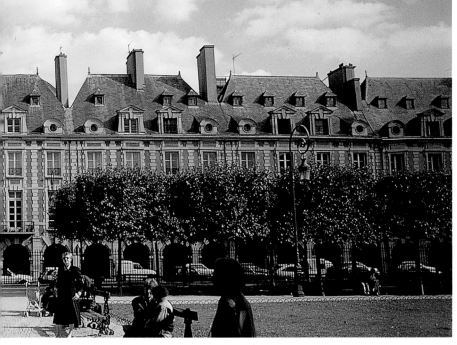

36 Ménars Chateau, 1760
Architect: Ange-Jacques Gabriel
The formality of the approach is enhanced
by the artificially trimmed trees.

37, 38 Champs-sur-Seine, Chateau
A formal building with a seemingly endless
axially landscaped park.

39, 41 Versailles Palace 1660
Architects: Le Veau and Mansart
Petit Trianon, 1760, Architect: Gabriel
The most immense palace in Europe,
reflecting the vast power of Louis XIV. The
enormity of the complex is difficult to grasp,
as is the immense formal landscaped park
and fountains surrounding it. Aside from the
the Hall of Mirrors, it is complex and less
satisfying aesthetically than smaller palaces
by the same architects.

40 Maisons–Lafitte Chateau, 1642–48
Architect: François Mansart
A grandiose urban chateau near Paris, of
majestic scale and great elegance.

36

37

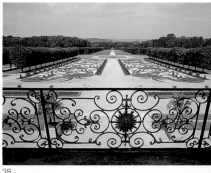

38

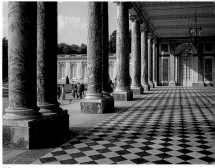

39

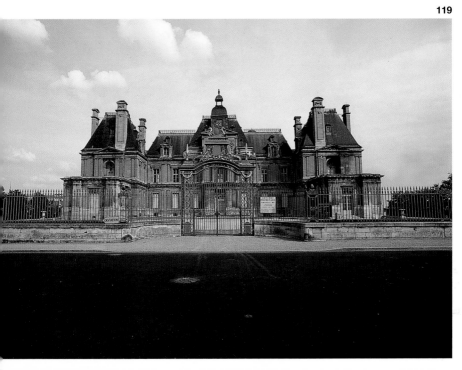

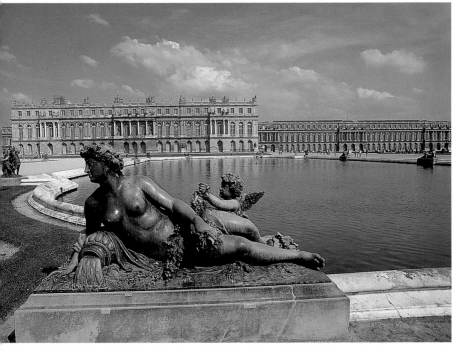

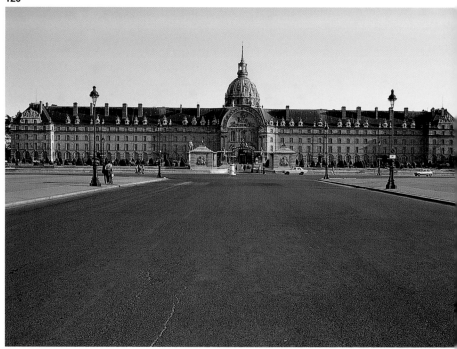

42

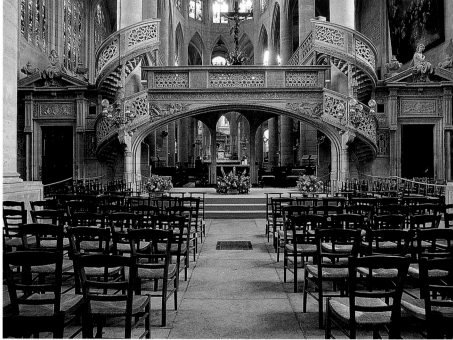

43

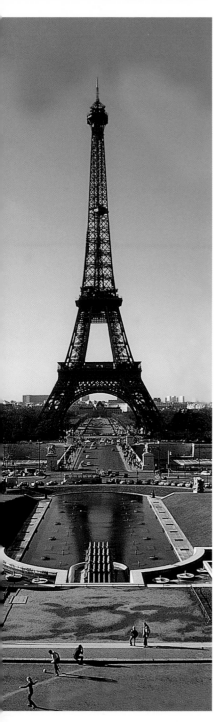

42 Paris, The Invalides, 1678–91
Architect: Libéral Bruant
With a 200-metre long façade, it is one of Paris' most famous landmarks. The building was used as a soldiers' hospital under Napoleon I, who is buried in the domed structure at the rear.

43 Paris, Saint-Étienne-du-Mont, started 1492
by Philibert de L'Orme
With its unique screen structure in front of the apse end, situated between two spiral stone stairs.

44 Paris, Eiffel Tower, 1889
Built for the universal exhibition, this daringly light steel structure has become the iconic landmark of Paris. It is symbolic of new methods of construction.

45 Paris, Place de la Concorde, 1750
Architect: Ange-Jacques Gabriel
This axially placed open urban space, at the very centre of Paris, is marked by a granite Egyptian obelisk (see Egypt, photo 12 for its pair).

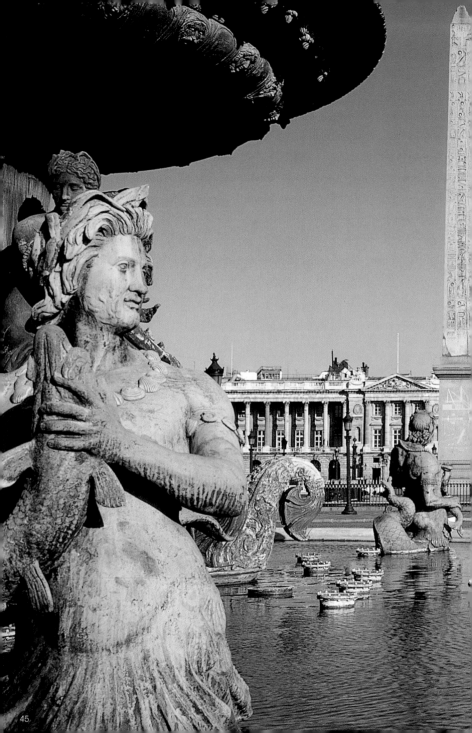

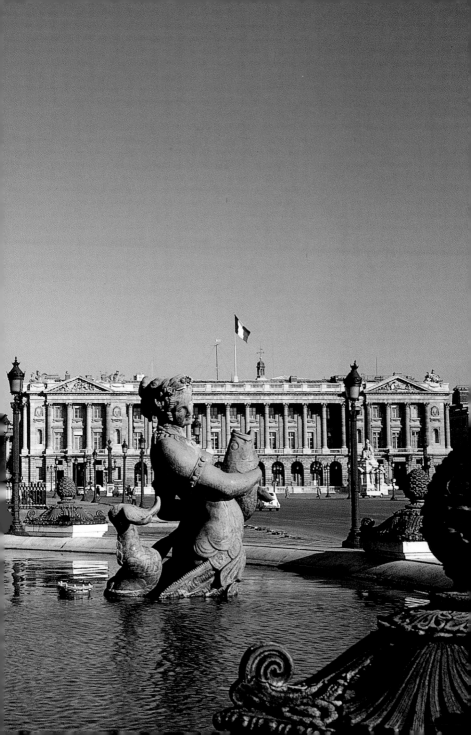

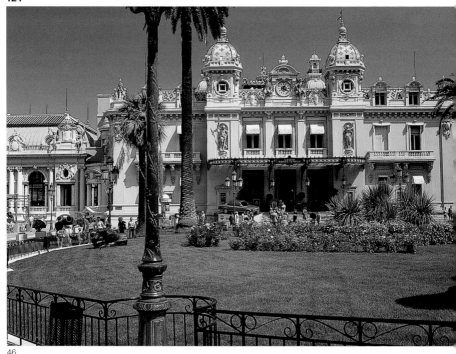

46

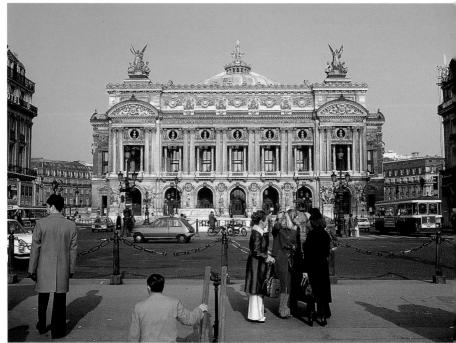

47

46 Monte Carlo, Casino, 1863
Architect: Charles Garnier
Symbolic of luxurious buildings in Europe's gambling capital.

47 Paris, Opera House, 1861–74
Architect: Charles Garnier
Built in the final phase of romantic 19th-century architecture, it is the ultimate example of decorative classicism.
A sumptuously curved grand staircase joins the high spaces of the foyer. A monument to the architect adorns one of its external walls.

48, 49 Paris, Rue de Rivoli, 1840
Architects: Percier & Fontaine
This arcaded straight row of buildings was erected by Napoleon I. Overlooking the Tuileries Gardens, it forms a monumental element in the planning of Paris.

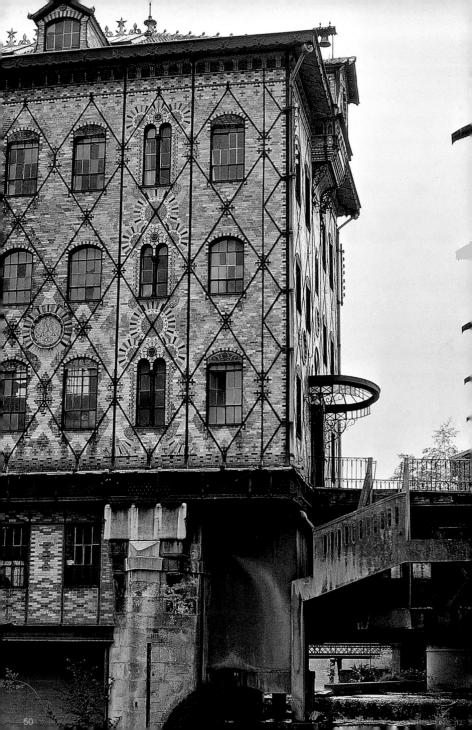

**Menier Chocolate Works, Noisiel-
-Marne, 1879**

...hitect: Jules Saulnier

...e first building to be supported by an iron ...eleton with non-structural brick infill ...erior walls.

**Paris, Library Sainte-Geneviève,
...50**

...hitect: Henri Labrouste

... early expressive wrought- and cast-iron ...lted structure.

Paris, National Library, 1860

...hitect: Henri Labrouste

...e spherical roof vaults, each with a sky- ...t, are supported by slim cast-iron ...mns.

Paris, Ave Rapp Apartments, 1900

...hitect: Jules Lavirotte

...ypical art nouveau exterior.

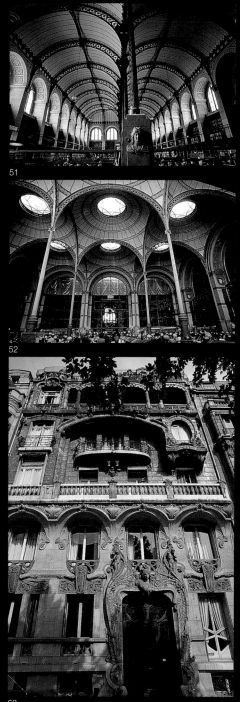

51

52

53

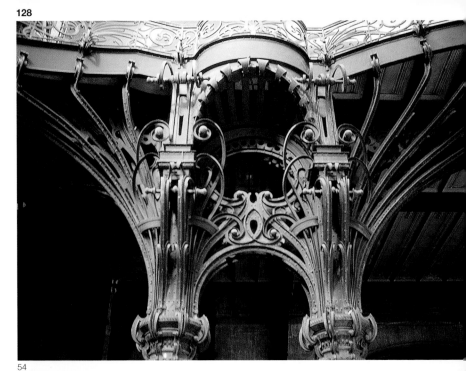

54

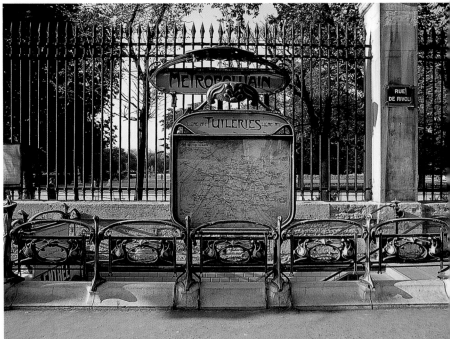

55

54, 57 Paris, Grand Palais, 1897–1900
Architect: Frantz Jourdain
The huge exhibition building supports
its glass dome roof with iron ribs using
inappropriate forms of traditional
masonry vaults.

55, 58, 59 Paris, Métropolitain Stations, 1900
Architect: Hector Guimard
Art Nouveau cast-iron and glass structures
in organic decorative forms.

56 Paris, Rue Reaumur, 1900
Architect: Georges Chedanne
An early example of exposed steel framed
construction.

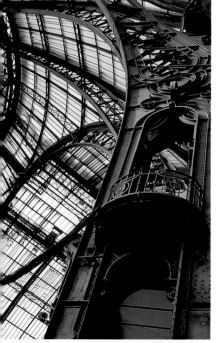

58

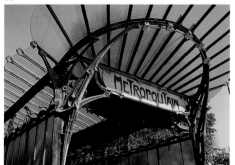

59

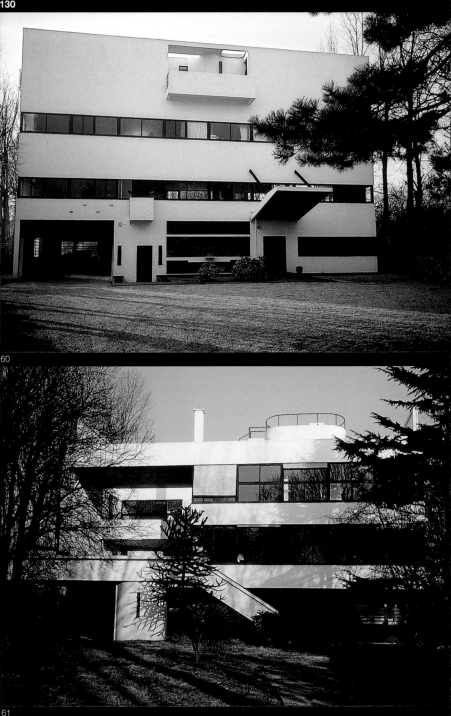

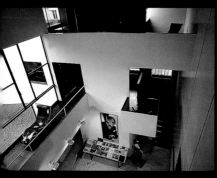

60, 61 Villa Garches, 1927
Architect: Le Corbusier
This luxurious house, built for the famous Stein family in the country near Paris, represents an important milestone in Le Corbusier's work. It demonstrates the clear separation of structure and infill, enabling spaces to be free and open aesthetically, both horizontally and vertically. This seminal building has influenced architecture to this day.

62-64 Paris, Villa La Roche-Jeanneret, 1923
Architect: Le Corbusier
An early duplex residence with interiors of spatial complexity. The building now houses the Le Corbusier Foundation.

65-66 Paris, Apartments, 1933
Architect: Le Corbusier
This glass and glass-block curtain-wall building houses the architect's two-storey penthouse and landscaped roof terrace.

67 Paris, Swiss Students Pavilion, University of Paris, 1930
Architect: Le Corbusier
Supported on central concrete pylons and a steel superstructure, all the students' rooms have straight south-facing glass walls, which contrasts with the sculptural forms of the common room and vertical core.

68–71 Poissy, Villa Savoie, 1929
Architect: Le Corbusier
The most iconic of the architect's houses, Villa Savoie is built in large grounds outside of Paris. The dramatic spatial fusion of the upper-level hollow centre with access ramps and spiral stairs makes this a supreme example of the coming together of art and architecture.

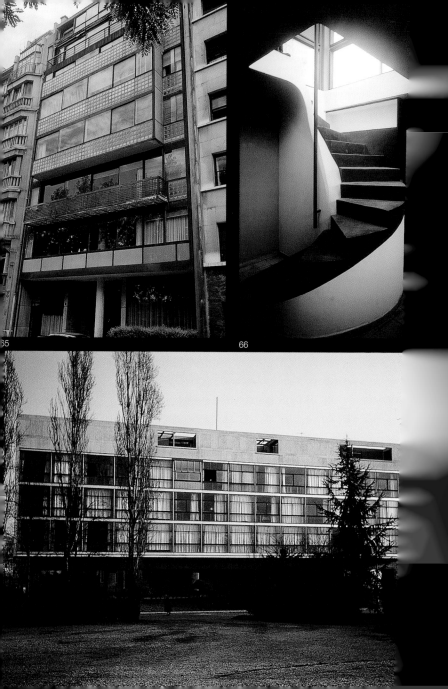

65

66

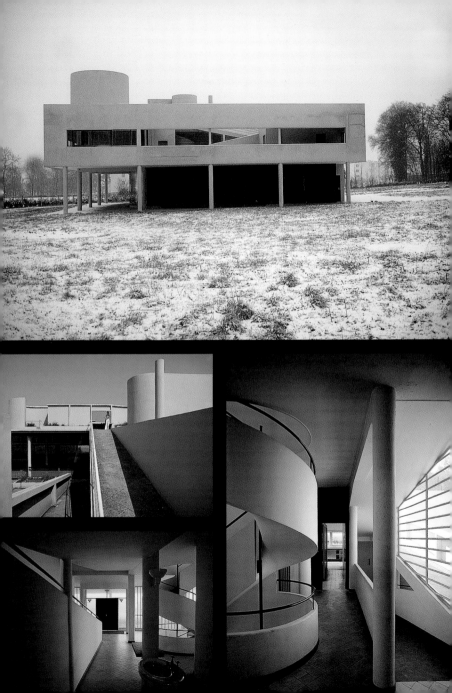

72 Paris, Salvation Army Refuge, 1929
Architect: Le Corbusier
An early framed structure and the first totally sealed and air-conditioned glass curtain-wall building. The façade was altered after World War II.

73, 75 Marseilles, L'Unité d'habitation 1947
Architect: Le Corbusier
The tower contains split-level apartments with a central shopping floor, a roof-top kindergarten and communal facilities.

74 Le Corbusier, 1887–1965

76-83 The Chapel at Ronchamp, 1950
Architect: Le Corbusier
This represents a unique sculptural departure from conventional modern architecture. The awe-inspiring curvilinear interior receives daylight from various apertures in side walls and top light through attached tower structures. The huge pivoted entrance is covered with a colourful metal mural that is also by the architect.

84, 85, 87 Paris, Brazilian Students' Pavilion, University of Paris, 1957
Architect: Le Corbusier
Each student's room faces a sunny balcony. The ground level adjuncts contain communal facilities and a separate wing housing the Director's residence.

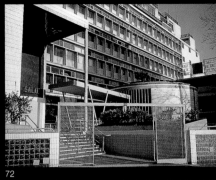

72

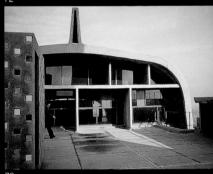

73

74

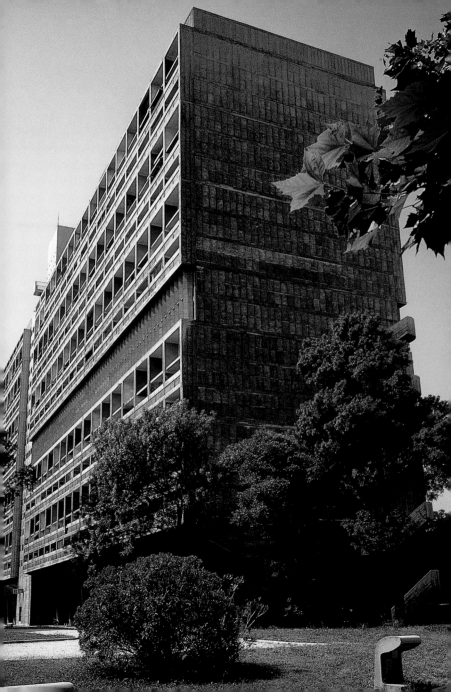

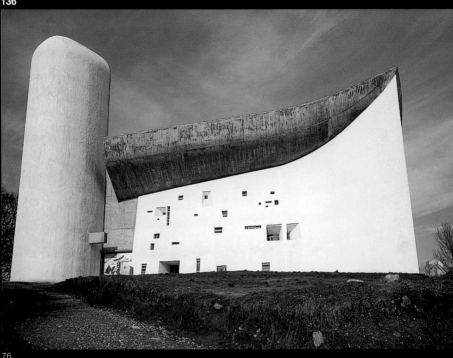

76

77

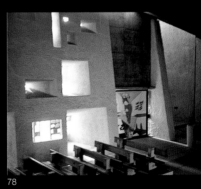

78

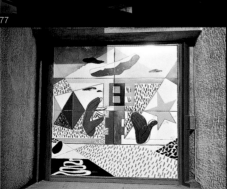

79

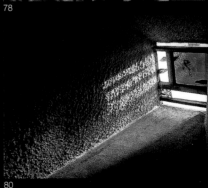

80

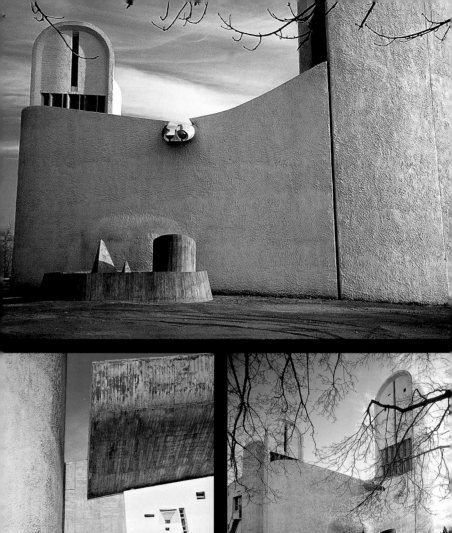
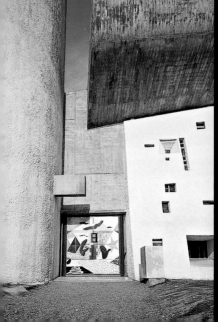
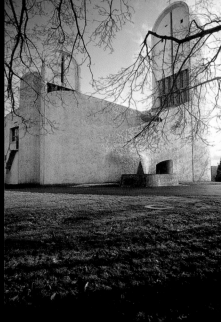

86, 89-93 Convent of La Tourette, 1960
Architect: Le Corbusier
The open central courtyard is surrounded
by monks' rooms and communal facilities.
A colourful, top-lit chapel is adjacent to the
large church hall.

88 Paris, Duplex Jaoul Residence, 1956
Architect: Le Corbusier
The brick walls and off-form concrete
Catalan vault structure's colourful interiors
remain unadorned.

94 Paris, The Pyramid in the Louvre 1981
Architect: Ieoh Ming Pei
The ephemeral transparent pyramid is
placed over the large entry space leading
down to the wings of the museum.

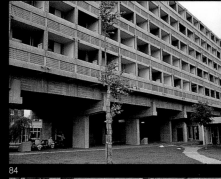

84

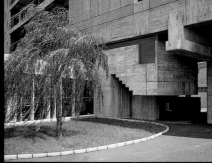

85

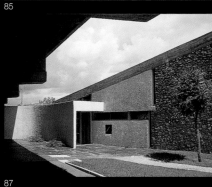

87

86

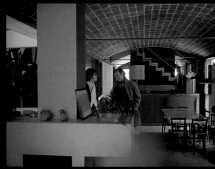

88

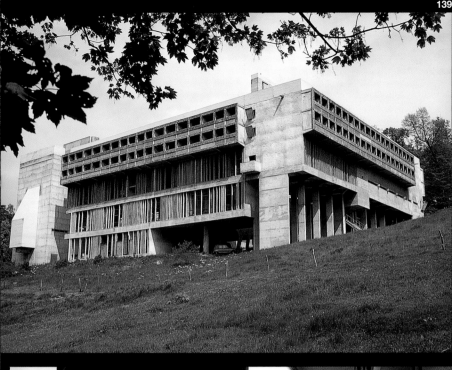

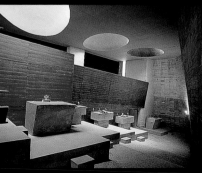

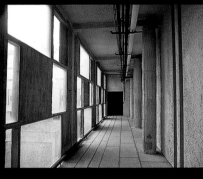

91

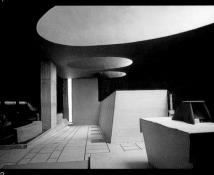

93

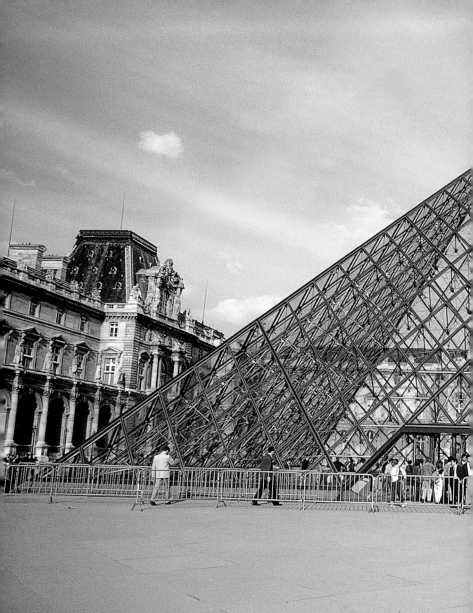

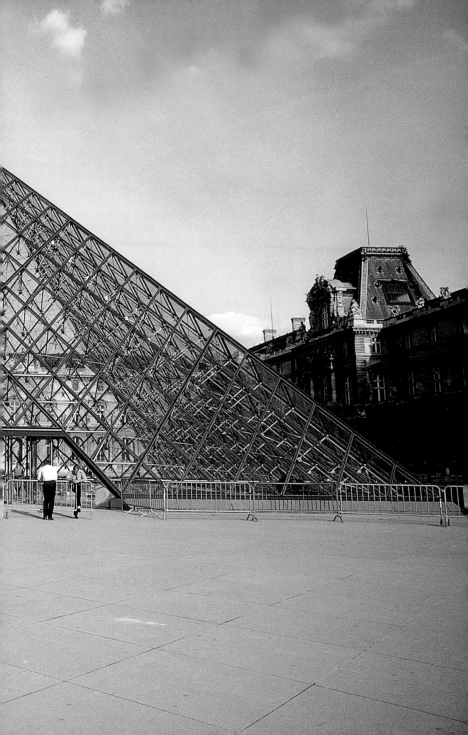

United Kingdom

The peak achievement in historic English architecture is the great number of churc and cathedrals built in the Gothic era. Medieval villages still maintain their uniqu charm, as does the elegant restraint of t numerous country manors and universiti built in the Renaissance and baroque periods.

Rather than the grandiose formal axes c French urban developments, the archite ture of English cities is on a smaller scal and gains from the interaction of diverse styles side-by-side, often built centuries apart.

The building of continuous long terracec housing developments in the 18th and 1 centuries lends its own grandeur to tow on a smaller scale, culminating in the superb urban planning of cities like Bath which has been meticulously maintainec and remains as valid today as it was 25(years ago.

The Industrial Revolution as well as othe technological and scientific advances we dramatic features of the 19th century, a brought a new vision to English architecture. Building upon 18th-century invention of the use of iron in constructic the (later) glass and iron exhibition buildi influenced the rest of Europe.

The development of modern architecture aesthetically did not gain a foothold in England until just before World War II, a only a few distinguished buildings remai Although leaders of the modern movem in Europe (Gropius, Breuer, Mendelsohn etc.) came to England in the 1930s, hav left Germany due to its emerging fascisr they were not welcomed professionally a left to teach and practice in the USA.

Advances in building technology took a leap forward after the war with the work of outstandingly inventive architects who now lead the way internationally.

1 Bath, Prior Park, 1755
Architect: John Wood Snr
This fine property and bridge were deve oped by the architect. The landscape architecture was done by Capability Brc

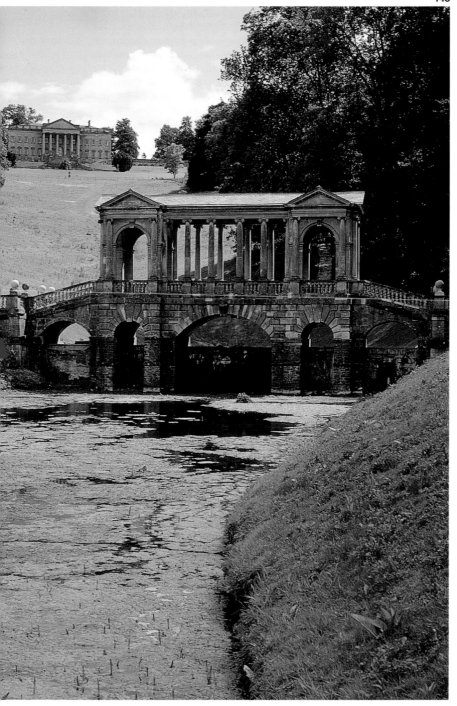

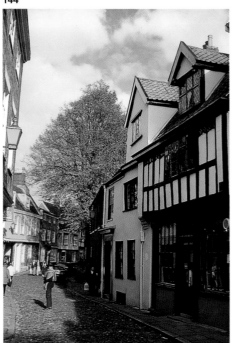

2

2 Norwich, Elm Hill
A charming, well-preserved medieval cobble-stoned street.

3 Norwich, Cathedral, 11th–14th century
One of the finest examples of early Engli Gothic.

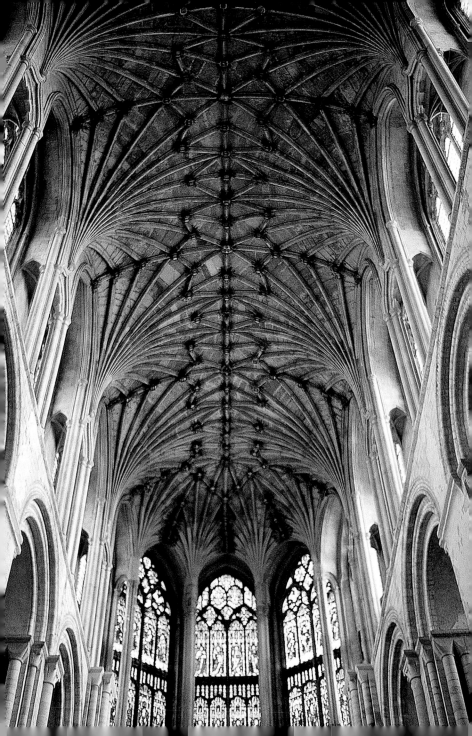

146

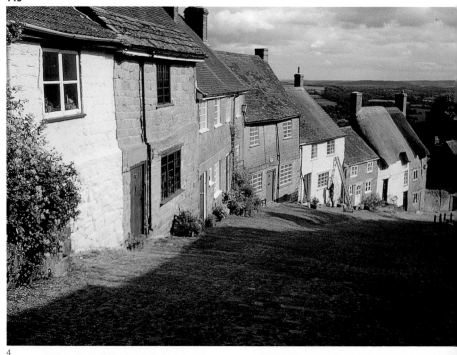

4

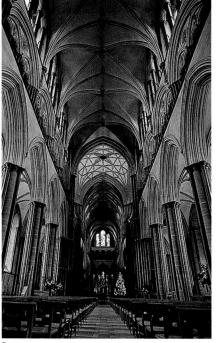

5

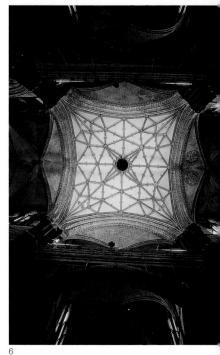

6

Dorset, Shaftsbury, Gold Hill
With its thatched roofs, it is a favourite
film location.

6 Salisbury, Cathedral, 1220–56
Considered the purest representation of
English Gothic architecture, it is cohesive in
style since it was built in a short time.

**Cambridge, King's College Chapel,
1512–15**
The perpendicular Gothic fan vaulting was
designed by John Wastell.

**Gloucester, Cathedral Cloister,
1360–nearly 1400**
Early experimental fan vaulting.

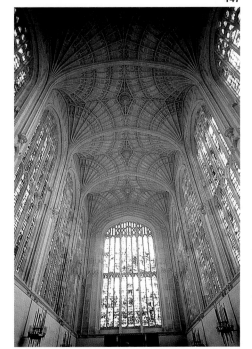

7

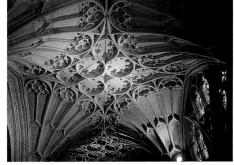

8

148

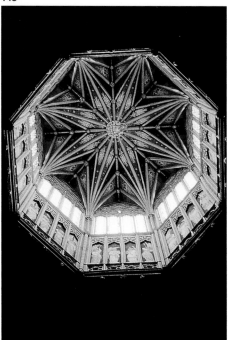

9

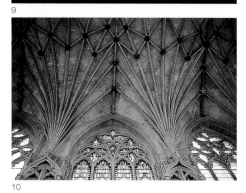

10

9 Ely, Cathedral Octagon, 14th centu
The central tower collapsed and was
replaced by the timber-framed lantern.

**10 Ely, Cathedral Lady Chapel,
15th century**
Vaulting.

11 London, Westminster Abbey, 1245

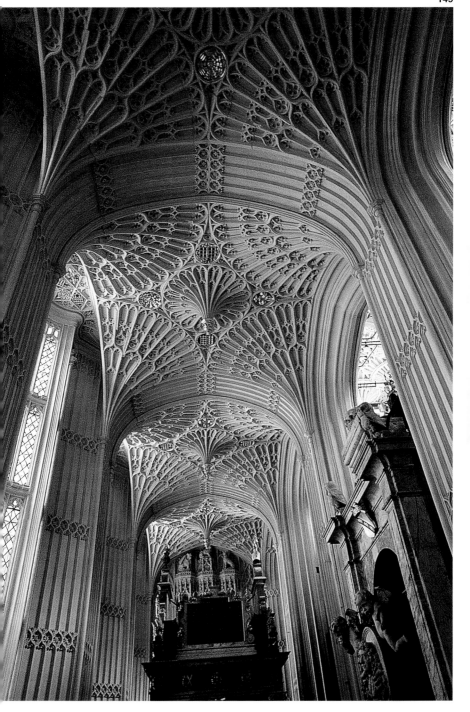

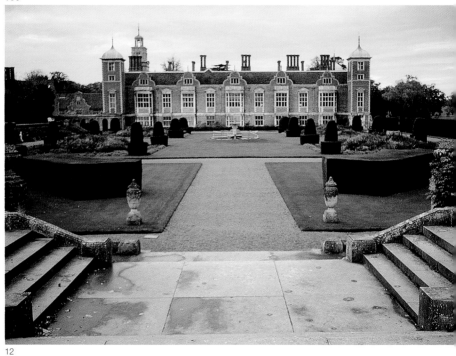
12

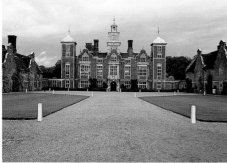
13

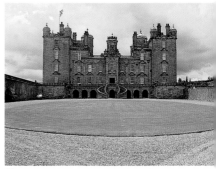
14

12, 13 East Anglia, Blickling Hall, 16th century
A Jacobean country house, once the home of Anne Boleyn, mother of Elizabeth I.

14 Scotland, Drumlanrig Castle, 1679–1691
Distinguished by baroque horseshoe-shaped entrance stairs and multiple towers.

15 London, Chiswick House, 1725
Architect: Lord Burlington
Country house with perfect Roman and Palladian elements. The focal space is ar octagonal domed salon.

16 London, Greenwich, The Grand H: 1700
Architect: Christopher Wren

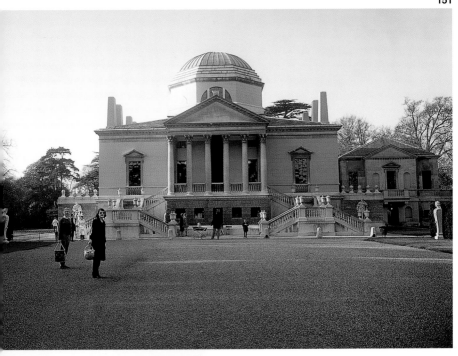

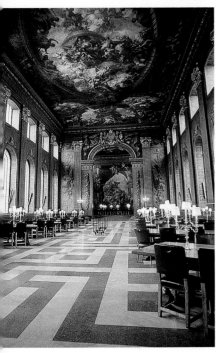

17 London, Greenwich, The Royal Naval College by Christopher Wren with the Queen's House beyond by Inigo Jones, 1620.

18 Oxford, Christ Church Cathedral, 1160

19 Oxford, Radcliffe Camera, 1750
Architect: James Gibbs

20 Oxford, Christ Church Tom Tower, 1681
Architect: Christopher Wren

21 Oxford, Queen's College

22, 23 Bath, the Royal Crescent, 1767
Architect: John Wood the younger
This grandiose town planning assembly of geometric building forms gives the whole town a cohesive character that is unprecedented. The housing was built by the Woods, as commercial development.

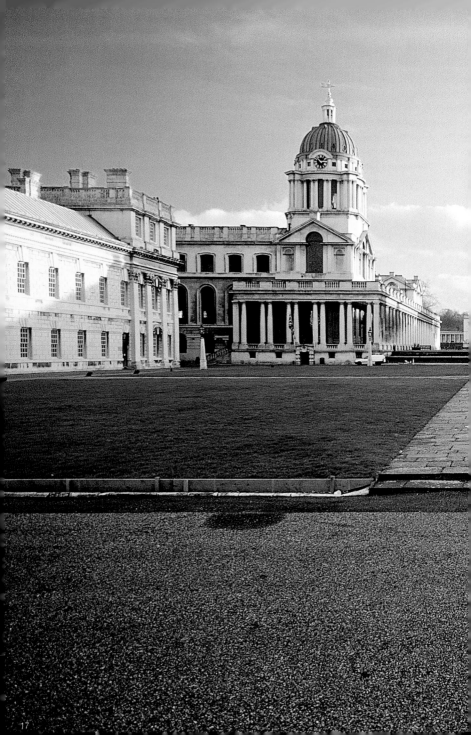

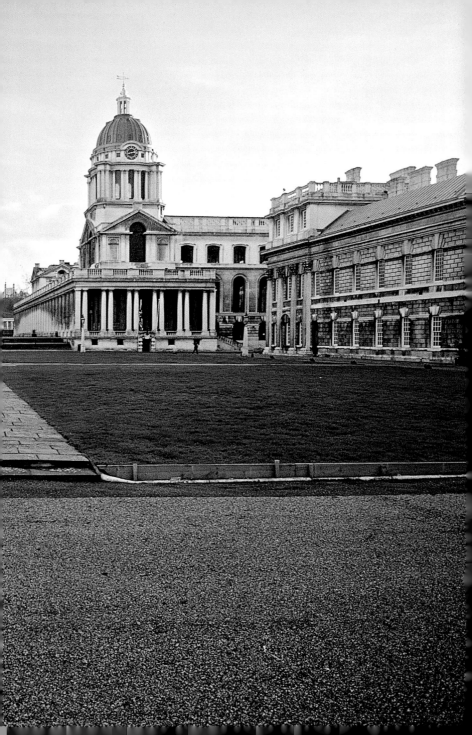

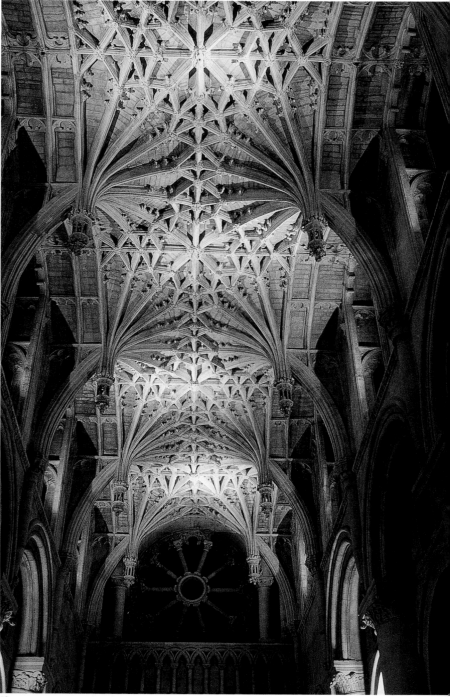

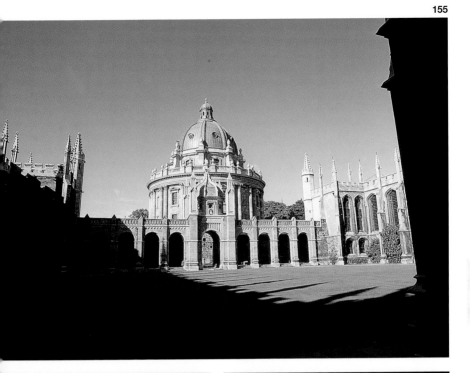

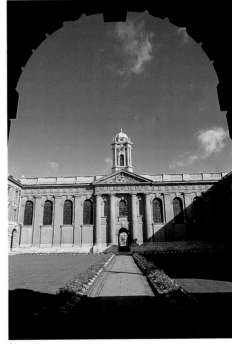

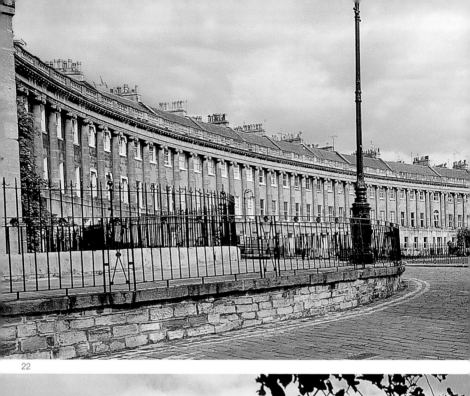

22

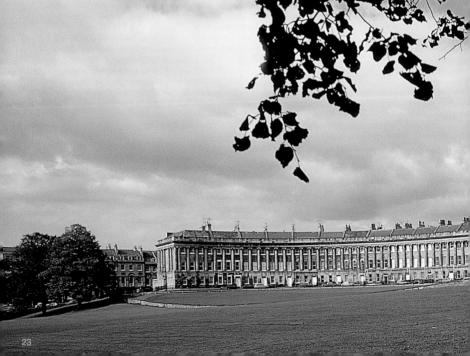

23

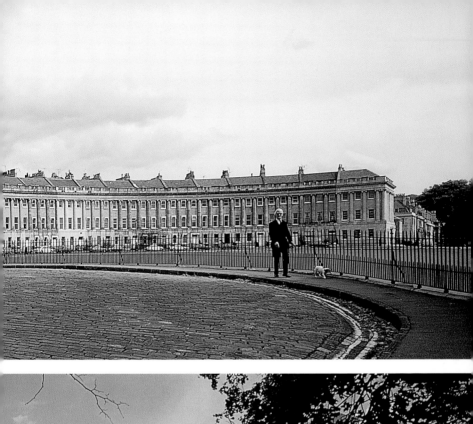
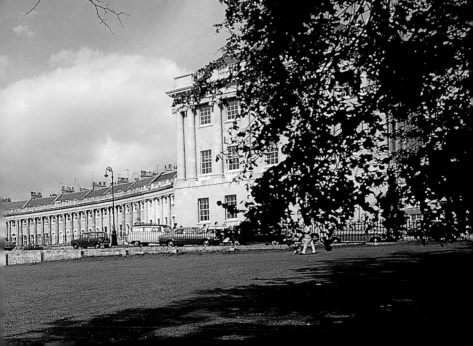

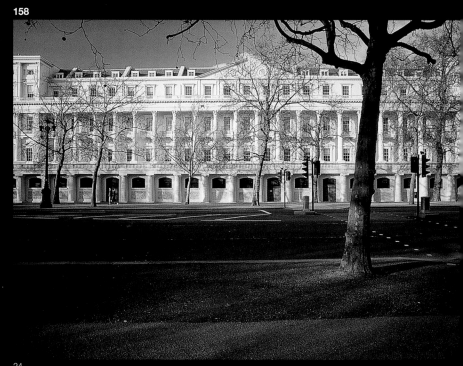

24

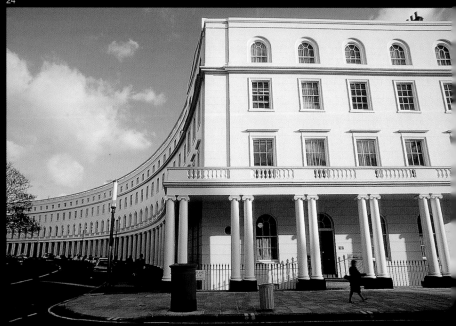

25

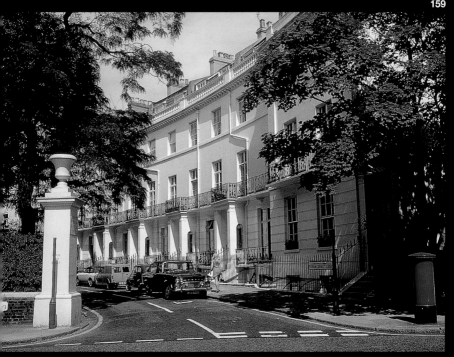

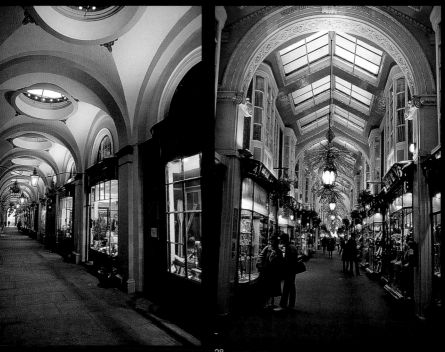

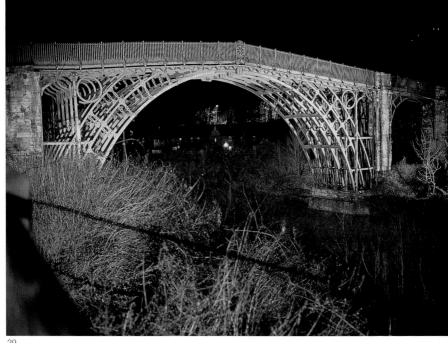

29

24 London, Carlton House Terrace, The Mall, 1827-33
Architect: John Nash
These formal, classical buildings form the boulevard leading to Buckingham Palace.

25 London, Regents Park Crescent, 1812
Architect: John Nash
The two colonnaded arcs facing Regents Park are amongst the grandest of terraced house developments.

26 London, Pelham Crescent, 1840
Architect: George Basevi

27 London, Royal Opera Arcade, 1818
Architect: John Nash
The strong co-ordinated architectural forms and cohesive timber shop-fronts are beautifully maintained.

28 London, Burlington Arcade, 1820
Architect: Samuel Ware
Small, finely detailed shops and glass roof have remained popular for nearly 200 years.

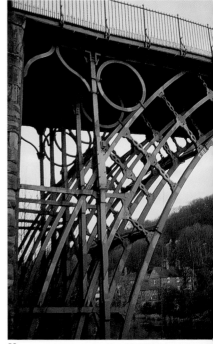

30

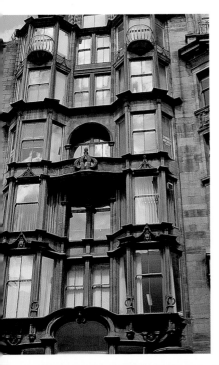

29, 30 Ironbridge, 1779
Engineer: Abraham Darby
The world's first iron bridge, which
revolutionised building methods.

31 Glasgow
Unified 19th Century, masonry row
housing and bay windowed glass fronts.

32 The Glasgow School of Arts,
1897–1909
Architect: Charles Rennie Mackintosh
The library demonstrates the new spatial
design by the architect, who influenced
pioneering Viennese architecture at the
time.

162

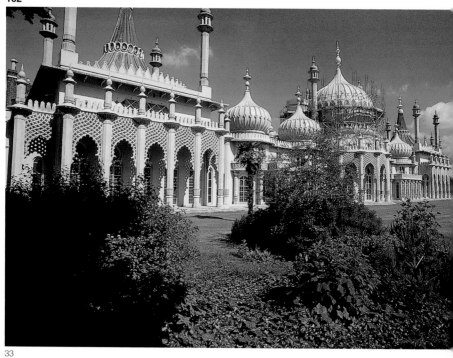

33

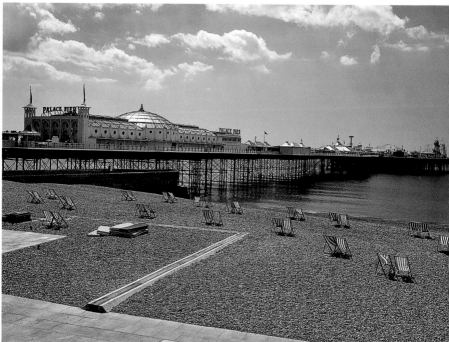

34

33, 35 Brighton, the Royal Pavilion, 1820
Architect: John Nash
This Orientally decorated building and its structure, seen in the kitchen, is characteristic of the Prince Regent's exotic taste.

34 Brighton, the Palace Pier, 1899
The focal point of this seaside resort.

36 Brighton
A typical Georgian residence, influential to colonial architecture in the 19th century.

37

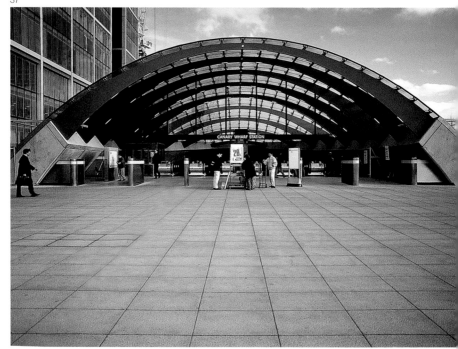

38

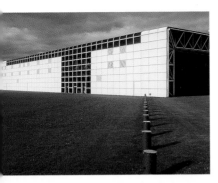

37, 39, 40 Norwich, Sainsbury Centre, 1978
Architect: Norman Foster
A technologically advanced structure with co-ordinated solid and glazed components.

38, 41 London, Canary Wharf Station, 1995
Architect: Norman Foster
A monumentally scaled underground station of structurally expressive concrete.

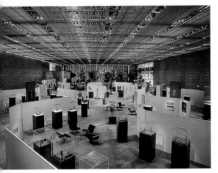

42 Stansted Airport, 1989
Architect: Norman Foster
A rare, refined example of airport architecture, free of normal visual confusion and clutter, with all services and signage co-ordinated within the inverted pyramidal shaped sky-lit steel supports.

43 London, British Museum, 2000
Architect: Norman Foster
The courtyard's flat glazed dome inventively uses glass as a structurally compressive element.

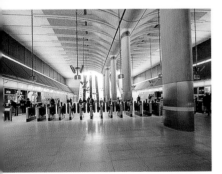

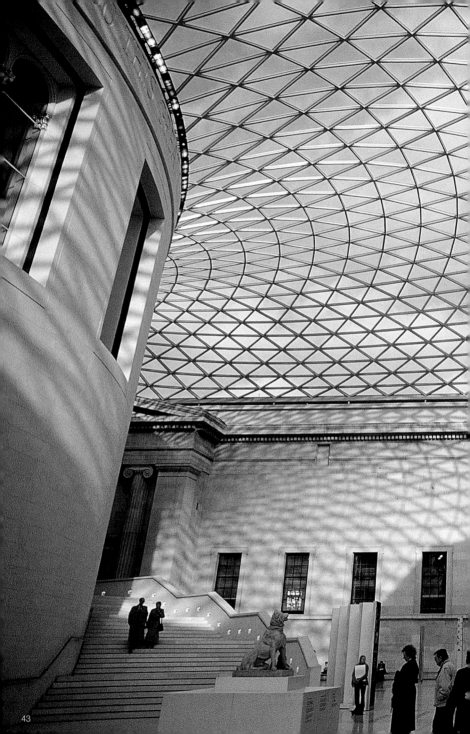

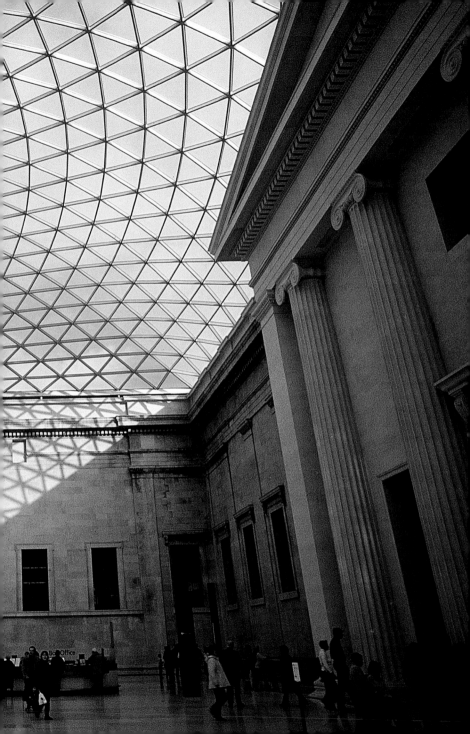

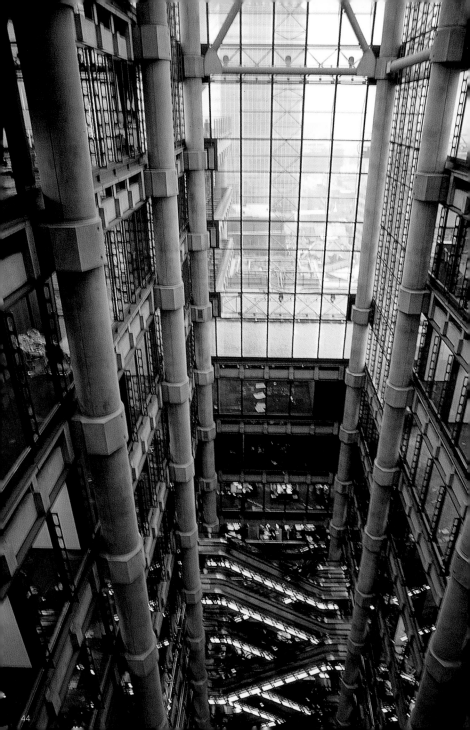

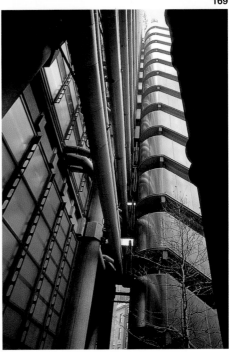

45

44, 45 London, Lloyd's Insurance Headquarters, 1982
Architect: Richard Rogers
An important building of advanced technology, with expressed structure and mechanical services.

Spain

Spain has had an extraordinary history, composed of cultural extremes of opposites. The Romans named the land Iberia, and also Hispania, built roads, bridges and huge engineering works such as the stone aqueduct in Segovia, which still serves its purpose after 2000 years. Invasions by the Moors from North Africa brought another kind of architecture, which thrived for centuries and stood side-by-side with fine late Gothic structures, such as those in Seville and Córdoba. The pleasure pavilions in Granada's Alhambra became the most celebrated pieces of architecture in Spain.

During the cruel, autocratic reign of Philip in the 16th century, vast monasteries were built of solid granite – such as "El Escorial" by virtual slave labour; many died on the building-site.

The cities of Spain are graced with wonderful, huge public plazas – ringed on all four sides by co-ordinated buildings. They were built in the 17th and 18th centuries and remain the popular focus of their towns.

The most extraordinary Catalan architect nearer our time, was Antoni Gaudí. He designed the church of La Sagrada Familia in 1883, which is still in construction long after his death. His intuitive structures are embellished within curvilinear forms, which characterise all his work.

During the Civil War and in the fascist Franco period, many architects and artists (such as Picasso) chose to live outside Spain. There are few modern buildings of distinction of that period.

1 Barcelona, Casa Milà, 1906-10
Architect: Antoni Gaudí
Detail of the façade.

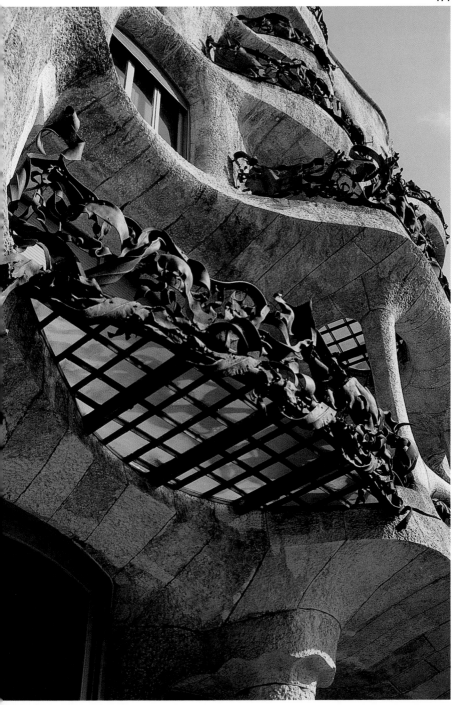

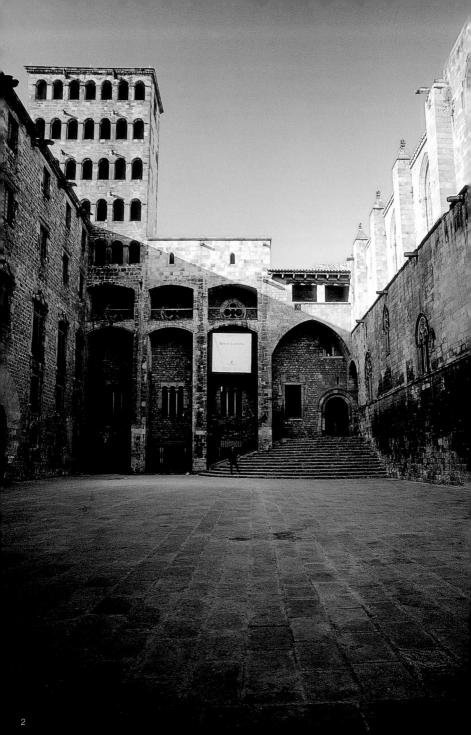

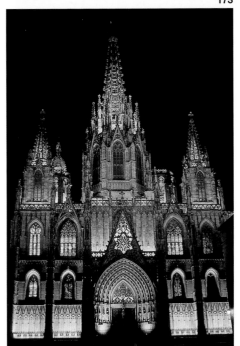

3

2 Barcelona
The Gothic quarter of Barcelona dates
back to Roman times, although built in the
13th–15th centuries.

3 Barcelona
The 15th-century Gothic cathedral is
originally of French design, reconstructed
in the 19th century.

4, 6 Barcelona, La Sagrada Família, 1883 – still in construction
Architect: Antoni Gaudí
This building is the landmark of Barcelona. Long after Gaudí's death the interior structure is finally being completed following the original design but executed in part by using pre-cast concrete instead of stone.

5 Barcelona, La Sagrada Família, 1883 – still in construction
Architect: Antoni Gaudí
In spite of its fanciful appearance, it contains rational structural expressions in its column form, predating the work of Piere Luigi Nervi.

7 Barcelona, Casa Milà, 1906–10
Architect: Antoni Gaudí
With its unique undulating façade and rooftop sculptural chimneys, this apartment building's character is extended to every detail of the interior.

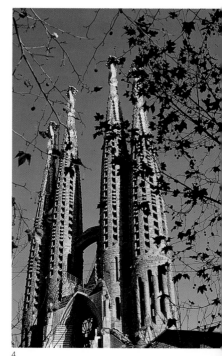

4

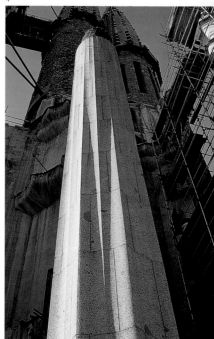

5

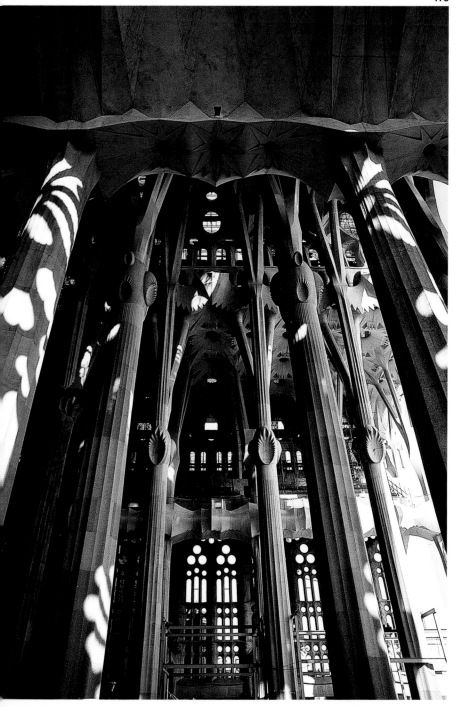

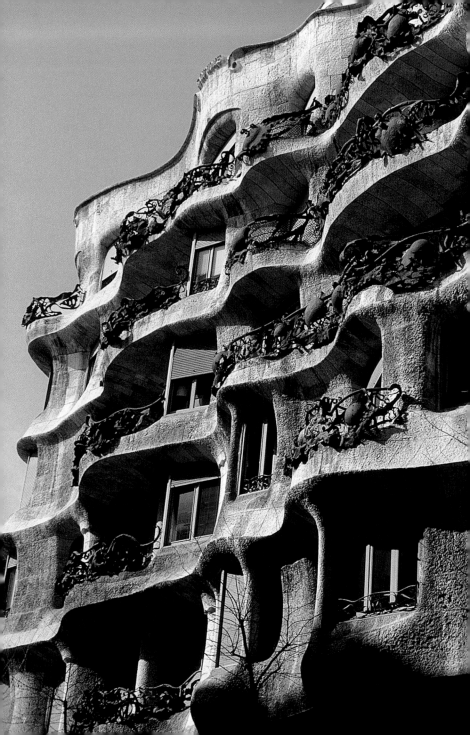

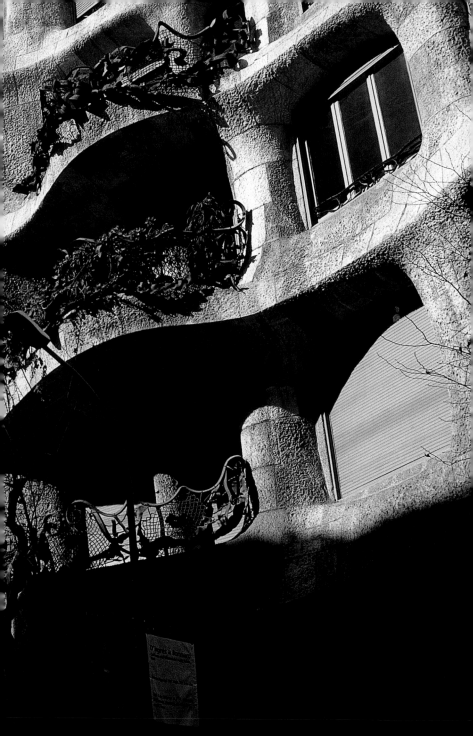

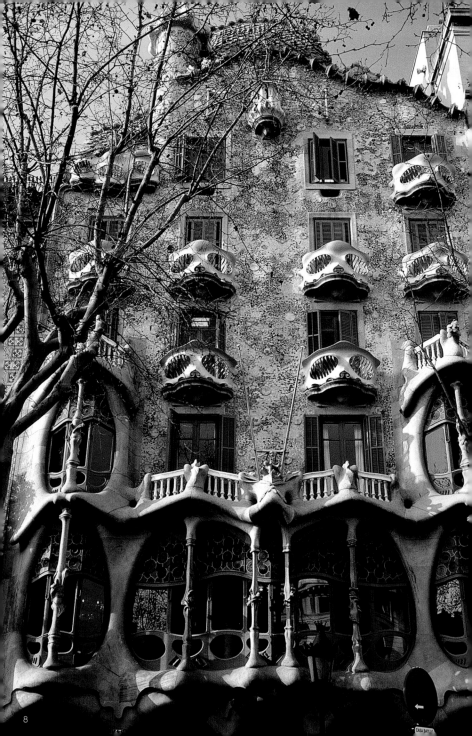

...arcelona, Casa Batlló, 1904
...hitect: Antoni Gaudí
... curvilinear stone façade recalls
...anic forms.

...arcelona, Güell Pavilion, 1885
...hitect: Antoni Gaudí
... fence.

...11 Barcelona, Casa Milà, 1906–10
...hitect: Antoni Gaudí
... doors of the main entrance are hand-
...de, of beaten wrought-iron.

...Barcelona, Casa Milà, 1906–10
...hitect: Antoni Gaudí
... rooftop's sculptural chimneys.

...Montefrío

...Toledo

...Setenil

...Olvera
...uthern Spain's characteristic white hill-
...wns gain visual consistency by using
...te-painted walls and terracotta roofs for
...buildings old and new.

...Castille
...isolated fortified medieval castle in
...Castille area.

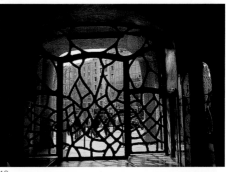

9

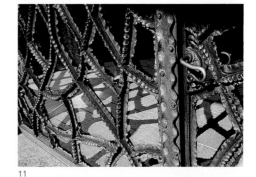

10

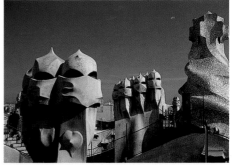

11

12

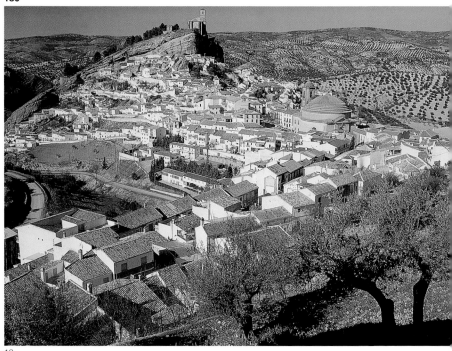

13

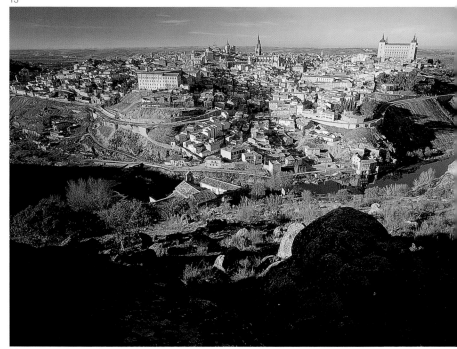

14

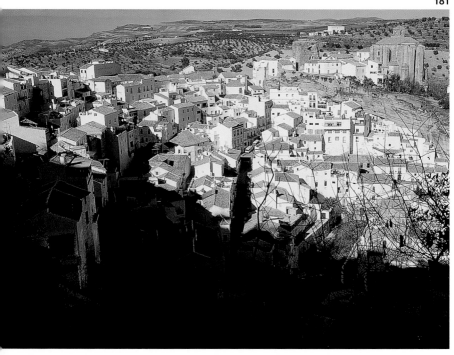

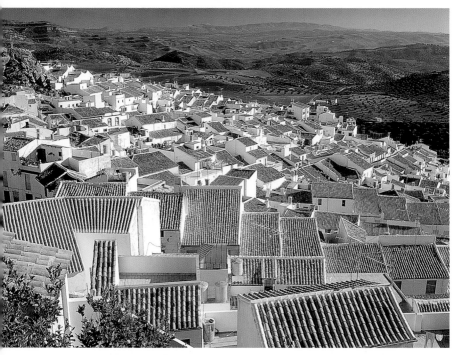

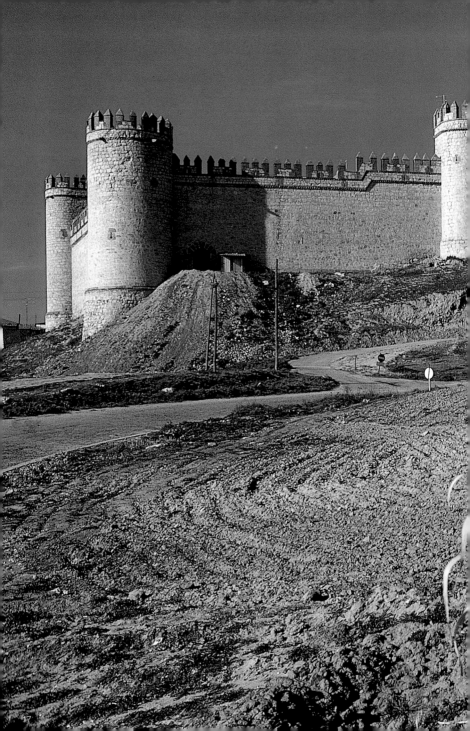

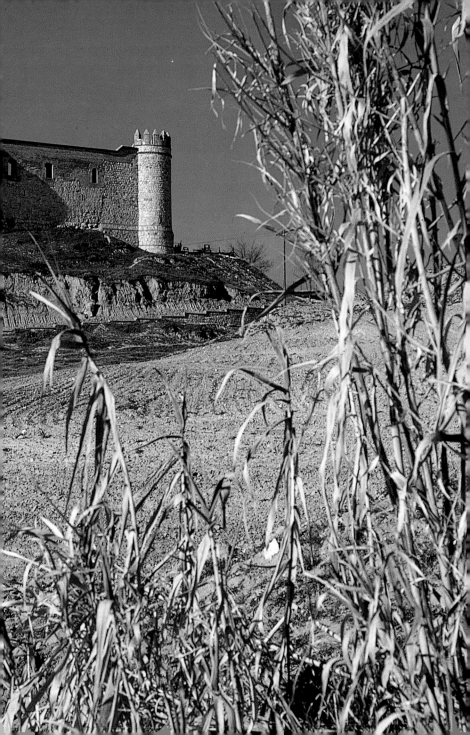

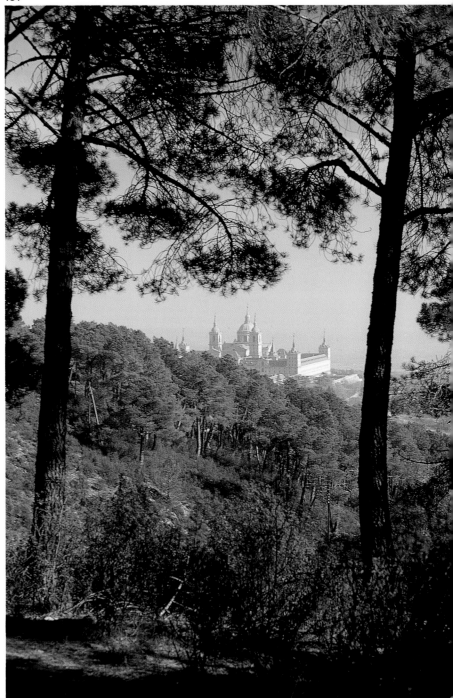

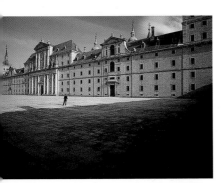

18–21 El Escorial Monastery, 1563
Architect: Juan de Herrera
The sober, clean-cut lines of this majestic monument belie its age. Built entirely of grey granite, it achieves the grandeur of a palace and the austerity of a monastery.

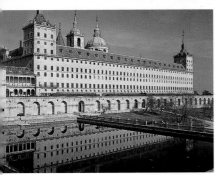

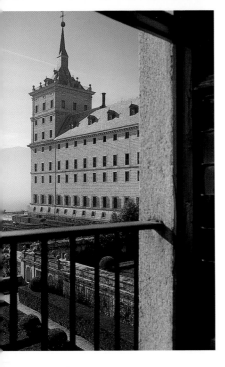

22–24 Segovia, Cathedral, 16th century
Architect: Juan Gil de Hontañón
A fine late Gothic work.

25 Segovia, Roman aqueduct
This daring 28 m high structure (1st century AD) still serves its purpose as an aqueduct.

26, 27 Ronda
This Roman town is built on a platform at the edge of a ravine. It contains the oldest bullring in Spain.

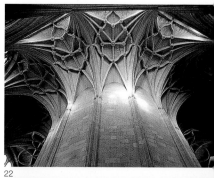

22

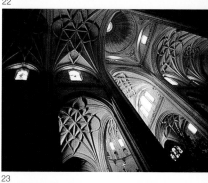

23

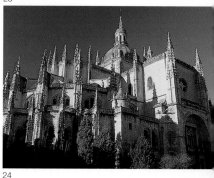

24

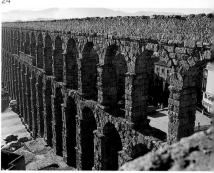

25

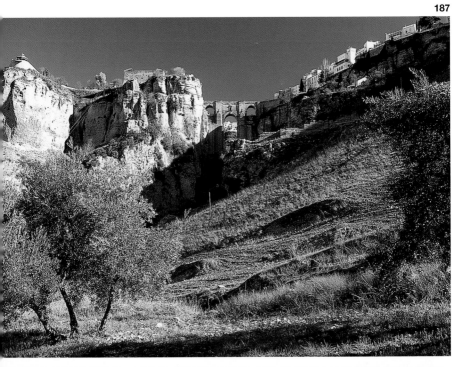

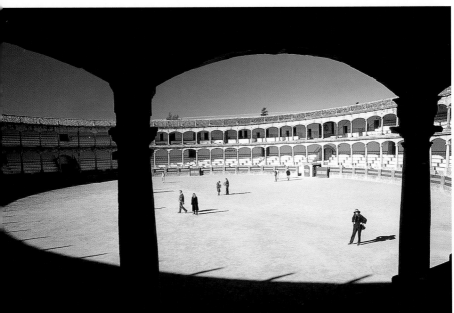

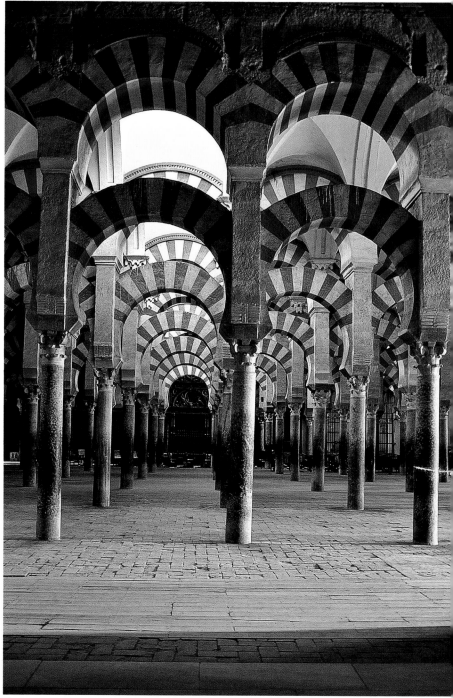

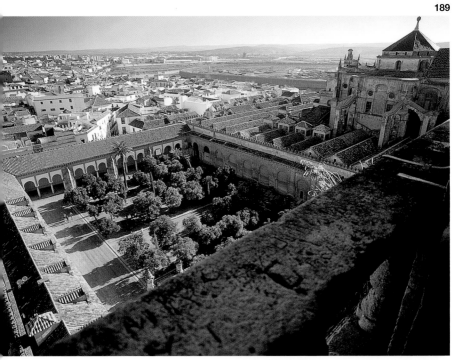

29 Córdoba
centuries, the centre of Muslim Spain.
huge arched mosque structure, 875–
AD, had a Christian cathedral inserted
s centre in the 16th century.

Córdoba
13th-century interlocking cross vaults
reminiscent of Guarino Guarini's work in
h-century Turin.

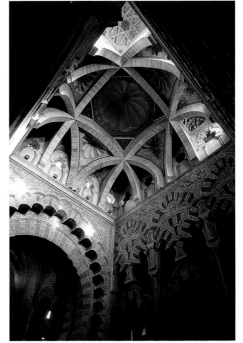

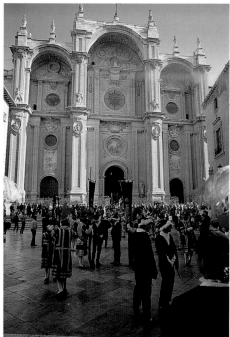

31 Granada, Cathedral façade, 17th century
Architect: Alonso Cano
Seen during a historic celebration.

32–35 Granada, the Alhambra, 1350
An elaborate and richly decorated Muslim fortress palace with formal pavilions; here the Lion Court and the arcaded Myrtles Court, with its central reflecting pool.

31

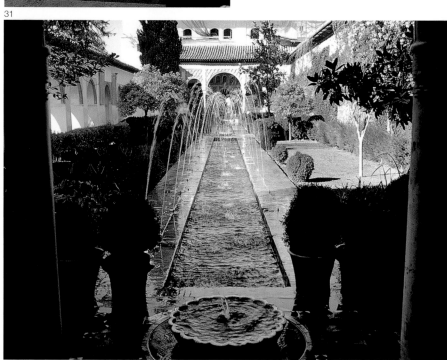

32

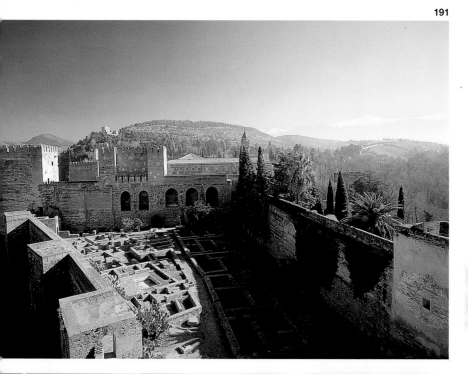

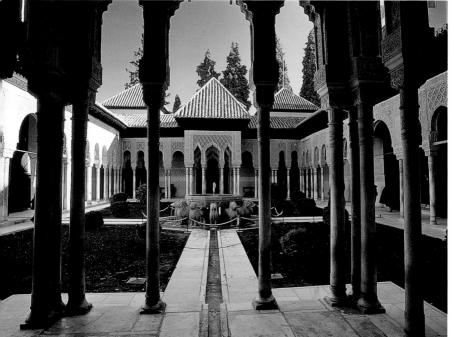

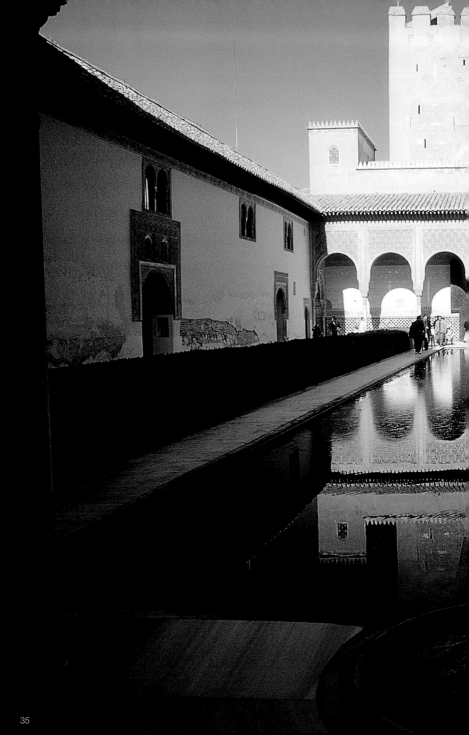

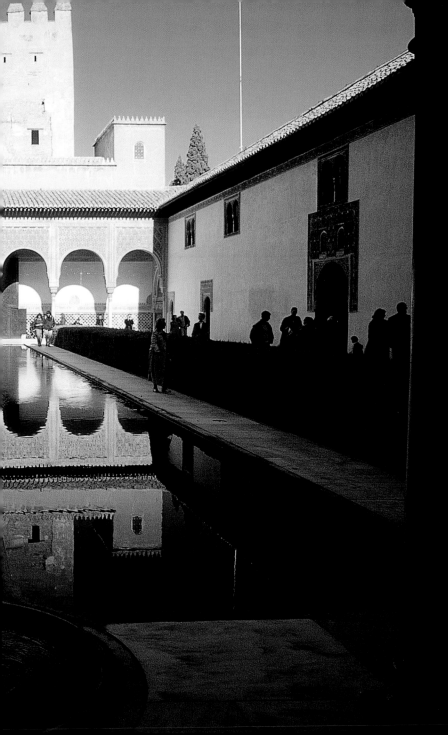

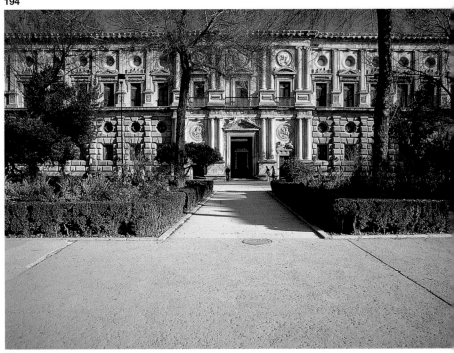

36

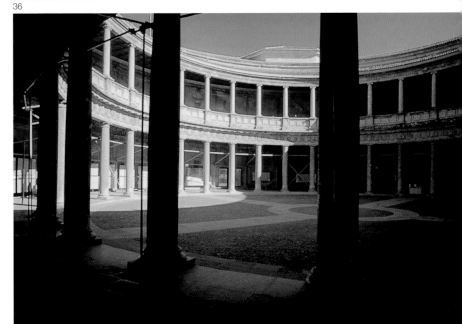

37

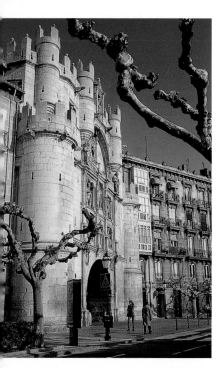

36, 37 Granada, Palace of Charles V, in the Alhambra, 1550
Architects: Pedro and Luis Machuca
A square Renaissance building, with an internal arcaded circular court.

38 Burgos, Town Gate
14th century

39, 40 Madrid, Plaza Mayor, 1620
Architect: Juan Gomez de Mora
This public square, surrounded by fine buildings, forms the focus of Habsburg Madrid, and is used for celebrations.

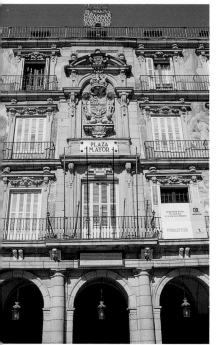

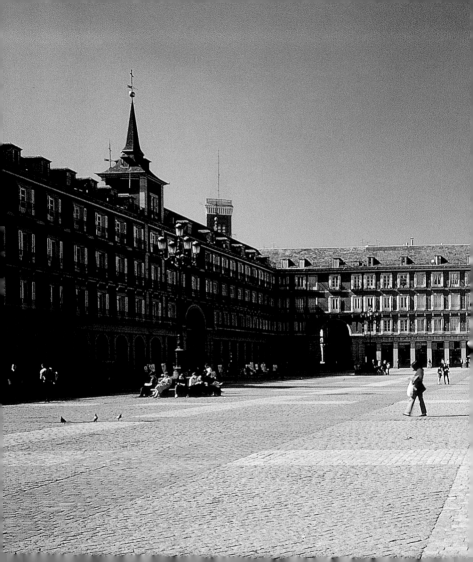

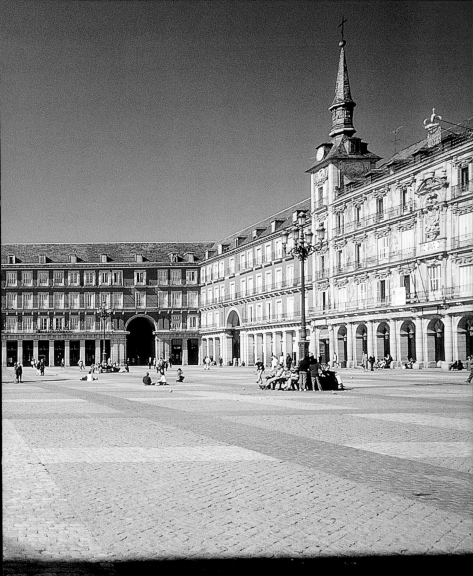

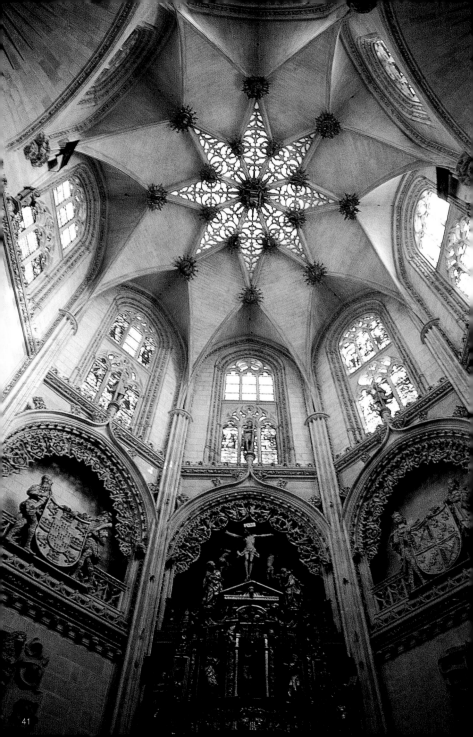

42

41 Burgos, Cathedral, 1490
Architect: Simon de Colonia
The octagonal Chapel Contestable.

42 Burgos, Cathedral
Sculptured Coroneria doorway.

43 Salamanca, Plaza Mayor, 1730
Architect: Churriguera Bros
One of the finest squares in Spain, much
frequented by university students.

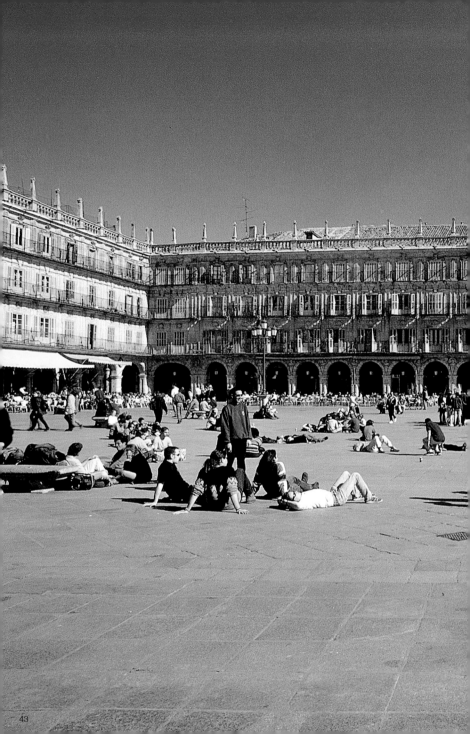

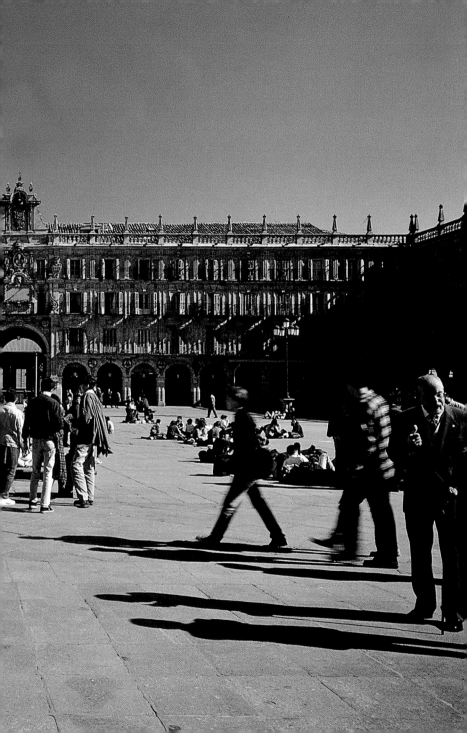

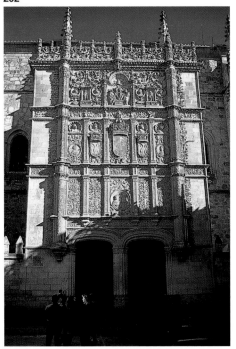

44

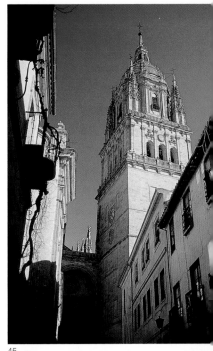

45

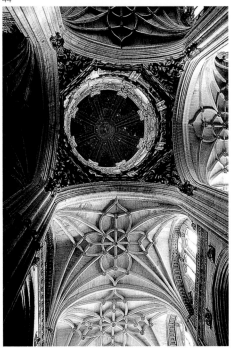

46

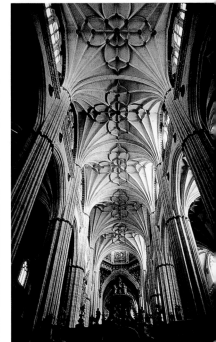

47

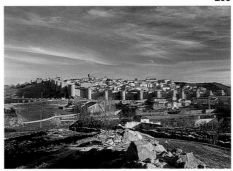

48

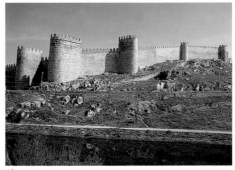

49

44 Salamanca, University, 1520
The sculpted entrance façade.

45-47 Salamanca, New Cathedral, started 1513
Architect: Juan Gil de Hontanon
The decorative fan vaulting extends into the transept.

48, 49 Ávila
This picturesque, fortified and still intact 11th-century town has continuous ramparts that remain accessible.

50–53 Barcelona, German Pavilion, 1929
Architect: Ludwig Mies van der Rohe

This ultimate icon of modern architecture was erected for the International Exhibition of 1929, demolished after a mere three months but then faithfully reconstructed permanently as a museum in 1986.

The concentration of support in regularly placed steel columns allowed the free disposition, independently, of screen-like walls that create a continuum of flowing space between them.

This spatial openness is dramatised by the use of the most sumptuous materials: polished marble, onyx, travertine and polished chrome. Two reflecting pools complete this dramatic demonstration of the new language in architecture, amplified by the architect's specially designed chairs, which have become famous internationally. There are no exhibits in the building, but the structure itself serves that purpose. The black carpet, yellow leather upholstery on the chairs and a red curtain, the colours of the German flag, confirm this.

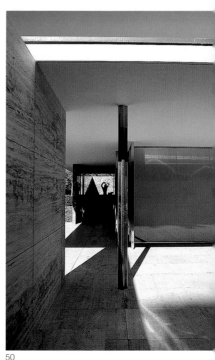

50

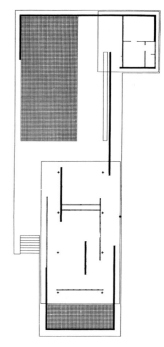

51

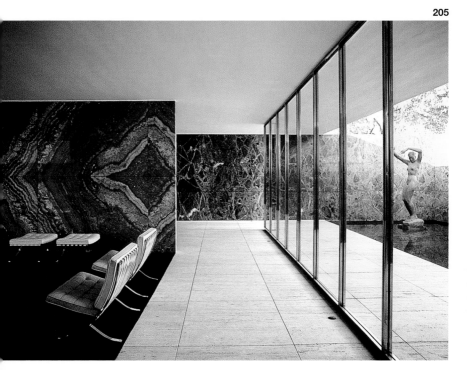

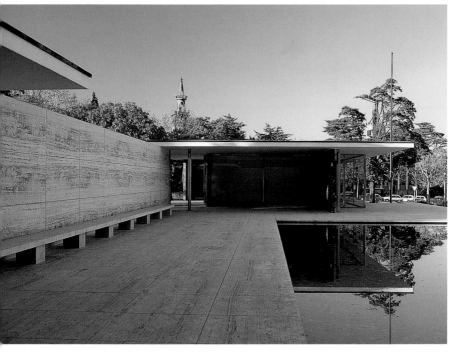

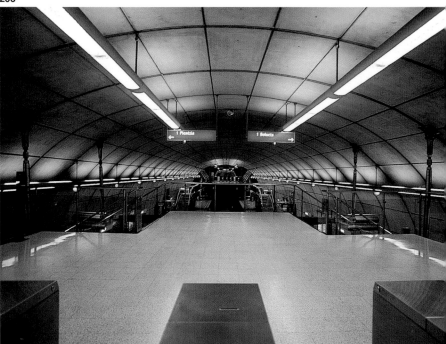

54

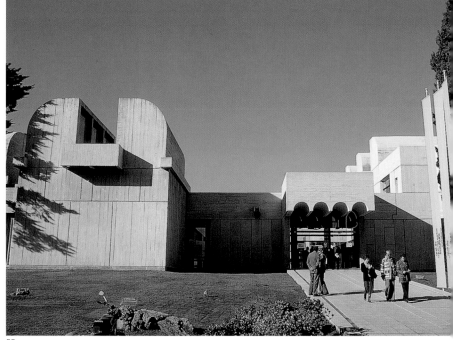

55

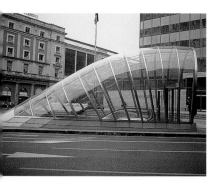

54, 56, 57 Bilbao, Underground Station, 1991

Architect: Norman Foster

Approached through glass-arched entrances from street level, the upper station concourse is suspended from the wide precast concrete vaulted station roof.

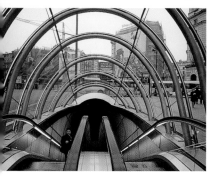

55 Barcelona, Miró Foundation, 1976

Architect: José Luis Sert

The museum is dedicated to Sert's friend and countryman, the Spanish artist Miró. The various pavilions showing different phases of Miró's work are top-lit from segmental concrete vaults, which throw diffused daylight onto the artworks and create a rich spaciousness within.

58 Bilbao, Footbridge, 1997

Engineer: Santiago Calatrava

This extraordinary structure has the translucent glass walkway (dramatically lit from within at night) suspended from a one-sided tilting arch support.

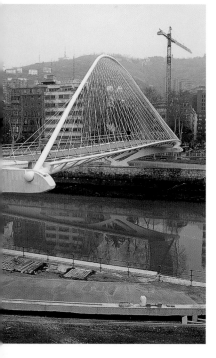

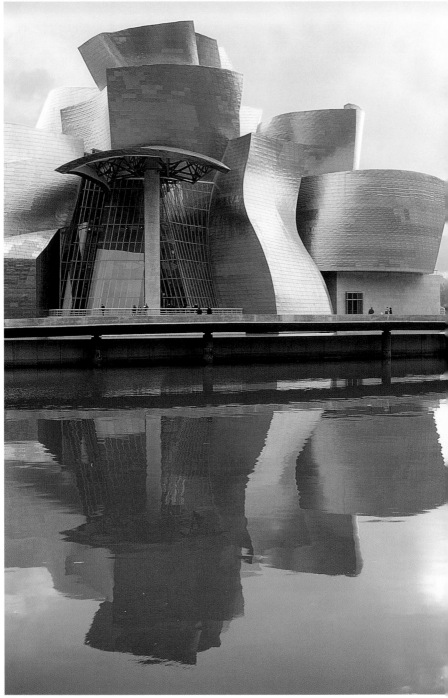

60

59–61 Bilbao, Guggenheim Museum, 1997

Architect: Frank Gehry

This amazing, unprecedented sculptural building is made possible in our computer era, which not only enables architects to draw such designs accurately, but by the computer's ability to instruct machines to produce all elements for assembly. There are virtually no straight or perpendicular lines in the building. The exterior is sheathed with panels of titanium.

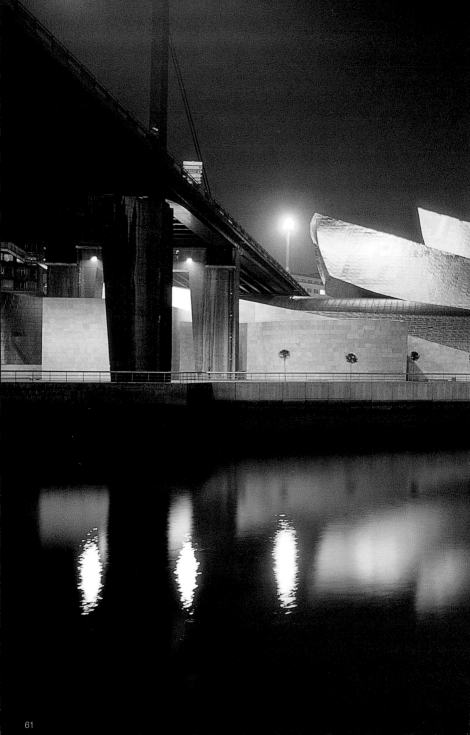

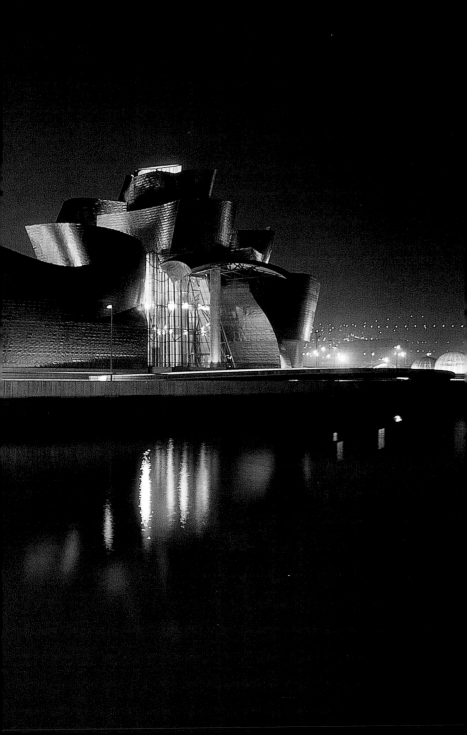

Portugal

Even though Portugal has some of the richest examples of Gothic and baroque architectural art, their importance and historic value have largely gone unnoticed. It seems that historians did not visit Portugal and have always concentrated on other centres of European architectural culture.

The country's rich background dates from the golden age of Portuguese discoveries when its navigators set sail to explore the New World. The country gained its huge wealth from trade in spices from the East and gold and sugar from plantations in colonial Brazil. The wealth made possible the many distinctive, well-preserved monuments.

Owing to the region's warm and sunny climate, central European architectural styles through the ages were transformed into more open and different configuration. A traditional craft, that of making fine blue "azulejo" wall tiles, transformed buildings and were used to cover large exterior wall areas. They give a unique character to Portuguese historic architecture.

The baroque buildings of the 17th and 18 centuries, in comparison to those of central Europe, create an extraordinarily flamboyant sculptural imagery, which find their parallels in the historic towns of Brazil

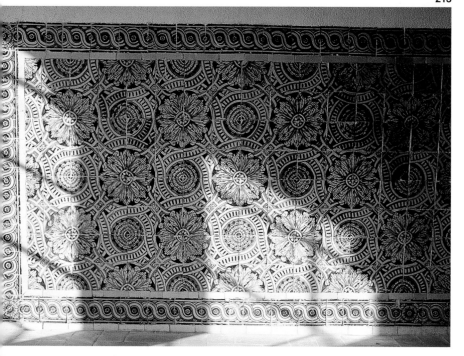

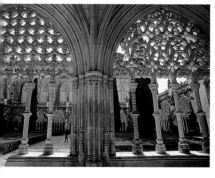

omar, azulejo wall

atalha, cloister, 1500

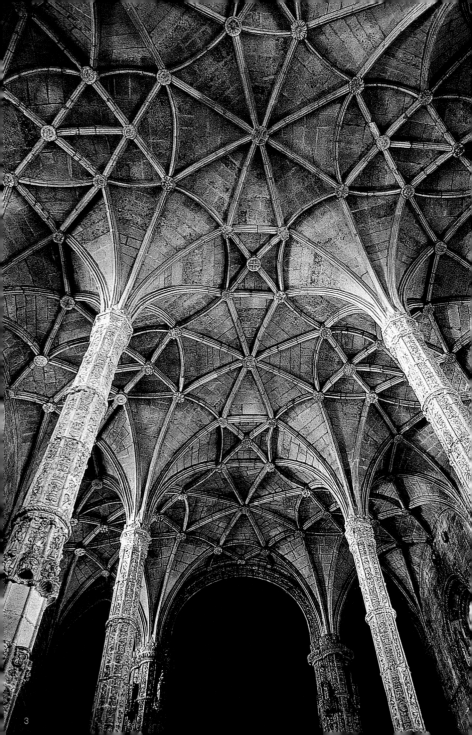

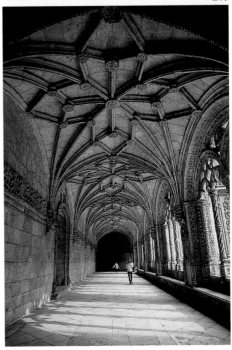

4

3, 4 Belém, Monastery of Jeronimos, 1495–1521

Architect: Diogo de Boytac
An example of Manueline architecture, with distinctive rib-vaulting and cloisters.

5–8 Tomar, Church of Nossa Senhora, 12th century

With an intricately carved façade, ribbed vaulting, curved stone stairs and azulejo-tiled cloistered courtyards.

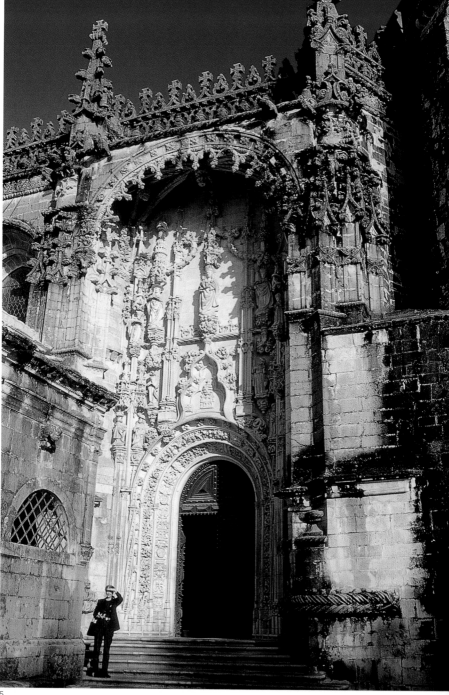

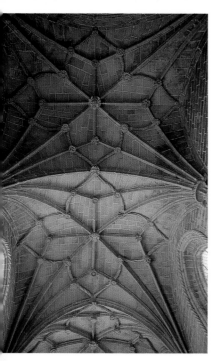

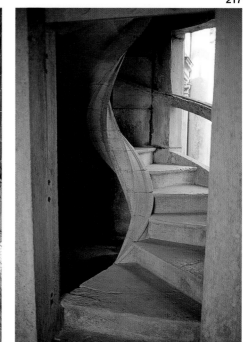

7

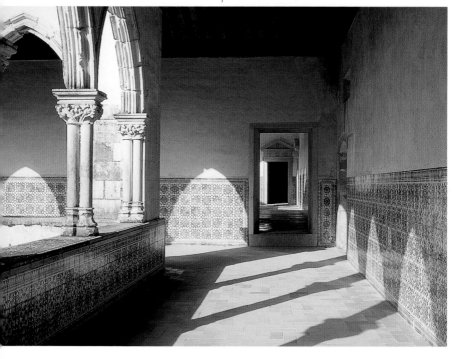

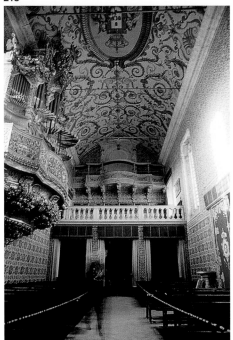

9

9 Coimbra, 18th century
A fine Manueline chapel by Marcos Pires decorated with azulejos.

10, 12 Batalha, Santa Maria da Vitóri
The late 14th-century monastery and church built by an Irishman in flamboyar Gothic style for the Queen, English-born Philippa of Lancaster. The Royal Cloiste surrounded by carved marble arcades.

11 Coimbra, Monastery of the Holy Cross, 16th century
With a freestanding Renaissance portico

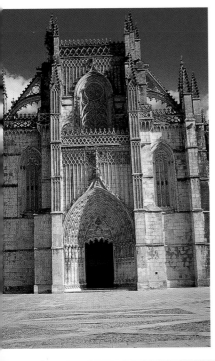

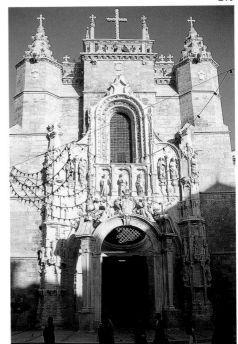

11

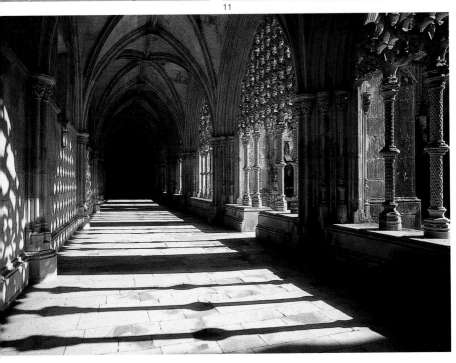

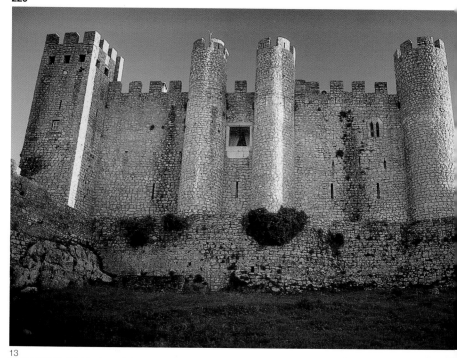

13

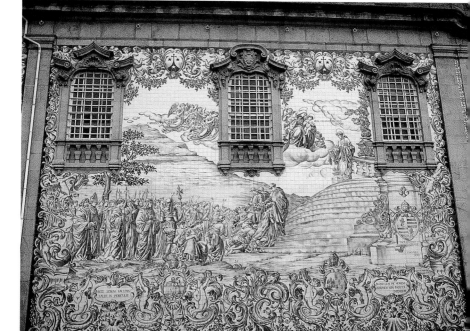

Óbidos Castle
 medieval building was transformed into
lace in the 16th century, built against
old town wall.

Porto
age azulejo-tiled exterior church wall.

Buçaco Forest
by a natural spring, the "Cold
ntain", flanked by staircases on both
s, cascades down in the magnificent
st.

Porto, Dom Luis I Bridge, 1886
neer: Theophile Seyrig
feat of iron engineering has two
erimposed roads, connecting both
er and lower levels of the town on
er side of the river.

Braga, Bom Jesus do Monte
itect: Carlos Amarante
twin-towered, 18th-century church of
image stands atop a granite and
ter baroque staircase, adorned with
tains and terracotta statues. The form
is long double staircase, built into the
ral hillside, is one of the richest
nples of baroque art.

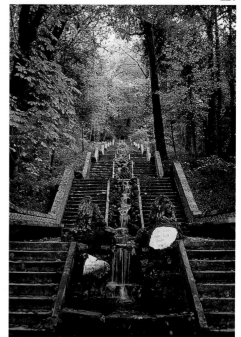

15

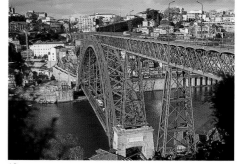

16

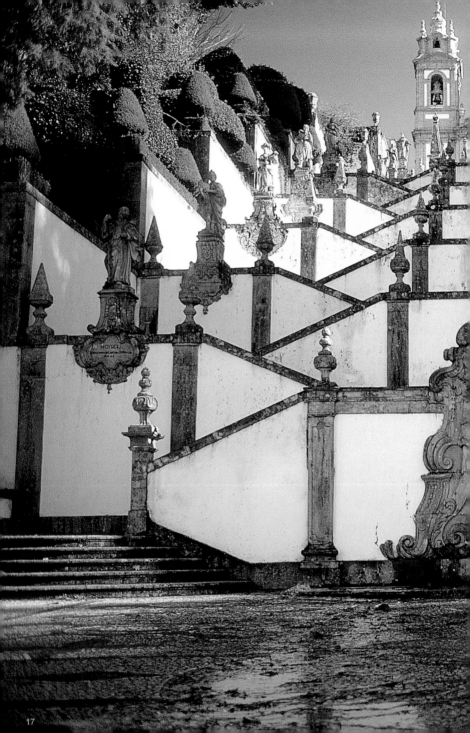

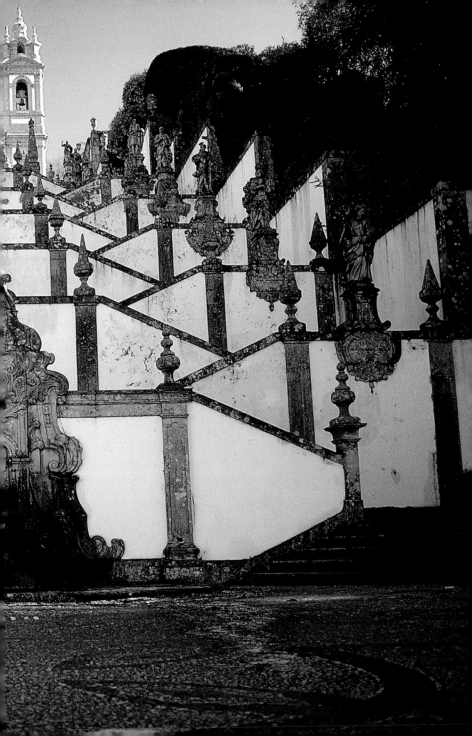

Netherlands

To most visitors, the cities of the Nether
lands, especially Amsterdam, conjure up
image of tree-lined canals with rows of
charming narrow-fronted houses on bot
sides; hence the name "The Venice of th
North".

Although this characterisation still pervac
the emergence of the architectural
"Amsterdam School" at the beginning of
the 20th century is prevalent in more red
buildings. It is a solid style of socially
"comfortable" buildings, with a few
individual architects raising it to architec
importance. The best known of these is
Hendrik Berlage, the architect of the
Amsterdam Stock Exchange, which is a
powerful and large building of brick, insi
and out, of visible structural expression a
no applied decoration. The few carved
embellishments are set into the fabric of
building to form an integral part of it.

In the 1920s and '30s, the "De Stijl" mov
ment, both in painting and architecture,
produced some buildings of world impo
tance, which influenced architecture in
the rest of the Western World, even to
this day. Aside from Dutch artists such a
Piet Mondrian and Theo van Doesburg,
revolutionary small house and its furnitur
designed by Gerrit Rietveld in Utrecht, a
the work of Jacobus Johannes Pieter O
have influenced modern building through
out the country.

Developing in parallel with the new art a
architecture at the Bauhaus in Germany,
some large pioneering buildings stand o
as landmark structures which are as vali
visually and physically as they were in th
1920s, such as the famous Van Nelle
factory in Rotterdam by Brinkman and V
der Vlugt, or the Bergpolder Gallery-Acc
Apartments by Willem van Tijen.

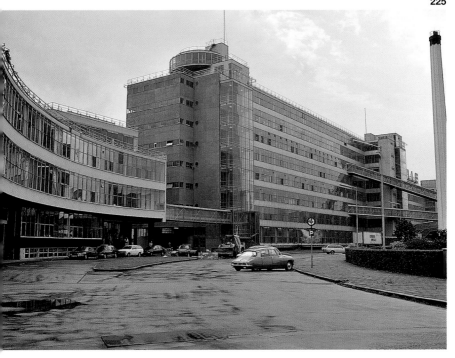

1 Rotterdam, van Nelle Factory, 1924
Architects: Brinkman and Van der Vlugt
One of the earliest wholly glass curtain-wall
buildings in Europe, expressly designed for
the comfort and safety of employees.

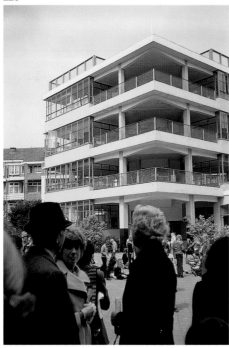

2

2 Amsterdam, Open Air School, 1930
Architect: Johannes Duiker
An early reinforced concrete glazed
structure with cantilevered corners. The
building is as new, still used for its original
purpose.

3 Amsterdam
Narrow-fronted buildings along canals with
characteristically Dutch gables, large
windows and lifting beams projecting from
the roof to raise furniture.

4 Amsterdam
A typically tree-lined canal with joined
buildings on both sides.

5 Amsterdam, Stock Exchange, 1903
Architect: Hendrik Petrus Berlage
An early minimalist, structurally expressive
brick building.

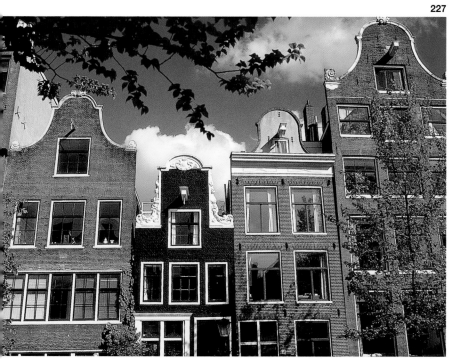

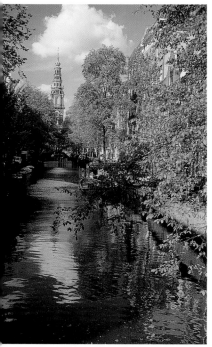

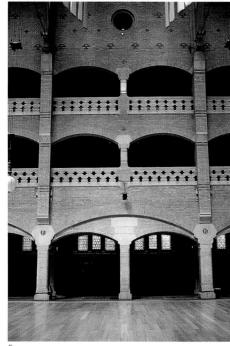

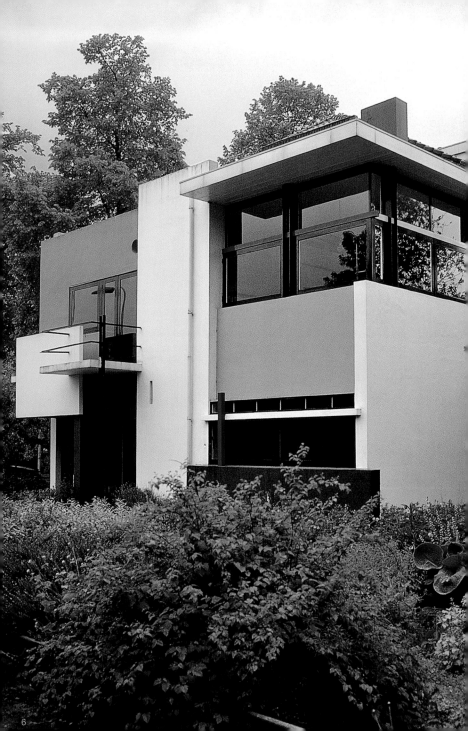

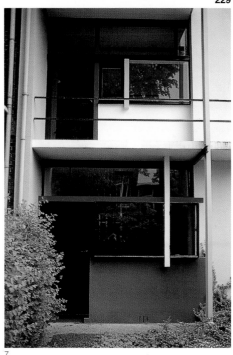

7

6, 7 Utrecht, Schröder House, 1924
Architect: Gerrit Rietveld

The most famous of "De Stijl" buildings with a flexible subdividable open interior is a publicly accessible museum.

Opposing vertical and horizontal slab-like walls and continuous glass areas create compositions with their "tensional" window sub-divisions, which recall the work of Dutch artists at the time.

Belgium

This small, multilingual country can boast fine, exceptionally tall Gothic cathedral in Antwerp and the 17th-century Guild Houses ringing Brussels' Grand Place as its historic heritage. The Guild Houses have richly decorated gabled façades, some adorned with gold leaf, between their large windows. The façades are all different and yet form a unified totality in this focal point of Brussels. The unique architectural development, however, emerged at the turn of the 19th and 20th centuries, in the work of Victor Horta, exemplified in his own house, which is now a public museum. His work is a rare combination of flamboyant Art Nouveau linear decoration (such as can be seen on the stair railings and lamp-posts), with deliberately exposed structural elements in iron, the columns and girders. These proudly show the pattern of their riveted connections, all intertwined with the the swirling curvilinear patterns of Horta's special kind of strap-iron ornamentation. The strength of this work is based on the contrast of plain wall surfaces of stone, tile or brick, with the unrolled curls and rosettes of his linear metal embellishment. Beyond the materials and the decorative combinations that are given, it is the new space Horta creates in his buildings that particularly heralds the future.

In his own house the central staircase gives access to open split-level arrangements of rooms leading from it. This allows for continuous spaciousness to emerge, however limited the size. Such fusing of levels and spaces became the hallmark of modern architecture more than two decades later.

1 Brussels, Solvay House, 1896
Architect: Victor Horta
The polished stone staircase and walls are combined with characteristically flat ornate iron railing. They are in contrast to the exposed riveted steel columns and beams

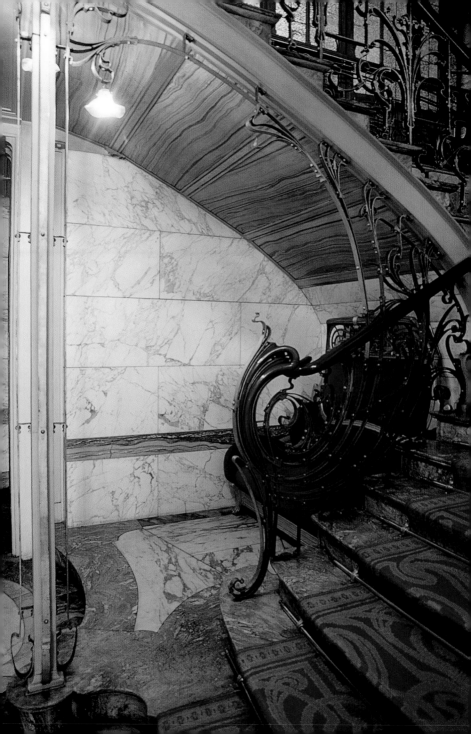

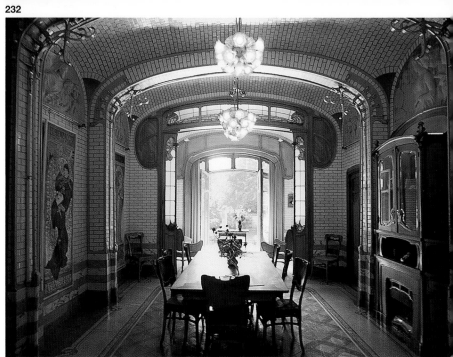

2

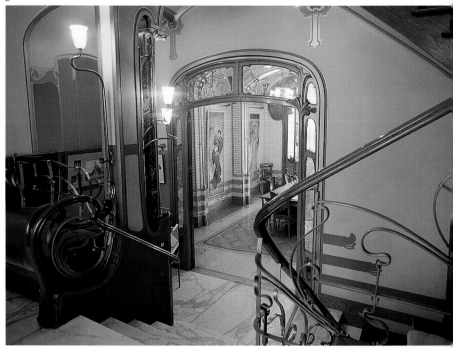

3

4

2–4 Brussels, Horta House, 1898
Architect: Victor Horta

The central curved staircase, with flat iron decoration, gives access to split-level floors, creating a continuity of spatial effects. Walls are of bare glazed brick and tiles reaching the top floor, which has a curved glass skylight.

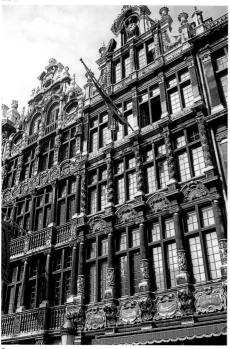

5

5 Brussels, 17th century
Guild Houses ringing the Grand Place, with
gold leaf decoration between large windows.

6 Antwerp
The Gothic cathedral, with its central tall
tower.

7 Antwerp
The town square, with touching
gabled façades.

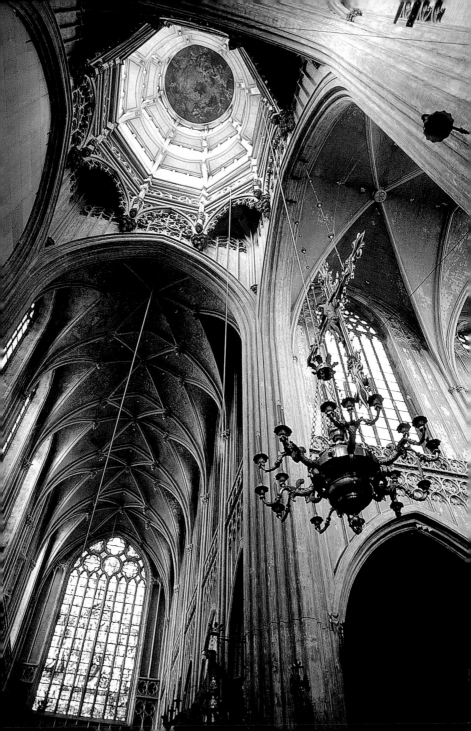

Denmark

Denmark's architecture is related to that
of other Scandinavian countries. The rich
decorated gables of historic structures
are punctuated by high spires, the most
famous being the 16th-century spiral tower
of the stock exchange in Copenhagen.
The country has consistently produced
excellent modern buildings, particularly by
the architect Arne Jacobson – whose
design of furniture and household objects
known worldwide.
The most brilliant of Danish architects,
however, is Jørn Utzon, who won the
international competition for the Sydney
Opera House – a building that has become
the very icon of Australia. After leaving the
project, owing to a controversy prior to its
completion, he proceeded to create some
wonderful buildings and furniture elsewhere.
One of the finest is the Bagsvaerd Church
and the exemplary Fredensborg group
housing near Copenhagen. It showed the
practical and aesthetic advantages of such
housing rather than merely routine
suburbia.

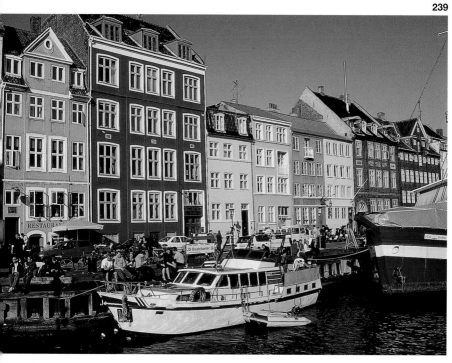

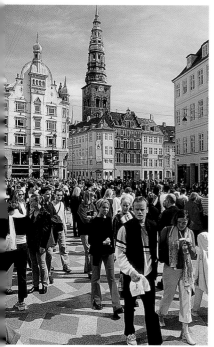

1 Copenhagen, Nyhavn
The picturesque canal dating from the 17th century, which has become a popular pedestrian promenade and site for boat anchorage.

2 Copenhagen
The charming central pedestrian district.

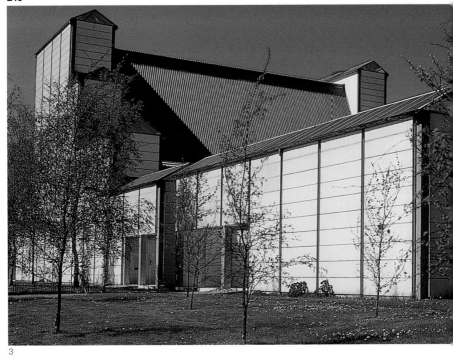

3

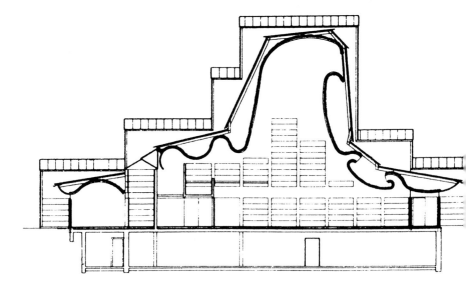

4

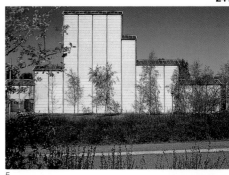

5

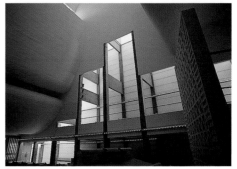

6

3–6 Copenhagen, Bagsvaerd Church, 1976

Architect: Jørn Utzon

One of the finest works of Utzon after leaving the Sydney Opera House project. The wave-like form of the interior is surrounded by a stepped rectilinear structure, and enclosed courts that create a unique dichotomy of spaces.

Finland

Formerly part of Sweden, Finland becar
an autonomous part of Russia, and Hel
its capital. The new neo-classical centre
was built largely by the German architec
Carl Engel, the focal point of which is th
hilltop Lutheran Cathedral of 1830. Its sp
ling white and gilded exterior still domin
the city.

The design competition for the Central
Railway Terminal was won in 1904 by E
Saarinen (father of Eero Saarinen, who
produced some fine architecture in the
USA). The building, completed in 1914,
displays the stylistic influences of Art
Nouveau, which dominated whole distri
of Helsinki. As in many of Saarinen's otl
buildings, the use of solid granite exteric
has ensured that it still remains in pristir
condition.

Geographically isolated from the rest of
Europe, Finland was late to be industri-
alised. It maintained its handicraft traditi
until the 1920s, which gave rise to the
creation of the finest modern design pro
ducts in the world today: textiles, glass-
ware, crockery, cutlery, furniture, etc.

The leading figure in Finnish architecture
and furniture design was Alvar Aalto. Aa
influenced a whole generation of moder
architects worldwide, and the reason fo
this lies in the high standard of design a
town planning in the country.

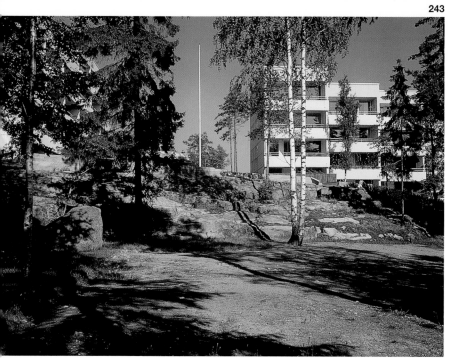

piola
cal groups of apartments set in
uched pine-tree forests and granite
crops.

elsinki, Lutheran Cathedral, 1830–52
itect: Carl Engel
glistening-white classic building stands
commanding hilltop.

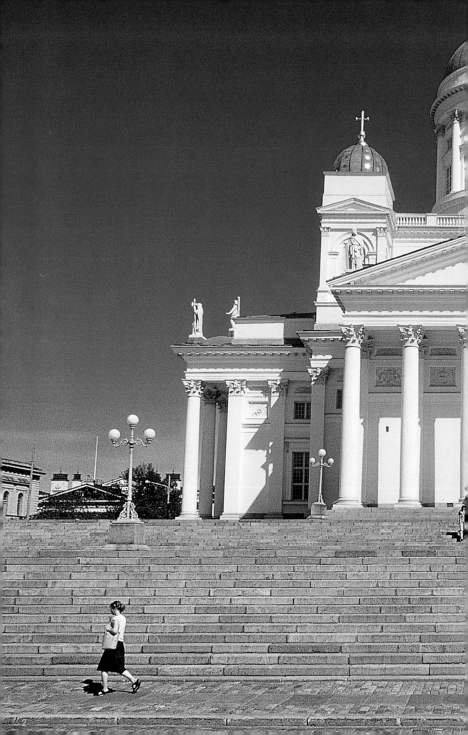

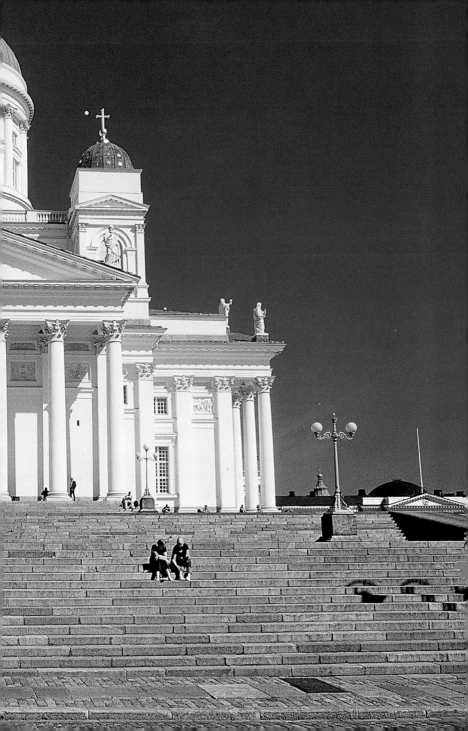

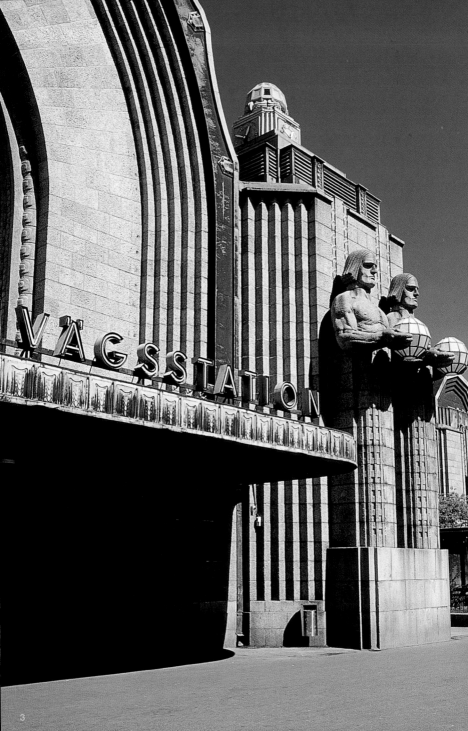

4

3 Helsinki, Central Railway Terminal, 1910
Architect: Eliel Saarinen
The solid granite building, with its Art Nouveau sculptures and decoration.

4 Helsinki, National Museum, 1902–10
Architect: Eliel Saarinen
Has a finely carved granite façade, featuring especially a bear, which is a Finnish symbol.

5

5, 6 Paimio, Sanatorium, 1929–33
Architect: Alvar Aalto
Standing in a remote forest of tall pine trees, this present-day, fully functioning, pristine-white building complex belies its age, inside and out. The interiors are cheerfully bright and colourful.

7 Helsinki Olympic Stadium Tower, 1940
Architects: Yrjö Lindegren & Toivo Jäntti
The 72 m high, elegantly slim concrete outlook tower was completed for the 19 Olympic Games, which – because of the outbreak of World War II – were not held there until 1952.

6

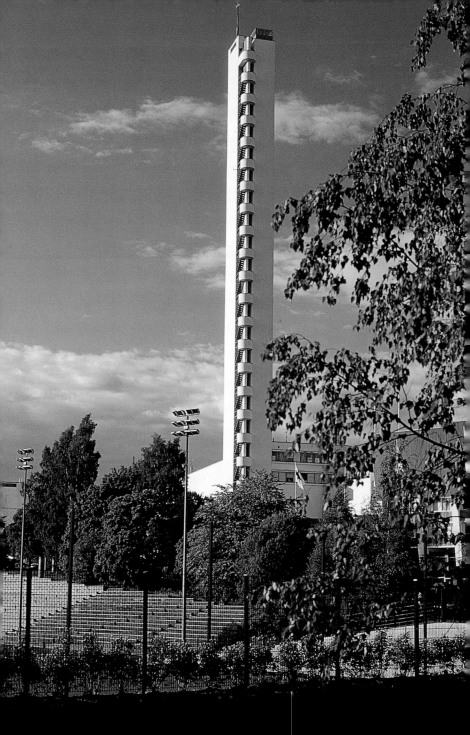

250

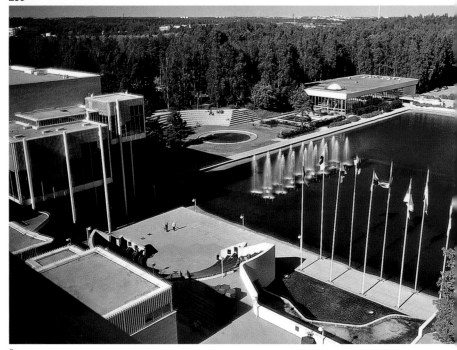

8

8 Tapiola Centre

The community buildings, a church, the Espoo cultural centre (architect: Arto Sipinen, 1989), a public pool, etc., are built around a lake, which had been an unused brick pit. In my view, the environment – created in the totally planned new town of Tapiola – achieves the highest physical standards for civilised life, anywhere in today's world.

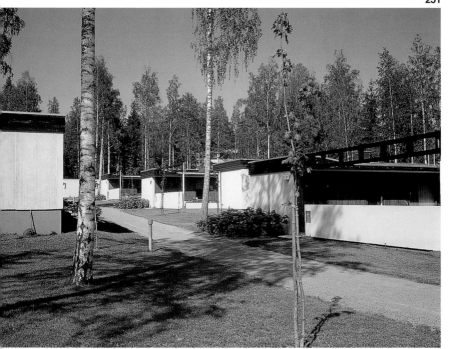

9, 10 Tapiola, 1950s
Planner/Architect: Arne Ervi
This Garden City, set in natural surroundings, is 10 km from Helsinki. It contains a variety of courtyard houses, spaciously placed waterfront townhouses and apartment blocks.

Austria

As I was born in Vienna and lived there the age of 15, I feel a particular affinity the city, which I grew to love as much a the spectacular mountain scenery in the countryside of Austria.

Vienna has a long and dramatic history started as the town Vindobona in Roma times and centuries later developed into capital of a large empire that covered n of Europe, from the Veneto to the bord with Russia, until its dismemberment in a small country after World War I.

What is left to us of Vienna, the capital a once wealthy empire, is a city serving small country with a heritage of extrava palaces and churches.

Massive Gothic cathedrals and monaste were built in the 12th and 13th centurie which had beautifully rib-vaulted naves a aisles of even height, and also the distin tively picturesque onion-domed towers village churches throughout the mounta ous provinces.

A great building boom started in the pe of peace following the defeat of the Tur armies in 1683 that had laid siege to Vienna. Surrounding the "Hofburg", the seat of the Hapsburg rulers, palaces w built by the nobles throughout the med city centre, which was surrounded by H fortification walls. Within these, during t 18th-century high-baroque period, the elaborate churches and ambitious establishments of the aristocracy came being. The celebrated architects of the time, such as Fischer von Erlach and L von Hildebrandt, are responsible for the Spanish Riding School, the National Lib the Schönbrum summer palace, etc.

In the mid-19th century, the wall surrounding the city was razed and a w boulevard, the "Ringstraße" took its pla lined with sumptuous civic buildings: th Parliament, the famous Opera House, museums (housing the Habsburg art collection), the City Hall, theatres, the University, etc., were al constructed.

At the turn of the 20th century, the ferr of feverish artistic activity created a rea against conservative Classicism in the a particularly in architecture, and this wa

bolised by the Sezession movement. Its
bition building's famous inscription
: "To each era its art and to art its
dom." With this credo, the foundations
odern architecture were laid by such
naries as Otto Wagner, Adolf Loos and
ef Hoffmann.
wing World War I, to alleviate the
dful housing conditions the newly
laimed republic dedicated itself to the
ding of public housing for all. More than
of Vienna's population now lives in
housing in exemplary planned areas
to date have no equal in the rest of the
sed world.

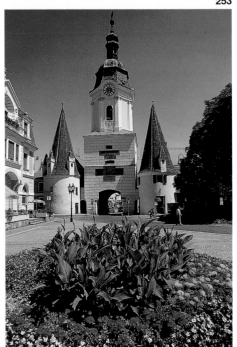

1

1 Krems
The town portal, with medieval and
baroque decorative towers.

3

2, 3 Maria am Gestade, 15th century
Structurally expressive ribbed vaulting and
Gothic decorated tower.

4

5

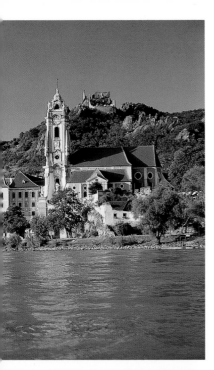

4 Wachau Church
Equally high Gothic vaulting over the nave and aisles.

5 Salzburg
Gothic vaulting.

6 Dürnstein
The 15th-century church was rebuilt in the Baroque period, standing on the edge of the Donau, below the high up castle where Richard Lionheart was kept prisoner in the 12th century.

7 Stein
Façade with applied baroque ornament.

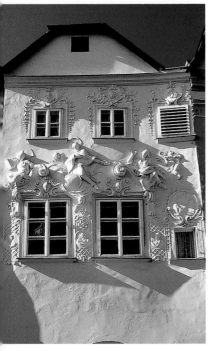

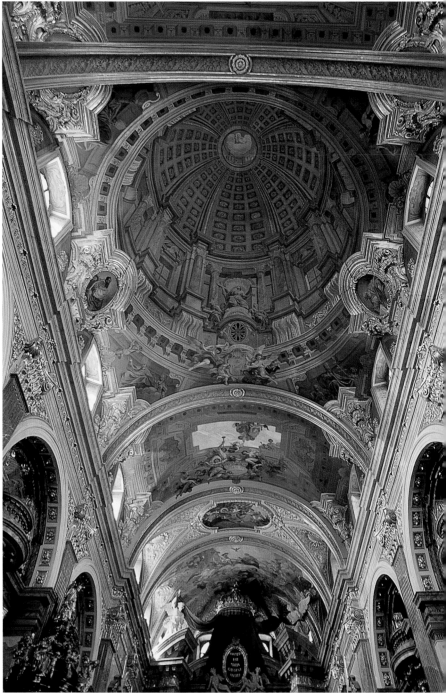

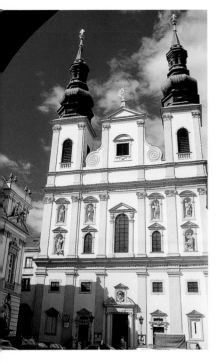

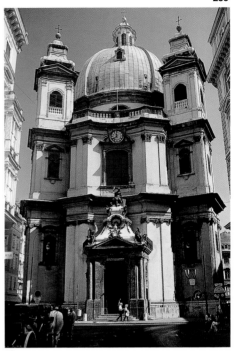

10

8, 9 Vienna, Jesuit church, 1626–31
The richly gilded interior is crowned
by a trompe-l'œil dome fresco by
Andrea Pozzo.

10 Vienna, St Peter's Church, 1702–30
Architect: Lucas von Hildebrandt
The exterior, with its inward tilted towers
and concave front façade, make the
building fit comfortably into the restrictive
site.

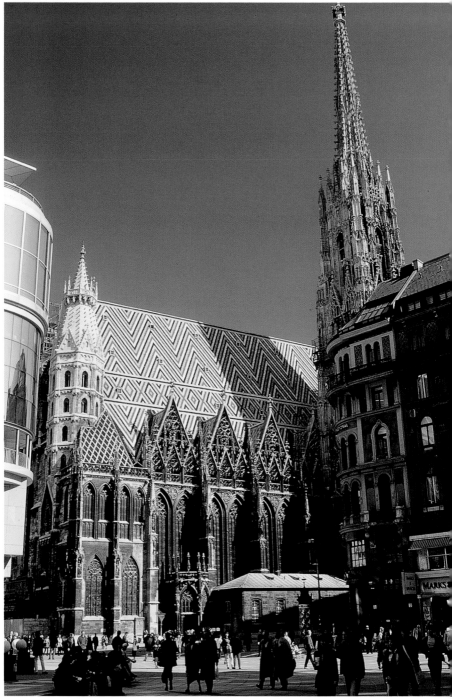

Vienna, St Stephan's Cathedral
14th-century cathedral stands in an
ensive pedestrian precinct. The glazed
dern Haas House façade opposite the
hedral would not be permitted in most
es. It adds to the rich mixture of
ortant buildings that surround it, all
ing from different centuries.

**Vienna, Spanish Riding School,
h century**
hitect: Fischer von Erlach
white colonnaded wide-span long hall
ome to the unique performances of
oizaner horses, trained to do difficult
ips, steps and dances, all in unison, to
sical accompaniment.

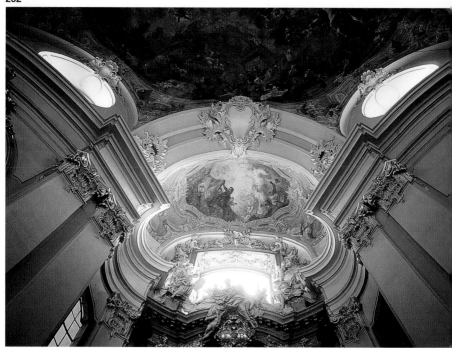

13

13, 14 Vienna, Piaristen Church, 170▉
Architect: Lucas von Hildebrandt
The brilliant baroque spatial interior has
indirect natural light reaching the central
nave from hidden overhead sources.

15 Vienna, Karlskirche, 1715
Architect: Fischer von Erlach
This amazing baroque church has a
classic temple portico flanked by two
freestanding minaret-like pylons that lea▉
to a high oval-domed interior.

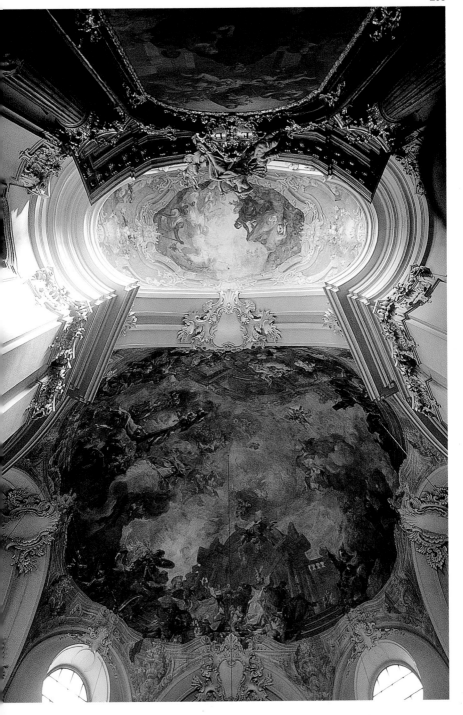

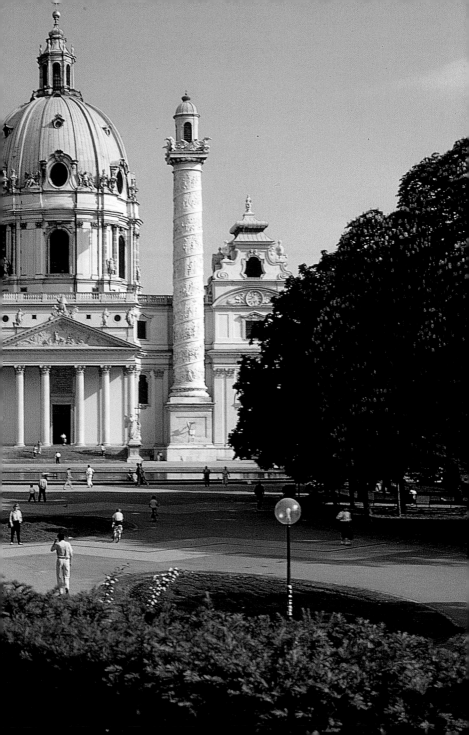

16

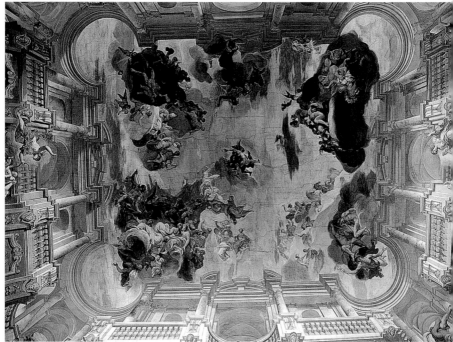

17

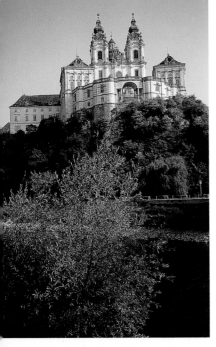

16, 17 Vienna, Liechtenstein Palais, 1700
Architect: Domenico Martinelli
A grand staircase rises to the central hall, which is decorated with a perspective ceiling fresco by Andrea Pozzo.

18 Vienna, Armoury, Am Hof, 1731–32
Architect: Anton Ospel
Originally built as a civil armoury, since 1870 it is used as Vienna's ornate fire brigade headquarters.

19 Melk, Benedictine Monastery, early 18th century
Architect: Jacob Prandtauer
Dramatically sited on a high rocky ledge above the Danube, the monumental church interior is sumptuously gilded, as is the adjacent library.

20, 21 Vienna, Belvedere Palace, 1721
Architect: Lucas von Hildebrandt
Built for Prince Eugene of Savoy in gratitude, after his defeat of the Turks who surrounded the city in 1683. The palace has a commanding view of Vienna over its formal gardens and fountains, which have not changed since Bellotto (called Canaletto) painted the scene in the 18th century.

20

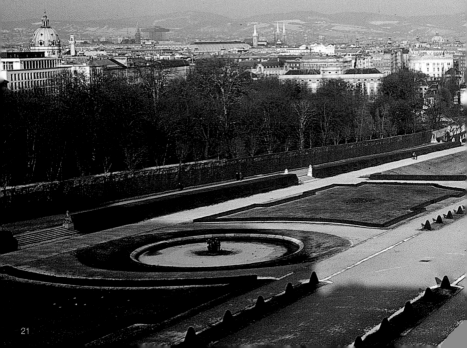

21

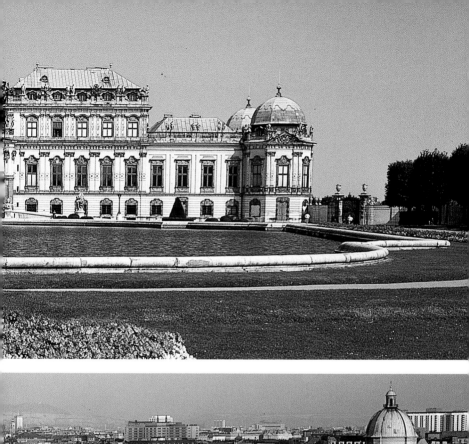
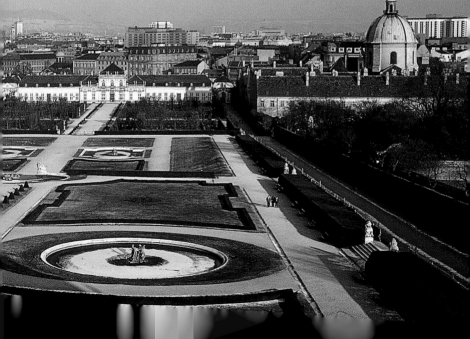

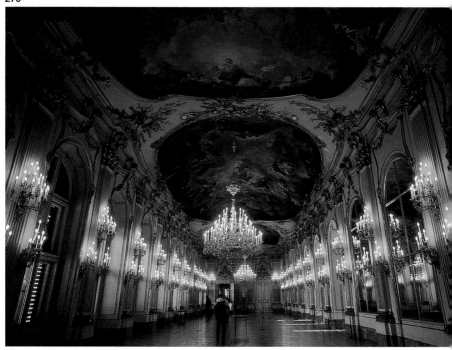

22

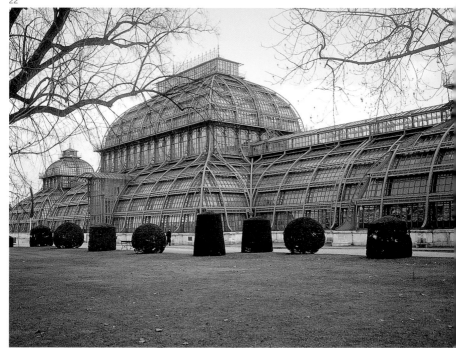

23

22, 23 Vienna, Schönbrunn Summer Palace, 1680–1740

Architects: Fischer von Erlach and Nikolaus Parcassi

The Empress Maria Theresa was determined to outdo Louis XIV's palace at Versailles. Even though Schönbrunn is smaller, it has charm on a more human scale. The interiors are sumptuously appointed and the axial formal gardens focus on the Gloriette (architect Von Hohenberg) built on high ground.

24, 25 Vienna, Schönbrunn Palm House, 1880–82

Architect: Franz von Segenschmid

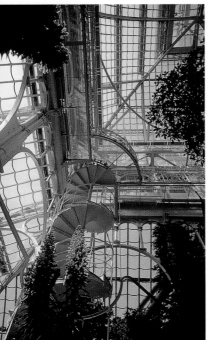

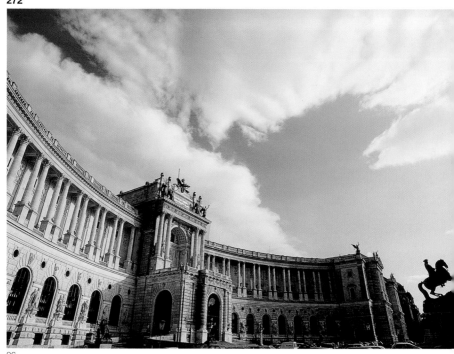

26

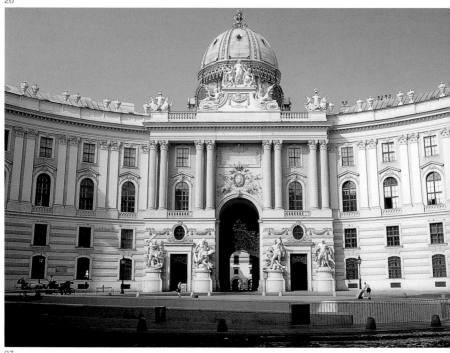

27

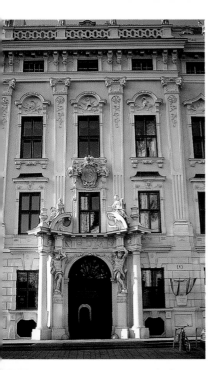

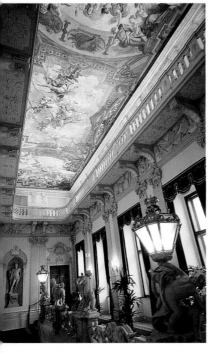

26, 27 Vienna, Hofburg Palace
The historic residence of the Emperor was built in many stages from the 15th to the early 20th century as various wings were added around formal courts.

28, 29 Vienna, Kinsky Palace, 1713–16
Architect: Lucas von Hildebrandt
The city residence of a noble has a grand staircase crowned with a fresco by Chiarini.

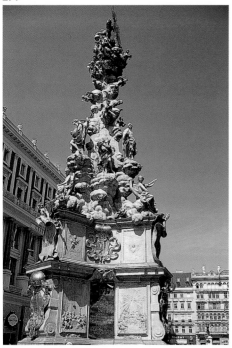

30

30 Vienna, Pestsäule, 1693
Architect: Fischer von Erlach
Erected on the Graben Plaza to give thanks
for the end of the plague, which had
decimated the population.

31 St Florian Abbey Library, 1690
Architect: Jacob Prandtauer

32 Hallstadt
Romantically picturesque town on
the edge of a lake at the foothills of the
Dachstein Mountain.

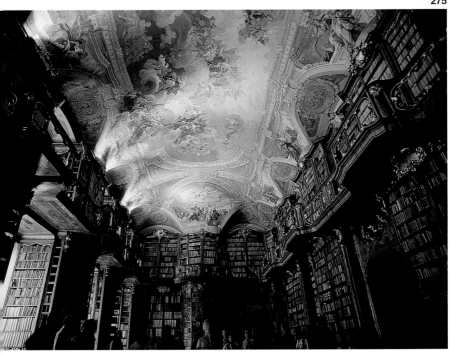

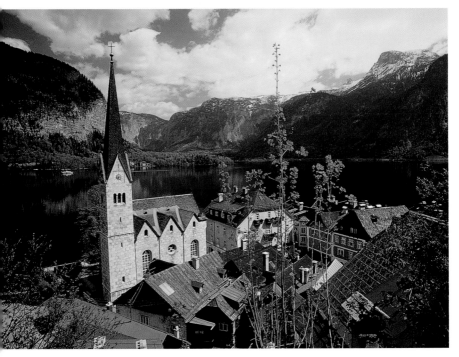

33 Vienna, Kunsthistorisches Museum, 1875

Architects: Carl von Hasenauer and Gottfried Semper

The grandiose, classical building houses the Habsburgs' important and extensive art collection.

34 Vienna, Steinhof Church, 1905–07

Architect: Otto Wagner

Even though the silhouette of the domed church appears classical, the embellishments and especially the interior speak a totally new visual language, with white marble, gilding and Secessionist forms.

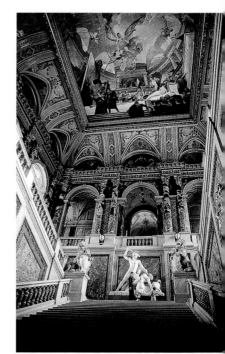

33

34

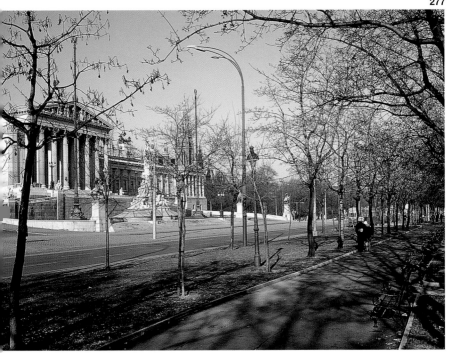

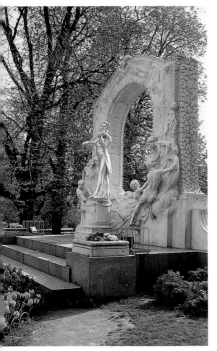

35 Vienna, Ringstraße
After the demolition of the medieval fortification walls in 1858, the Parliament (1874, architect Theophil Hansen) and other public buildings and parks were built along the resulting wide tree-lined boulevard.

36 Vienna, Stadtpark
Gilded monument to Johann Strauss.

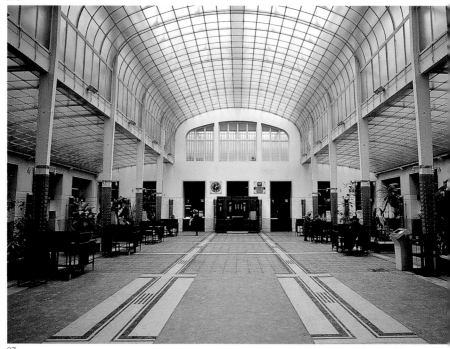

37

37 Vienna, Postsparkasse, 1906
Architect: Otto Wagner
With its glass-roofed banking hall and specially designed air heating columns, light fixtures and furniture, this is a most inventive and progressive building for its time.
The thick granite exterior facing is secured with exposed metal bolts.

38 Vienna, Loos Haus, 1910
Architect: Adolf Loos
The first totally undecorated façade, situated opposite the Imperial Palace, offended the Emperor. The architect had to add window flower-boxes.

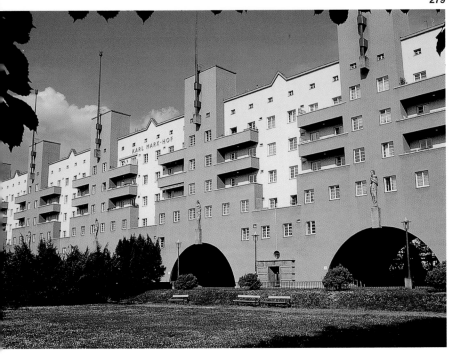

Vienna, Karl-Marx-Hof, 1926
hitect: Karl Ehn
e of the first of many public housing
ects built by the City following the
ablishment of the Republic after World
r I. SIxty percent of the Viennese now
in such housing.

40

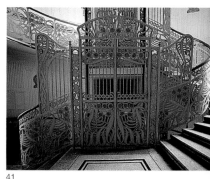

41

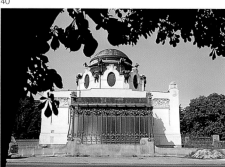

42

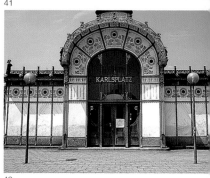

43

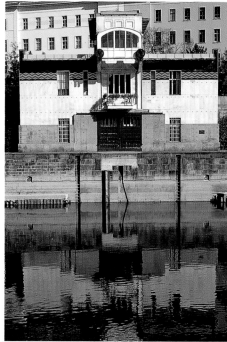

44

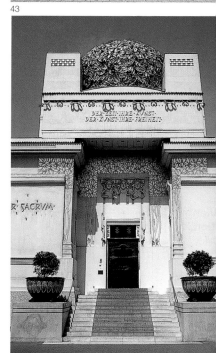

45

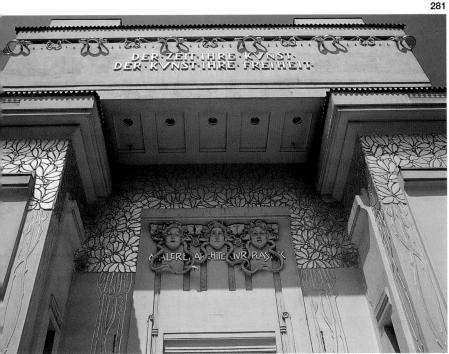

41 Vienna, Wienzeile Apartments, 98
hitect: Otto Wagner
façade is decorated with gilded plaster.
interior iron elevator and stair railings
ak with tradition.

Vienna, Hof Pavilion, 1898
hitect: Otto Wagner
private underground train station built
r the Schönbrunn Palace for the
peror, with Art-Nouveau inspired
oration.

Vienna, Karlsplatz Underground tion, 1898
hitect: Otto Wagner
gilded iron-framed structure contains
ls of white marble panels, said to be the
non-weight bearing "curtain wall".

44 Vienna, Flood Control Building, 1906
Architect: Otto Wagner

45, 46 Vienna, Sezession Exposition Pavilion, 1898
Architect: Joseph Maria Olbrich
With the famous inscription "To each era
its art and to art its freedom".

47

48

49

50

51

47–50 Vienna, Postsparkasse, 1906
Architect: Otto Wagner
Specially designed air-heating columns, light fixtures and furniture. The thick granite exterior facing is secured with exposed metal bolts.

51 Vienna, Candle Shop, 1964–66
Architect: Hans Hollein
The façade is entirely of jointlessly fused aluminium sheets.

52 Vienna, Holocaust Memorial, 2000
Artist: Rachel Whiteread
The solid stone exterior is without openings. The doors are also solid, and the walls are in the shape of inverted books – all is hidden, inaccessible and inexplicable forever.

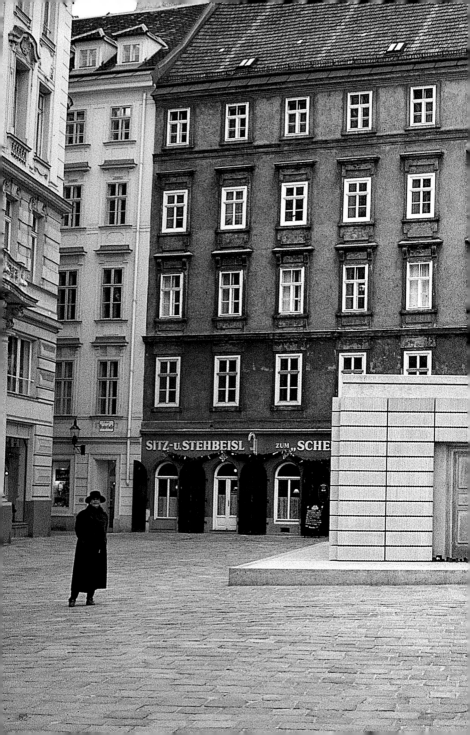

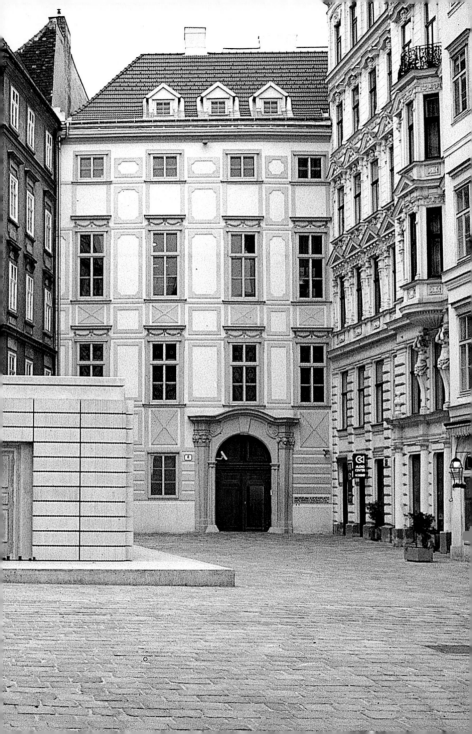

Switzerland

It is hard for this small country to compe
with the historic architecture of its large
neighbours, France, Germany and Italy.
Without their war damage, however, the
medieval charm of Swiss towns and the
breathtaking mountainous scenery are h
to beat. Of particular note is the
extraordinary Einsiedeln Benedictine Ab
with its baroque interior, planned arounc
pilgrimage area in its centre.

Modern architecture developed a strong
foothold in the 1930s with the applicatic
of high-quality technology and character
tically solid construction evident, particu
in the new schools and public buildings.

The wealth of the country resulted in
patrons commissioning some of the bes
progressive architects to design their
houses and buildings, such as Le Corbu
and Marcel Breuer.

Outstanding amongst the local creative
talents is the pioneering structural engin
Robert Maillart, whose bridges span the
deep chasms in the Swiss Alps, and the
artist and architect Max Bill.

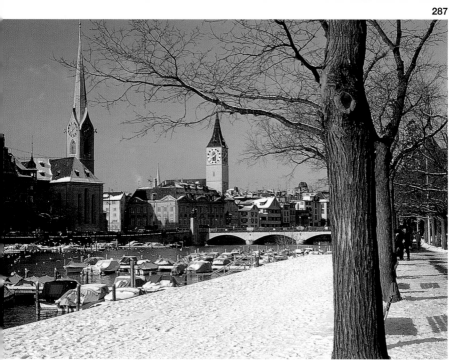

urich

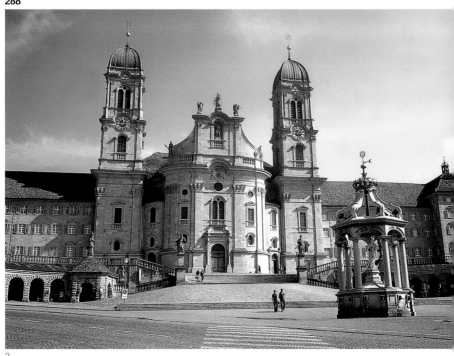

2

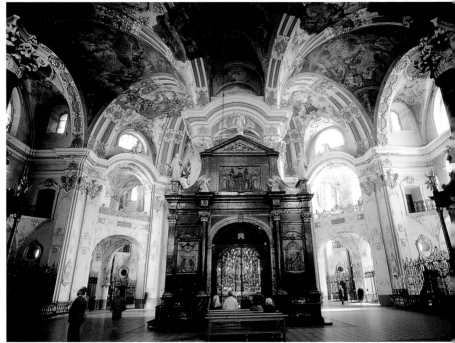

3

2–5 Einsiedeln, Benedictine Abbey, 1704–47

Architect: Kaspar Moosbrugger

Dominating the large town square, the church's unusual plan places the pilgrimage area in the centre of a large oval entrance space. This results in a dramatically radiating arched support structure. To increase the apparent depth of the nave is an iron screen that creates lines which play with perspective.

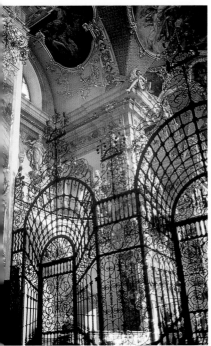

6 Geneva, Vessy Bridge, 1936
Engineer: Robert Maillart
A seminal example by a pioneer of a concrete structure that is expressive of rational static forces whilst still achieving fine visual results.

7 Zürich, Doldertal Apartments, 1935
Architect: Marcel Breuer
The two identical residential buildings face a steep wooded river valley. They are celebrated icons of early modern architecture.

6

7

8

9

8, 9 Moscia, Koerfer House, 1963
Architect: Marcel Breuer
Built on a rugged hillside commanding a
sweeping view of Lago Maggiore, this
concrete structure is exposed both inside
and out. It stands on granite rubble walls,
which fit the house into the terrain.

10 Zürich, La Maison de l'Homme, 1967
Architect: Le Corbusier
The exhibition pavilion is the result of the
private initiative of Heidi Weber and was
built in a public park close to Zürich Lake.
One of the few steel structures by Le
Corbusier, its form is defined by two
opposing umbrella-like roofs. The brightly
coloured exterior panels contrast with the
off-form concrete access ramp.

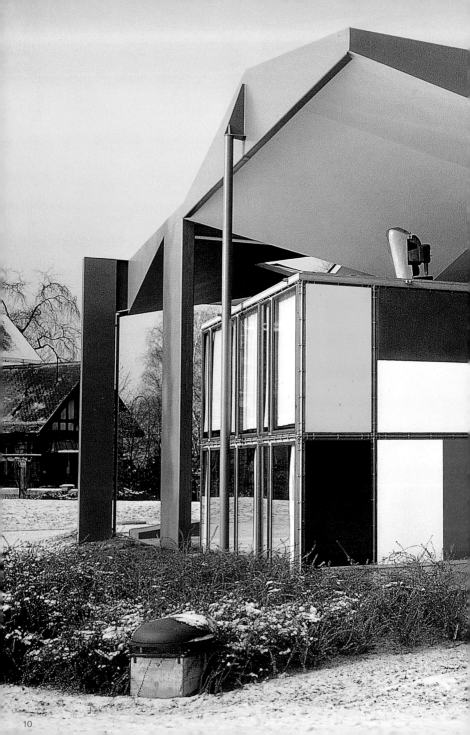

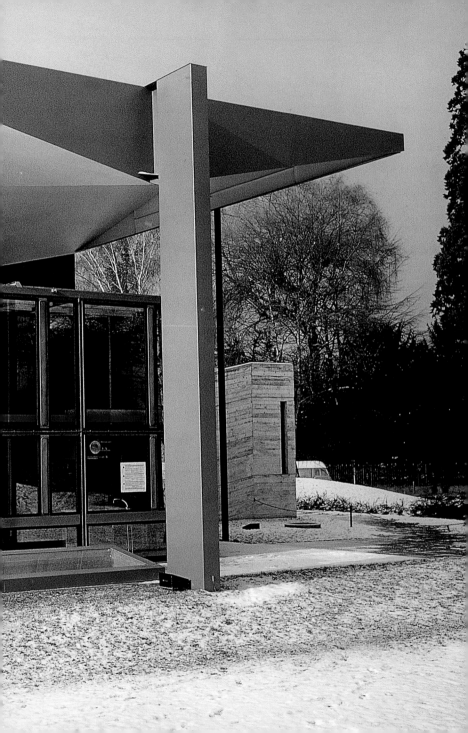

Czech Republic

This small country has a varied history. Before World War I, it was a part of the Habsburg Empire, then it joined with its neighbour Slovakia, and now it is on its own. It is known not only for its beautiful small towns, which date from the Middle Ages, but also for its technologically advanced industries and universities.

The German army's advance to the east the beginning of World War II caused little damage to the World Heritage old town such as Telc, Cesky Budevice, Cesky Krumlov, etc. Since the dissolution of the Soviet Bloc, Prague has become the treasure-house of architectural heritage from the Gothic, baroque and modern era. St Vitus Cathedral, dating from the 14th century, the Hradcany Castle's rib-vaulted King's Hall and the charming alchemists' tiny houses next to the palace, are all unique. Aside from the classical baroque churches, built in the 18th century, the little-known architect Jan Santini produced some amazing buildings, such as the church in Zdar.

One of the first large modern public buildings, the Pensions Institute of 1924 (architects Havlicek and Honzik) is evidence of the country being the first to adopt modern architecture wholeheartedly.

Recognised throughout the civilised world as the very icon of modern architecture the Tugendhat House, 1929, by Mies van der Rohe, built in Brno. It is not only an aesthetic triumph, but the methods and materials used in its construction would also strain the resources of today, 75 years later.

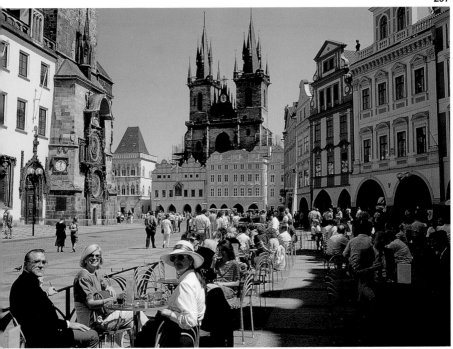

Prague
Town Square, with its 15th-century
Church.

2

2 Prague, Cernin Palace

3 Prague, Castle entrance

4 Prague
Three façades in Old Town Square, dating
from 14th to the 18th century.

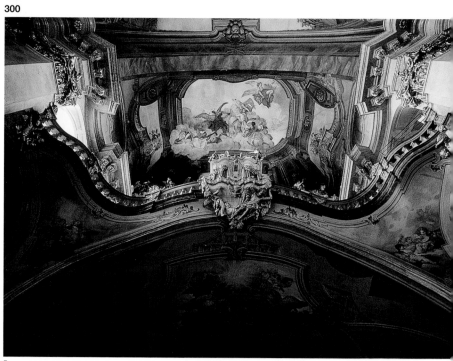

5

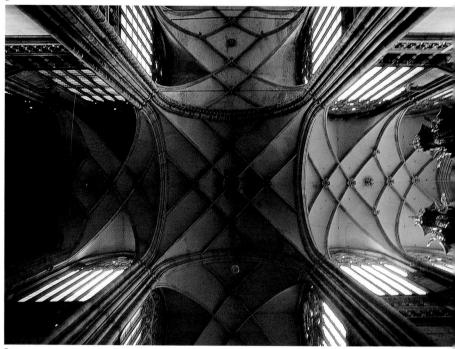

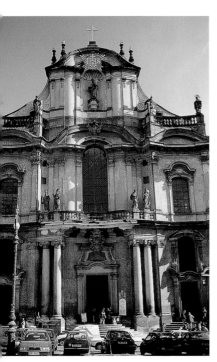

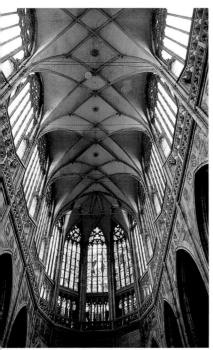

5, 7 Prague, St Nicholas Church, 1700
Architect: Christoph Dientzenhofer
A superbly flamboyant example of baroque architecture, both inside and out.

6, 8 Prague, St Vitus Cathedral, 14th century
Architects: Peter Parler and Matthias of Arras
The structure spanning the high nave and crossing consists of exceptionally narrow columns and high clerestory, rising to inter-locking ribbed vaults.

9, 10 Prague Castle, Vladislav Hall
15th–16th century
Architect: Benedikt Rejt
The exposed curved vaulting ribs are largely decorative and of doubtful structural value.

11, 12 Prague, Strahov Abbey and Philosophical Hall, 18th century
Ceiling fresco by A. F. Maulbertsch.

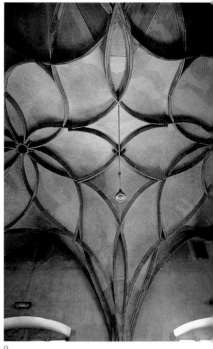

9

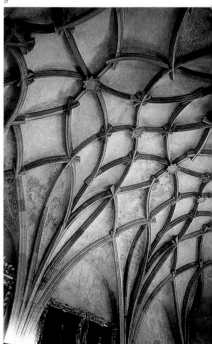

10

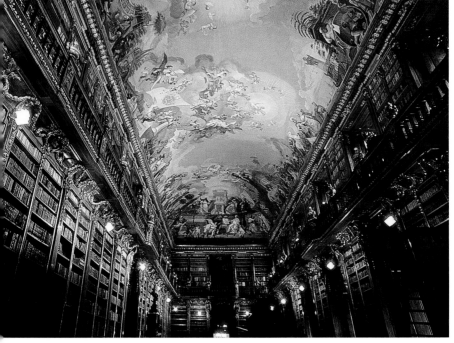

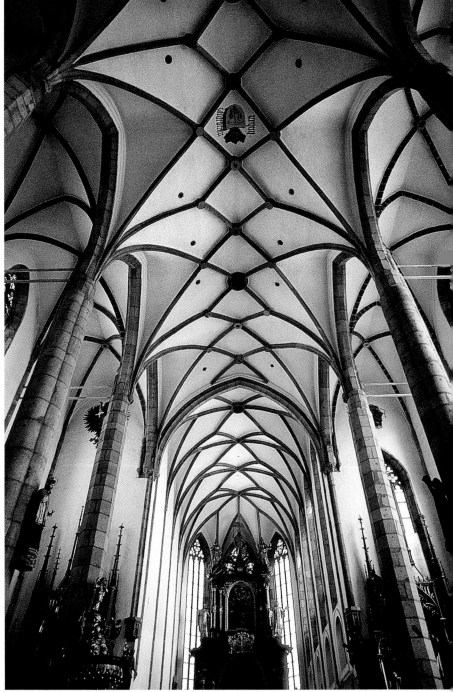

304

13

13 Cesky Krumlov, St Vitus Church, 1439

14 Brno Cathedral, 15th century
Architect: Anthony Pilgram

15 Kutna Hora, St Barbara Cathedral, 1380
Architect: Matyas Rejsek
The delicately interwoven vault ribbing.

16 Telc
The main square in this World Heritage listed town is ringed by continuous arcaded buildings. Although they have different façades, the result is a harmonious totality.

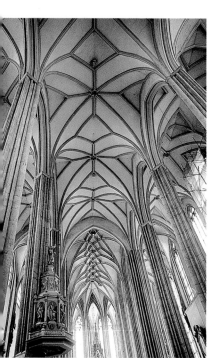

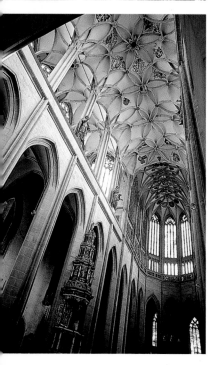

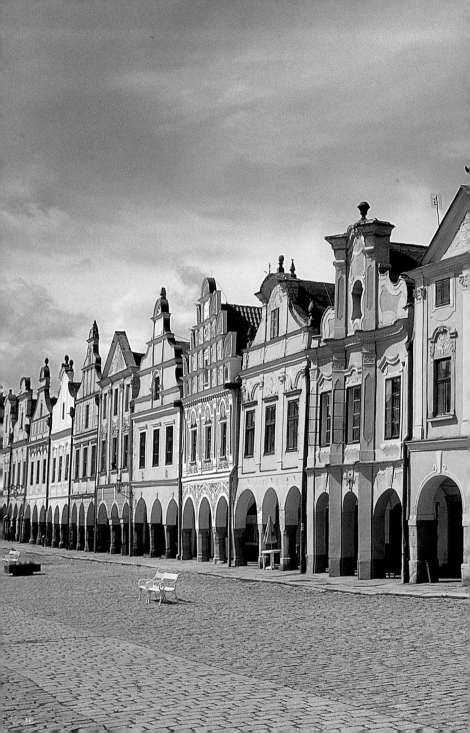

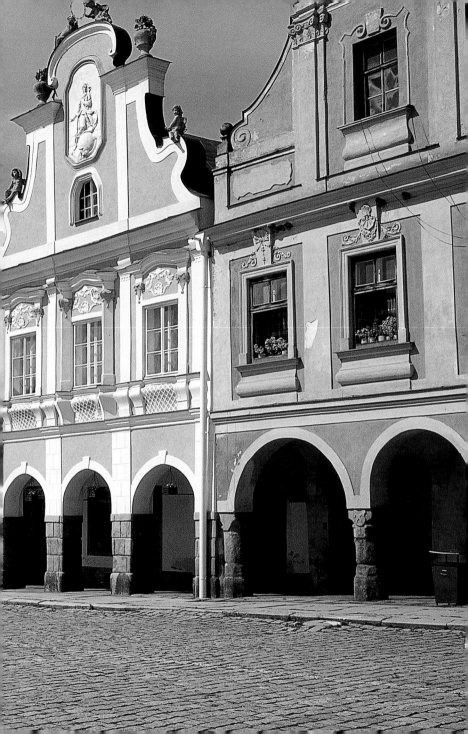

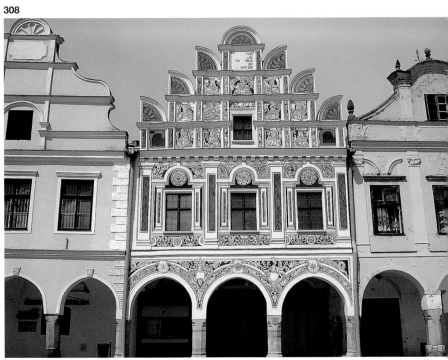

17

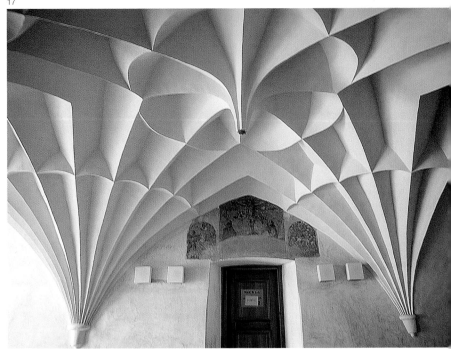

18

17 Telc

18 Slavonice
Sixteenth-century "diamond" vaulting in an
entry court.

19 Cesky Budevice
The huge square, surrounded by arcaded
buildings and the Town Hall, forms the
popular focus of this small town.

20, 21 Zdar, St Nepomuk Church, 1722
Architect: Jan Santini
This five-sided domed church (a UNESCO
Cultural Heritage site) is based on
extraordinary geometry, which changes
from the inside to the richly sculptural
exterior. Surrounding the churchyard is
typical Santini, with chapels of alternating
concave and convex plan outlines.

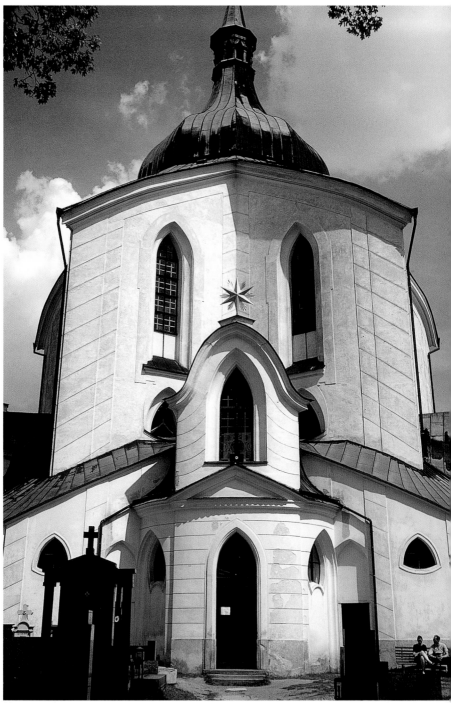

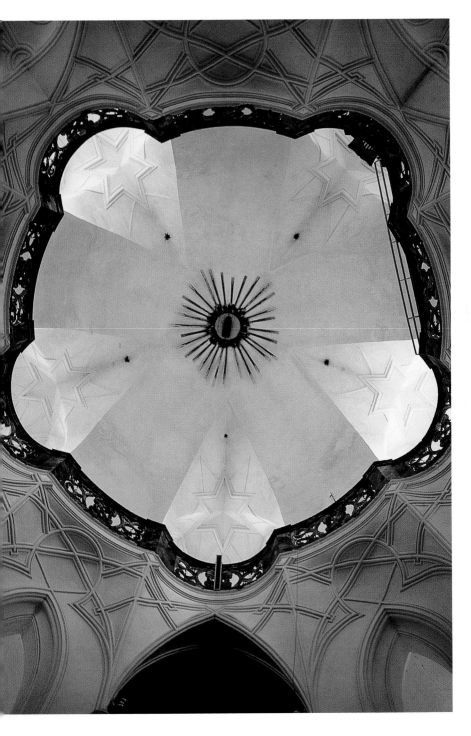

312

22, 24–26 Brno, Tugendhat House, 1929
Architect: Ludwig Mies van der Rohe
This house, built for the Tugendhat family in 1929, is one of Mies van der Rohe's masterpieces. The free-flowing spaces are made possible by the use of technologically construction that was advanced for its time, such as exposed chromed steel supports and enormous areas of glass, which can be electrically lowered down below the floor. Neglected and vandalised during World War II, it is now a faithfully restored house museum, furnished with the famous tables and chairs Mies designed specially for the house. Onyx and palisander screen walls create a sumptuously elegant atmosphere, which is an icon in modern architecture.

23 Ludwig Mies van der Rohe, 1886–1969

27 Marienbad Colonnade, 1889
Architects: Miksch and Niedzielski
This popular spa, set in a park, is typical of the late 19th century. The long ambulatory is of ornate cast-iron construction.

22

23

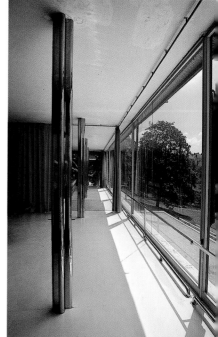

24

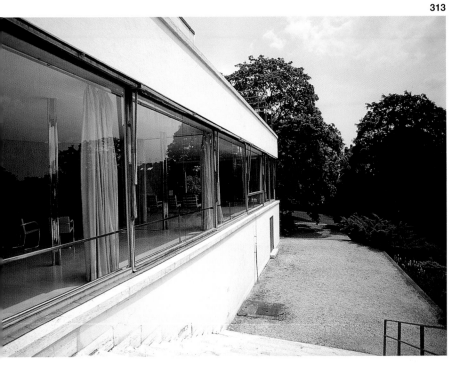

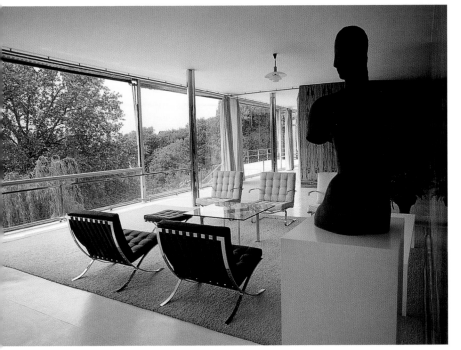

Hungary

This small country has a unique background, starting with the Magyar people migration from Central Asia, the language they brought (with its only parallel in Finland) and the 150-year-long occupation by the Turks. All these contributed to a vibrant architectural development over the centuries.

After the Turks were driven out in 1686, country came under Habsburg rule, and was absorbed into the Austro-Hungarian Empire.

Budapest, the second capital in the Empire has many parallel characteristics to those of Vienna; an almost identical Opera House and similar palaces belonging to members of the aristocracy. The most ambitious and outstanding of those who built such estate were members of the Esterhazy dynasty. The rivalry between the two countries is given expression in Prince Miklos Esterhazy's famous challenge, made as two dynasties were vying to outdo each other: "Anything the Habsburgs can afford I can too." After building design during the 19th century began to follow the modes Classicism and Gothic Revival, a number Hungarian architects became some of the first to practise modern architecture in Europe. The best known of these are two men who became key figures at the German Bauhaus, Marcel Breuer in architecture and furniture design, and László Moholy-Nagy in art.

1 Fertőd, Esterhazy Palace, 1760
Very reminiscent of Vienna's Schönbrunn Palace, down to the yellow-ochre exterior colouring.

2 Budapest, Heroes Square, 1886
Architect: Schickendanz
With statues of Hungary's greatest leaders from the founding of the State to the 19th century.

3 Budapest, Neo-Gothic Parliament Building, the "Orszaghaz", 1885–1902
Architect: Imre Steindl
Built on a dramatic waterfront site facing the Danube.

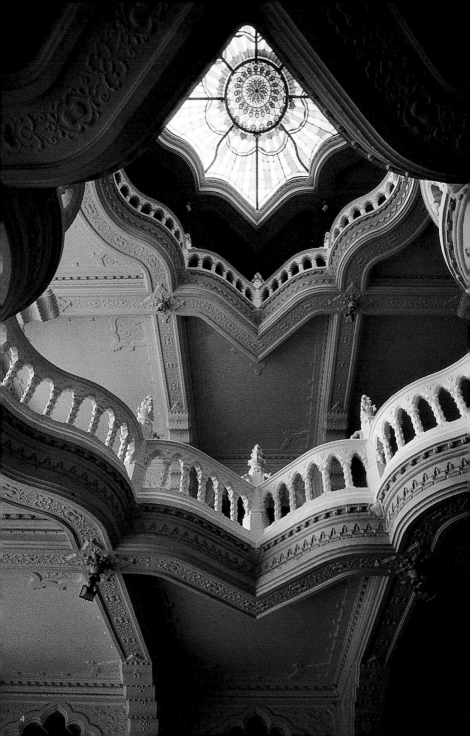

5

4 Budapest, Museum of Applied Arts, 1883–96
Architect: Ödön Lechner
Curvilinear central interior space, designed to emphasise the Eastern origin of the country.

5 Budapest
Cast-iron candelabra on the Café Hungaria building.

Bulgaria

Being on the international route from Eastern and Central Europe to Asia Minor and the Middle East, Bulgaria's architecture displays diverse influences. A strong Roman tradition left a predominance of arched structures, aqueducts, amphitheatres and thermae. Byzantine domed structures recall the long-lasting invasions of Ottoman Turks.

Culturally, the country has had a strong affinity with Russia. The most distinctive building complexes are the numerous monasteries throughout the country. Often built in isolated mountainous regions, which were liable to attack, they were built with bland and solid high surrounding walls. It was turned inward onto large courtyards lined with arched access galleries. The focal point of the establishments is always the church, freestanding and sculpturally elaborate, resulting in an architecturally distinctive, island-like totality.

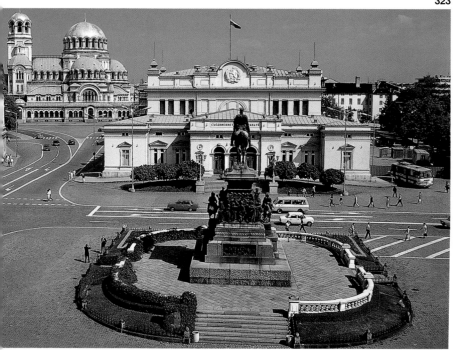

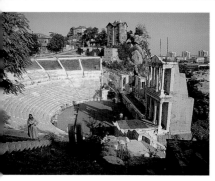

1 Sofia
The city square with the gold-domed Alexander Nevski Cathedral, 1912, and the central Parliament House.

2 Plovdiv
The Roman amphitheatre built by Philip II of Macedonia.

3, 5 Plovdiv

Typical of the 19th-century revival school architecture, with flamboyantly decorated curvilinear façades.

4 St Kirik Monastery

A fortified medieval monastery with an 11th-century church in the central court.

6 Rila Monastery, 13th–14th century

This listed world monument is built around a large internal court with an angular-sited Byzantine church at its focus. The surrounding arcaded galleries afford the only access to the monastery's rooms. For protection, the exterior walls of the complex are blank.

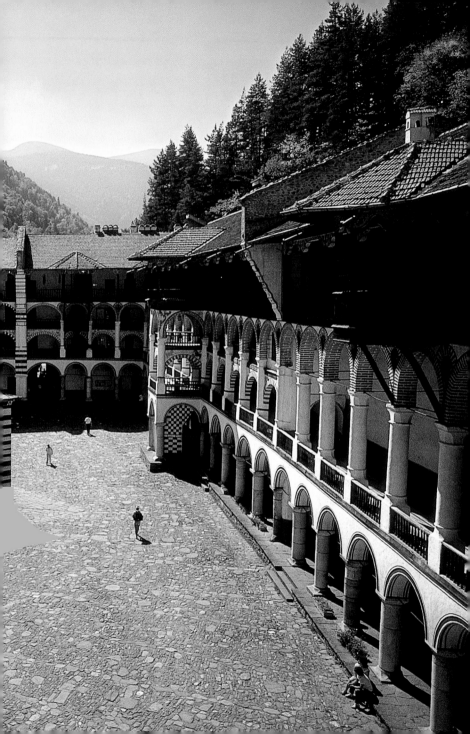

Russia

It was the ambition of Peter the Great to bring Russia closer to Europe that result in the founding of St Petersburg in 1703, its being proclaimed the new Russian cap in 1712.

The grandiose palaces, standing in huge public spaces, and the spiky tower of the admiralty, built along the Neva, are the ar tectural highlights of the city and attest to great urban vision. The Italian architect E Rastrelli was responsible for the Hermita Winter Palace, fronting the historic palac square, with its gilded interiors filled with priceless artworks, the Catherine Palace and the Smolny Cathedral and Convent, built between 1750 and 1760.

Rastrelli also built the Peterhof, which is surrounded by innumerable fountains and cascades and rightly called the "Russian Versailles". The palace was heavily damaged in World War II but was reconstructed.

Moscow was the first city in the world to invite Le Corbusier to build a large government complex in the 1920s, the Centrosoyus. This was indicative of the country's promising avant-garde Constru tivist movement in the arts of the 1920s, exemplified by the work of Malevich, Kandinsky and Rodchenko.

In the 1930s this came to an end when Stalin stopped progress and decreed reversion to classical building forms. Sev wedding-cake-like skyscrapers were buil in the 1950s and remain to this day, as reminders of the absurd results of dictate ship's misguided edicts in art and archi- tecture.

The Kremlin in Moscow contains the city most impressive buildings. The walled precinct contains a group of 15th-centur gilded domed churches, the purest of th being the vaulted Assumption Cathedral. The immense extent of Red Square, with the bizarre St Basil's Cathedral at one er is the very centre of the city. The wealth the 19th century is reflected in the Gum Department Store, which forms one full length of the Square. The glass-vaulted iron construction is reminiscent of earlier shopping arcades in Milan and Naples.

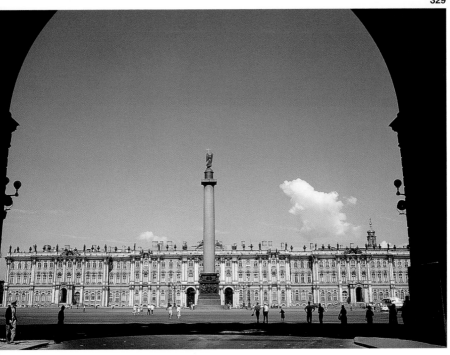

1 St Petersburg, Hermitage Winter Palace, 1764
Architect: Bartolomeo Francesco Rastrelli
The long building facing the river on one side, with the historic square on the other, is a sumptuously appointed structure with internal courtyards.

2 St Petersburg
The historic square, with the 47 m high Alexander column, commemorating the 1812 victory over Napoleon.

3 St Petersburg
The Hermitage's river façade.

4

5

4, 5 St Petersburg, Hermitage
The monumental entrance with gilded decor.

6 St Petersburg
Peter the Great's "The Bronze Horseman" statue, facing the Neva.

7 St Petersburg
The reconstructed Peterhof Palace with fountains playing and ballet dancers performing, to celebrate an anniversary.

8 St Petersburg
Museums and palaces facing the Neva.

9 St Petersburg, Catherine Palace
The long façade overlooking the park setting.

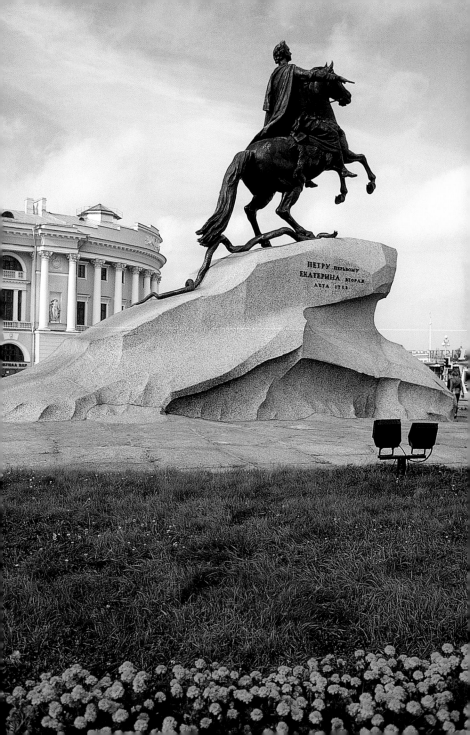

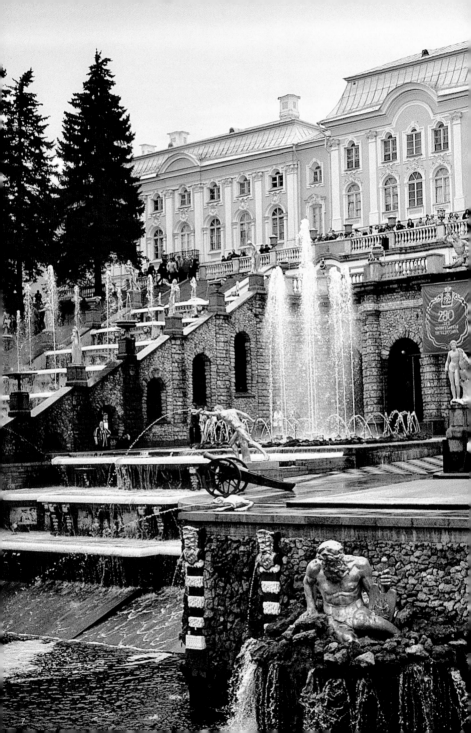

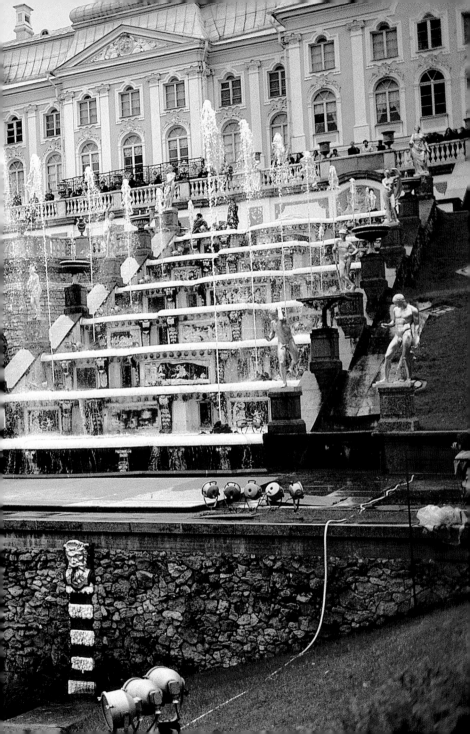

8

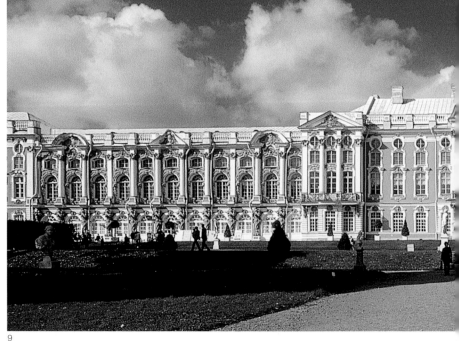

9

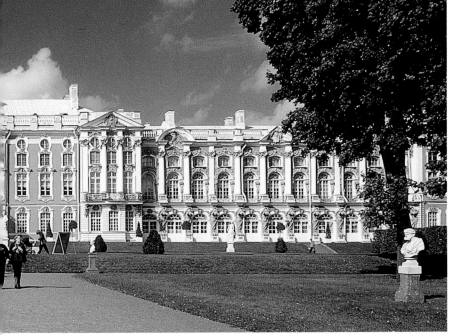

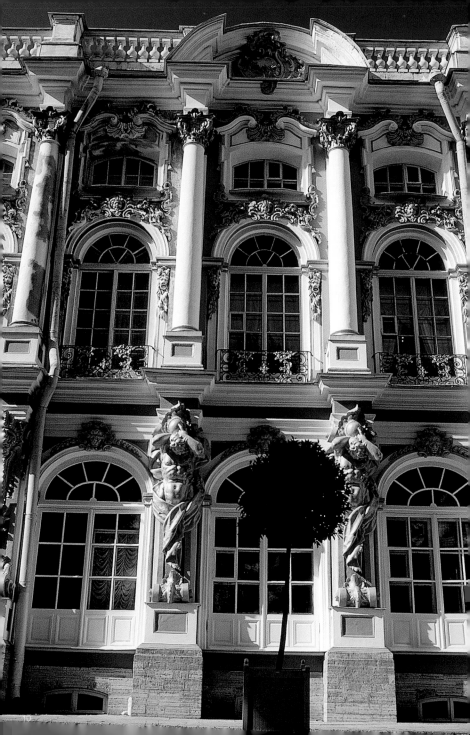

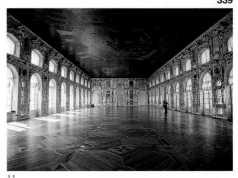

11

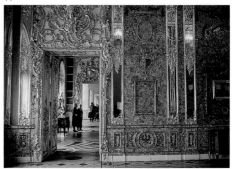

12

10 St Petersburg, Catherine Palace
Details of the reconstructed façade.

11 St Petersburg, Catherine Palace
The Great Hall

12 St Petersburg, Catherine Palace
The reconstructed Amber Room, which
was destroyed during World War II.

**13 Smolny, Cathedral and Convent,
1764**
Architect: Bartolomeo Francesco Rastrelli
The Cathedral is the centrepiece of the
large group of buildings. Rastrelli aimed
to combine baroque detail with a forest
of onion domes typical of a traditional
Russian monastery.

14

16

17

14 St Petersburg, Catherine Palace
The Grotto Pavilion on the lake in the park surrounding the Palace.

15 St Petersburg, Catherine Palace, Pavilion in the Palace Park, 1750
Architect: Charles Cameron
The gallery building is in fact only an arcade to connect the Palace with the park.

16, 17 Moscow
Underground stations, built in the 1930s with elaborate traditional marble decoration to evoke an atmosphere of palatial splendour for the masses of users.

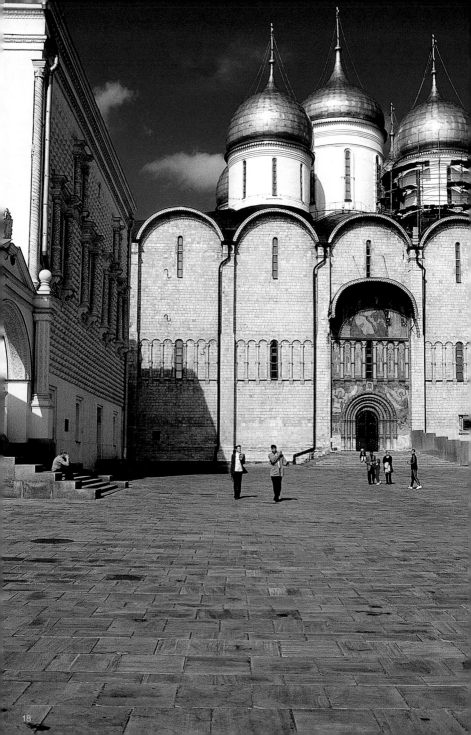

19

18 Moscow, Kremlin, Assumption Cathedral, 1470
The beautifully proportioned arched façade is crowned with circular towers surfaced with gold.

19 Moscow, Kremlin, Archangel Cathedral

20 Moscow, Red Square
The focal point of the city, with the colourfully decorated domes of St Basil's Cathedral and people lining up to see Lenin's tomb.

21 Moscow, GUM Department Store, 1895
Architect: Alexander Pomerantsev
Along Red Square is an elaborate complex of iron- and glass-vaulted shopping galleries.

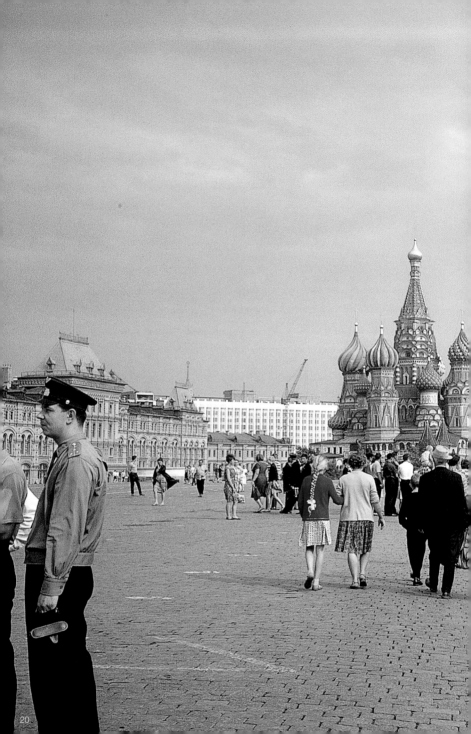

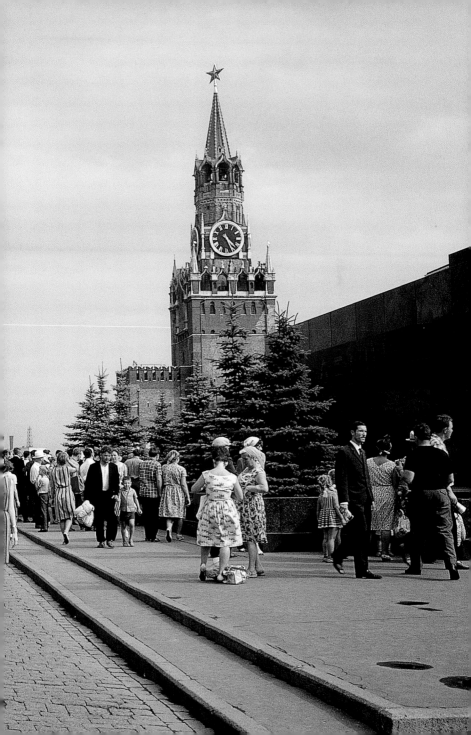

Turkey

What emerges from the country's thousands of years of colonisation, wars and occupation is one amazing building, built under Emperor Justinian in about 550 AD the Hagia Sophia in Constantinople (now Istanbul).

There had been various attempts at ambitious church construction on its site for 3 years, resulting in successive structural failures. Even though the area is subject earthquakes, Justinian's daring construct has survived with some structural additio It remained the biggest vaulted structure until St Peter's in Rome, built some 1,000 years later.

Its vast volume is based on a transition from a square structure to a circular don supported on semi-circular arches and pendentives between them. The spatial effect on the interior, with its 70-metre length and the 31-metre superimposed dome, is breathtaking. In 1453, the build became a mosque and in 1935, a muse The other landmark structure is the Blue Mosque, built 1,000 years later. What Hagia Sophia has on the interior, this building has in its exterior composition. Another architectural highlight is the restored Greek and Roman city of Ephes particularly the Library of Celsus. The restoration of its main façade was undertaken by the Austrian government. Cappadocia is an area in central Turkey which is in large parts covered with eroc mountains of tufa, a soft volcanic stone. Over centuries, people have carved spac and caves into these and created virtual cities both inside the mountains and underground. These excavated spaces maintain a constant temperature, enablir people to avoid the extreme climate of the area – both intense heat and cold – live comfortably and to store vegetables and fruit. They create a vast sculpturesq landscape of perforated peaked mounta and valleys.

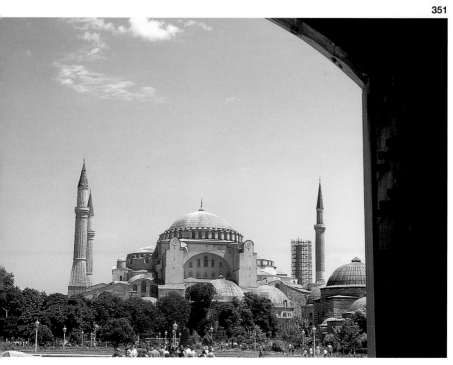

tanbul, Hagia Sophia, 6th century

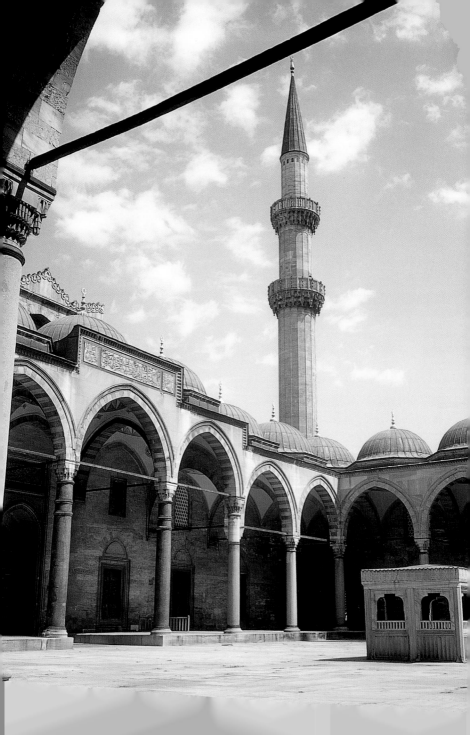

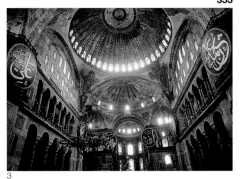

3

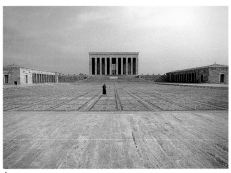

4

2 Istanbul, Mosque of Sultan Ahmed (the Blue Mosque), 1606–16
Architect: Mehmet Aga
The forecourt is surrounded by a domed arcade leading into a square structure with heavy supporting piers. Six minarets add to a finely proportioned totality.

3 Istanbul, Hagia Sophia, 6th century
This enormous church interior, with its suspended central dome, represents a heroic structural feat for its time.

4 Ankara, Memorial to Atatürk, 1944–53
The country's revered leader who "brought Turkey into the 20th century". A vast ceremonial open space is surrounded by arcades, with the stripped classically styled mausoleum on its axis.

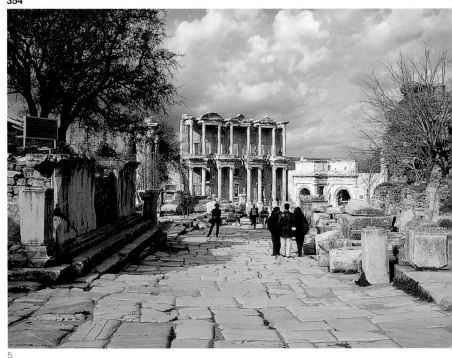

5

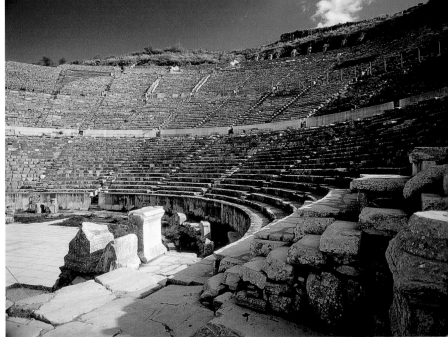

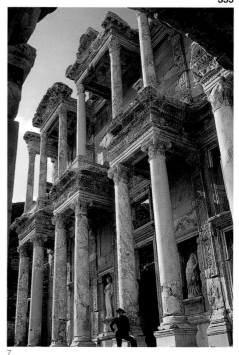

7

5, 7 Ephesus, The Library of Celsus, 260 AD
The reconstruction and preservation of the
façade were conducted by Prof. Friedmund
Hueber of the Austrian Archaeological
Institute. Alternating curved and triangular
pediments above and flat offset entabla-
tures below are carried by columns, which
create a scintillating façade composition.

6 Ephesus
The Roman amphitheatre, built into
naturally sloping ground.

8 Cappadocia
Entrances to ancient cave dwellings,
cut into eroded mountains of soft tufa.

Israel

The architecture of Israel can be divided two parts; the ancient monuments, whi are more of religious than architectural interest, and the new architecture in the cities, especially in Tel Aviv, which is a young and rapidly developing metropol The urban plan for Tel Aviv was designe by Sir Patrick Geddes, starting in 1931 Speedy development took place follow his plan, which coincided with the arriva of German refugee immigrant architects led by Erich Mendelsohn.

The results are a unique example of a ci comprising exclusively of modern architecture, and consistent white structures mostly built by architects train in the tradition of the Bauhaus. Of partic interest are the wide boulevards with ce tree-lined pedestrian routes, and separa traffic lanes on either side (such as the Rothschild Avenue). The image of the ci one of unified architecture of medium-height white buildings. Areas of earlier structures (50 to 80 years old) are now being restored progressively to look as new. The larger, recent areas of apartments, city office towers and unive buildings, are of very high standard.

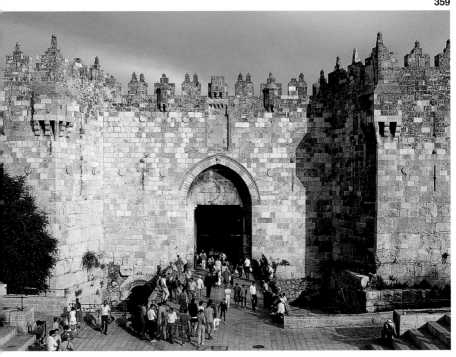

1 Jerusalem
The Damascus Gate leading to the Old City through the Citadel.

2 Jerusalem, the Israel Museum Shrine of the Books, depository of the Dead Sea Scrolls, 1965
Architects: Friedrich Kiesler and Armand Bartos
The accessible form of the Museum Hall is based on the profile of the ancient container in which the scrolls were found. The arresting sculptural exterior is clad in gloss white ceramics.

3 Jerusalem, The Western or "Wailing Wall", 20 BC
This is a remnant of the temple destroyed in 70 AD. The grand public space in front of the wall is the most revered urban area of the city. The gilded "Dome of Rock" of 690 AD is seen in the left background.

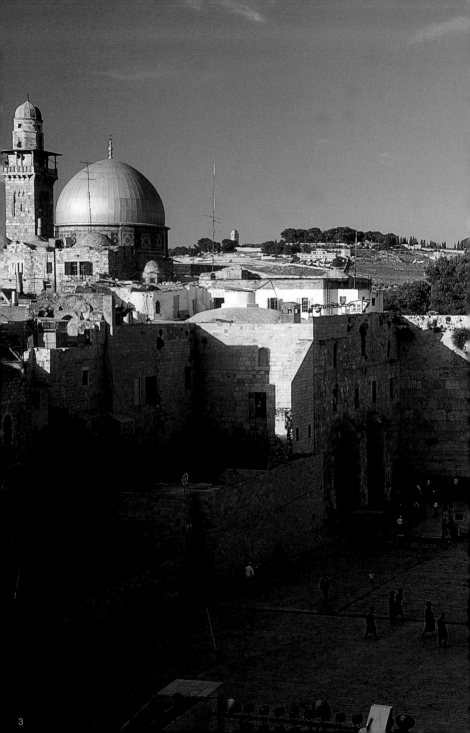

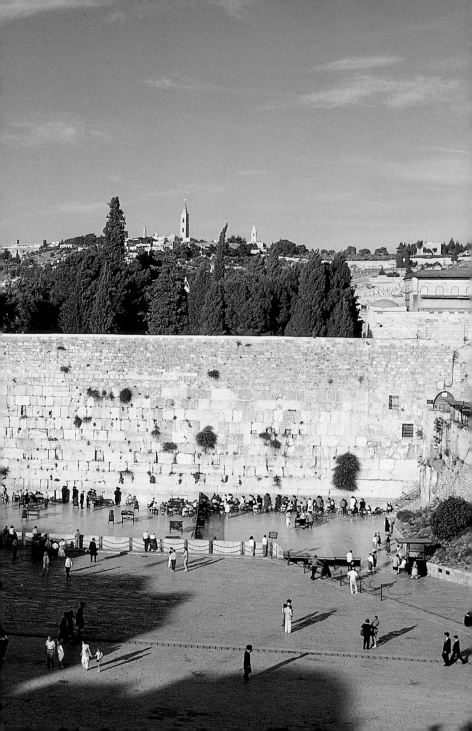

4

4 Jerusalem
View from the ramparts surrounding the
Old City with the Citadel's Tower of David.

5 Jerusalem
The Billy Rose sculpture garden in the Israel
Museum. Freestanding screen walls form
an open spatial environment through which
visitors can stroll. The screen walls create a
background for each individual work of art
without visual distraction.

6 Jerusalem, the Hadassa Hospital, 1939
Architect: Erich Mendelsohn
This excellent facility was built by the emin-
ent and influential German modern architect
who had left Germany in the early 1930s.

Jordan

With a history going back millennia, the country that stretches from the Sea of Galilee in the north to the Gulf of Aqaba the south, is a veritable treasure-trove c architectural delights.

The most spectacular of these is the ros red ancient city of Petra. Virtually none of buildings is freestanding; instead, they ar carved into the face of the rugged sands mountains. The approach is through a natural gorge more than 1 km long, 2 m wide and 200 metres deep. When one emerges from this chasm, the first glimps the "Treasury" building takes one's breatl away. The Roman influence is evident in finely wrought façade-architecture, some which recalls surprising baroque characteristics long before its time.

The earliest inhabitants were rock-cave dwellers, and some spaces in the hollowed-out sandstone were lived in b nomadic Berbers until recent times.

The remains of the Roman town Jerash with its curved open forum, surrounded freestanding stone columns, is a superb example of Roman town planning.

Crusader strongholds such as Shobak a Ajlun in the north are exceeded in desig by the desert castles of Qasar-Kharana Qusayr Amra, serenely freestanding in tl vast expanse of the eastern desert area Their simple geometric forms and fine s walls are recognised by UNESCO as W Heritage sites.

To the south is the dramatic mountaino and sandy Wadi-Rum area, the setting the film "Lawrence of Arabia".

1 Petra, Treasury, 1st century AD
Approached through the Siq, a 1.2 km narrow gorge, one suddenly comes upc this rock-cut building. It is the ultimate tl of discovery for the visitor.

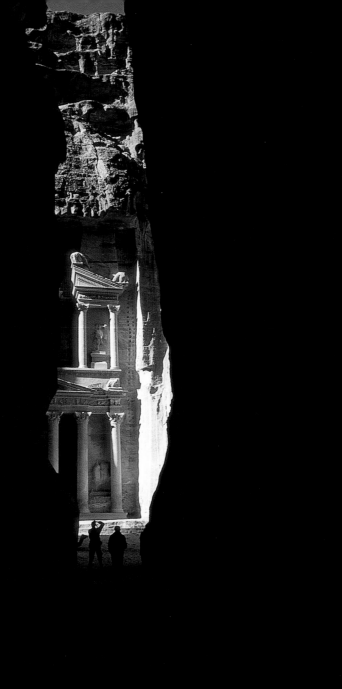

2

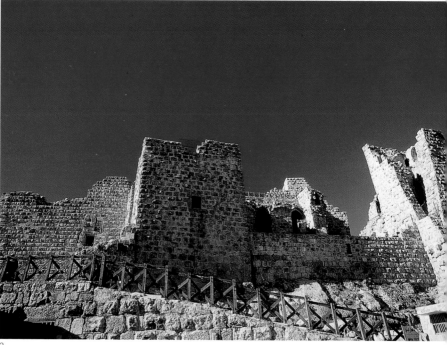

3

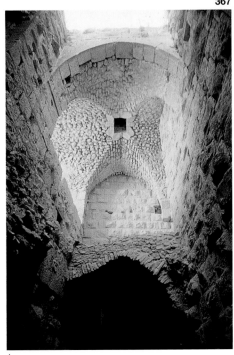

4

2–4 Ajlun, Ar-Rabad, 1185

The hilltop stone castle near the Jordan Valley is typical of Islamic military architecture. Its spaces are connected by stone-vaulted intersecting passages.

5–14 Jerash, 333 BC–500 AD

The Roman city is entered through
Hadrian's Arch, 129 AD. The oval-shaped
forum is defined by freestanding columns,
which are connected at their capitals.

6 Temple of Artemis, 150–170 AD

7 Hadrian's Arch, 129 AD

10 Jerash

The forum's colonnade extends to define
the main streets of the town, lined with
monumental public buildings.

12 The Agora

Surrounding columns and stone benches
create a decorative centre in this market
square.

13 Nymphaeum, Temple to Artemis, 191 AD

14 Jerash

The egg and dart stone carving of
a Roman entablature.

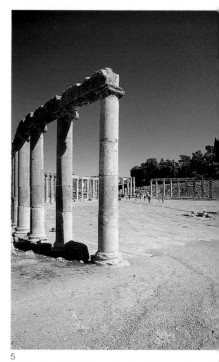

5

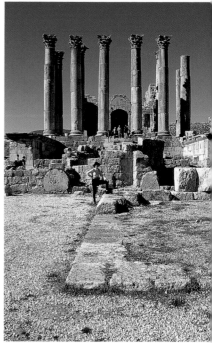

6

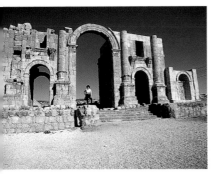
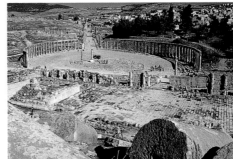

8

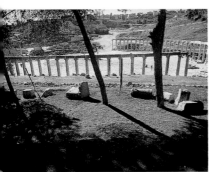
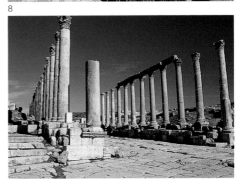

10

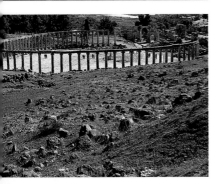

12

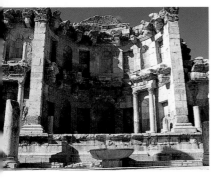

14

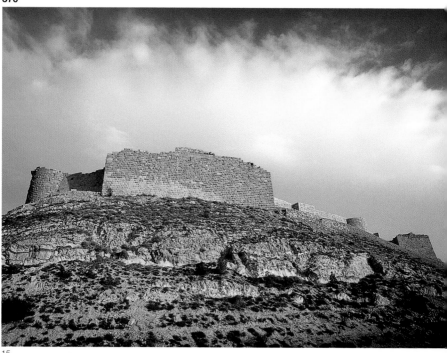

15

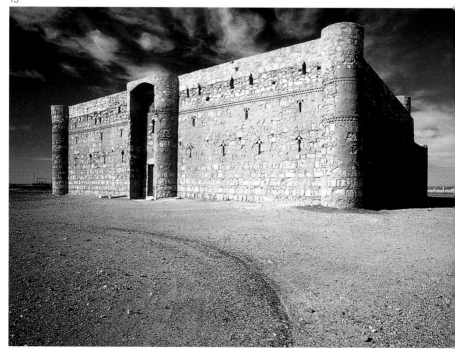

17

15 Shobak, 1115 AD
A fortified hilltop crusader castle, with
a fine silhouette.

16, 17 Qasr-Kharana
Standing alone in a treeless desert area,
this impressive building has finely
proportioned exposed stone walls. The
internal spaces face an open central court.

18 Qusayr Amra, 705 AD
The barrel-vaulted structure, with domes
and frescos, is influenced by Roman
precedents. It was restored and is now
a UNESCO World Heritage site.

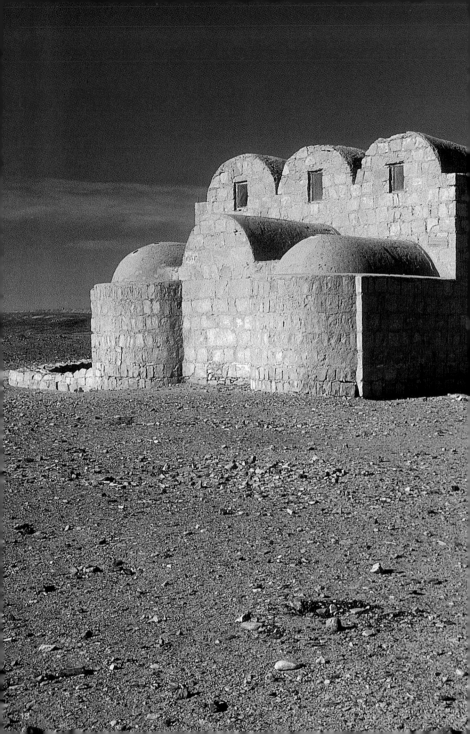

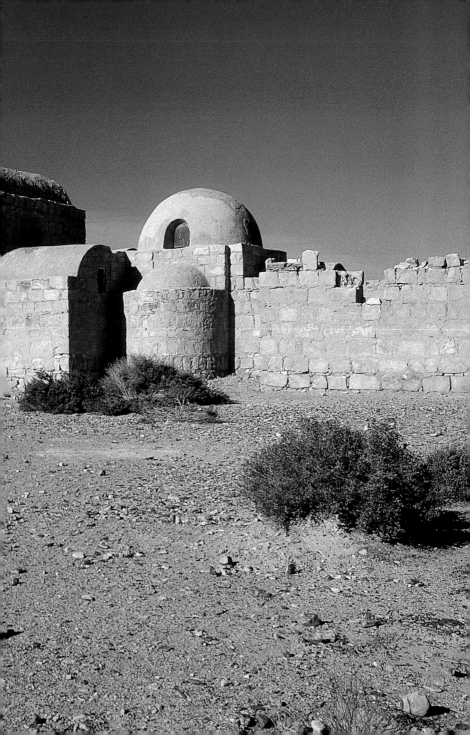

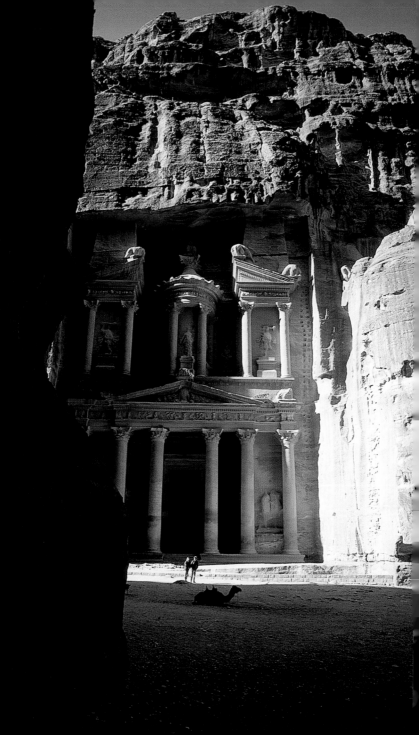

Petra Treasury

...ved into the rock-face on one side of a ...ring, this edifice creates an ...orgettable image. The classical Roman ...ade, with its broken pediment, pre-...ots baroque forms of 1500 years later.

Petra Monastery

...nding high on a mountain top, the ...k-cut structure is architecturally ...iniscent of the Treasury, but faces ...ide-open plateau.

Petra

...ock-cut tomb.

25 Petra

...ades of rock-cut buildings surround the ...s of Petra's extensive central valley.

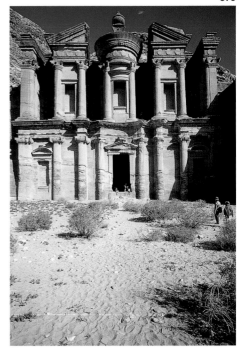

20

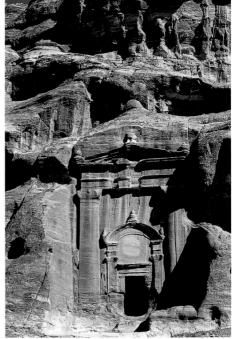

21

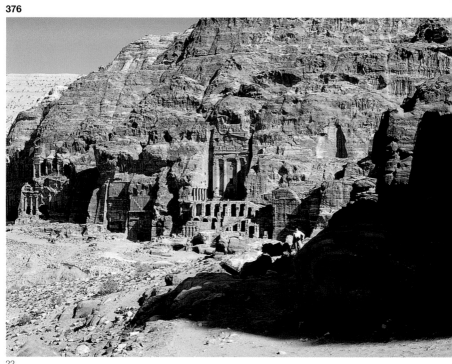

22

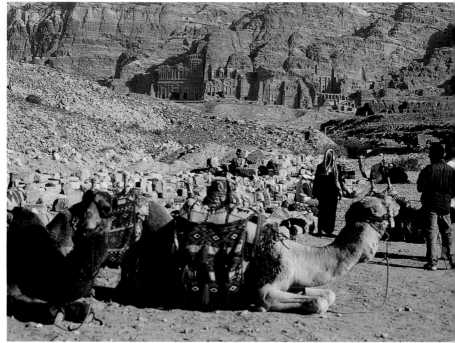

23

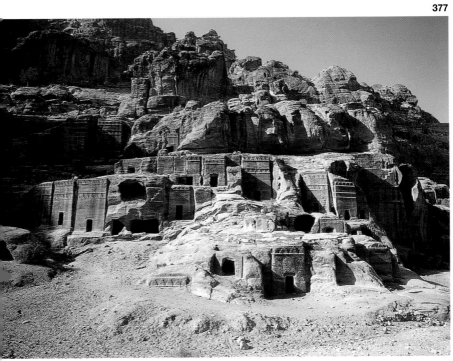

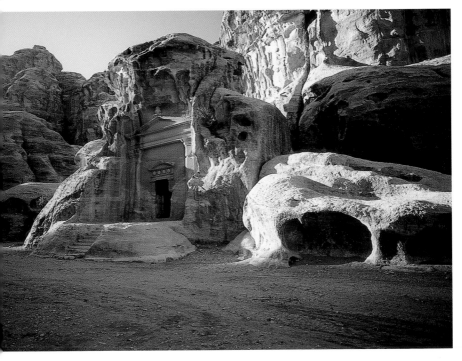

Iran

Of all the cities of what used to be Persi
it was in Isfahan that Islamic architectur
reached its peak, in the 16th century.
Located in a seemingly endless expanse
of rock and sand, Isfahan resembles a
huge oasis, with large trees and lush
foliage. Emerging from this canopy of
vegetation are the inimicable shapes of
domes, cupolas and minarets of the city
glistening with brightly coloured geometri
patterned ceramic exteriors.

The focal point of the city is the half-kilo
metre long central square, the Meydan,
surrounded by domed structures. At its
short end stands the blue Imam Mosque
From its entrance atrium, facing the
square, the main building turns at a forty
five degree angle, which creates a stron
visual opposition to the rectangular,
often water-filled reflecting surface of the
Meydan.

At the opposite end of the long surface o
the square is the gateway to the ancient
bazaar, with its top-lit vaulted passages
filled with shopping stalls.

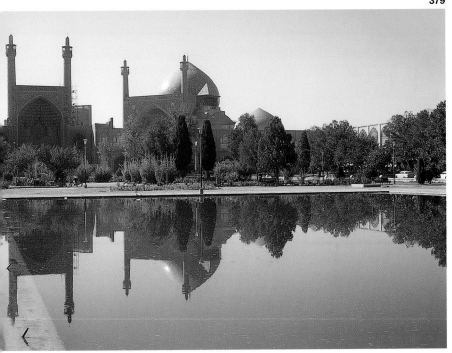

fahan, Imam Mosque, 1612–30
ected at the end of the water-filled
dan focal square of Isfahan.

fahan
n of the Meydan Square

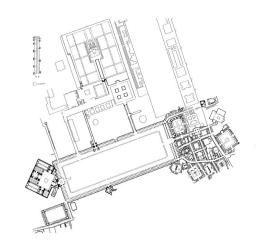

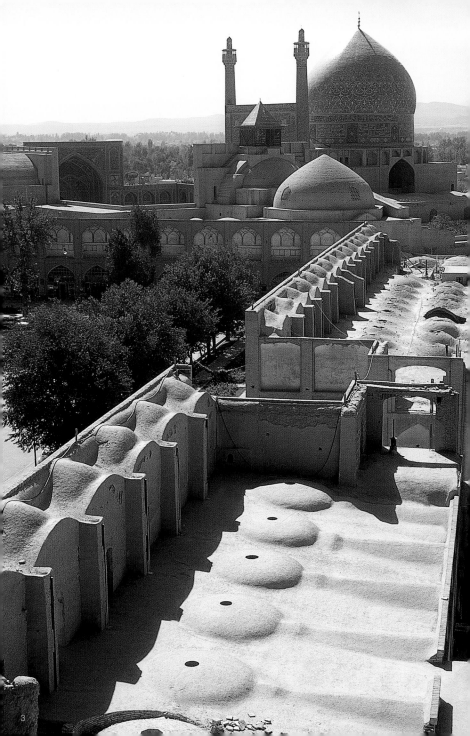

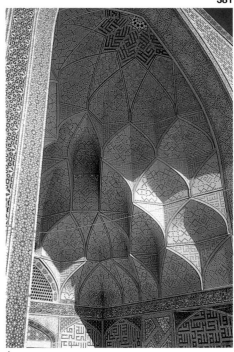

4

3 Isfahan
View on to the Meydan from the roof of a
galleried arcade.

4 Isfahan
Arched and decorated entry portico.

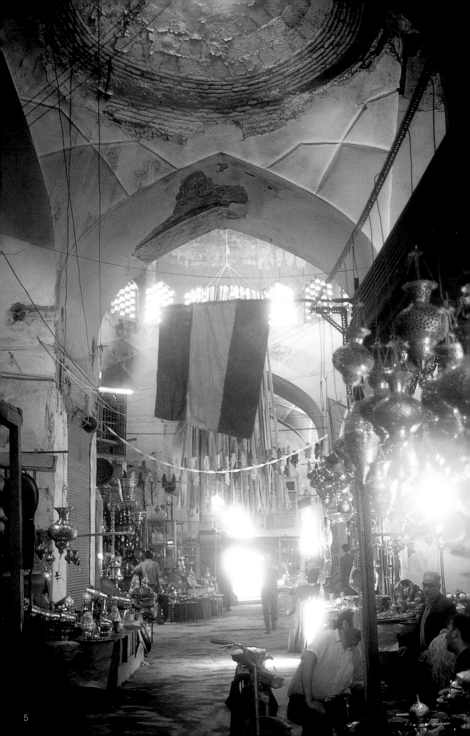

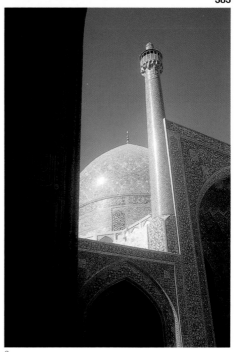

6

5 Isfahan
The ancient bazaar – a high, top-lit vaulted structure with stalls lining the criss-crossing passages.

6 Isfahan
The pointed dome and minaret of the Imam Mosque.

7 Isfahan
The Masjit-i-Imam, with typical geometric repeated ceramic surfaces that permit infinite numbers of permutations.

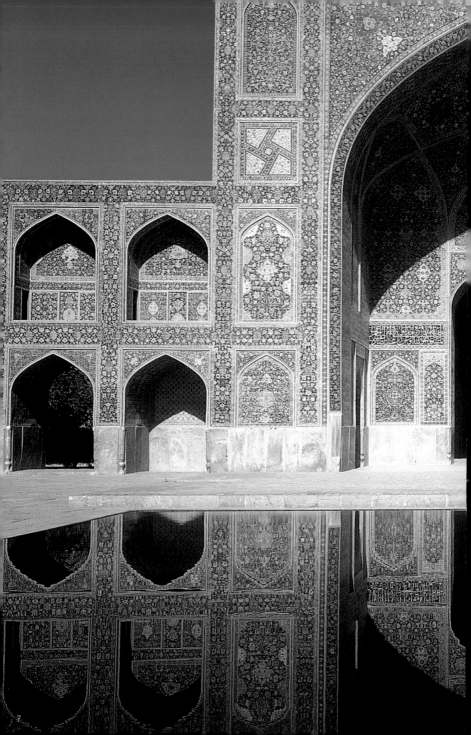

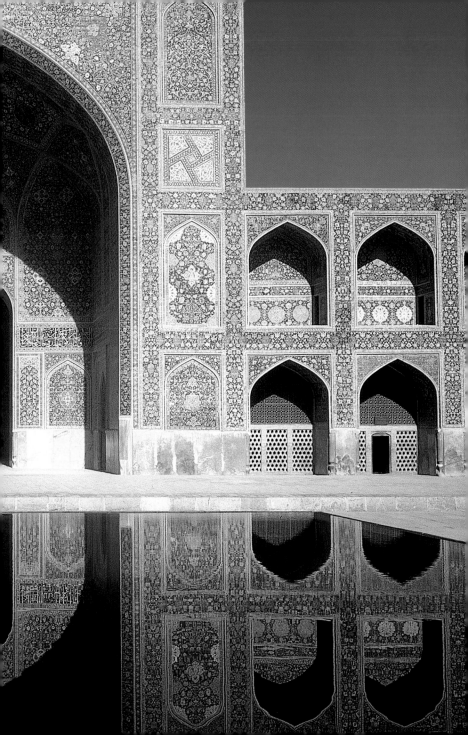

Morocco

Lying between the Mediterranean and the Sahara, the country is traversed by the dramatic Atlas Mountains, snow-capped most of the year. Historically inhabited by resilient Berber population, the country has never been subjugated by numerous invaders.

Of particular architectural interest are the ancient fortified hill-top towns and the villages in valleys of the foothills on both sides of the Atlas Mountains. Built of mud-brick walls with flat roofs, they create uniformly coloured but unique abstract patterns in the mostly dry and barren landscape.

The fortified towns, with tall defence towers, are the Kasbahs – built mostly in the dry river valleys of the Draa and Dao. The best known of these is at Ait Benhaddou, which is a popular film location.

The cities of Morocco have densely populated centres (the "Medina"), with alleys rather than streets – barely more than a metre wide. A focal point is the souq (bazaar), the commercial backbone of the city in which workshops, wool stores and living quarters have not changed in centuries. The uninitiated visitor is easily lost in this labyrinth, which lacks any street names.

The imperial cities of Meknes, Fes and Marrakesh share architectural focal point surrounding walls with protective towers and distinctive palaces and mosques.

1 Taroudant
The town is surrounded by magnificent crenellated red mud walls.

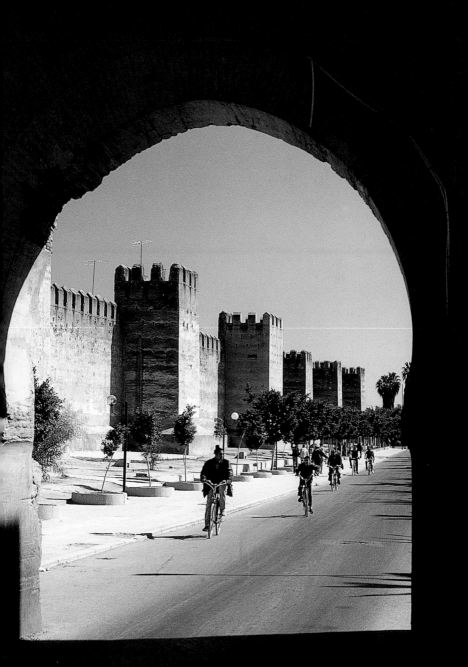

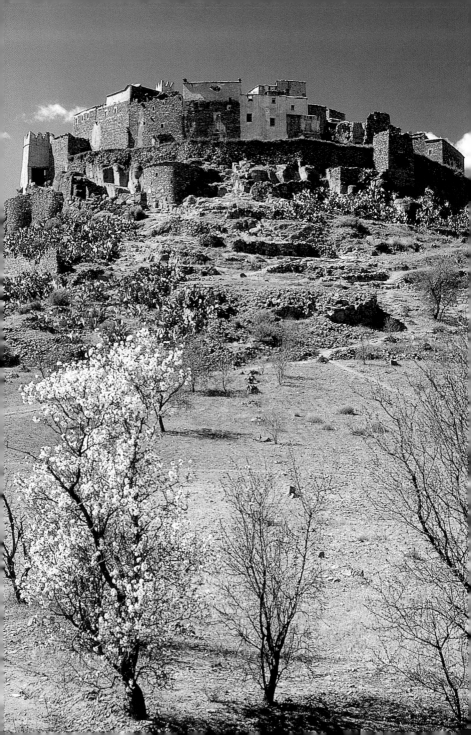

ïoulit
rotected town in the Anti-Atlas.

4 Dades Valley
d mud-brick villages of the Dades Valley
ate evenly coloured, rectangular abstract
terns seen against the snow-covered
h Atlas Mountains.

3

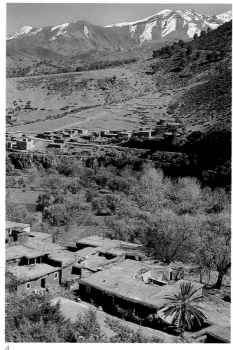

4

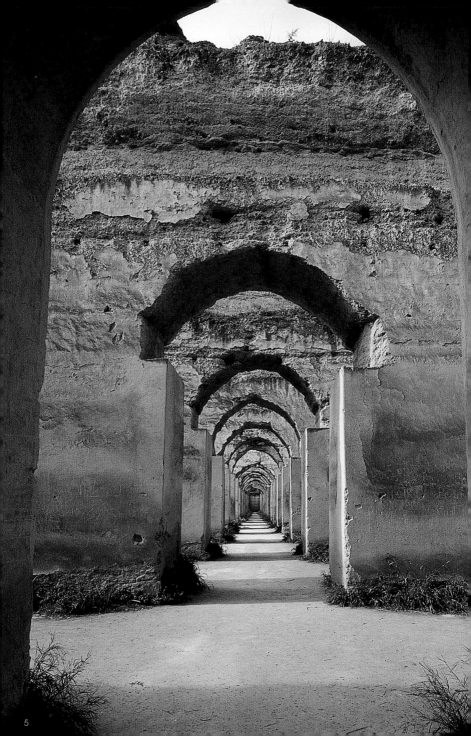

...eknes, The Rouah
...ns of the 17th-century royal stables,
...ch at one time housed 12,000 horses.

...arrakesh
...tective city walls.

...eknes
...ail of King Mohammed VI's palace
...es, made of gold.

6

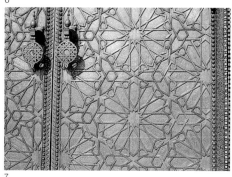

7

USA

From the early days of European migratio
to America in the 17th century, the buildi
prototype was based on English precede
even if mostly translated into the locally
available material in abundance: timber. 7
predominance of European culture contin
and reached a high point under Presider
Thomas Jefferson, who was influenced b
European classical architecture during hi
term as America's ambassador to France
He was a naturally gifted amateur archite
which is evidenced in his exemplary desig
for the campus of the University of Virgir
(1819–26).

American architects in the early 19th
century followed the English and French
prevalent stylisms until the Industrial
Revolution, when dramatic advances we
made technically and aesthetically. The u
of iron enabled buildings to rise higher, a
this was aided by the development of th
Otis elevator. Economic expansion and
consequent wealth allowed such archite
as Louis Sullivan and Frank Lloyd Wright
unfold their inventive genius in structural
daring, and a new spaciousness in their
buildings. It helped skyscrapers reach
unprecedented heights in the early 20th
century.

The 1930s saw the arrival of European
émigré architects who could no longer te
or build under the rise of the totalitarian
Nazi regime. Walter Gropius, who found
the influential Bauhaus, Marcel Breuer, t
pioneer of steel furniture, and the renow
teacher and designer Mies van der Rohe
its last director, were all invited to teach
Harvard and I.I.T. in Chicago and obtain
increasingly important commissions to bu
This had immeasurable influence on the
young generation and large competing
firms of architects such as Skidmore
Owings & Merrill. Architecture of high qu
reached its zenith in the 1950s and 197
Under pressure for commercial and
advertising newness, "a new architectur
every Monday morning", architects brou
style fads into existence, fed by a media
which published and listened to influenti
articulate but opportunistic practitioners.
The cultural base that brought modern

opean architecture into existence was
sing, but was soon replaced with
nions of historistic decorative modes in
1970s and '80s (Post-Modernism,
constructivism, etc.), all meaningless
els coined by non-practising academics
journalists. As with all fads, these soon
ed the appetite for "newness" and
appeared.
ertheless, important progressive build-
s, skyscrapers for successful
porations, museums, fine houses and
riors (mostly for the wealthy) had been
ught into existence, by Breuer, Neutra,
s van der Rohe, Pei, Saarinen, Meier,
the most brilliant of them all, Frank
d Wright. Le Corbusier designed his
y US building at Harvard University.
the end of the 20th century and with the
th of pioneering architects, a hiatus of
thetic development gave way to aim-
ness, fake historicism and an elusive
rch for convincing directions.
contrast to most European countries, in
USA, driven by market forces, no large-
le town-planning or high-quality social
sing has so far come into existence.

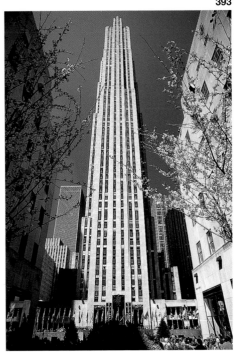

1

**1 New York, Rockefeller Center,
1929–40**
*Architects: Reinhard & Hofmeister with
Raymond Hood*
Simultaneously with the Empire State and
the Chrysler Tower, this landmark of New
York was built during the Great Depression.
It consists of nine buildings of varying
height, with the 70-storey RCA Tower its
centrepiece. What is admirable in the
complex are the large open pedestrian
spaces, which have remained a magnet,
attracting people to its malls and plazas.

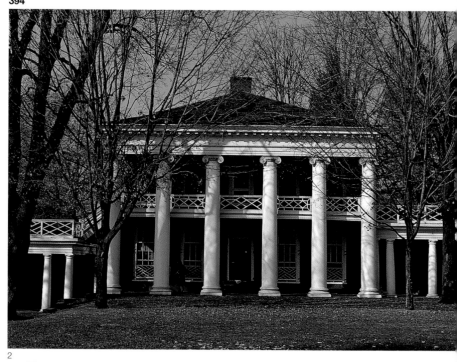

2

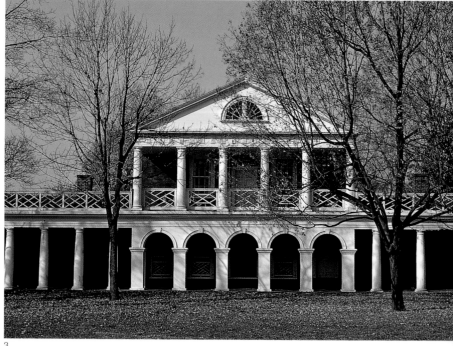

3

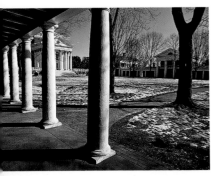

2-7 Charlottesville, University of Virginia, 1819–26

Architect: Thomas Jefferson

The symmetrical U-shaped central space terminates in the Roman Pantheon-like library building in this serenely beautiful environment. Five double-storey pavilions connected by low classical colonnades contain teaching and living accommodation. Jefferson was a naturally gifted amateur architect. His direct and ingenious planning was exemplary, not only aesthetically but also through inventive structural devices such as the long and thin self-supporting wave-shaped brick walls, which achieve much with little effort and material.

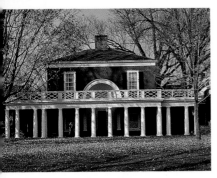

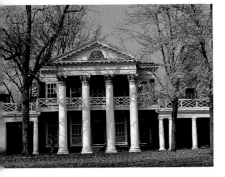

Chicago, Illinois, Carson Pirie ... tt, 1899–1904

...itect: Louis Sullivan

... influential pioneer architect was the
... to give expressive strength to early
...scraper buildings, which were based on
...on-skeleton construction. The ground-
... exterior is encased in cast-iron
...orative panels, the American
...nterpart to the European Art Nouveau
...e time.

...hicago, The Rookery, 1885–88

...itects: Daniel H. Burnham,
...n Wellborn Root, Frank Lloyd Wright
...onstruction)

... exposed iron structure supporting the
...ral glazed court roof is an example of
...gressive engineering design of the 19th
...ury.

9

10

11

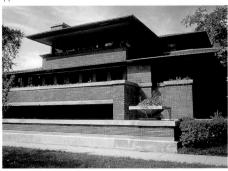

12

13

11, 14 Oak Park, Illinois, Unity Temple 1904–07

Architect: Frank Lloyd Wright

One of the first "binuclear" or "H plans", later used extensively by others, whereby the main hall and subsidiary spaces are separate and connected with a narrower entrance link. The powerful solid concrete building makes a clear structural expression in the hall, which is emphasised by the source of daylight. There are deep glazed coffers in the roof and horizontal windows placed between the corner supporting elements.

13 Frank Lloyd Wright, 1867–1959

12, 15 Chicago, Illinois, Robie House 1906–10

Architect: Frank Lloyd Wright

This is one of Wright's most famous works, characterised by hugely cantilevered low slung roof planes, interlocking volumes and planes and sweeping horizontals.

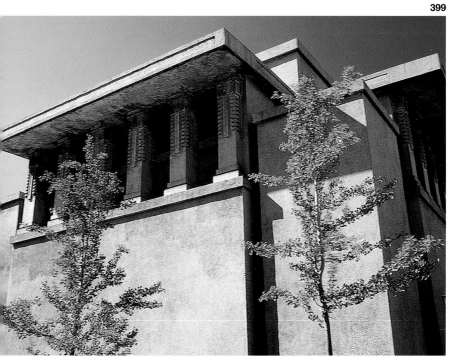

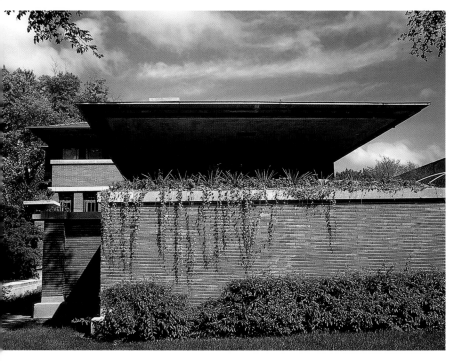

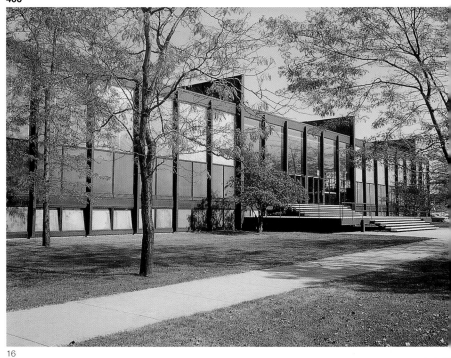

16

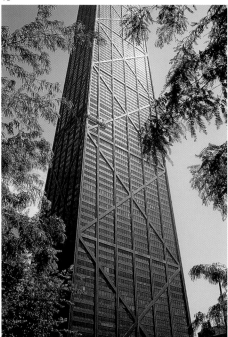

17

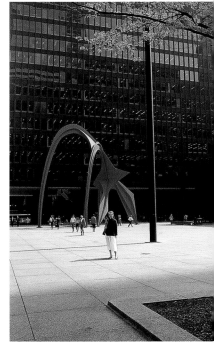

18

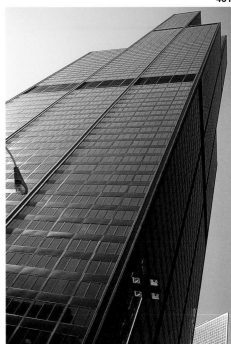

19

Chicago, Illinois, Crown Hall, I.I.T., 1950–56
Architect: Mies van der Rohe
The main floor of this architecture school consists of a single large space, supported by an external steel frame and enveloped in glass. It is one of Mies' most expressive concepts of a powerful minimal structure.

Chicago, Illinois, John Hancock Tower, 1965–70, 1968–75
Architects: Skidmore, Owings & Merrill
This huge tapering tower contains both commercial office space and apartments. The external structural cross-bracing gives the building its distinctive character.

Chicago, Federal Center, 1970
Architect: Mies van der Rohe
A typical black-framed curtain-wall tower made unique by the placing of the large orange-coloured Alexander Calder stabile sculpture.

Chicago, Sears Tower, 1974
Architects: Skidmore, Owings & Merrill
Until 1996 it was the tallest building in the world. Its silhouette is made up of a cluster of smaller towers of varying heights, generated by the different heights of the groups of elevators.

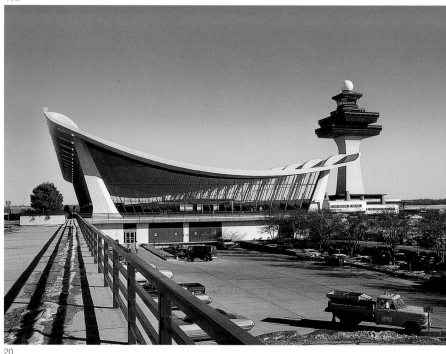

20

20 Washington DC, Dulles International Airport, 1958–62
Architect: Eero Saarinen
The sweeping catenary roof structure is supported by outward-leaning concrete pylons and steel tension cables hung between them, resulting in a huge column-free space.

21 Washington DC, Monument
The focal axis of the capital, with its obelisk as seen from the Lincoln Memorial (1911–1922, architect Henry Bacon), is based on the Washington Plan by Pierre Charles L'Enfant in 1791.

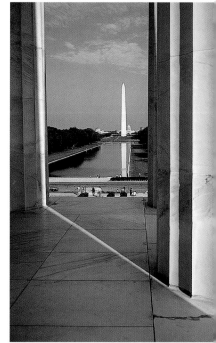

21

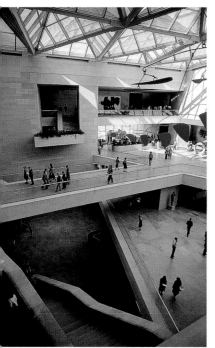

22, 23 Washington DC, East Wing, National Gallery of Art, 1975

Architect: Ieoh Ming Pei

The basis of this superbly designed monumental building is triangular geometry and forms derived from it. The central main space is covered with a glass roof from which a red Alexander Calder mobile sculpture hangs and is kept in constant motion by the ventilation system.

24 Ieoh Ming Pei, *1917

25 New Harmony, Indiana, The Atheneum, 1975–79

Architect: Richard Meier

Built in a historic town founded by a Utopian community in 1815, this is a centre for visitors' orientation and community cultural events. The elaborate spatial complex contains exhibition areas and an auditorium, all connected by internal access ramps. The generous glass areas allow views over the lushly planted surroundings and the nearby Wabash River.

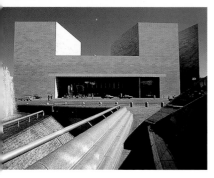

24

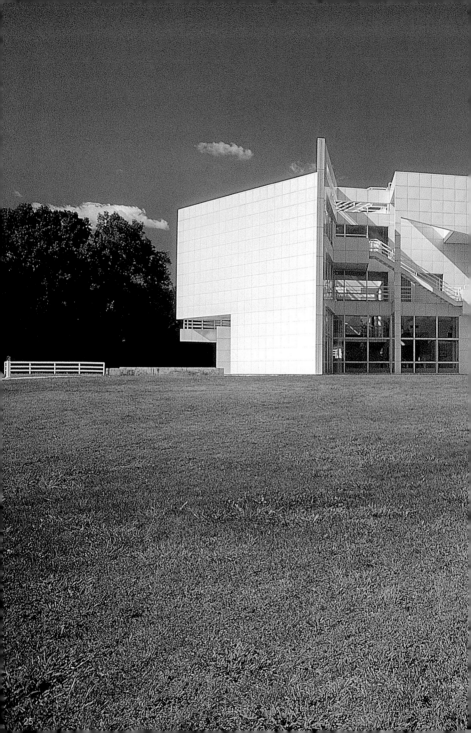

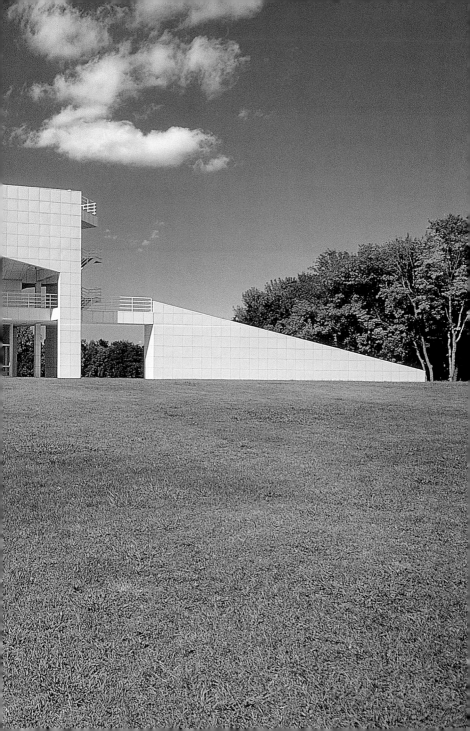

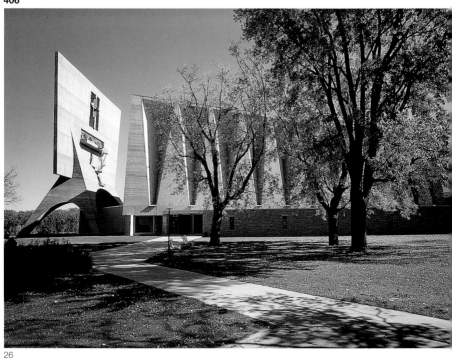

26

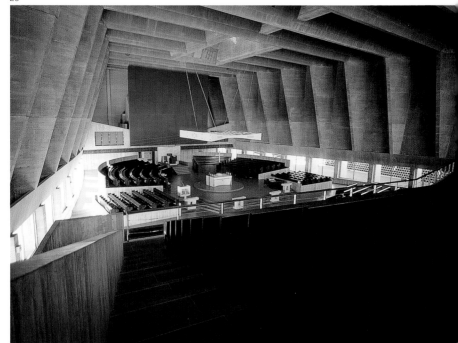

27

31

31, 32 Syracuse, NY, Everson Museum, 1968

Architect: Ieoh Ming Pei
The contrast between the minimalist rectilinear sculptural exterior and the interior could not be greater. The flying cantilevers outside give way to constantly changing spatial excitements inside. The main space is traversed by a curvilinear staircase and ramp, with linear sources of daylight.

32

33, 34 Fort Worth, Texas, Kimbell Museum of Art, 1972

Architect: Louis Kahn

The Museum is composed of six parallel concrete vaults that span the length of the structure. The "servant" spaces between them allowed variations of displays between the top-lit galleries within the long vaults.

35 Bear Run, Pennsylvania, Fallingwater, Kaufmann House, 1936

Architect: Frank Lloyd Wright

This is Wright's world-famous house, cantilevered over a gushing waterfall in the most beautiful, wild natural setting. The vertical rough stone piers support daringly hovering horizontal concrete elements of terraces and suspended spaces. Even though romantic in character, the off-white house is clearly influenced by the modern European architecture of the time.

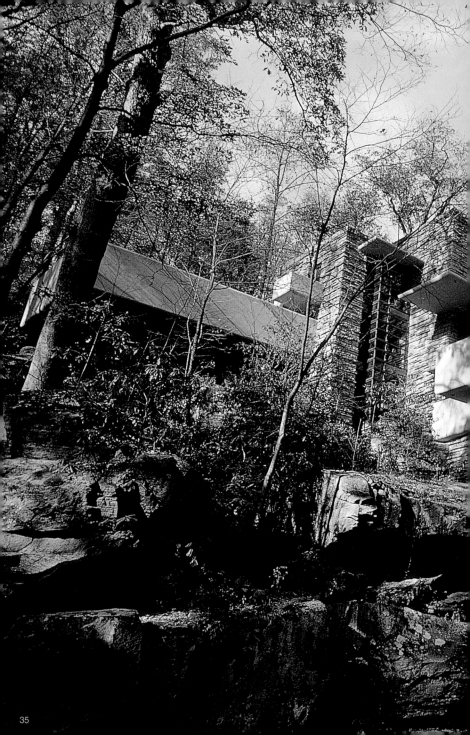

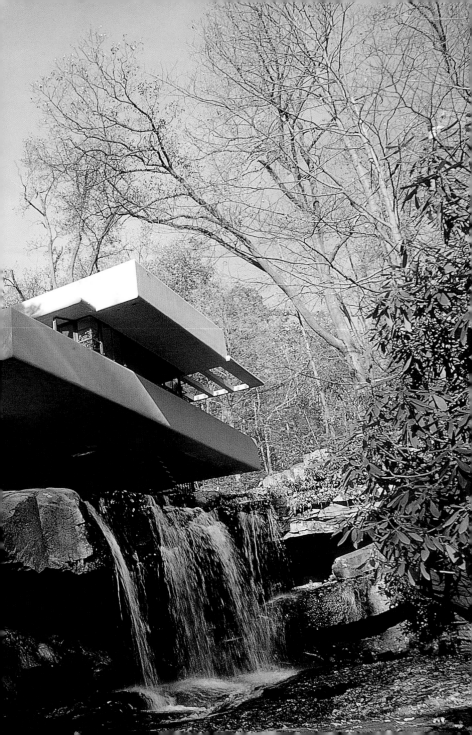

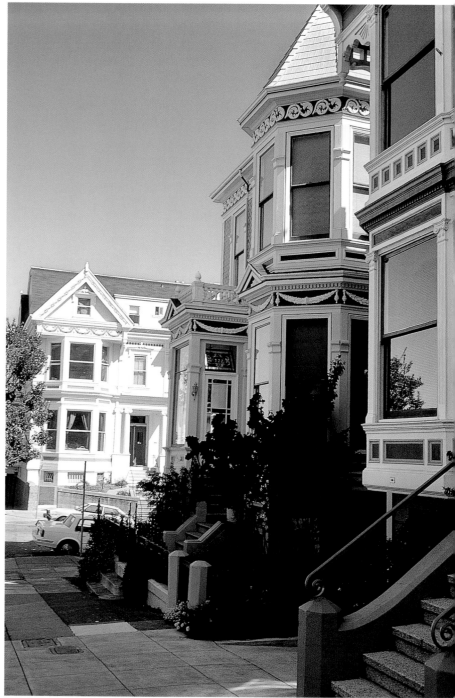

36 San Francisco Houses
These vernacular 19th-century houses with carved timber decorations give whole districts of the city their unmistakable character.

37 San Francisco, Cal., Office Building, 1890
An early steel-framed city building with a glass curtain wall façade, built long before this was re-introduced by European émigré architects 50 years later.

38 San Francisco, Cal., Russell Residence, 1948
Architect: Erich Mendelsohn
One of the few American buildings by Mendelsohn, this lavish residence overlooks an expansive public park.

39 Oakland, Cal., Oakland Museum, 1961
Architect: Kevin Roche
The museum consists of low pavilions, connected by landscaped roofs that create the impression of a large stepped park.

40 San Francisco, Cal., Crown Zellerbach Building, 1957
Architect: Skidmore, Owings & Merrill
This office tower is freestanding in landscaped grounds. A circular low bank building with a folded plate roof creates a focus for occupants looking down.

41

42

43

41 Los Angeles, Cal., Lovell House, 1928
Architect: Richard Neutra
This well-known house is one of the first
examples of uncompromising modern
architecture in America. Its light steel fra
construction and spacious multi-level
interiors influenced much later design
in the US and Europe.

42 Palm Springs, Cal., Kaufmann House, 1946
Architect: Richard Neutra
Based on a pin-wheel plan, the different
wings allow individual panoramic views
the surrounding mountains and desert
scenery in every room.

43 Los Angeles, Cal., Charles Ennis House, 1924
Architect: Frank Lloyd Wright
This hillside house, built of decorated ca
concrete blocks, brings to mind Mayan
stone carved architecture.

44–46 Los Angeles, Cal., The Paul G Center and Museum, 1984–97
Architect: Richard Meier
Located on a hilltop above the city, this
complex of buildings is the most elabora
anywhere dedicated to art. The various
pavilions contain study centres and
museums, grouped around large open
spaces with gardens, fountains and
restaurants. Most buildings are clad in
white metal, but some are of split traver
stone resulting in deeply textured surfac
enhanced by strong sunlight.

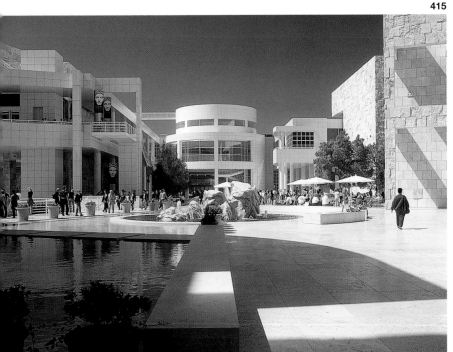

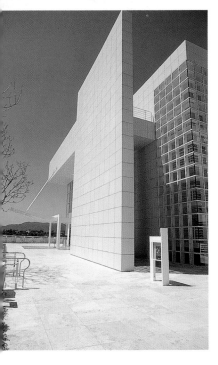

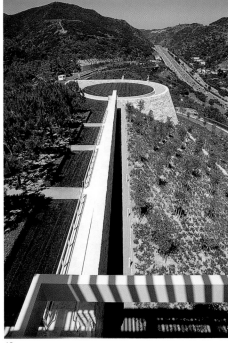



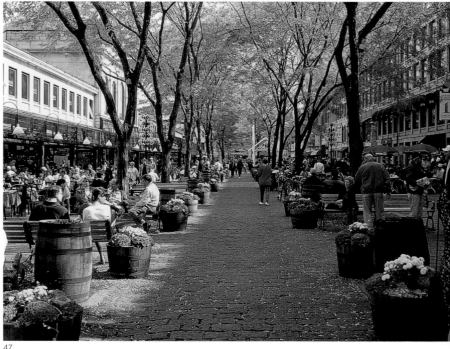

47

47 Boston, Mass., Quincy Market, 1976
Architect: Ben Thompson
This successful urban renewal project revitalises an early 19th-century market and warehouse area (designed by Alexander Parris).

48, 50, 51 Lincoln, Mass.,
Walter Gropius House, 1937
Architects: Walter Gropius, Marcel Breuer
This revolutionary house is the first work by these two recently appointed and influential Harvard professors. The simple rectilinear outline of the building is sculpted with hollowed-out spaces, stone walls and screens. The angular entrance is recalled in an opposing slanting wall in the living area. Other than in books, it is the first deeply impressive masterpiece of modern architecture that Gropius' students have seen (myself included).
Photo 50, the 1946 photo, is the earliest taken to feature in this book.

48

49

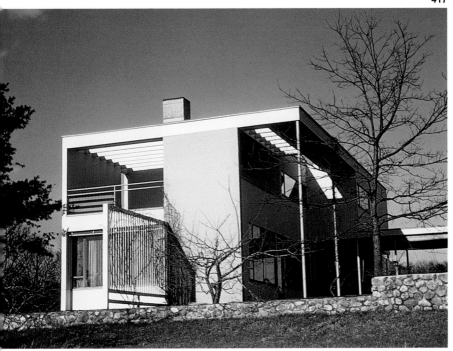

49 Cohasset, Mass., Hagerty House, 1938

Architects: Walter Gropius, Marcel Breuer
The entrance side of the seaside villa faces the ocean on the other side with large areas of glass. The two sides are joined by the open ground space under the suspended part of the house. The resulting landscaped open area is enclosed with stone walls.

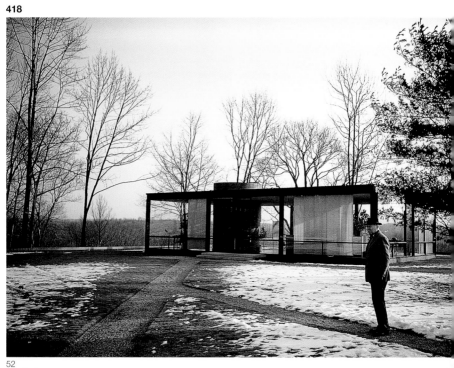

52

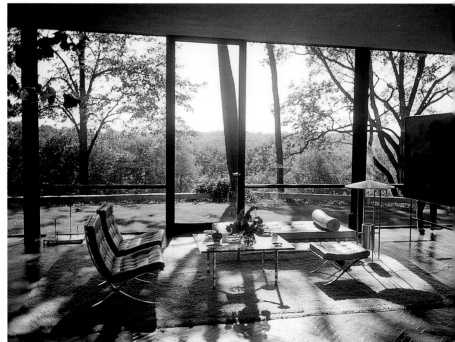

53

, 53 New Canaan, Conn., ass House, 1949

chitect: Philip Johnson

a visit in 1955, Marcel Breuer (see
oto) took me to see this steel-framed
ss pavilion. It was the first of such totally
zed houses in the USA. It is built in an
tensive park-like setting and was later
ed by other small buildings: a sculpture
vilion, an underground museum and a
est-house.

es van der Rohe had sketched such a
ss house in 1934 and built the elegant
rnsworth House in Plano, Ill. in 1951.

, 55 Boston, Mass., useum of Fine Arts, 1981

chitect: Ieoh Ming Pei

s stone-clad addition to the large
sting museum complex has a central
ss-vaulted spine, from which exhibition
aces emanate horizontally and vertically.

, 57 Cambridge, Mass., Carpenter nter for the Visual Arts, 1963

chitect: Le Corbusier

lt at Harvard University, this is Le
rbusier's only building in North America.
idio spaces are located on either side of
owing access ramp that penetrates the
lding and connects two parallel streets.
tivities in the studios are visible to all who
ss through the building.

e south-facing spaces are equipped with
ernal sun louvres, which add texture to
off-form concrete building. The Center
one of Le Corbusier's most stunning,
ilpturally and constructionally. It is also
best maintained of all his buildings.

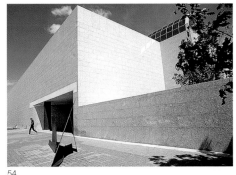

54

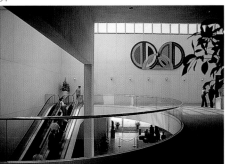

55

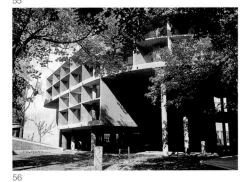

56

57

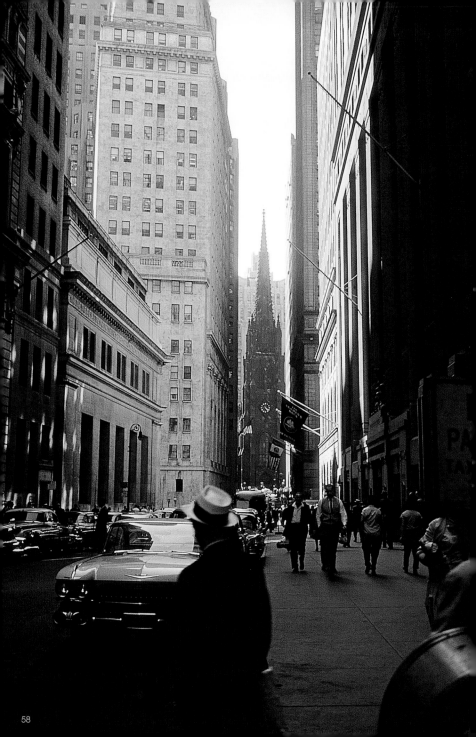

Manhattan, New York, Wall Street
e financial business district's very narrow
eets are lined with skyscrapers dating
n the early 20th century. The high-rise
dings now dwarf the church tower,
ch was once a tall landmark.

**New York, George Washington
dge**
s advanced feat of engineering – a steel
spension bridge across the Hudson River
as built in the 1930s. When Mies van
Rohe was interviewed in 1957 and
ed what he considered to be the best
ding in New York, he named this bridge.
s photo was taken in 1946 by stopping
car on the bridge and climbing onto the
tpath!

59

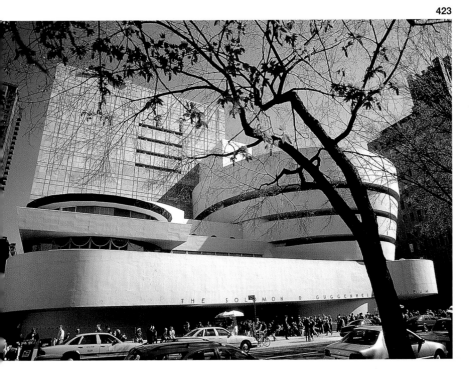

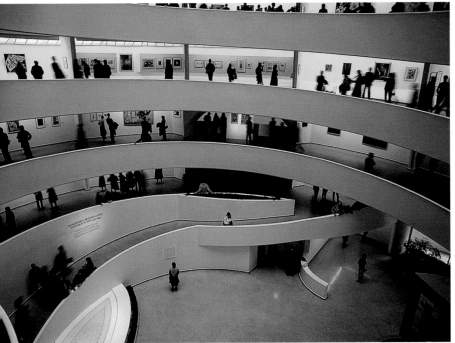

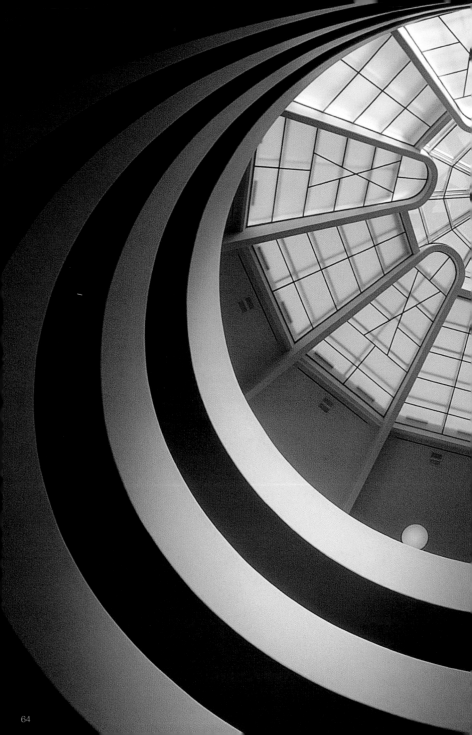

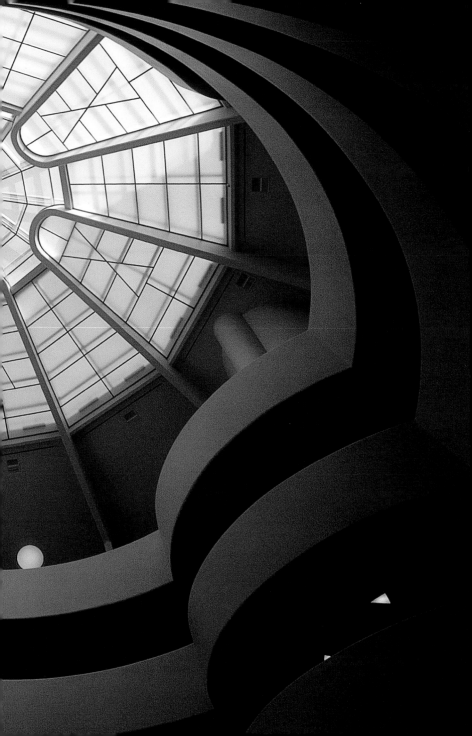

65

66

65, 67 New York, Whitney Museum of American Art, 1966

Architect: Marcel Breuer

Placed on a small corner site, the grey granite-clad square building steps out toward the top to leave space for an outdoor sculpture court below street level. Unique trapezoidal windows admit daylight to the gallery floors. The beautiful Alexander Calder exhibition of 1976 demonstrated the success of the flexible display lighting from the squared concrete grid ceiling.

66, 68 New York, Seagram Building, 1958

Architect: Ludwig Mies van der Rohe

Mies' masterpiece is recognised as the quintessential skyscraper of the 20th century. The tower is set back from Park Avenue, creating a public space in which huge sculptures are often displayed. The minimalist "almost nothing" design of the tower asserts its monumentality and longevity by being clad in bronze. Even wall-wash lighting, developed for the building by Richard Kelly, was used for the first time on the high travertine-clad entrance walls.

428

69

70

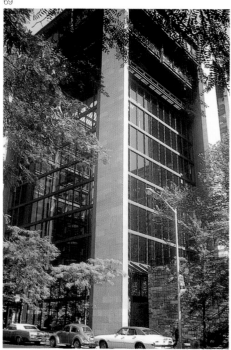

71

72

**New York, United Nations
elopment, 1969**

itect: Kevin Roche

arly example of tower architecture that
ndons a routine rectilinear silhouette.

**73 New York, Chase Manhattan
k, 1957–60**

*itects: Skidmore, Owings & Merrill
don Bunshaft)*

architecture of this quality headquarters
e building offers a neutral background,
gains stature by the placement of major
ptures by Dubuffet at ground level, and
ugh a sunken court by Noguchi.
office of the Bank's Head, David
kefeller, continues this theme: elegant
malism, enriched with large colourful
orks.

**72 New York, the Ford Foundation,
8**

itects: Eero Saarinen and Kevin Roche

headquarters building maximises the
ortunity offered by its site, which is
cent to a park. The high central atrium
verlooked from the L-shaped office
s and faces the other two full-height
s walls toward the park. High
alyptus trees in the atrium extend the
inside.

73

74 World Trade Center Towers, 1966–73

Architect: Minoru Yamasaki

For some 30 years the 100-storey twin office towers were the most visible land marks of Manhattan. On September 11 2001, they were destroyed in a terrorist attack when hijacked jet aircraft were d into their sides, causing an inferno and killing some 3,000 people. The world as – how could this have happened?

When visiting the buildings during con- struction in 1970, I remember being amazed at the exclusive use of lightweig building materials. Their steel structure sisted of closely spaced exterior columr and 20 m floor beams spanning to the elevator core. No concrete was used around firestairs or elevator shafts; inste layers of plasterboard were chosen. The immense heat generated by the explosi of jet fuel on impact weakened the stee structure to such an extent that it cause the progressive collapse of both towers short time.

Nevertheless, the structural steel desigr the buildings is ingenious and given nor usage would have lasted indefinitely, excluding such an outrageous terrorist attack. My contention remains, howeve that concrete buildings would have bee damaged by the impact, but would not have collapsed.

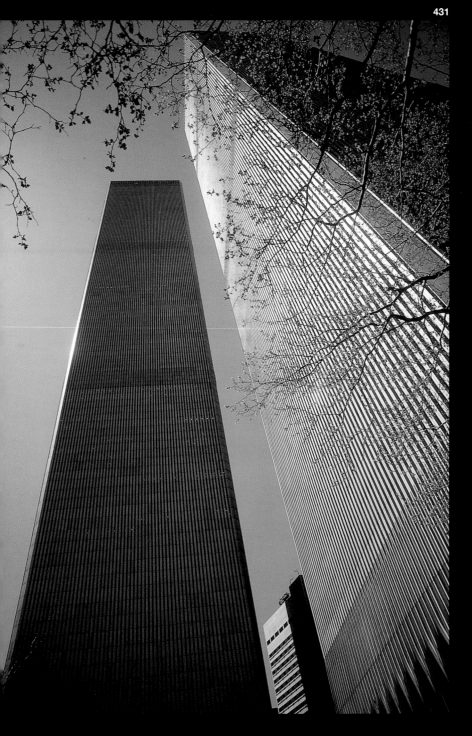

Canada

There are many fine 19th-century public buildings and modern city towers in Canada – mostly adhering to American prototypes – in the large cities of Toronto and Montreal. There is, however, a distinct historical French influence in eastern Canada, particularly in Quebec City. The only time I spent there was during World War II, without opportunities to take photographs since I was behind barbed wire as an 'enemy alien' internee. In recent years I did visit an outstanding building at the University of British Columbia in Vancouver.

1, 2 Vancouver, Museum of Anthropology, 1976
Architect: Arthur Erickson
Based on local timber tradition, the concrete structure consists of a post-and-beam vertical frame connected with glass wall and roof infills. The dramatic, naturally lit interiors of the museum house an unusually fine collection.

1

Mexico

Mexico has been the home of numerous
civilisations for over 3000 years. The Pre-
Hispanic peoples already had a highly
developed culture by the time they were
destroyed by the Spanish conquistadores
in only a few years. Christianity was
imposed on the population, and was
responsible for much fine 16th- and
17th-century architecture, especially stone
churches, palaces and public buildings in
the cities. Their modifications, Spanish in
origin, even surpass their European
prototypes, with highly decorated gilded
interiors and altars.

What I find to be the most remarkable and
memorable aspect of Mexican architecture
is the legacy of the ancient Mayan culture
around Oaxaca and on the Yucatan
peninsula, in such centres as Uxmal and
Chichén Itzá. The planning and compo-
sitions of the structures that remain seem
to generate a particular affinity with the
visual concerns of our own time.

The buildings and monuments have beau-
fully proportioned openings and simple
façades of minimal outline that are cove
in controlled areas only, with geometric
stone carvings. The steeply sloping
pyramids and their relationship to the low
rectangular structures continue these
compositions through their placement
within the site.

Mexico's modern architecture is different
from contemporary American or Europe
work. This is particularly evident in the w
of Luis Barragán and Ricardo Legorreta
whose large-scale and unadorned,
dramatically coloured wall surfaces seem
recall the country's ancient buildings.

...xmal, the Ruler's Palace,
...-900 AD
...stone-carved building is in the Mayan
...c style.

...itla
...-century Zapotec recessed stone-
...ed opposing patterns.

...ichén Itzá, Pyrámide de Kukulkan,
...AD
...fine stone building with its geometric
...uette is of Mayan religious significance,
...sacred vault spaces within.

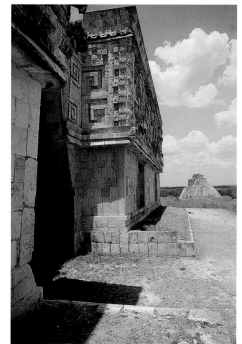

1

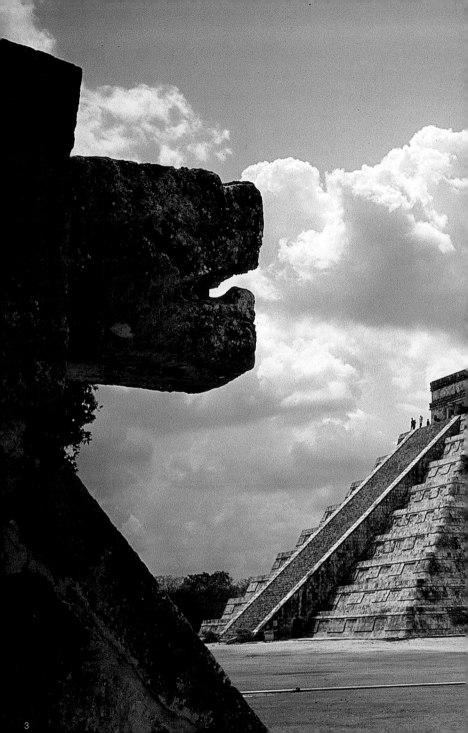

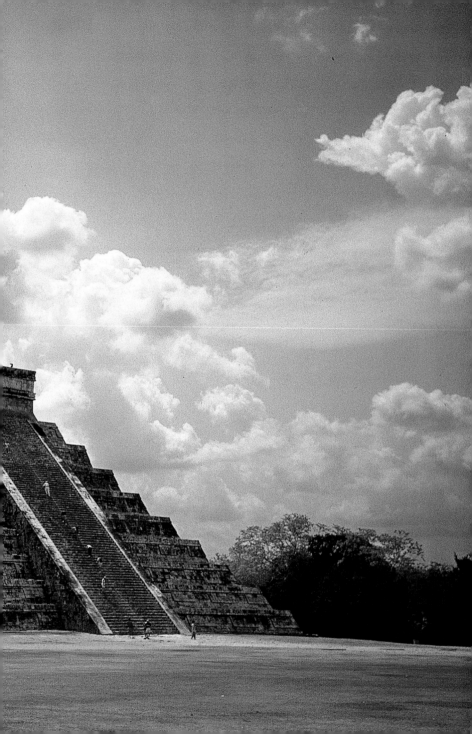

4

4–7 Chichén Itzá, 1000 AD
Surrounding stone buildings are seen fr[o]
the top of the pyramid: the long parallel
walls of a ball court with projecting ston[e]
"goal" rings, and the Temple of the
Warriors, with its group of a thousand
stone columns.

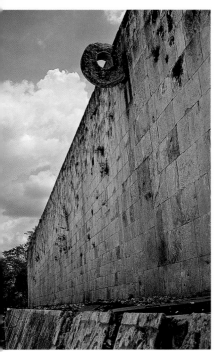

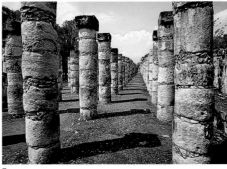

7

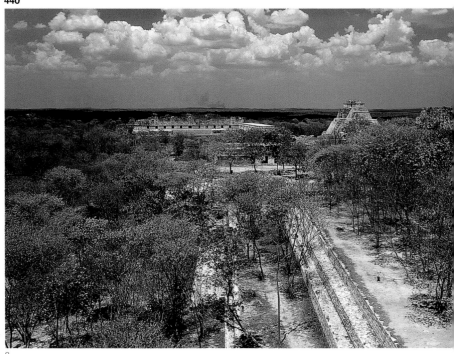

8

9

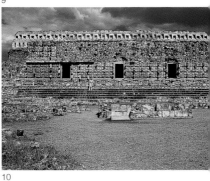

10

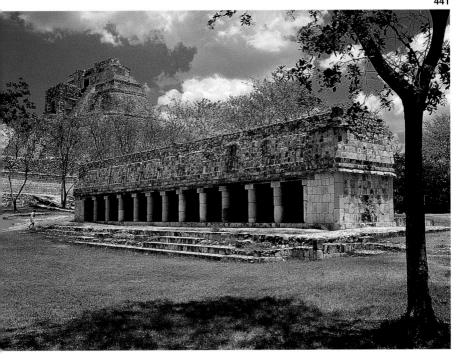

1 Uxmal, 600–900 AD

̤ well-preserved stone buildings are of
̩st impressive architectural design. The
̩ planning and disposition of the
̩ctures create admirable spaces and
̩as between them.

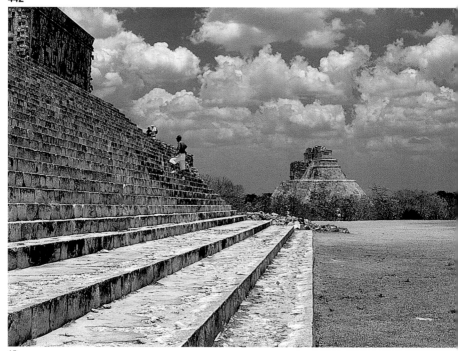

12

12–15 Uxmal, 600–900 AD

Grouped around a central pyramid are lo
structures arranged to form large open
courtyards between them. The placemen
of openings in the façades and particular
the design and proportions of the sculpte
stone surfaces are some of the most
memorable in Mexico.

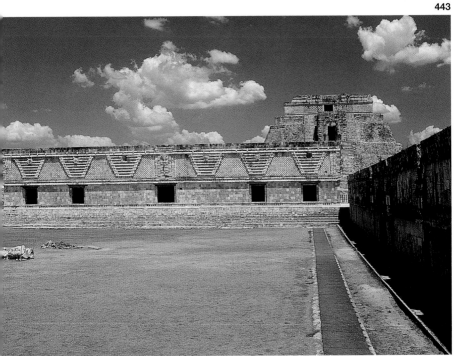

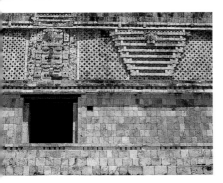

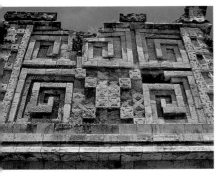

444

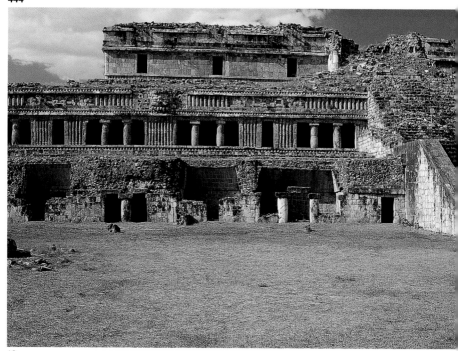

16

16–18 Sayil, El Palacio
This is only three-tiered Mayan building to
have three tiers. It has an 85 metre long
façade decorated with grouped columns
and sculpted friezes of masks. The Mayans
did not know arch construction, evidenced
by the collapse of the outer portion of the
steeply stepped stone ground-level
galleries.

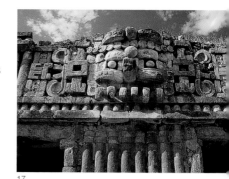

17

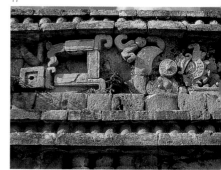

18

19 Dzibilchaltun

The 130 metre long palace entry steps
are still in fine condition over 1000 years
after they were built. The Danish architect,
Jørn Utzon, cites them as his inspiration for
the wide entrance stairs to the Sydney
Opera House.

20 Teotihuacan, 150–600 AD

The site of this ancient Aztec city lies
50 km north of Mexico City. It was once
the capital of Mexico's largest Pre-Hispanic
empire. The focal structures in this vast
linear development are two pyramids. The
largest is 70 metres high and is dedicated
to the sun, the smaller pyramid to the
moon. The surrounding stepped structures
were once colourfully painted.

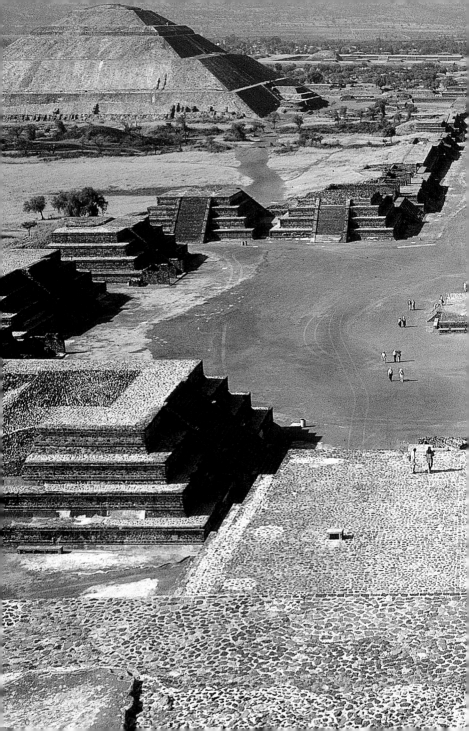

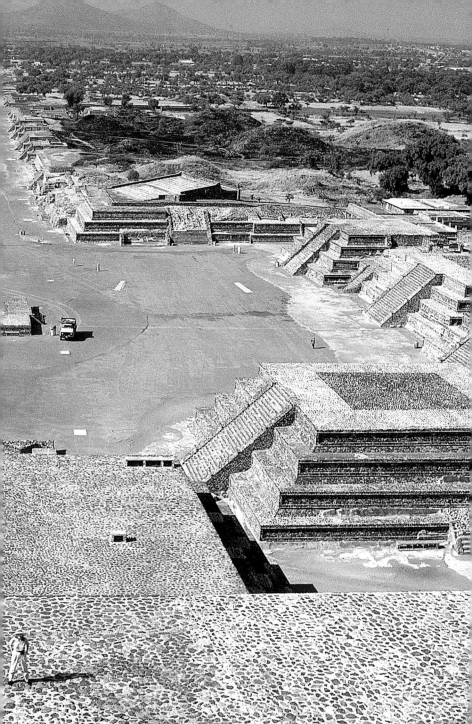

448

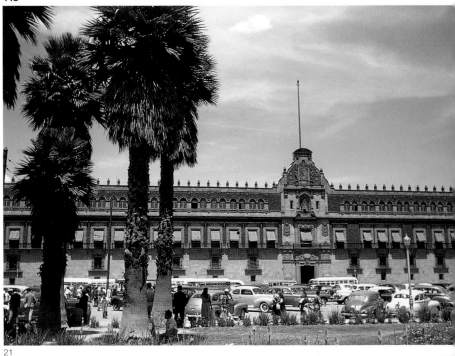

21

21 Mexico City, Palacio Nacional, 16th century

The long beautiful façade of this focal building, seat of the Mexican Government, takes up one side of the Zocalo. It contains dramatic murals by Diego Rivera (photo taken in 1948).

22 Mexico City, Metropolitan Cathedral, 16th century

The highly decorated and gilded recessed interior space of the altar is reminiscent of Spanish church architecture of the time.

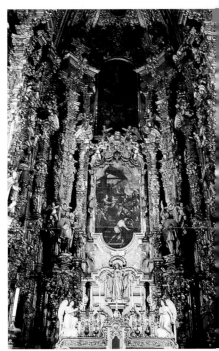

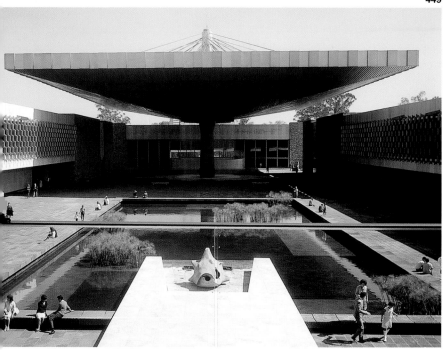

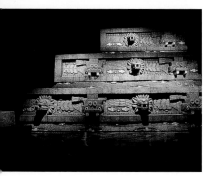

23–25 Mexico City, Anthropological Museum, 1964
Architect: Pedro Ramírez Vazquez
The large complex of exhibition wings creates an open plaza with a huge umbrella-like fountain supported by a single column. The excellent exhibits depict Mexico's history with models of ancient Aztec cities and carved façades.

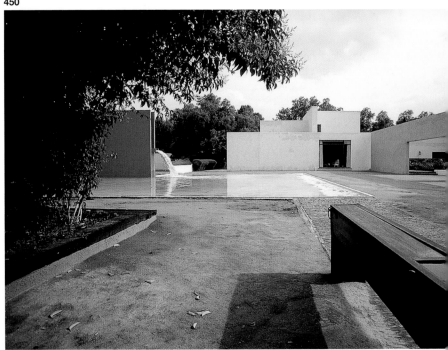

26

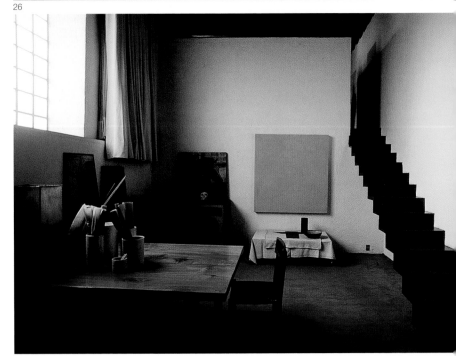

27

28 Mexico City, San Cristobal Stable
 House, 1968
hitect: Luis Barragán
 large complex of brilliantly coloured
 standing pavilions, house, stables
 screen walls creates a rich spatially
lptured totality. A pond and gushing
 ntain are in the exercise yard for the
 ners' thoroughbred horses.

Mexico City, Luis Barragán's house,
 7
 unassuming modest house, owned by
 architect, is full of surprises in its
 nplex interior spaces and their natural
 sources. The library's minimal
 nposition has an open timber staircase
 itioned between two opposing white
 s and leading to the upper floor.

Mexico City, Casa Gilardi Indoor
 mming Pool, 1978
hitect: Luis Barragán
 pool is composed of smooth and
ured wall andcolumn surfaces in blue,
 and white. The colours change
 the ripple of the water and create an
xpected translucence. To the user it
 st be like swimming through
ork of art.

Luis Barragán, 1902–1988

28

29

30

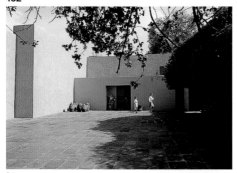

31

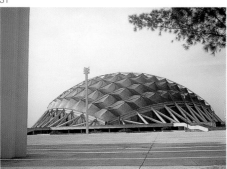

32

31 Mexico City, San Angel Casa Prieto Lopez, 1950
Architect: Luis Barragán
This house has a typical Mexican entrance courtyard surrounded by brightly coloured walls. The inside spaces interact beautifully with large single pane windows opening onto tranquil gardens.

32 Mexico City, Olympic Sports Palace, 1958
Engineer: Felix Candela
The ingenious space frame structure expresses its triangulated protruding elements, which results in a uniquely sculptural exterior.

33 Mexico City, Centro National de las Artes, 1994
Architect: Ricardo Legorreta
The staircase leading to the buildings inf the centre is typical of Mexican modern architecture, which uses brilliantly coloured walls.

Peru

The most truly outstanding and memora
site in Peru is Machu Picchu, the "Lost C
of the Incas", which the marauding Span
Conquistadores never discovered. Locate
some 2400 metres high up in the Andes
straddles a mountainside in a spectacula
setting.

It was inhabited from the 14th to the 16
centuries by a particularly constructive
Pre-Hispanic Andean society that left mu
evidence of their aesthetic creativity.

Machu Picchu was home to some 1,000
to 2,000 people, who created an amazin
environment of a city meticulously planne
and built to incorporate housing and agri
cultural terraces. Open public spaces an
long flights of stairs connect different
districts.

Culminating in the high-up "Temple of th
Sun" the entirety is like an enormous scu
ture consisting of man-made and natural
elements in particularly sympathetic
relationship.

The capital city of the area, Cuzco, bears
evidence of its Inca origins in its stone
ruins alongside its Spanish colonial
architecture.

On the outskirts of the town are the
remains of a fort, built of cut-stone block
fitted together so perfectly that no morta
was required. The interlocking irregular
shapes of the enormous blocks preserve
the walls for centuries, even though the
area is subject to frequent earthquakes.

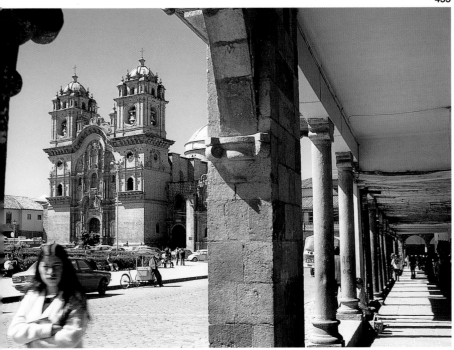

Cuzco, Cathedral
e focal point of the city's central square
a fine piece of 16th-century Spanish
roque architecture, with its elaborate
re gold interior decorations.

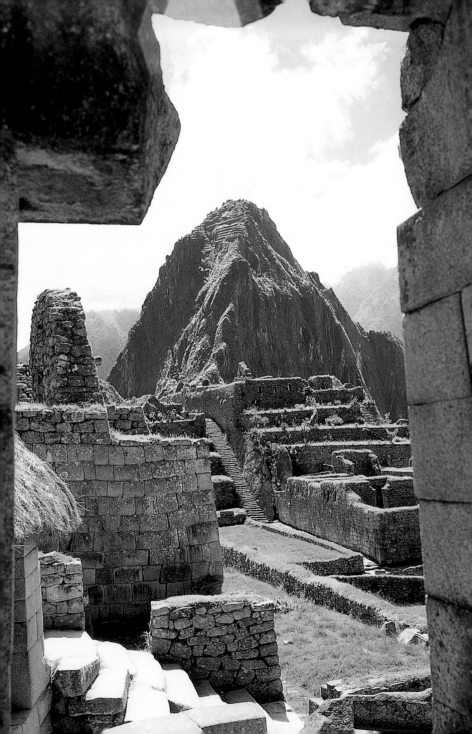

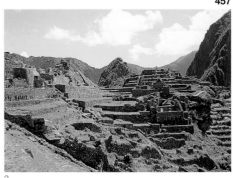

3

4

2–4 Machu Picchu
The Inca city high up in the Andes Mountains, with houses and agricultural terraces ingeniously connected by long flights of stone steps.

5 Cuzco
Inca fortification walls of tightly fitted blocks of stone, which have resisted earthquakes due to their interlocking shapes.

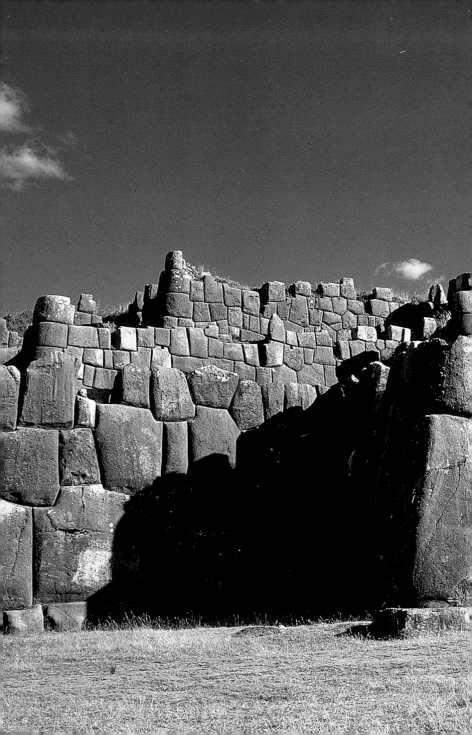

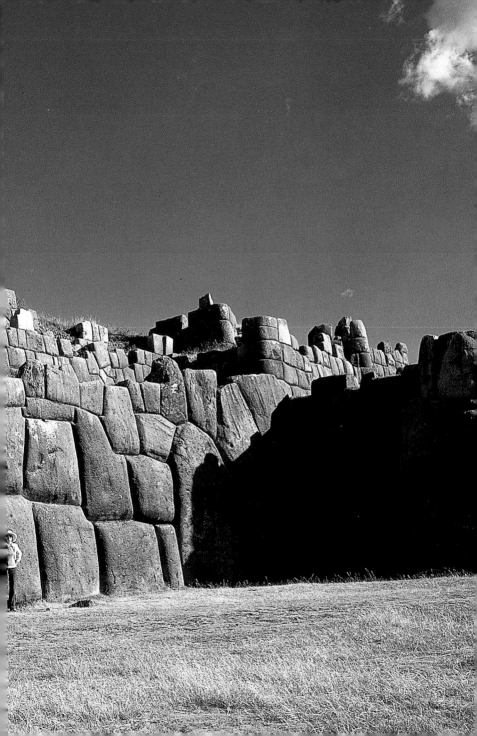

Argentina

Argentina is symbolised by its capital, Buenos Aires, which is rightly referred to as the "Paris of South America", a city that has a strong European feeling in its architecture and planning. In the early yea of the 20th century the wealth of the country was evidenced by the extravagar public buildings and squares, its opera house and the extraordinary high-rise apartment towers that line the big avenue and betray a definite Latin influence in the architecture, combining classical stylism with uniquely exuberant cornices and domed tops.

The huge scale of the city is made particularly apparent by Avenue 9 de Juli said to be the widest street in the world, with its centrally placed obelisk and eight traffic lanes on each side.

In total contrast to the monumental struc tures of the city, the La Boca area on the waterfront has small tin-clad houses painted in all colours of the rainbow. In the nearby town of La Plata, Le Corbusie designed a house and office for a doctor overlooking a park. Supported by a grid circular pilotis, the surgery facing the stre and the house at the rear are connected by ramps that cut through between the two separate structures, generating fascinating outdoor/indoor spatial effects

1 Buenos Aires, Plaza de Mayo
The large civic square of the city, used fc public celebrations and demonstrations, lined with important buildings, including t impressive Casa Rosada, the President's Palace.

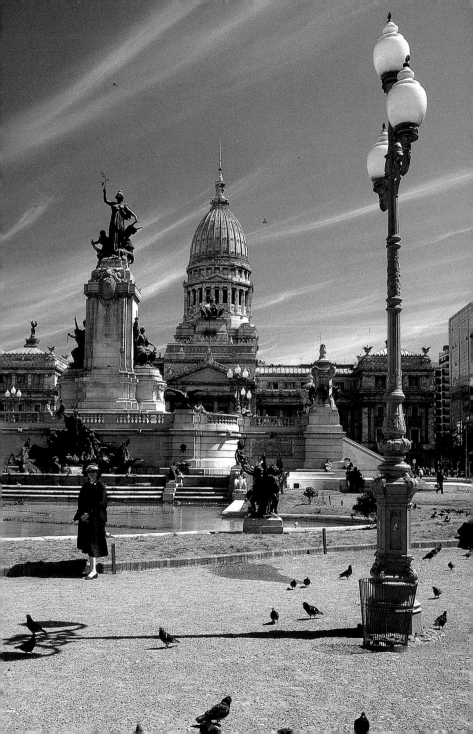

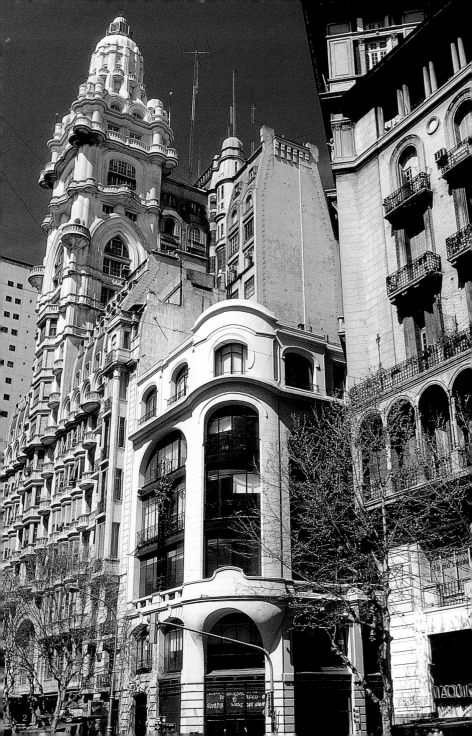

3

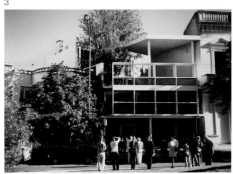

4

2 Buenos Aires
The typical elaborately decorated high-rise apartment towers, built at a time when Argentina was one of the wealthiest countries in the world.

3 Buenos Aires, La Boca
The colourful district of tin-clad buildings near the waterfront.

4 Le Plata, Dr Currutchet House, 1949
Architect: Le Corbusier
Le Corbusier's only building in Argentina. The separate wings of surgery and house are intertwined with intriguing spatial effects.

Brazil

The influence of Portuguese architecture was paramount during Brazil's colonial (16th–19th centuries). Historically protec cities such as Ouro Preto are rich in fine 17th-century baroque churches. Althoug these are mostly well protected and wor visiting, the architectural focus of Brazil i its modern architecture. This is what I wa determined to experience during my sta there in 1948. I spent three months working with Oscar Niemeyer, and the dramatic developments of his architecture had a lasting affect on me. A that time, soon after World War II, there was virtually no comparable modern architecture in the USA, and buildings su as the new Ministry of Education in Rio were overwhelmingly convincing as the appropriate architecture for our time. Gropius, in his writings, referred to Nieme rather disparagingly as the Paradiesvogel (Bird of Paradise) of architecture. His completed buildings have a certain flamboyance and curvilinearity in common which recall the qualities of Brazil's coloni baroque period. Undoubtedly influenced Le Corbusier (who visited Brazil in the 1930s) in the essentials of planning and structure, Niemeyer's work has a disarm directness and clarity of concept that is raised to the level of a unique art form. H appointment as the designer of a new capital city of Brazil led to an unsurpasse large-scale planning solution (in collaboration with Lucio Costa) and grou ings of buildings without equal. As an example, there is no need for traffic light nor were any planned for, in this city whe the ingenious road system makes these redundant.

One of his latest works (at over 90!) is th Museum in Niteroi. This daring concept a structure is beyond belief or description. After a visit one feels confident that there hope for our time: that modern architect will develop into an art form that can tak its place alongside the finest buildings m has ever produced in the past.

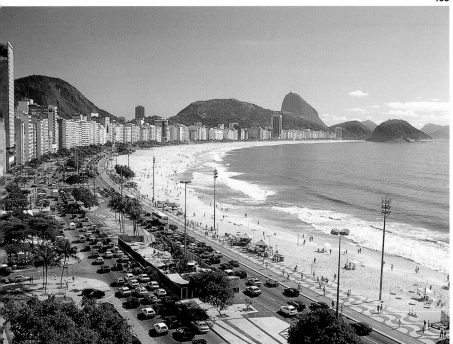

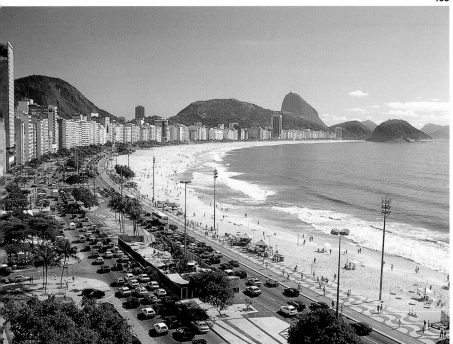

Rio de Janeiro, Copacabana
is part of one of the most beautiful
es in the world. Copacabana is the
st known of several beachfronts, with its
at sweep of sandy shoreline edged by
arallel row of tall buildings. Steep, bare
nite mountains such as the "Sugarloaf",
n the dramatic background.

Drawing by Oscar Niemeyer,
aracteristic of his flamboyant curvilinear
hitecture.

**5 Rio de Janeiro, Ministry of
Education, 1941**

*Architects: Le Corbusier, Oscar Niemeyer
and others*

This pioneering structure demonstrates the effective use of adjustable horizontal louvre sun protection on its fully glazed northern façade. The 10 m high open ground-level portico is adorned with an azulejos mural by Portinari.

Oscar Niemeyer, 1907–2012

4

5

6

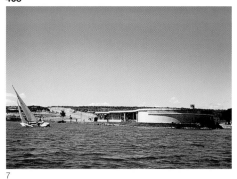

7

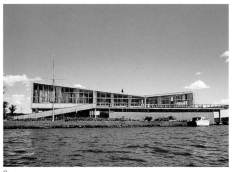

8

7–10 Pampulha, Mina Gerais, Recreational buildings and a church built around a lake, 1943

Architect: Oscar Niemeyer
Near Bello Horizonte, the capital of the State of Minas Gerais, a restaurant, yacht club, a church (with a tile mural by Portinari) and a casino were built on the shore of an artificial lake. They represent a display of mature modern Brazilian architecture by Niemeyer.

11 Brasilia, the new capital, 1957–60

Architect: Oscar Niemeyer
This focal point of Brazil's new capital places the two National Congress chambers on a platform. Their opposing convex and concave circular forms, with dual administrative towers between them, have produced the iconic silhouette of the city.

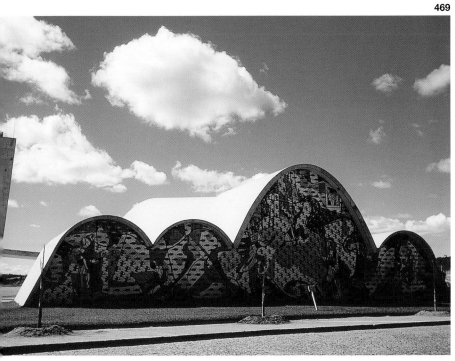

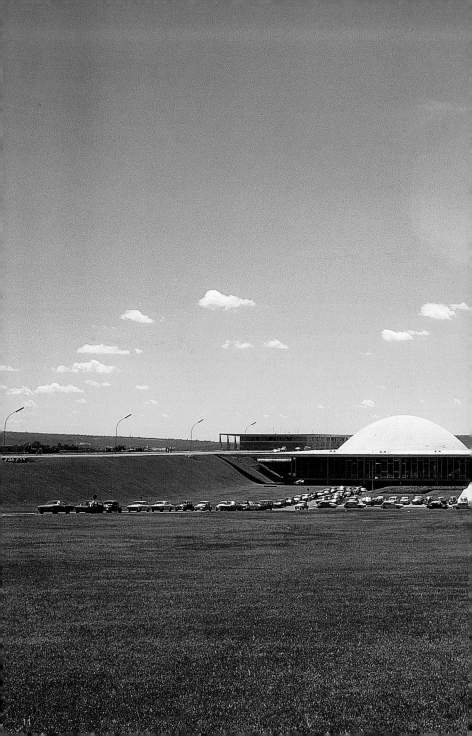

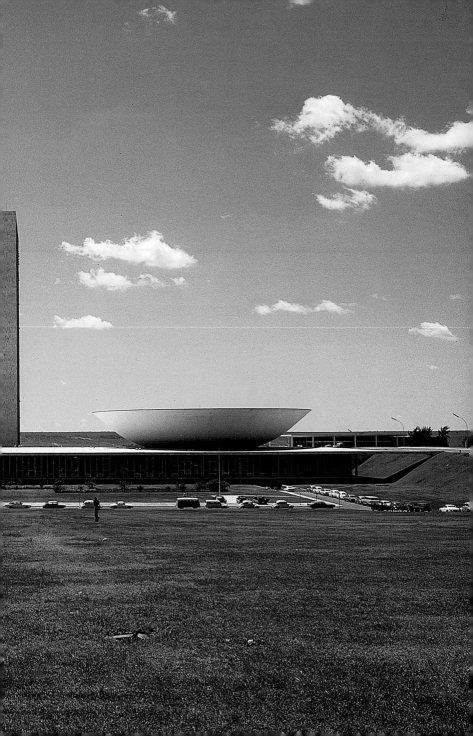

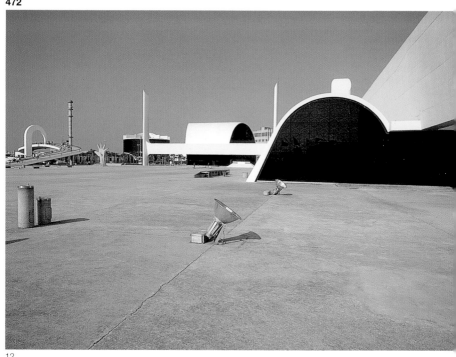

12

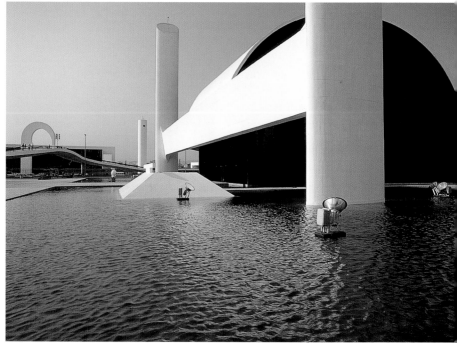

13

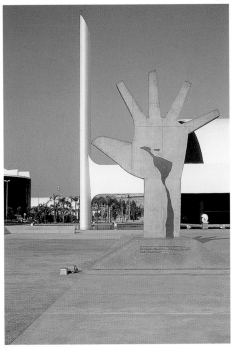

14

12–14 São Paulo, Memorial of the Latin American States, 1990

Architect: Oscar Niemeyer

The large urban site contains an assembly plaza with a symbolically bleeding open-hand sculpture by Niemeyer. Crisp white freestanding buildings surround the space. Their long-span concrete structures create an interactive sculptural totality.

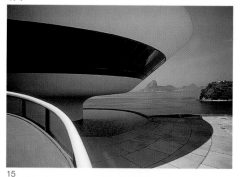

15

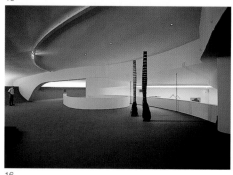

16

15–18 Niteroi, Contemporary Art Museum, 1996

Architect: Oscar Niemeyer

Built on a peninsula reaching into Rio's harbour, the form and structure of this incredible building borders on the unbelievable. Pre-stressed radial interior ribs emanate from its central supporting hollow ring column. The upward sweep of the mushroom-shaped glazed exterior wall runs parallel to the Sugarloaf mountain in the distance.

19 São Paulo, Copan Building, 1951

Architect: Oscar Niemeyer

This co-operative apartment building takes on a wave-shaped form to fit onto the irregular inner-city site. Two continuous horizontal louvres to each floor act as effective sun protection and afford privacy to the inhabitants.

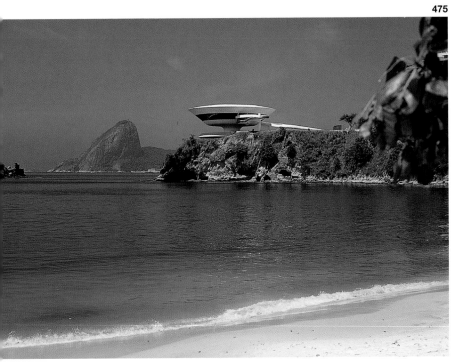

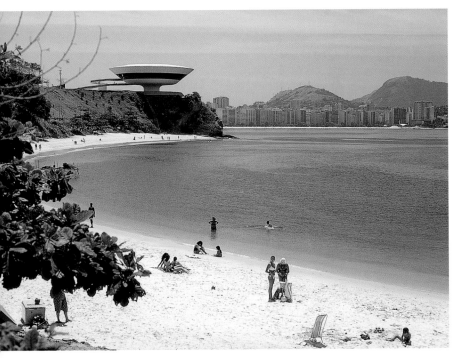

Japan

The architecture of Japan was influence historically by Chinese building practice, although many differences developed. Japan's humid and warm summer clima as well as its frequent earthquakes requ lightweight timber buildings raised off the ground and therefore resistant to earth tremors.

The visual simplicity of important palace structures has had an influence on West architecture in the 20th century. Elegant refinement and austere minimalist open interconnected spaces have influenced modern architecture in much of the worl exemplified by the work of Mies van der Rohe. Some of Frank Lloyd Wright's wo has been influenced by Japan, and con- versely his multi-level entrance spaces ir the Imperial Hotel in Tokyo have had an effect on modern Japanese architecture Some parts of the lobby space have bee reconstructed elsewhere in Japan after the Hotel's demolition in 1960.

After World War II, great strides were ma in modern Japanese architecture, not only through advancing technology, allowing the construction of tall, earth- quake-resistant buildings, but also by the re-introducion of the expressive characteristics of traditional Japanese architecture, which were infused into modern buildings. The restrained formal geometries of Japanese interiors are melded into landscape and garden architecture, resulting in a particularly refined fusion. A romantically peaceful serenity results.

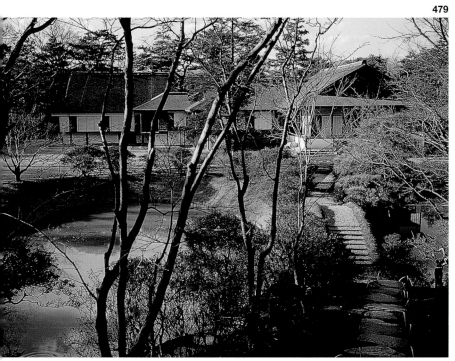

Kyoto, Katsura Palace, 1620-62
Architect: Kobori Enshu

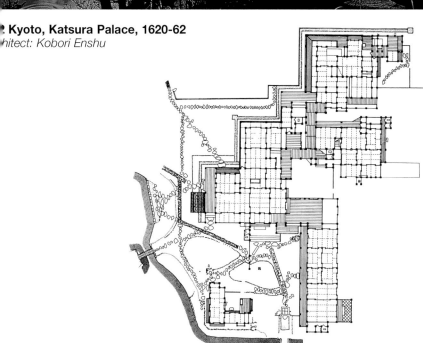

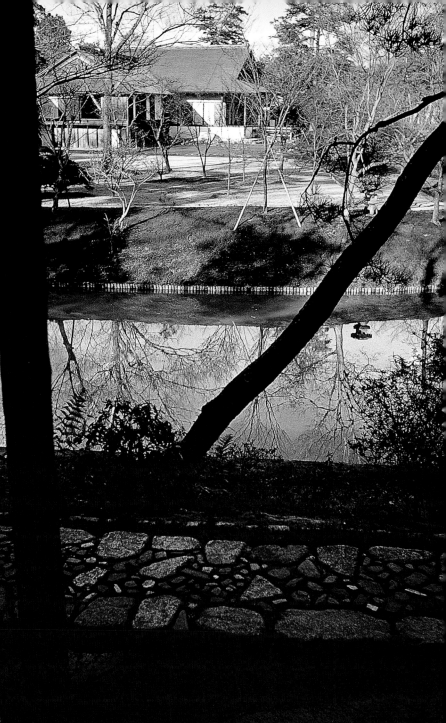

4

5

3–5 Kyoto, Katsura Palace, 1663
Architect: Kobori Enshu

This masterpiece of serene simplicity is set in harmony with a picturesque landscape environment. The restrained minimalism of the timber building consists only of supporting columns and an open-planned interior that can be subdivided, opened or closed to the outside with sliding panels, serving diverse uses.

The garden surroundings are contrived to idealise nature, bringing water, stepping stones, paths and plants into a romantic scene of perfection.

The unornamented interiors are devoid of Western furniture, with a bare geometric order created by the use of multiple tatami rice-straw floor mats.

6

7

6, 7 Kyoto, Shishinden Imperial Palace, rebuilt 1855

The dominant concave roof covers a structure of equally spaced columns. Although the building is centuries old, it is repaired and rebuilt periodically, as is evident in the façade of adjacent old and new timber columns.

8 Kyoto, the Golden Pavilion, 1397, rebuilt 1950s

The gilded shrine is built in a park surrounded by water. It exudes an atmosphere of untouchable perfection.

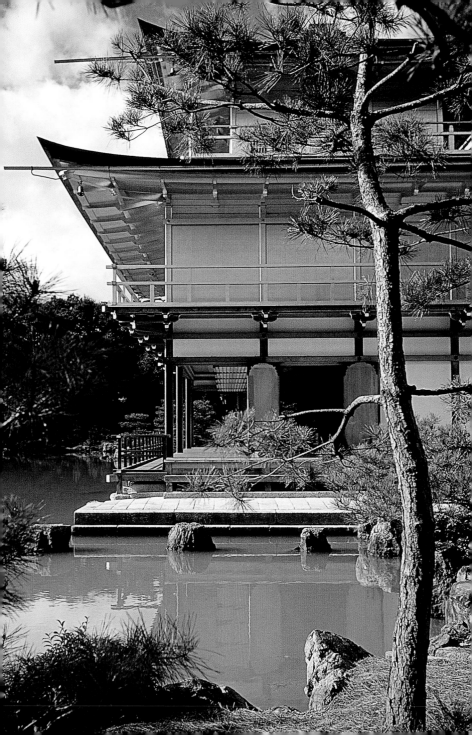

484

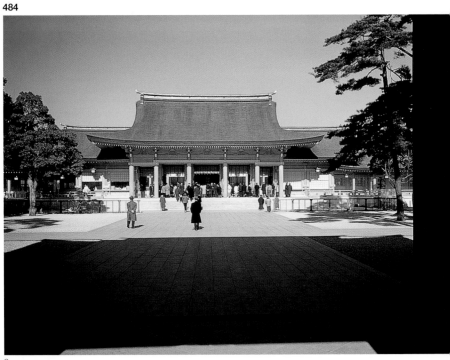

9

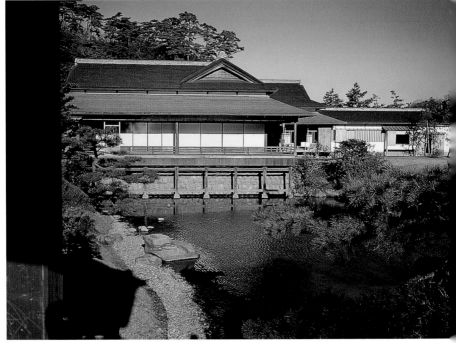

10

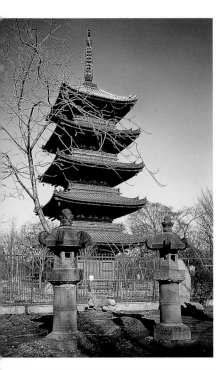

9 Kyoto, Heian Shrine, 1882
The large overhanging roof and widely spaced columns mark the entrance to a series of courtyards within.

10, 12 Yokohama, Imperial Villa, straddling a stream.
The weathered-timber old garden court entrance gate.

11 Kyoto
A typical pagoda, a religious structure, was built following historic Chinese architectural practice.

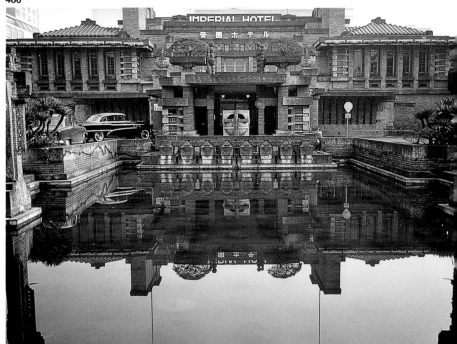

13

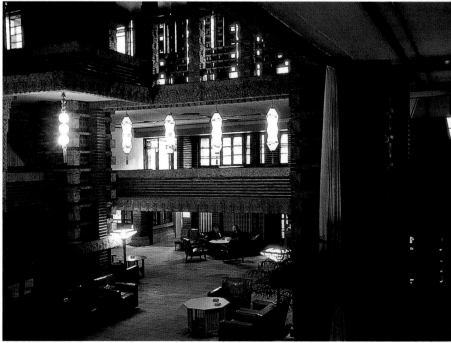

14

15

**13–15 Tokyo, the Imperial Hotel,
1916–22 (demolished 1967)**
Architect: Frank Lloyd Wright
Penelope and I stayed in the hotel just
before its demolition. All interiors and
furniture, designed by Wright, were still
intact. The entrance hall was the most
remarkable space in the huge complex.
It had seven different levels, interacting
spatially and all merging into the entrance
foyer.
Built of brick and carved lava stone, the
structure was supported on an ingenious
system of driven piles, which saved the
building in the disastrous 1923 earthquake.

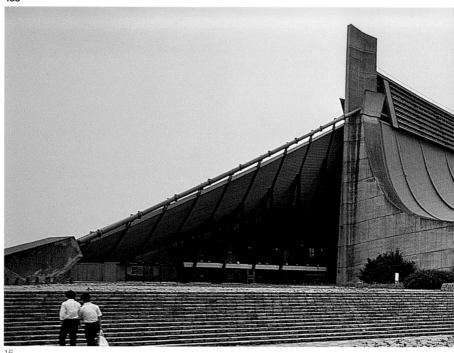

16

16–18 Tokyo, Olympic Pool, 1964
Architect: Kenzo Tange
A unique structure of only two concrete
supports, with a pre-stressed steel net
covering the concave roof.

17

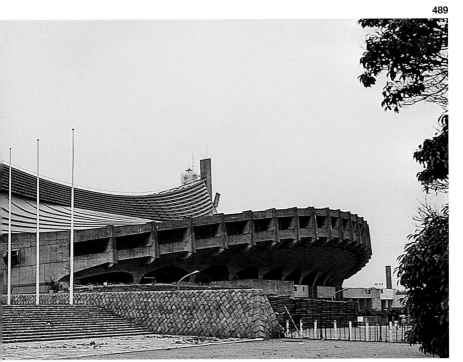

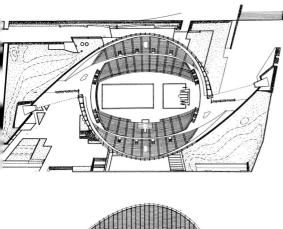

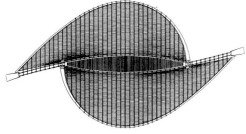

19

19, 20 Takamatsu, Kagawa Prefecture, 1955–58

Architect: Kenzo Tange

Solidly built of exposed textured concrete, this modern office building recalls traditional Japanese ponds with sculptural stone blocks.

The projecting concrete floor beams are reminiscent of early timber structures.

China

This ancient land enjoys a long history a
great achievements, including many
architectural miracles such as the Great
Wall, built to protect the northern border
from the predatory mountain people of t
Steppes. The 6000 km long structure
contains guard towers and garrison tow
It is said to be the only man-made struc
that is visible from the moon.
"The Forbidden City" contains the most
impressive series of monumental structu
that are interspersed with large courtyar
connected by white marble stairs. The
entrance court is traversed by a wave-
shaped watercourse that creates a uniq
atmosphere in this vast open space.

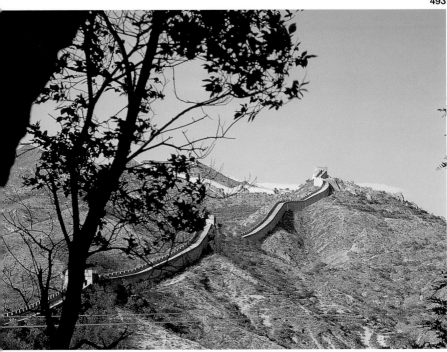

Beijing, Great Wall of China

cessive emperors ordered the wall to
:onstructed to protect the country from
hern incursions. The wall was started
veen the 7th and the 5th centuries BC,
was continuously strengthened over
years to become 7m high and wide,
: on an internal earth core, faced with
< exteriors on a stone base. The huge
, some 6000 km long, winds up and
/n across the mountainous landscape.
;cale is unparalleled in the architecture
ortifications.

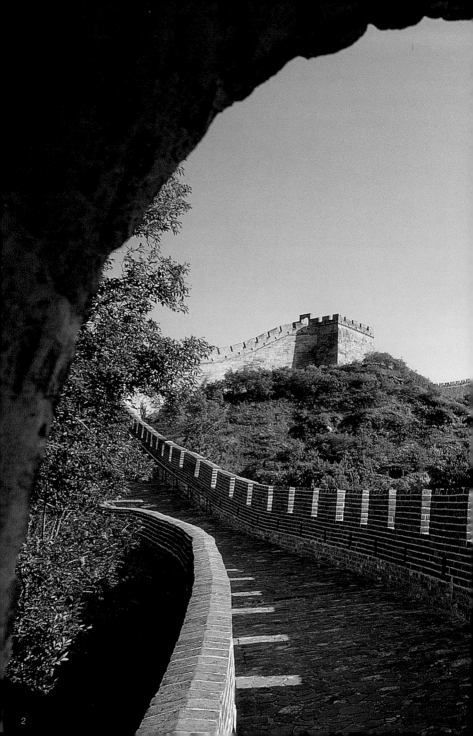

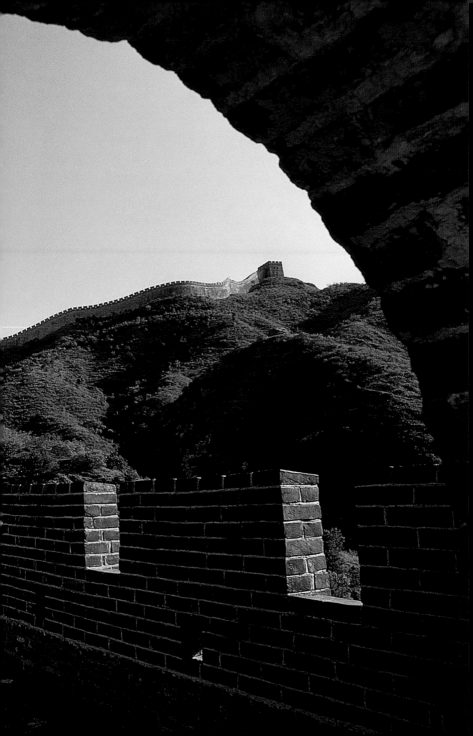

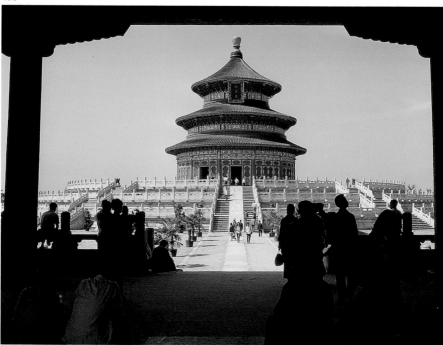

3

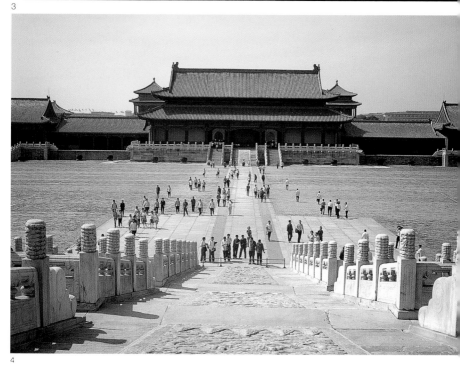

4

5

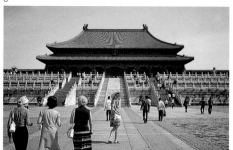

6

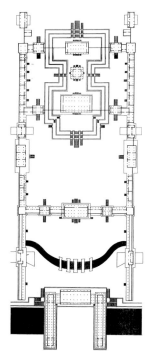

Beijing, The Forbidden City,
3–20

Imperial Palace housed the emperors
n the 14th until the early 20th century,
consists of a virtual city, with halls,
ilions and towers covering a walled
npound of some 720,000 square
res, which takes more than half an hour
raverse. Buildings face a series of large
rtyards interrupted by temple structures,
s of residence and religious shrines.
my second visit, in 1977, new snow fell
ight and offered a unique view of the
large court snow-covered. It is the only
ce containing a curvilinear watercourse
stone foot bridges.

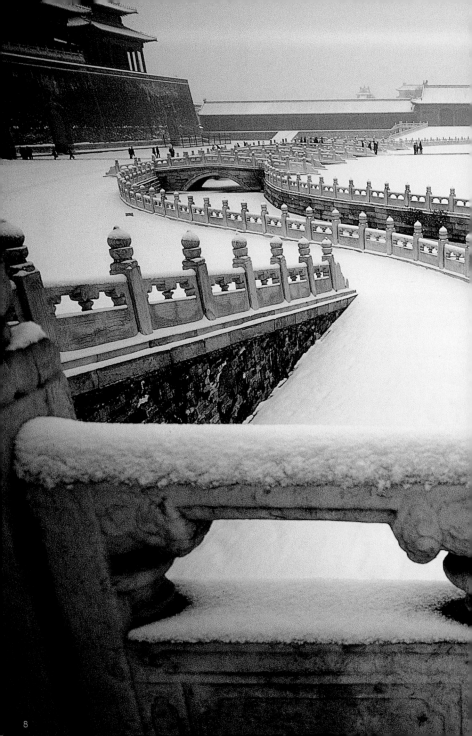

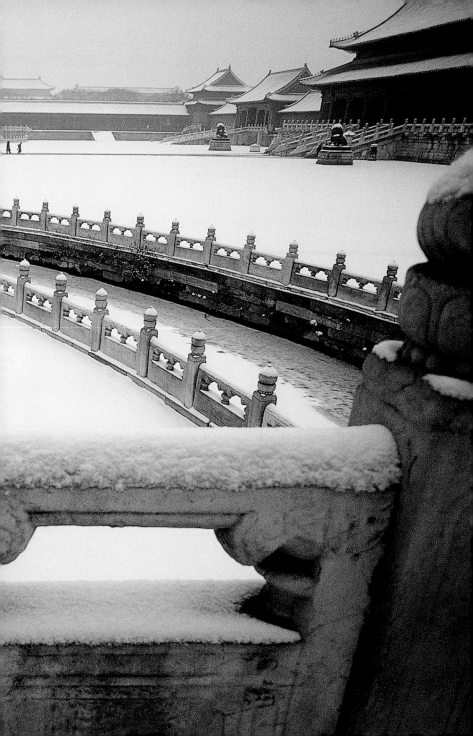

9

9 Hong Kong, Bank of China Tower, 1982–90
Architect: Ieoh Ming Pei
A landmark of the city, this building has a triangulated exposed steel frame that displays the three-dimensional form of the structure.

10, 11 Beijing, Temple of Heaven
The colourfully carved timber ceiling structure of the circular Temple of Heaven shrine.

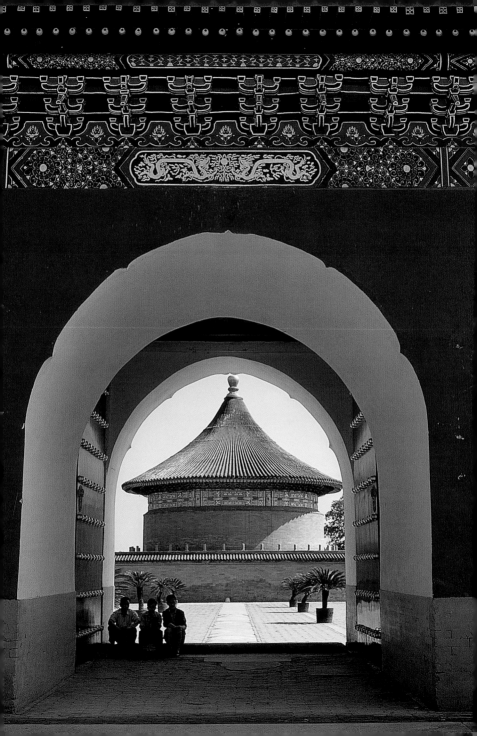

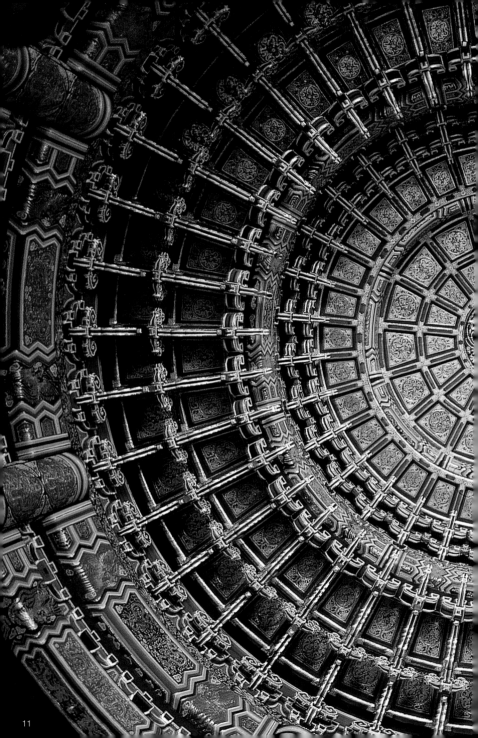

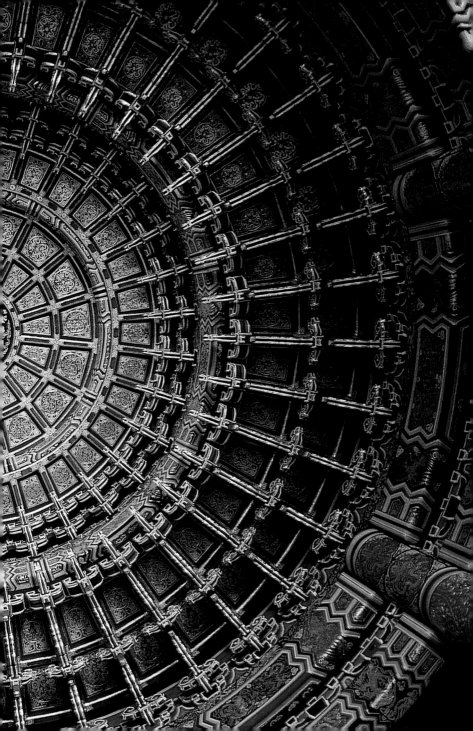

Java, the central island of Indonesia, is the
most architecturally fascinating and popu-
lous in the republic, with over 200 million
inhabitants. It contains the finest remaining
Hindu and Buddhist temple architecture c
the 7th to 10th centuries.
Of the world's active volcanoes, 34% are
Indonesia. In the central area, where once
stood 240 temples, most have collapsed.
The reconstruction of them has been in
progress since the 1930s.

1 Java, Parambanan

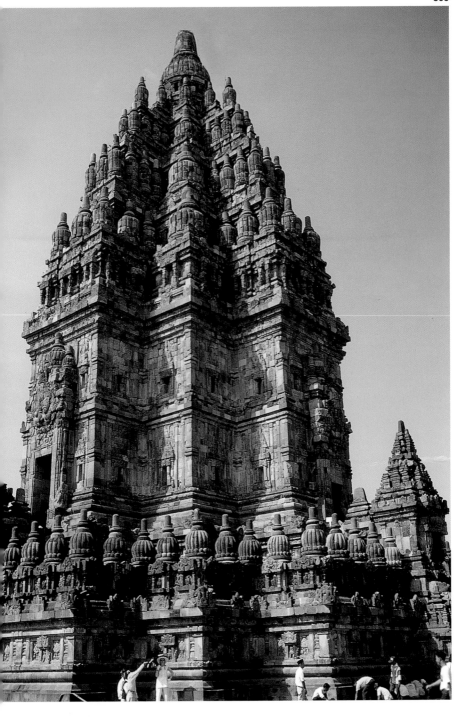

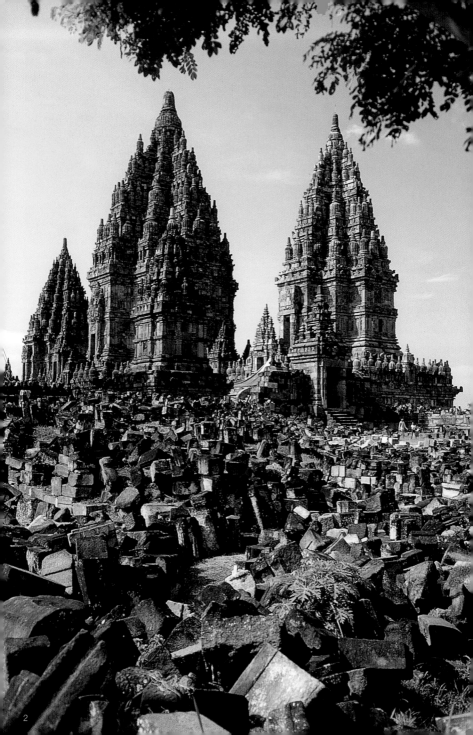

Java, Parambanan

progress of restoring and rebuilding
temples in central Java is a slow task
has lasted for decades and is still
tinuing. The blocks of dark volcanic
e have been collected and assembled,
a number of temples now completed.
y are solid, tall structures, covered
he outside with elaborate decorative
ings and figures reconstructed using
scattered stone blocks. If one stands
e open landscape, the visual impact
ese monolithic tower structures is very
erful.

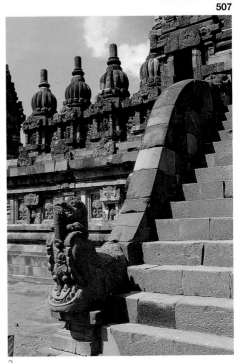

3

4

5–8 Java, Borobudur

The most memorable of temples is the terraced, solid-stone square pyramid, w statues, relief carvings and stupas rising continuously along winding terraces and steep steps to the 34 m high roof. The tallest inverted, an 8 m high stupa, form the top and is ringed with smaller perforated, inverted bell-like enclosures, each with a sculpture of a sitting Buddha displaying a different gesture contained within.

5

6

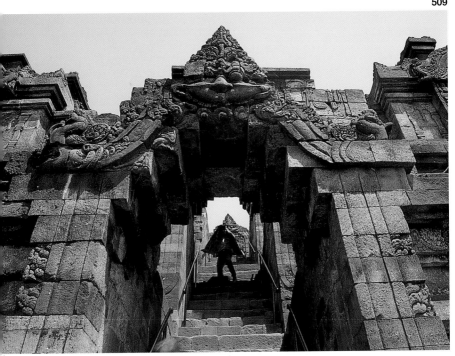

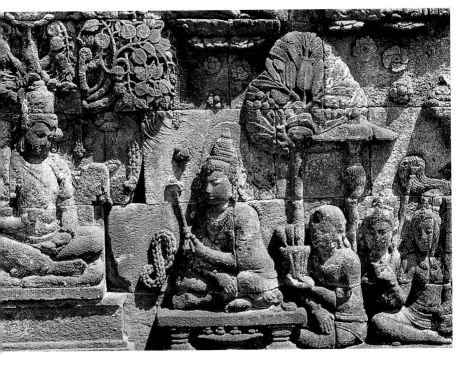

India

The enduring achievements of Indian civilisation lie in its architecture. Constructed during the rule of various dominant cultures – Persian, Indian and Mughal – architectural styles merge in buildings of great refinement. These were often erected centuries apart, for example the palaces, temples, forts, tombs, astrological observation structures and expansive town planning schemes. The most memorable of these were built during the powerful Mughal Empire in the 16th century, mainly located in Rajasthan, in Delhi and Agra.

The British influence in the 19th century produced grandiose government buildings. Mumbai (Bombay) remains today the preeminent Victorian gothic city of the world. New Delhi was created as India's capital city by Lutyens in 1912 and was built in hybrid of European and Indian architecture modes.

In the early 1950s Le Corbusier was invited to undertake the planning and building of huge new city, Chandigarh, in the Punjab which had lost its capital, Lahore, during partition.

This immense undertaking can be compared to Brazil's new capital Brasilia, both successful, totally planned, new cities of 20th century and both created by two of the era's greatest architects.

1 Agra Fort, Khass Mahal, 1565
This white marble pavilion housed the private apartments of the Emperor.

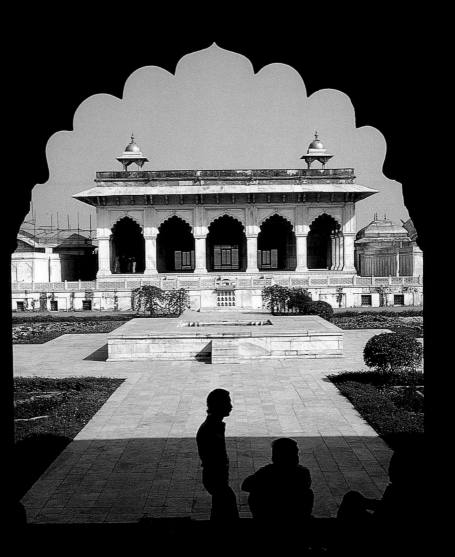

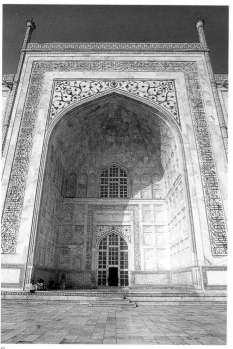

2

3

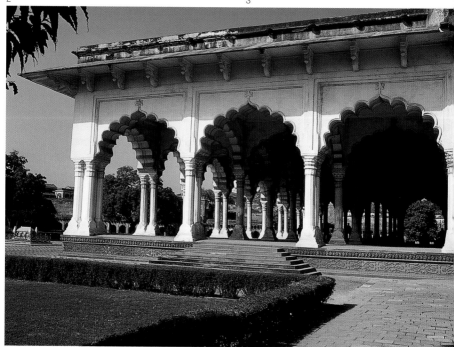

gra, Taj Mahal

detailed entrance displays dark stone
d surfaces within its white marble
rior.

Agra Fort

ved marble surrounds the pool, and
loped arches support the pavilion.

gra Fort

v from Agra Fort towards the Taj Mahal
ιe distance.

gra, Taj Mahal, 1631–57

ιitect: Isa Khan

mausoleum was constructed by
ɔeror Shah Jahan in memory of his wife.
world-famous white marble and now
ɨc building has a graceful composition,
its arrangement of a central dome,
ɜrs and pointed arches, all raised on a
ɨum and focused on an axial reflecting
ɜrcourse.

gra, Itimad Ud Daulah
ɜ Small Taj), 1622–28

is the first white marble temple built
inlaid precious stones, foreshadowing
Taj Mahal. The building uses beautiful
ɿmetric proportions and perforated stone
ɜ exteriors.

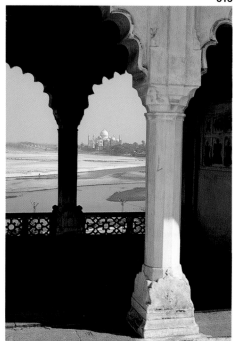

5

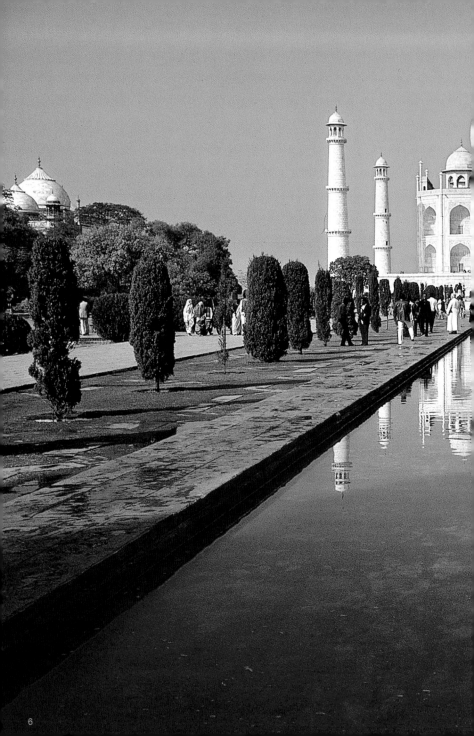

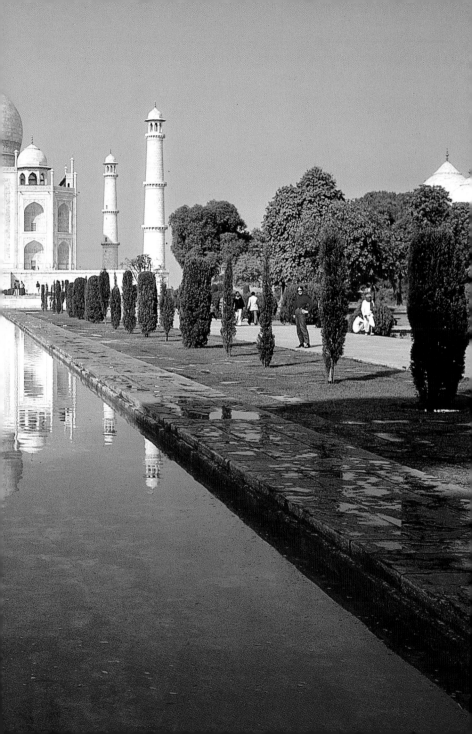

8

9

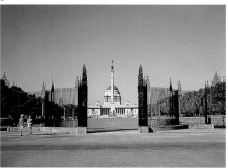

10

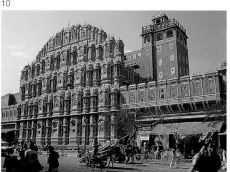

11

8–10 New Delhi, Parliamentary Compound, 1912–30

Architects: Lutyens and Baker

A grand axial boulevard focuses on the domed Vice Regal Palace's formal gate, leading to the sumptuous multi-winged establishment.

Flanking both sides of the approach are government offices that have characteristic Indian Chattri pavilion projections with parasol-shaped domed roofs.

The circular Parliament House, designed Baker in 1930, is surrounded by a recess colonnade above a solid stone base.

The atmosphere of this central government area is a grandiose imperial gesture, the final stage of the British Empire's rule in India.

11, 12 Jaipur, Hawa Mahal (Palace of the Winds), 1799

Architect: Maharaja Pratap Singh II

Jaipur's landmark is only a façade, through which the city's main street can be over-looked via projecting honeycombed sand stone bays and Chattri half-domed roofs.

13 Jaipur, Jantar Mantar (or Observatory), 1728

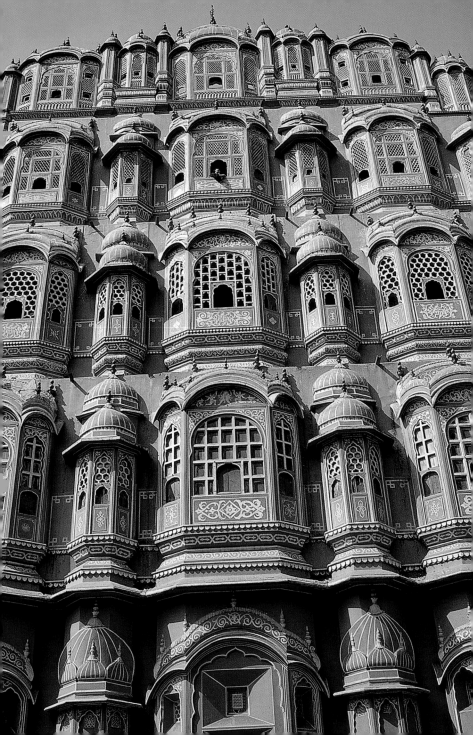

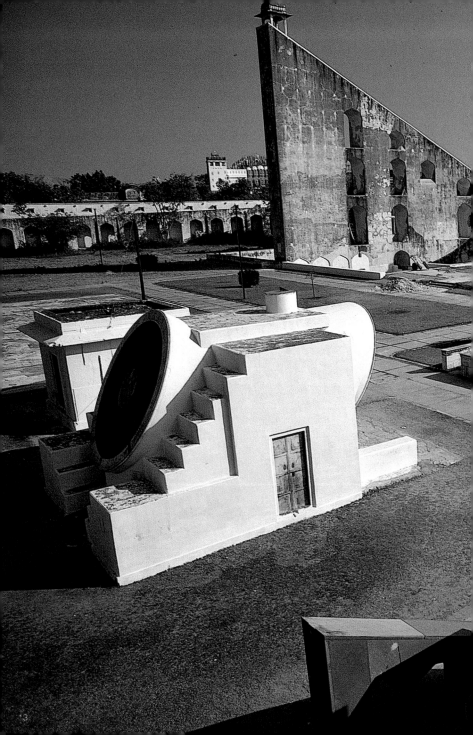

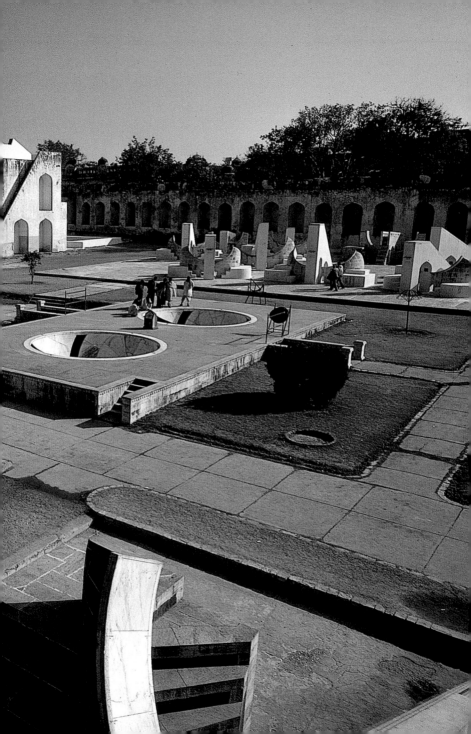

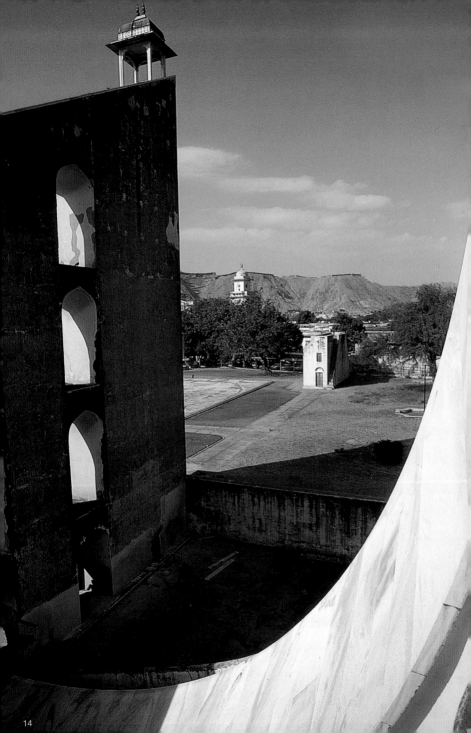

14

-16 Jaipur, Jantar Mantar Observatory), 1728

ntar Mantar is the manifestation of the
out Jai Singh's passion for astronomy.
vering a large open area are sculpture-
structures from which positions of
rs, altitudes and azimuths can be
served and eclipses calculated.

18 Jaipur, City Palace, 18th century

cated in the heart of the old city, a
ies of arched entries lead to courtyards,
dens and inner buildings, all with typical
erhanging thin-edged cornices and
forated stone screen façade infills.

15

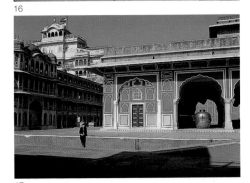

16

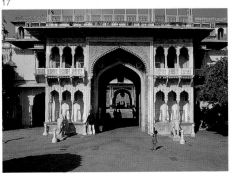

17

18

524

19

20

19–21 Udaipur, Lake Palace,
by Maharana Jagat Singh II, 1754

Located in the centre of Udaipur and built
on an island in the lake, this formal royal
palace must be the most romantic, superbly
crafted and extravagant creation anywhere.
Surrounded by stone arched pavilions facing
the water, its central courtyards are filled
with lotus ponds and swimming pools. The
palace is now used as a luxury hotel.

22

22–30 Fatehpur Sikri, 1571–85

Capital of the Mughal Empire. This is among the finest cities built by edict of an Indian emperor (Akbar) in the 16th century. The interlocking layout of various-sized open spaces and watercourses, ringed and punctuated by freestanding and skilfully positioned structures, all provide constantly changing vistas as one strides through this amazing city. Built of durable red sandstone (with some opposing white marble pavilions), perforated screens and fine workmanship, this city is still something of a mystery: why was it deserted so soon after its completion? The only explanation offered is its problem with water supply for its population.

This cohesive complex creates a beautiful totality without equal.

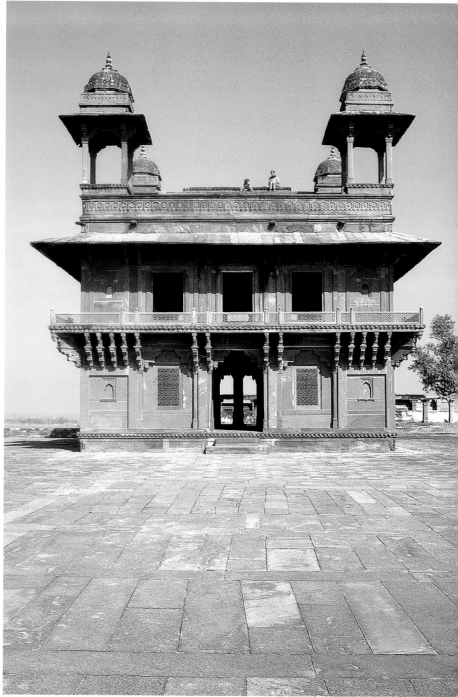

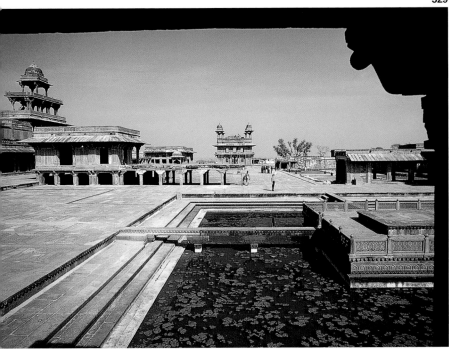

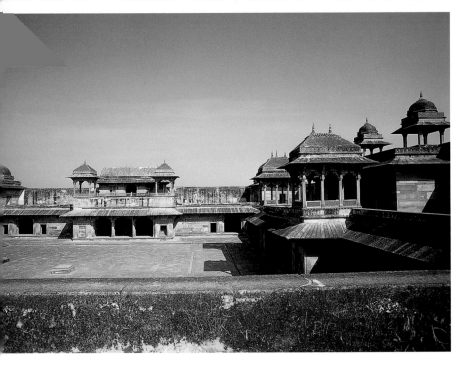

27

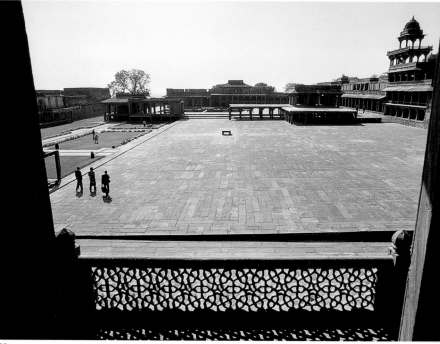

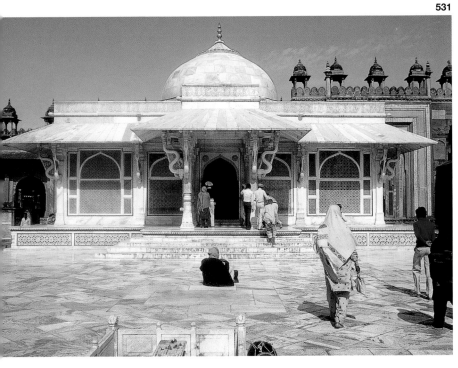

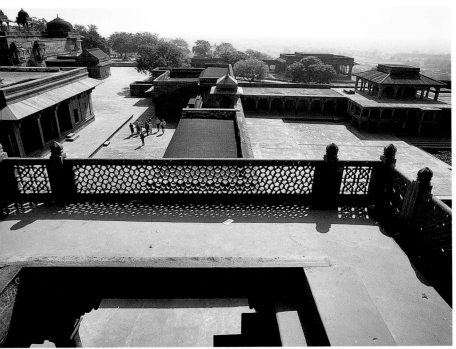

532

31 Chandigarh, 1950–85
Architect: Le Corbusier
The plan of the capital to the north of the
city shows the High Court, the Parliament
and the Secretariat, with the open-hand
sculpture and the Governor's palace to be
built later.
Housing districts for 150,000 people were
to be enlarged to accommodate 500,000
inhabitants.

32 Chandigarh
The Secretariat during construction, on
my first visit when I met Le Corbusier in
Chandigarh, in 1955. The towers attached
to the slab building contained access
ramps used for women labourers carrying
up buckets of concrete. The entire city was
built by hand.

33 Chandigarh
The Parliament building seen with the
foothills of the Himalayas in the distance.
The two chambers of government are in
the centre of the building, projecting far
above the roof and surrounded by circu-
lation space.
Offices are planned against the exterior
walls, covered with sun-protection blades.

31

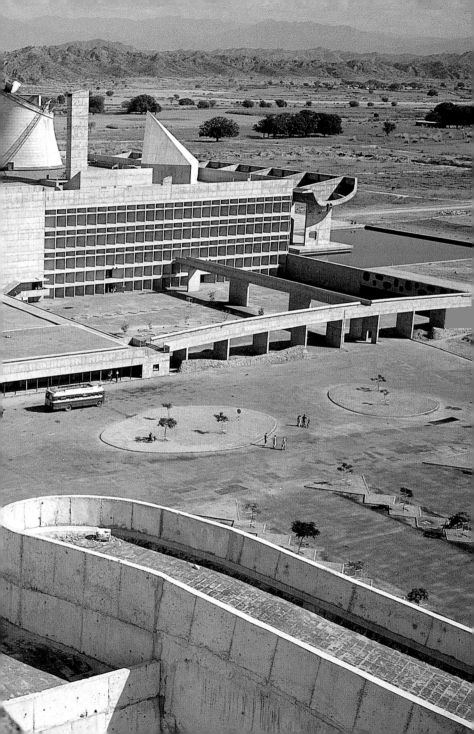

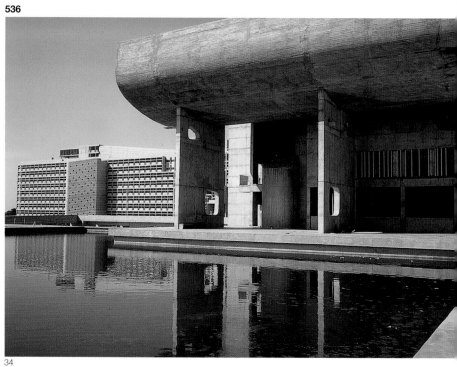

34

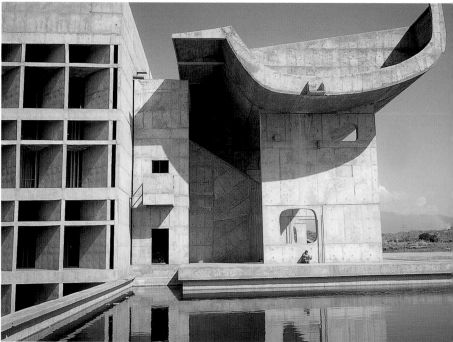

35

-36 Chandigarh, e Parliament building

e dramatically upswept portico of the main trance, with the Secretariat in the background, both reflect in the large water basins. e plan and cross-section show the top- continuously changing inner space ound the chambers, which is the most autiful of any of Le Corbusier's interiors.

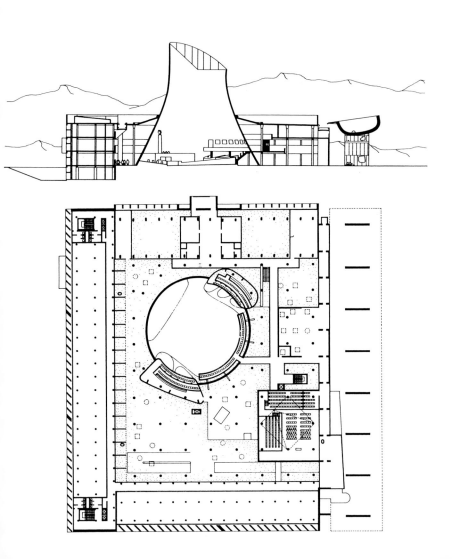

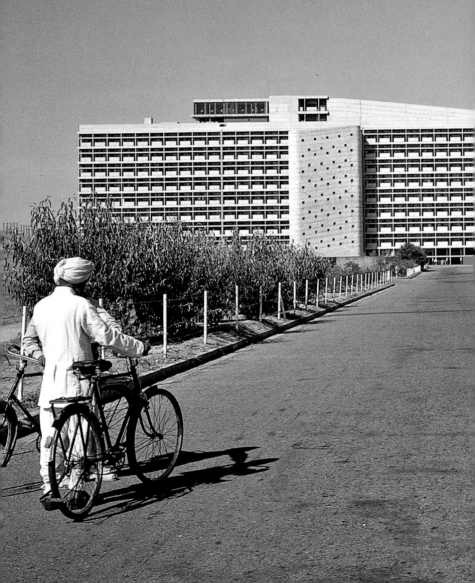

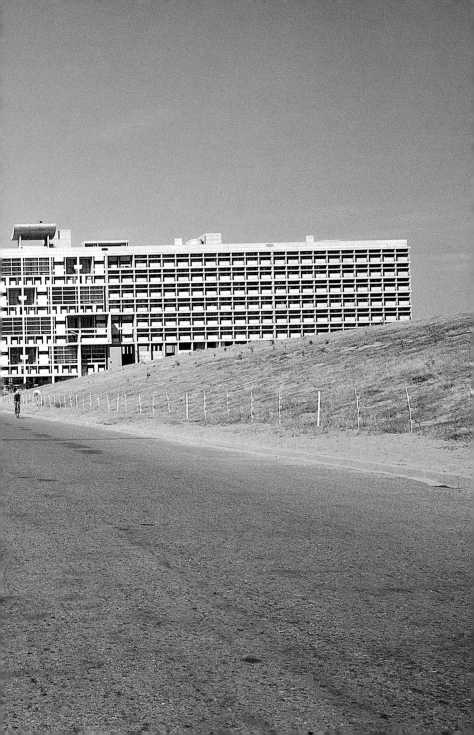

37, 38, 40 Chandigarh

The Secretariat building is 254 meters long
and 42 meters high, with the ramped
pedestrian access tower projecting from
the façade. The continuous, repetitive sun-
protected office galleries are interrupted
by ministerial offices and formal meeting
spaces of irregular height, all of which,
including the offices' proportions, are
based on Le Corbusier's modular system.

39, 41 Chandigarh

The High Court building has an arched
parasol-like roof structure which, together
with the brise-soliel along the ground floor
courts, protect the building from the heat.
The open entrance portico leads between
pylons toward winding ramps that lead to
upper-floor offices. Great sculptured
spaces result.

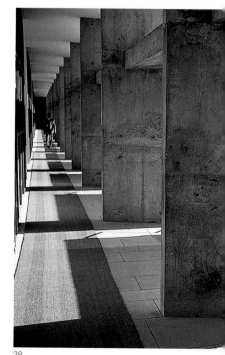

38

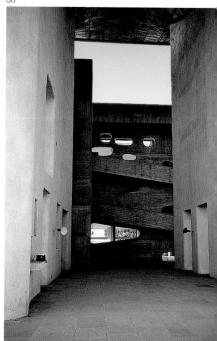

39

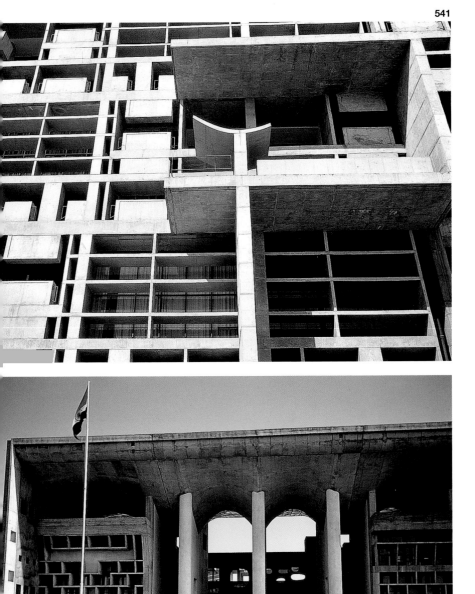

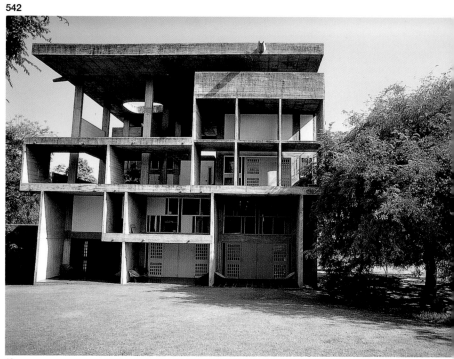

42

43

42, 44 Ahmedabad, Shodhan House, 1951

Architect: Le Corbusier

Following the construction of Chandigarh, some industrialists in the city of Ahmedabad invited Le Corbusier to build houses and the headquarters of the Millowners' Association. The most dramatic of these is the Villa Shodhan, a three-storey building of sculptural plasticity, penetrating spaces and intertwining exteriors and interiors, with modular proportioned glass and solid infill walls.

43, 45 Ahmedabad, Sarabhai House, 1955

Architect: Le Corbusier

This ground-level house is built of regular low concrete arches supported on regularly spaced beams on brick walls. The open interior in this tropical climate allows air currents across and longitudinally through the entire house. For the sons of the house, a concrete slide allows their speedy descent into the swimming pool in the garden.

46

46, 47 Ahmedabad, Millowners' Association Building, 1954
Architect: Le Corbusier
Overlooking a river edge, the street approach leads over an inclined ramp into the open central space, to the offices and meeting halls. Both east and west façades are protected by brise-soleil from the strong sunlight. The form-boarded concrete gives a rugged texture to the entire structure.

48 Ahmedabad, Indian Institute of Management, 1963–74
Architect: Louis Kahn
This 65-acre campus accommodates all teaching areas, staff and student housing, in garden courts. The flat arched brick façades are tied with tensioned concrete lintels that give a distinctive form to the whole complex.

Thailand

Bangkok, the modern capital of Thailand, was founded in 1782 and consisted of encircling moats and walls that guarded the hinterland from the main river.

King Rama V patronised European architecture and town planning, which resulted in an amalgam of Victorian and Thai-style structures. The most remarkable assembly of such buildings is in the wall-enclosed Grand Palace, used by the King for certain ceremonial occasions. Gold-encrusted, high-pointed spire shrines, colourful sculptured figures and triple-layered gabled religious pavilions create an astonishing group of buildings.

The tremendous reclining golden Buddha, 46 metres long and 15 metres high, is only one of 394 gilded Buddha images in temples and museums throughout Bangkok.

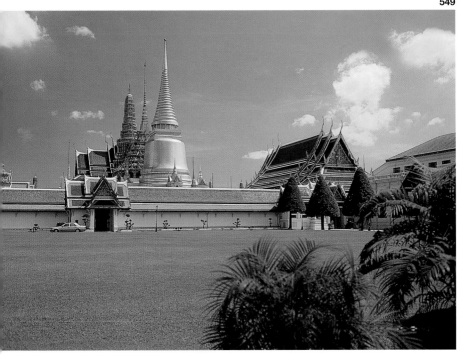

1–3 Bangkok, Grand Palace, 1782
The wall-enclosed Grand Palace contains Bangkok's glistening golden landmark: a huge shrine with a pointed spire.

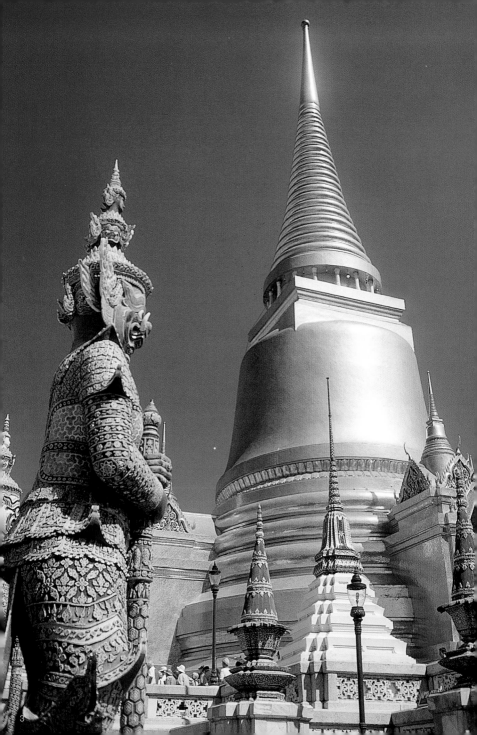

5 Bangkok, Wat Pho, 1781

is wat contains the golden reclining
ıddha. At 46 metres, it is the world's
ıgest.

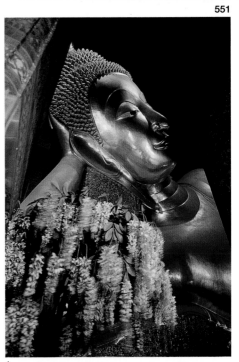

4

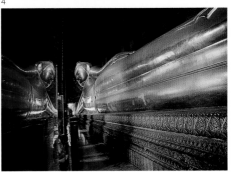

5

Cambodia

During the Khmer Kingdom of Angkor (900–1200 AD) some of the world's most magnificent architectural masterpieces we constructed. The Angkor area consists of various compounds of Hindu and Buddhis structures and contains over 70 major tem ples and other buildings. The mostly squa concentric courts contain colonnaded galleries with the focal tower buildings increasing in height at intersections.

After Siamese attacks Angkor was abandoned in the 15th century and only Angkc Wat remained, as a shrine for Buddhist pilgrims. The other temple structures became enveloped by the tropical forest, with huge trees growing out of some of th compounds, until restorations commence in 1908.

From my observation, I believe that Angkc Wat is the only area built on a 2-metre thi basalt stone foundation, in comparison to other areas that have very thin and largely collapsed foundations. That is the main reason for Angkor's survival.

Structural failures also occurred since only layers of progressively cantilevered stone were used across gallery roofs (segmenta arch construction was unknown at the time).

Of great interest are the "apsara, or heavenly nymph" reliefs, that appear on all buildings. Bas-reliefs cover entire walls, depicting warriors in battle and marching elephants.

1 Angkor Wat, 12th century
Entrance gallery with carved basalt relief sculptures.

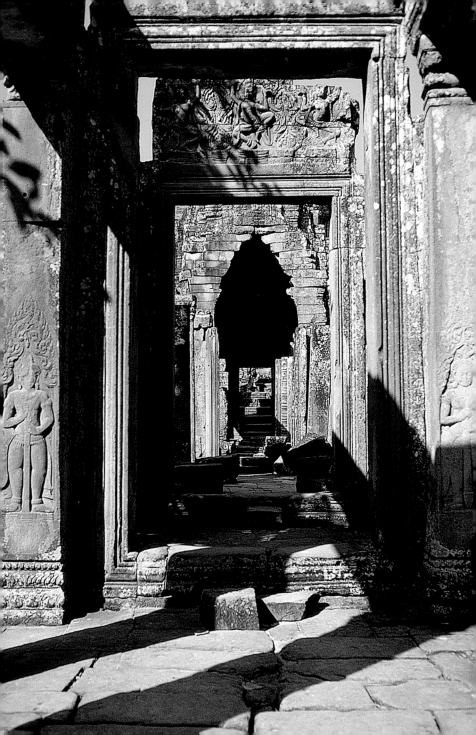

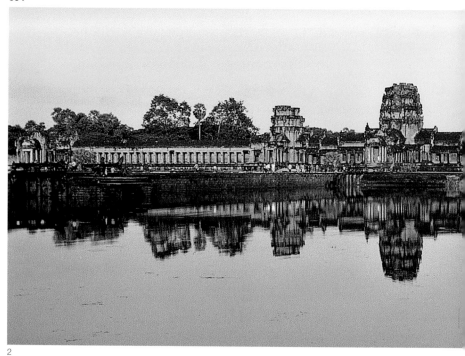

2

2 Angkor Wat

Entrance causeway with tower structures.

3, 4 Angkor Wat

Tower structure rising from a courtyard and ground plan showing central structures and open courts.

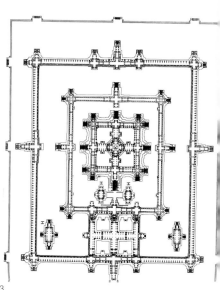

3

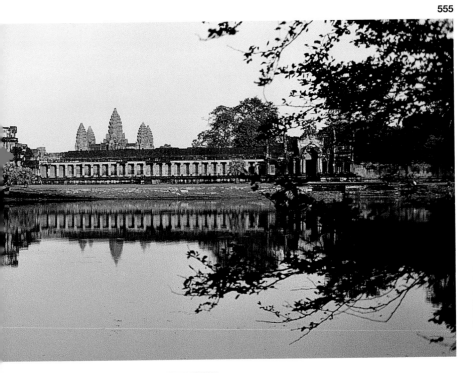

5

5–7 Angkor Wat
"Apsara" relief sculptures and views of courts.

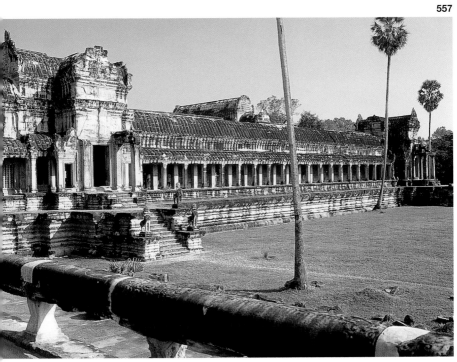

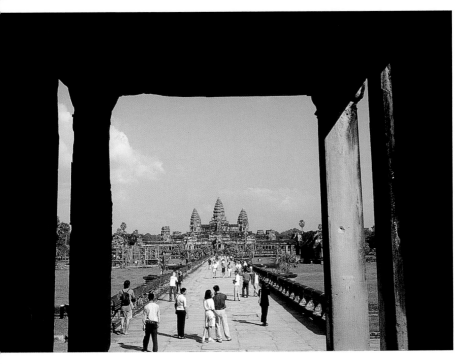

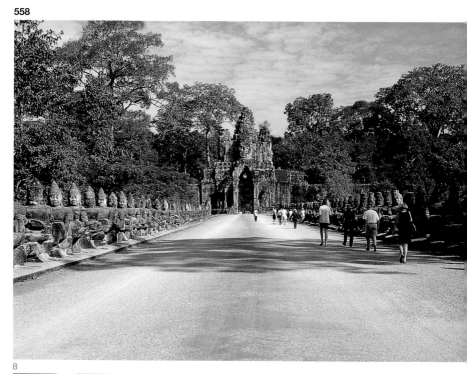

8

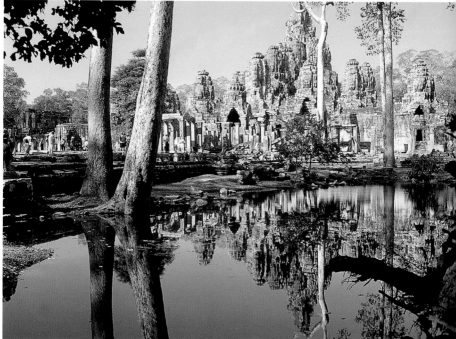

8 Angkor Thom, South Gate
Main entrance gate, lined with heads of gods and demons.

9 Angkor Thom, Bayon, 1200
Entry from reflecting pool.

10, 11, 13 Angkor Wat
Bas-relief wall sculptures.

12 Angkor Thom
Terrace of carved elephants.

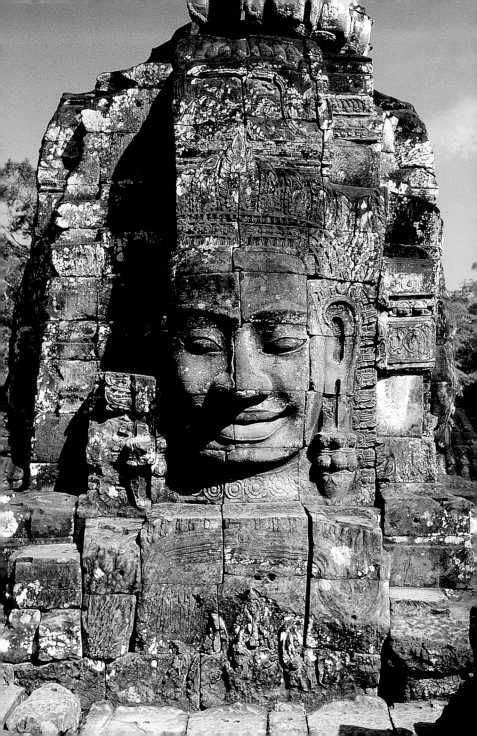

15

16

14 Angkor Thom, Bayon
One of many enigmatically smiling carved heads.

15 Angkor Thom
Centre of the Royal Palace.

16 Ta Prohm, 1186
This Buddhist temple has been left to be swallowed by the jungle. The buildings have been enveloped by tree roots for centuries.

17

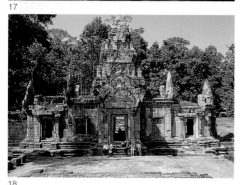

18

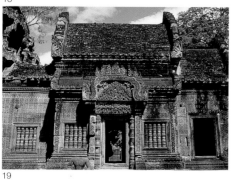

19

20

17–21 Banteay Srei, 10th century
This Hindu temple is decorated with beautiful filigree carved reliefs depicting deities.

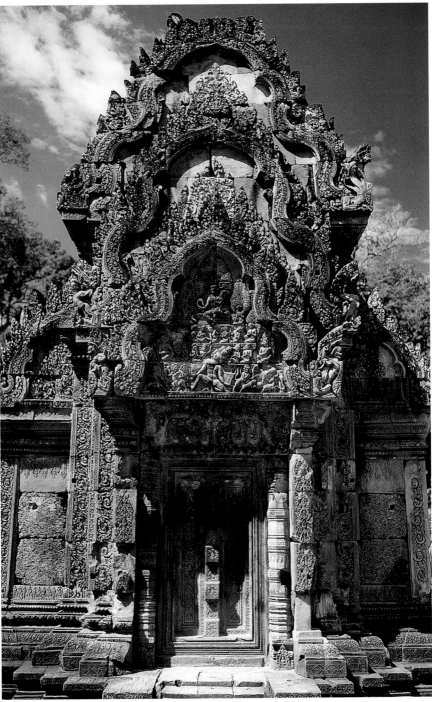

Australia

A penal colony established in Australia soon
after the first landings in 1788 included an
English architect Francis Greenway who
had been transported for committing a
forgery. Upon his arrival, Governor
Macquarie engaged him to design
numerous public buildings that became the
pride of Australia's colonial architecture.
The buildings were intelligently modified
18th-century English Georgian work
constructed within the restricted means
available in the colony and adjusted to the
semi-tropical climate. With the arrival of
large numbers of settlers and immigrant
workers in the early 19th century, contin-
uous-row housing, or "terraces" were built.
They were adapted versions of English pro-
totypes with shaded verandahs and deco-
rative iron railings, brought from Europe as
ballast in sailing ships.
Of all the architecture produced in the inter-
vening years only one building stands out
dramatically, which has become the very
icon of the country: the Sydney Opera
House. The 1957 international competition
was won by the Danish architect Jørn
Utzon. Standing on a peninsula reaching
into the harbour, the multiple vaulted forms
of the building are based on ingenious
geometry, executed in pre-stressed, pre-
cast concrete ribs with a white glazed
exterior surface. Following a change in gov-
ernment in 1966, with the building by then
structurally complete Jørn Utzon was
dismissed and left the country never to
return. His estimate of time to complete the
building had been considered excessive at
one and a half years. It took the new
government seven years to complete the
work in 1973, with a resulting interior
universally considered to be a great
disappointment.
Australia's record in its treatment of archi-
tects is very poor. Walter Burley Griffin, the
Chicago architect who won the international
competition for the design of the country's
capital, Canberra, never built there and left
the country. The rights and freedom of
architectural endeavour have been
hampered by aesthetic jurisdiction
remaining in the hands of untrained local
government bureaucrats.

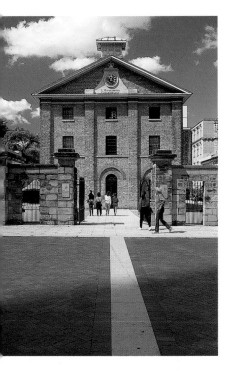

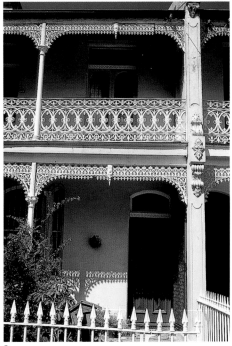

2

1 Sydney, Hyde Park Barracks, 1817–19
Architect: Francis Greenway
A typical colonial brick building of fine proportions following English Georgian precedence.

2 Sydney, Terrace House, mid-19th century
Typical row house with shaded verandah and English iron railings, imported as ballast on sailing ships.

3 Francis Greenway, 1777–1837

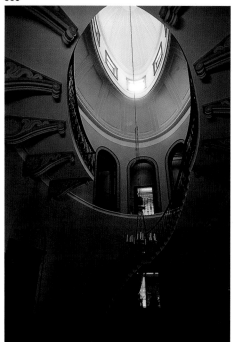

4

4 Sydney, Elizabeth Bay House, 1835
Architect: John Verge
An elegant domestic interior space
reflecting English Georgian taste.

5 Sydney, The Mint, 1814
Typical colonial-era building with colon-
naded verandahs.

6 Sydney, terrace houses,
late 19th century
A row of typical "stepping-up" terrace
houses found in the hilly inner districts of
the city. Brick cross-walls support timber
floors and slate roofs. The narrow
allotments have enclosed gardens at the
rear.

7 Sydney, Opera House, 1957–73
Architect: Jørn Utzon
Selected at an international architectural
competition, this unique pre-cast concrete
ribbed structure is covered with glazed
white tiles. After structural completion, there
was a dispute between Utzon and the
newly elected state government client, after
which the architect was dismissed in 1966
never to return. The building was
completed by others and resulted in
disappointing interiors. The exterior Opera
House design is considered the very icon
of Australia.

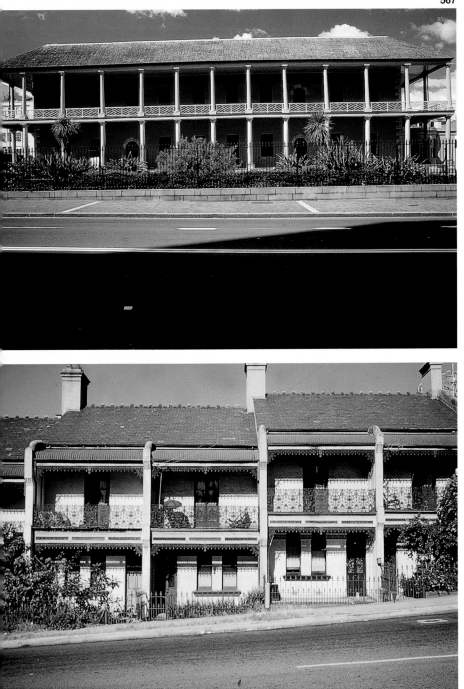

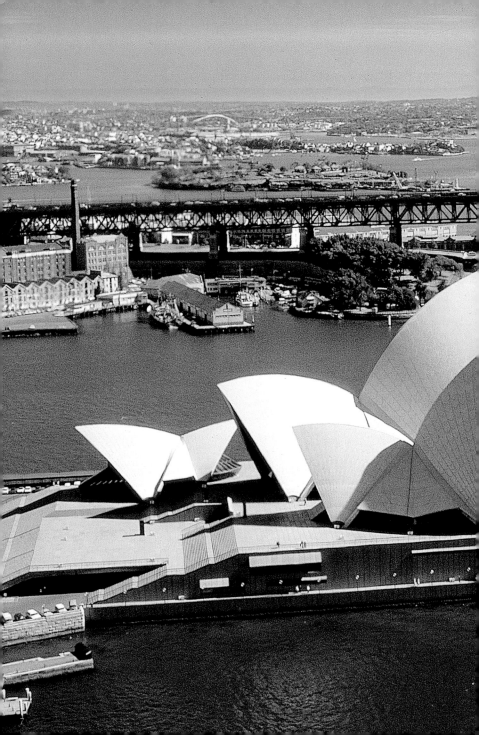

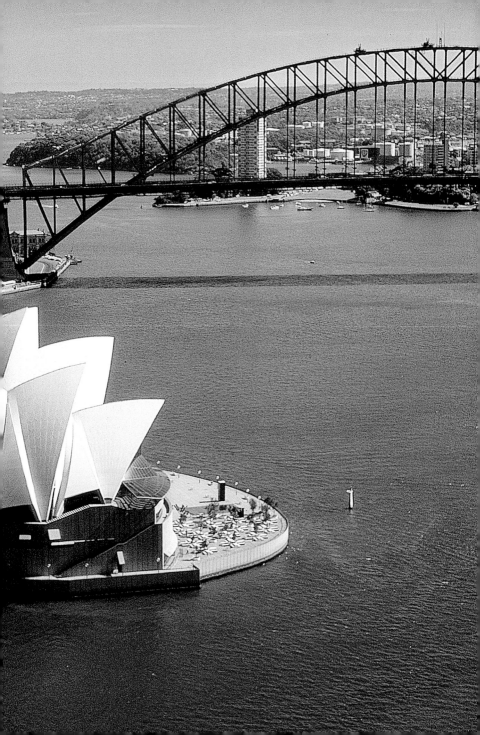

Biography

Harry Seidler (1923–2006), who was born in Vienna, became Australia's foremost architect.

Following the Anschluss occupation in 1938 he fled to England where, after the outbreak of war in 1940, he was interned as an enemy alien. During his internment he was transported to Quebec, but almost two years later he was released to study architecture at the University of Manitoba. In 1945–46 he attended the Master's Class at Harvard University as a student of Walter Gropius. He later studied design under Josef Albers at Black Mountain College. He worked with Marcel Breuer in New York (1946–48) and with Oscar Niemeyer in Brazil on his way to Australia in 1948.

He went to Australia to build a house for his parents: the "Rose Seidler House" in Sydney 1950, which is now a house museum owned and operated by the Historic Houses Trust of NSW.

In over more than fifty years of practice he built a great variety of works, from houses to skyscrapers, both in Australian cities and internationally. His work is widely published and he won many awards, including the RIBA Gold Medal in 1996. He taught and lectured extensively. One of his last works was a housing community situated beside the Danube in Vienna.

During his many trips to his various international projects, Seidler developed a love of photography, documenting what he considered to be the peak achievements of architecture throughout the ages.

This is the first book of his photography. Seidler's work is not illustrated in this book. For a pictorial record of the architectural work of Harry Seidler and Associates, see www.seidler.net.au.

100 Interiors Around
the World

100 Contemporary
Houses

100 Contemporary
Wood Buildings

Contemporary
Concrete Buildings

Julius Shulman

Small Architecture

Green Architecture

Interiors Now!

Tree Houses

Cabins

Modern Architecture
A-Z

Bookworm's delight:
never bore, always excite!

TASCHEN
Bibliotheca Universalis

Frédéric Chaubin.
CCCP

domus 1930s

domus 1940s

domus 1950s

domus 1960s

domus 1970s

Decorative Art 50s

Decorative Art 60s

Decorative Art 70s

1000 Chairs

1000 Lights

Design of the
20th Century

Industrial Design A-Z

The Grand Tour

Architectural Theory

Piranesi.
Complete Etchings

Scandinavian Design

Living in Mexico

Living in Bali

Living in Morocco

Living in Japan

The World
of Ornament

Racinet.
The Costume History

Fashion History

20th Century Fashion

Illustration Now!
Fashion

Extraordinary
Records

Funk & Soul Covers

Jazz Covers

Logo Design

100 Contemporary
Fashion Designers

100 Illustrators

Illustration Now!
Portraits

Film Posters of the
Russian Avant-Garde

Fritz Kahn.
Infographics Pioneer

Mid-Century Ads